Art in the Land

ART in the LAND

A Critical Anthology of Environmental Art

EDITED BY
ALAN SONFIST

E. P. DUTTON, INC. NEW YORK

to my friend
Blythe Bohnen

Published in the United States by E.P. Dutton, Inc.
2 Park Avenue, New York, N.Y. 10016

Library of Congress Catalog Card Number: 81-72014
ISBN: 0-525-47702-0

Published simultaneously in Canada by
Fitzhenry & Whiteside, Limited, Toronto
COBE

10 9 8 7 6 5 4 3 2 1

First Edition

Lawrence Alloway: "Robert Smithson's Development." Reprinted from *Artforum* 11, no. 3 (November 1972), pp. 52–61, by permission of *Artforum* and the author.

Michael Auping: "Earth Art: A Study in Ecological Politics." Copyright ©1983 by Michael Auping. Printed by permission of the author.

Elizabeth C. Baker: "Artworks on the Land." Reprinted from *Art in America* 64, no. 1 (January–February 1976), pp. 92–96, by permission of *Art in America* and the author.

Jack Burnham: "Hans Haacke—Wind and Water Sculpture." Reprinted from *Tri-Quarterly*, supplement no. 1 (Spring 1967), pp. 1–24, by permission of *Tri-Quarterly* and the author. Copyright ©1967 by *Tri-Quarterly*.

Jonathan Carpenter: "Alan Sonfist's Public Sculptures." Copyright ©1983 by Jonathan Carpenter. Printed by permission of the author.

Jeffrey Deitch: "The New Economics of Environmental Art." Copyright ©1983 by Jeffrey Deitch. Printed by permission of the author.

Kenneth S. Friedman: "Words on the Environment." Copyright ©1983 by Kenneth S. Friedman. Printed by permission of the author.

Contents

Preface

This book is concerned with the idea of art in the land and specifically with eighteen artists whose combined work became a movement. As "Environmental Artists: Sources and Directions" shows, very few of these artists began by doing anything remotely related to this type of work. Most of them have devoted only portions of their careers to environmental art but what they produced during those periods warrants their inclusion in this book.

The essays selected for this book either deal with an important issue of art in the land or present a good view of an artist's work. The Joshua C. Taylor and the Robert Rosenblum essays, for instance, are concerned with landscape painters of the nineteenth and twentieth centuries. Photography and nature are written about by Charles Traub, and Michael McDonough discusses certain architectural aspects of environmental art. Politically, art in the land has been detrimental as well as valuable, as the essay by Michael Auping points out. The economics of financing and constructing an environmental work is discussed by Jeffrey Deitch. How various artists make words an essential aspect of their work is the subject of Kenneth S. Friedman's article, and the essays of Mark Rosenthal and Elizabeth C. Baker cover the works of various groups of artists. Cindy Schwab and Jeffrey Wechsler are writing about specific shows devoted to environmental art. The essays by Jack Burnham, Lawrence Alloway, Jonathan Carpenter, Pierre Restany, Donald B. Kuspit, Diana Shaffer, Grace Glueck, Kate Linker, Carol Hall, and Harold Rosenberg are all concerned with how a specific artist responds to the environment through his or her work.

I should especially like to thank Elizabeth Brown, Gerald Donlan, Ashley Durham, Ann Fin, Robert Hudson, Alice Jones, Ari Kamboris, Nancy

Schuessler, Holiday Weiss, and Holly Woodward, who efficiently coordinated many aspects of the final draft, including checking dates and footnotes, fine-tuning the writing herein, and rewriting certain portions so as to present this work as a unified publication.

I also wish to express my profound gratitude to Cyril Nelson and Julie McGown, without whom this project would not have been realized.

Introduction

A growing concern for nature has appeared worldwide over the last two decades. Now, at the end of the twentieth century, society faces crucial decisions about its way of life. Art has always reflected the questioning of a society by itself and often takes an active role in the search for the answers to those questions. This concern for nature is manifesting itself strongly in the United States, where American artists are proposing answers through their work.

A group of artists whose work makes a statement about man's relation to nature has appeared over the last decade. These artists have at one time or another used natural substances such as earth, rocks, and plants in much of their work and have frequently constructed the work outside on natural sites. Although these artworks refer to nature, the artists' methods, styles, and even intentions vary widely. They really cannot' be said to form distinct groups but to occupy places on a broad spectrum.

At one end of the spectrum the idea of monumentality, of earth moving, is made possible by industrial tools: bulldozers, dump trucks, and so forth. The work these artists produce gives rise to thoughts of "wide open spaces," unlimited amounts of American land, and the tradition of its conquest. These artworks were built to speak of themselves, not the land they occupy. At the other end of the spectrum there are artists pursuing the relatively new idea of cooperation with the environment, which they see as necessary because of the threat of its destruction. These artists respond sensitively to the work's site, changing it as little as possible. This group is especially interested in stimulating an awareness of nature and the Earth.

The artists' awarenesss of the Earth is growing worldwide, but the United States has become the center of artistic activities focusing on the idea. Art in the land is an American movement. The experimental atmosphere in the

United States has led to the development of this innovative art within only a few years. In addition, it is significant that America still possesses great quantities of land to which artists have access. Land has always been a primary element in forging the American consciousness. One of the primary motives for coming to America was land. As long as there has been land, the direction of culture has been one of constant expansion.

The first move on the part of American artists to attract the attention of the American public to the natural environment was in the 1820s. The name Hudson River School was not applied to a group of artists for its geographic accuracy but because it grouped together a number of painters who held similar views and employed similar techniques. Thomas Cole, credited with being the founder of the school, was one of the first American painters to see that "wilderness was the most characteristic feature of the American scene."[1] Many painters, writers, and, later, photographers of the 1800s foresaw the need to protect the natural environment. Documentation was an important motivation behind much of this work, reflecting the artists' understanding of how rapidly the American landscape would change. In most cases their work only inspired an interest in travel rather than preservation on the part of the public.

Roughly a century and a half later, artists in the 1960s began producing work with some of the same motivations as those of the Hudson River painters. The artists in this book have had their work grouped together, correctly or incorrectly, under such labels as "earth art," "environmental art," and "land art." For reasons as varied as the artists themselves, they have focused public awareness on the use of nature in art, and on nature itself. The motives behind the more than casual allusions to nature all these artists have made are left up to the reader to sort out. It may be important at the end of the twentieth century to ask "In what direction are artists leading our society?"

NOTE

1. Quoted in Barbara Novak, *American Painting of the Nineteenth Century: Realism, Idealism, and the American Experience* (New York: Harper & Row, 1979), p. 71.

Art in the Land

JOSHUA C. TAYLOR

A Land
for
Landscapes

The changing relationship between American artists and the American landscape that has oc-curred over the last 150 to 200 years is the subject of an essay by the late Joshua Taylor, author and director of the National Museum of American Art, Smithsonian Institution. Translated through the works of artists like Cole, Durand, Bierstadt, Inness, Ryder, and the more contem-porary artists O'Keeffe, Strand, Weston, Avery, and Sonfist, this changing relationship has been traced from the beginning of American landscape art. In many ways, what was once expressed through "landscape painting" now takes the form of "environmental art." How have artists' motives changed over this time and why has the landscape remained such a predominant subject in their work? American art, like the nation in general, has approached the landscape from a wide range of viewpoints, from the need to dominate nature to the hope of preserving it.

Artists were late in discovering landscape as a meaningful subject for their work. Except as a setting for human activity, landscape at first had little significance for painting beyond recording a specific site. Because art was regarded as the projection of human understanding—helped by a divine spark of genius—there seemed little point in simply representing what one saw. But attitudes toward both art and nature materially changed between the beginning of the seventeenth century and the time when American artists began noticing the attractions of their own wilderness, some two centuries later.

The first appraisals of American nature were made with an eye toward production: how a patch of landscape would favor agriculture, settlement, shipping, or prosperity in general. Of course, there were remarks about agreeable vistas and natural curiosities, but the wilderness was there to be

won, not admired. By the mid-eighteenth century, cultivated Englishmen were beginning to talk about nature as a balm or stimulant to the human mind, how a cataract could provoke sublime emotions, how one could pleasurably lose oneself in the inviting disorder of wild nature, or find calm and assurance in a well-ordered, smoothly contoured landscape. Through the persuasive power of their forms, natural surroundings, it was averred, had an effect on man's character and even on the way he thought.

Such ideas gained currency in America just as the country was becoming newly aware of itself. So rural estates were planted to afford the proud owner the peace of the smoothly "beautiful" or the spiritually stimulating irregularity of the "picturesque," making the garden a mentor for the emotions and a complement to the mind. Areas were searched for picturesque views and, above all, for overwhelming natural phenomena that could move the reverent observer to an awareness of the sublime. About the only natural event that could be counted on for this latter soul-stirring experience was the thundering Niagara Falls, which was painted at least once by every artist with even a slight interest in landscape from the beginning of the nineteenth century on.

The drama of American landscape as discovered in other aspects of its wilderness was first revealed by the New York painter Thomas Cole. Prepared to be moved by the jagged forms of storm-struck trees and the contest between light and shade set up by sun and rolling clouds, he found along the Hudson River all of the elements necessary to stir the soul to an awareness of God's rule and the fragility of human destiny. Unspoiled nature, in which America abounded, still spoke God's truth, and through the drama of its ever-changing forms, man could escape his petty concerns to become one with a moral universe. America's raw nature could inspire the human spirit to achieve a level of morality as no man-trammeled European nature could. When Cole went to Europe to study, America's nature poet William Cullen Bryant warned him not to be seduced by the softer aspects of foreign skies.

The generation of American painters inspired by Cole saw little reason to dramatize the spiritual quality of nature in his forceful way, neither were they inclined to interpret a thunderstorm as a hell-and-brimstone sermon. They accepted the fact that nature was a manifestation of God, but saw the face of deity in a more smiling aspect.

By the 1840s nature was not threat but promise. Asher Brown Durand in his great painting of Dover Plains, New York (1848), shows nature to be

bounteous on two levels. Cows forage in peaceful fields watered by a placid lake, sheep graze beneath the flourishing trees, and in the background grain is being harvested. Meanwhile a group of young people clamber over the undisturbed boulders picking lush berries from the wild vines. But on the topmost rock a young woman shields her eyes to take in the grandeur of the extensive scene. The warm sun, the rolling hills masked in a delicate blue haze, and the open, inviting space provide a spiritual feast no less important or nourishing than the edible products of the land.

Durand and his friends were very conscious of these spiritual values. They spoke of their landscape studies not in terms of composition and technique but in terms of moral value. Nonetheless, a meticulousness of rendering was important to them. If nature was to be seen as the manifestation of God's hand, who were they to change it through predilections of their own? Visual truth became a moral principle; to deviate from exact appearance was a kind of blasphemy. The artist's role was not to boast of his own feelings and his creative accomplishments but to call attention to the verities of nature in such a way that nature, not the artist, moved the spectator. Art, in other words, was only as good as its success in identifying itself wholly with nature. It was the means, as Ralph Waldo Emerson was wont to point out, for a more receptive encounter with nature itself. In *Nature* he had written:

> In the woods, we return to reason and faith. There I feel that nothing can befall me in life—no disgrace, no calamity (leaving me my eyes), which nature cannot repair. Standing on the bare ground—my head bathed by the blithe air and uplifted into infinite space—all mean egotism vanishes. I become a transparent eyeball; I am nothing; I see it all; the currents of the Universal Being circulate through me; I am part and parcel of God.

So artists journeyed through the countryside, sketchbooks in hand, to study art not in European galleries of artistic masterpieces but in the woods, the mountains, and peaceful fields of the United States. One need not be an artist, of course, to commune with nature, and people traveled to mountain retreats and resorts on the rocky seacoast to be won over by the spell of nature. As life became more urban, the importance of such healthful sessions became greater, as did the collecting of landscape paintings. Each painting was a quintessential experience of nature, a moral reminder in an otherwise busy, gainful life.

The mountains and the shore were two attractive poles: the grandeur of high places and tall woods, or the threatening yet consoling vastness of the ever-active sea. Rough waves assaulting rocks, whether on the Isles of

Shoals, New Hampshire, or at Marblehead, Massachusetts, seemed to cleanse the mind of other associations, absorbing the entire attention of the seeker after natural truth. The symbol of the seashore as a spiritual restorative was formed early and lasted late, well past the magnificent seas of Winslow Homer and the sun-flecked waves of Childe Hassam. The shore outlasted the mountains in America as an image in art.

By mid-century, although many artists were content with even the most modest aspects of nature—an attitude not unlike Thoreau's—some regularly lamented the fact that for the really overwhelming impact of nature one had to travel through the Alps or take a boat down the Rhine. The early enchantment of Niagara had gradually worn a bit thin. Then the miraculous happened. Artists accompanying surveying expeditions to the West began to bring back exciting images of Yellowstone, the Rocky Mountains, and Yosemite. Here was rugged grandeur second to none. Albert Bierstadt, who first traveled West in 1859, expressed his awe and admiration of the mountainous scene in huge canvases that drew the imagination into a realm of vast peaks, mirrorlike lakes, and mysterious veils of iridescent mist that promised more mountain wonders beyond. Whereas Frederic Edwin Church's paintings of immense spaces and snow-capped mountains in South America were exotic and fascinating in their intricacy, Bierstadt's grandiloquent experiences were a part of America. In fact they quickly became associated with the new American dream of infinite expansion to the West, of new discoveries and potentialities, of a triumphant march of westward progress. There was in Bierstadt's pictorial hymns to Western grandeur both a mystic idealism and attention to material fact, two qualities they shared with the spirit of *Westward Ho!*

This was a new kind of landscape painting. It was big, often so in size and always in conception. The eye could not grasp it all at once but had to wander through its spaces, enjoying the passing scene but looking for more. Thomas Moran saw the West as a member of expeditions to the Yellowstone and down the Colorado and painted such epochal works as *The Grand Canyon of the Yellowstone* (1893–1901). As from an eagle's perch, the viewer can focus on an isolated pinnacle and exult in the vast surrounding space. The sun, in these sweeping paintings, is never passive but kindles brilliant fires in the clouds or on the walls of strange eroded canyons. This was God's country, one liked to say, but the powerful, ragged images seemed, in their challenge, to affirm the importance of man. America began to identify itself with the intractable West, considering its distances and demanding mountains to be both test and symbol of American character. The exultant poetry of Whit-

man, not the reflective philosophy of Emerson, matched these epic proportions.

A different poetry of landscape, however, developed in these same years in direct contrast to the exclamatory verse of the expanding West. George Inness was no more interested than Bierstadt in losing himself in the moral minutiae of a domesticated woodland, but he shied away from overtowering grandeur. Landscape for him was a way of feeling. He wished his paintings of eastern scenes to mirror his state of mind, not just to imitate the landscape that produced it. More and more his creations in paint became moody evocations with little attention given to the specific place or time. At first such works were rejected as being morally suspect: they did slight justice to the details of God's handiwork or were lacking in American stature. But by the 1870s and 1880s there was a growing appreciation for the haunting effect of his sensuous elegies. Alien to the forces of progress, his personal dream in the face of nature confirmed a different aspect of individuality. The deeply rooted strain of feeling reached by sensuous suggestion rather than descriptive statement could be understood in terms either of religion or simply of art. Inness looked on his reaction to nature as religious—although not in the way of Cole or Durand—because it put him in touch with his own inner spirit, which, he assumed, was not unlike the spirit that motivated all men and nature as well. The painting was a creation of the artist who had been inspired by nature; more than a view, it was a landscape of the mind.

Some of the nostalgic mood of Inness's paintings reflects the quality he found in the works of such French painters as Rousseau and Millet, innovative and initially unpopular artists who had chosen to lead the peasant life in a rustic spot outside Paris called Barbizon. There the forest was wild, the fields rugged, giving evidence of the struggles of the humble peasants who depended on that land. The peasant, ever toiling in the tradition of his ancestors, blended perfectly into this ages-old landscape. But to American painters, attracted by this vision, traditional peasant life seemed more than exotic; they tended to accept the scene as a pure Vergilian eclogue with no overtones of social problems. The peasant became only a poetic symbol who, as at times with Inness, might appear in a New Jersey landscape.

Landscape as visual poetry had some notable supporters in the last quarter of nineteenth-century American art. As with Inness, Ralph Blakelock's nocturnal scenes were based on his own observations, but his paintings were built up of evident paint, form by form, color by color—the way Poe assembled a poem—until the canvas itself evoked the feeling he associated

with nature. Nonetheless the paintings relate to the known environment if only because, after looking at a late Inness or Blakelock, one sees the surrounding landscape differently, as having new potentiality for the reflective mind.

The most powerful visual poet of landscape was Albert Pinkham Ryder. Whether he painted a farmyard or a boat tossed at sea, he endowed each object and shape with a mysterous aura. His forms are simple because each one was built up over the years with layer on layer of paint until there was not a line or shape that failed to carry its haunting message. Ryder also wrote poetry, but whether his medium was words or paint his goal was to open the mind to an expanding radiation of thought and feeling, for which his landscape image was only the starting point. To explore landscape was to explore the inner life of man.

The association of sentiment with landscape was strong in America—so strong that when American painters were attracted to the new range of prismatic color introduced in Paris by the Impressionists, they adapted it to their own expressive purposes rather than following the objective procedures of Monet or Pissarro. John Twachtman ruminated on the somber beauties of autumn or winter or evoked the blissful reminiscence of a protracted summer afternoon. J. Alden Weir found the sunlight falling across the upland pasture of his Connecticut farm an adequate excuse for quiet, reflective contemplation. Even Childe Hassam, who followed more closely than most the new French scheme of divided color, saw landscape not just as vision but as mood. The Americans at this point were unwilling to give up their hard-won right to visual poetry; objective vision was a separate, long-established tradition in America. Landscape belonged not to God or country but to the artist who looked at it.

Even the American artists who embraced those exciting concepts of art from Paris early in the twentieth century came back to rethink the new forms in the face of the American landscape. John Marin, fascinated with the intermingling of time and space that made the Cubist and Futurist paintings so dynamic, discovered the full power of the new vision on the coast of Maine. Georgia O'Keeffe discovered the most eloquent expression of her refined, purist taste of the 1920s in the bleached forms and spare landscape of New Mexico. There also Edward Weston, Paul Strand, and others proved the subtlety of photography, using the dunes and the sky to test infinite refinement of photographic line and value. Art in America grew out of the American landscape, and the landscape has never been far from any artist's consciousness—regardless of aesthetic direction.

In the 1930s, when Depression America was trying to reestablish direction, eyes were turned once more to the land, and artists rediscovered the country from Maine to California. They might paint the fertile midwestern fields, as did Grant Wood and John Steuart Curry, New England countrysides in the snow, or personal fantasies of small towns and haunted forests. But in the American landscape they found and provided the public with a credible sense of stability through a renewed feeling for place.

The artist in more recent years has, no less than his forerunners, found in the American landscape a means for reaching out to the world around him while remaining in touch with his own inner promptings. The ever-changing complexity of these corners of the environment not yet dominated by man retains a rejuvenating newness to even the most jaded eye. Milton Avery found an everlasting summer of glowing hues and unconstructed forms; Karl Knaths never tired of the shifting puzzles of space and light. The artist has used his sensitivity to the natural prospect as a way of adjusting and refining the response of man to his surrounding world.

In a society devoted to definitions and limits, the immensity of nature has proved a vital challenge to the artist. Earth sculptors have created huge forms that become a part of nature and punctuate its spaces, and—for those who have found that concepts can outstrip the reach of some forms—the Earth itself has become a part of the artist's imaginative calculations. On the other hand, some—like Alan Sonfist, in his collage from *The Leaf Met the Paper in Time* (1971)—have reacted to a cosmic consciousness by returning to specific nature in its smallest detail.

For art in America, the landscape has meant freedom and expansion, or, when useful, discipline and concentration. But once the artist took possession of his environment, the natural bounty of America was never far from the surface of his art.

CAROL HALL

Environmental Artists:
Sources and Directions

What were the artistic beginnings of the artists associated with the environmental art movement? How did they start their careers and what kind of work did they produce? This essay by free-lance journalist Carol Hall points to the fact that artists came to this movement from a variety of creative orientations and, for a time, found in it a common ground of expression.

Environmental art began in the early 1960s and, gathering support and artists along the way, by the end of the decade had become a movement. It grew and, contrary to the simplicity of the label, developed outcroppings that went off in a number of directions, some of which are still generating artwork today. Of the artists discussed in this anthology, all major contributors to the movement, only a few began as "environmental artists" per se. Many began as painters, some as sculptors, and some as photographers or writers.

The chronological beginnings of these various artists are spread over the years this movement has encompassed. In the mid-1950s Robert Morris was a painter who suspended himself from a scaffold over his canvases on the floor. He appplied commercial tinting colors with either a spatula or his hands. Robert Smithson was also painting in the late 1950s. A 1959 review of some of Smithson's early work describes it as "painted collages based on vertical bars within which are caged raving, multi-eyed dinosaurs and flesh-eaters. These monsters, whelped by Surrealism and primitive art, are realized by frenzied Action Painting."[1] Michael Heizer, the son of an archaeologist, was an expressionistic figure painter until 1964. Jan Dibbets painted until 1967, when he turned to photography. His paintings were

Minimal works that dealt with how simple geometric shapes affect the illusion of perspective.

A large number of the environmental artists discussed in this anthology began, logically enough, as sculptors. For many, environmental art became a natural extension of their sculpture, whereas for some, although they continued to manipulate objects, their later work could only loosely be called sculpture. Newton Harrison began as a sculptor in the 1950s but turned to painting in the 1960s. In 1961 he did *The Gather Series,* paintings using sand mixed with colors and modeled in areas. In 1962 Christo Javacheff stacked painted oil drums on the Cologne waterfront, and Walter De Maria was constructing boxes and geometric shapes from plywood. One artwork, a "statue" of John Cage, consisted of eight tall dowels in a cagelike arrangement. *Pointer Board* (1961) was a piece of plywood with holes in it and a pointer for the purpose of pointing them out. Mark Boyle, in 1963, constructed "assemblages," one of which was a collage of a paint-smeared palette, paint tins, and brushes.

Others who began as sculptors first attracted notice in the mid-1960s or later. Mary Miss's early sculpture was an exploration of her materials' physical properties. In 1966 Charles Ross's first show contained *Prism No. 5,* a five-sided Plexiglas column filled with water and mounted on another clear column. *Column No. 4,* on the other hand, was composed of thin Plexiglas slices, variously colored and stacked to form rainbow-hued columns. Michael Singer's earliest works, sculptures, were made with steel and milled wood. In 1971 he began working out of doors with wind-felled logs to create a group of pieces called *Situation Balances*. These were built in relation to the site chosen by Singer.

Other artists who were to be associated with environmental art began in media more remote from large-scale construction. Nancy Holt was a photographer and video artist before beginning her constructions. Throughout the early 1960s Holt took photographs and in the mid-1960s became especially interested in making pictures of New York City life. Alice Aycock, around 1971, was shooting photographs of "abstract" things in nature, their directions and boundaries. Hans Haacke's first show (1962) consisted of lithographs and relief prints. The lithographs were clusters of pale yellow dots assembled on white grounds in random formations or loosely constructed rectangles. The relief prints were similar collections of dots in inkless intaglio. Peter Hutchinson originally came to an American university from England to study to become a plant geneticist. He switched to art and in 1964 showed small grids made with wooden strips on which letters were pasted and some color painted. Hutchinson, an avid writer, contributed many articles to

various art publications. In 1968 he combined his interest in art and nature and attempted to plant wild phlox and mushrooms on the ocean floor, a prelude to much of his later work.

Obviously, artists of such various beginnings came to work with the land from different media and intellectual commitments. They carried these earlier viewpoints into their work with nature. Each person's work and ideas developed and changed enough so that, for all their subsequent divergence, they crossed a common ground at some point.

ALICE AYCOCK

Alice Aycock was working on various photographic projects in 1971. Nature frequently figured as part of her theme and material and played a large part in *Sun Glass* (1971), a temporary piece located in a field. "It consisted of seven rows of mirrors, each row set at a different angle to pick up and reflect the sun's path across the sky, which naturally hardened, cracked, and shrank, setting up its own organization and organic scale."[2] In 1972 she moved her work out of doors and constructed *Maze,* a labyrinth of concentric circles with a sod roof on Gibney Farm, New Kingston, Pennsylvania. In this same period she also put a 13-foot-high construction called *Stairs (These Stairs Can Be Climbed)* in a gallery.

"Aycock's work varies physically, but it is generally concerned with natural processes or systems and with the human consciousness of and responses to them."[3] She went on to build *A Simple Network of Underground Wells and Tunnels* (1975), by this time having displayed her bent for the re-creation of specific environments. This project consisted of six 7-foot-deep wells in the earth connected by tunnels. The "viewer" would descend a ladder into a well and crawl through the 25-foot-high tunnels. The inspiration for this apparently came from childhood fears of attics and cellars. Her main interest was in seeing how the participants would respond to the small spaces. In 1976 she took part in a group show called "Labyrinths" and in 1977 produced *The Beginnings of a Complex,* a wooden building facade with nothing but steps behind its front.

Also in 1977 she produced *The True and False Project.* The piece was composed of a drawing and a construction; the drawing a microcosm of five architectural projects from the past: early Christian catacombs, a giant English telescope, an engraving by Piranesi, a building from a Bosch painting, and a Russian Constructivist stage set. The construction actually built is a large white box with ladders leaning on it and steps cut into it. There are crawl

spaces, ladders whose rungs come together at the top, and stairways whose widths narrow as they spiral upward. Her studies of Germanic medievalism inspired a simple architectural piece, *Studies for a Town* (1978).

Alice Aycock clearly has always been interested in environments and how they affect people. She has explored her feelings concerning the natural environment, the psychological environment, and the architectural environment during the last decade.

MARK BOYLE

Mark Boyle began to be noticed in the early 1960s for his assemblages. A 1964 piece titled *Assemblage No. 3* was a sculptural collage of glass eyes, spectacles, an old master reproduction, and a wax eye and nose. By 1966 he had begun to stage Happenings, referred to by him as "presentations" or "events." At one, Boyle invited the audience backstage after the performance was supposedly over. The curtain went up a few moments later, and the audience became the players, as they could be seen looking through the

1. Alice Aycock: *Williams College Project.* 1974. Concrete block chamber, 24″ x 73″ x 48″ inside, covered with an earth mound, approx. diam. 15′. Williamstown, Massachusetts. (Photograph: John Weber Gallery)

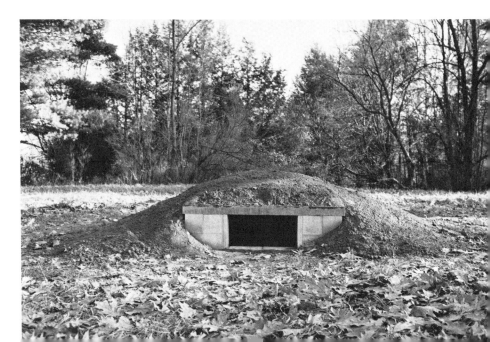

props and handling the costumes. No directions were given, but, Boyle noted later, the audience felt that something was expected of it. His events, assemblages, plus the poetry he was writing, all used extensive symbolism as well as a large degree of chance in their creation.

In 1967 Boyle and his wife, Joan, presented *Son et Lumière for Bodily Fluids and Functions*. Boyle described it as "an event in which we extracted all the available fluids from ourselves on the stage, and projected them onto ourselves and the screen to the accompaniment of the amplified sound of our bodies."[4] The fluids were put on slides for projection, and microphones amplified the various noises made by their bodies. In 1969 he showed works that consisted of electron-microphotographs of random squares of his skin.

Over a period of time during 1968 and 1969 Boyle asked arbitrarily selected people to participate in the process of making an artwork. The peo-

2. Mark Boyle: *Shattered Concrete Study—Breakers Yard Series.* 1976–1977. Earth, glass, and wood on fiber glass, 72″ x 72″. (Photograph: eeva-inkeri; courtesy Charles Cowles Gallery, Inc.)

ple, who agreed to be blindfolded, were to throw a single dart at a large map of the world Boyle had in his studio. He collected 1,000 random locations this way and plans to go to all of them in the future. Since 1970 he has been going to as many locations as possible. Once at one of these sites, he takes photographs and makes castings, square yards at a time, of different surfaces there: sidewalks, street corners, manhole covers, or, if the site is outside of a city, he casts rocks, dirt, sand, and so forth. In 1972 he showed the *Thaw Series*, fiber-glass castings of squares of melting snow. That same year *Rock Series* appeared; casts of variously located rocks comprised the series. Still traveling the globe and working on his documentation of it, Boyle held a show in London in 1978 at which he exhibited a variety of his castings.

CHRISTO

Known for his controversial "wrapping" Christo, who was born in Bulgaria in 1935, has received a tremendous amount of attention and been very successful in making people aware of land art. Because his work is often controversial, he is, as a result, often in the headlines. As Charles McCorquodale once said, "Christo is certainly an artist in public relations. He has that innate sense of how to provoke public opinion into positive or negative responses that will either hit the headlines or be placed not far below them."[5] In 1958 he began wrapping his first objects: tables, chairs, bicycles, and sometimes even his own paintings, using canvas or polythene as the enveloping material and then, of course, binding them up within a mesh of string, twine, or rope. *Inventory* (Paris, 1958) consisted of just such unmodified, wrapped, and painted objects. In the period from 1958 through 1965 he purposefully utilized life-size objects; his wrappings were inherently mysterious and brought to mind images of containment, concealment, imprisonment, intervention, and ambiguity. The beauty of the wrappings came not only from the packaging itself but from the tug and pull exercised on the fabric by the object wrapped—a kind of tension. In 1959 he made tables on top of which were wrapped objects packaged in such a way that their identity was obscured. Lawrence Alloway called it "an exploration of the geometry of surfaces" in which "the packaging obscured, wholly or in part, the core, but without destroying the impression of containment."[6]

In his exhibition at the Galleria Apollinaire, Milan (1963), Christo presented a collage of advertisers' packaging slogans, slightly ironic in nature, illustrating his technique for using found industrial materials and waste as material for art, which is a crucial aspect of Christo's work.

Likewise, in *Iron Curtain* (1962) Christo blocked the rue Visconti, Paris, with a wall of used metal oil barrels. It has been said of Christo that he rarely uses objects or materials that have an artistic function of their own. It is, rather, through association and through the intervention of the artist himself that they become material for art.

He began building fake storefronts in New York in 1964, on the inside windows of which were hung either curtains, cloth, or sheets of brown paper. The viewers' vision of the inside of the storefront was, therefore, partially obstructed in much the same way as it would have been purposefully obstructed by a window designer changing a window. These storefronts were human in scale, the earlier ones reminiscent of a vernacular New York design but completely sealed up; doors and windows either closed or blocked—completely inoperative. At the Castelli Gallery (1964) he presented a storefront with the blinds drawn but a light on inside and what looked like an air conditioner tied up into a package over the door. The later storefronts

3. Christo: *Dockside Packages.* 1961. Rolls of paper, tarpaulin, and rope, 16′ x 6′ x 32′. Cologne harbor, West Germany. (Photograph courtesy the artist)

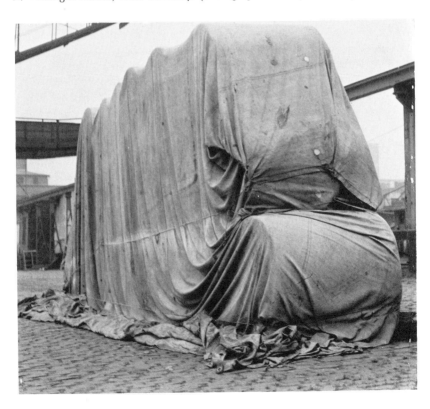

(1965–1966) were less colorful, more severe, and evoked the "mid-century production line rather than the nineteenth-century craftsman as the source of form."[7] In 1961 Christo began playing on the theme of transportation. Among other things, he wrapped a Renault car in 1961, a baby carriage and a motorcycle in 1962, and a Volkswagen in 1963.

There is also a certain paradox inherent in Christo's wrappings. *Wrapped Girl* (1968), a delicate, sensuous drawing of a woman wrapped in semitransparent material then tied, as all of Christo's packages are tied, in rope, and *Packed Girl* (1967), in which the woman's wrapping are even more reminiscent of a shroud or mummified being, are drawings, both of which have accompanied and expounded on Christo's project for a wrapped girl, first exercised in Paris in 1962, then again in London (1963), Minneapolis (1967), and in a number of other cities. In this project Christo actually wrapped—temporarily, of course—a live girl. The drawings "recall the ancient Peruvian custom of making nice, neat parcels of their dead. . ."[8] In fact, it has been suggested that the idea of wrapping is itself a means of preserving, enshrouding, and protecting objects much in the same way as the ancient Egyptians preserved, through wrapping, the bodies of their dead. By wrapping objects, Christo takes them out of the world of everyday usage and elevates them into the world of art. "Since the object or building has not been affected or transformed and since the wrapping is a mechanical and not a stylistic device, we must conclude that it is not the wrapping per se but rather the artist's decision to intervene and transfer a given object or building from a found object to a chosen context that elevates it to the level of art."[9]

He has also wrapped many buildings, mostly museums. In 1968 27,000 square feet of polyethylene was used to wrap the Kunsthalle, Berne—the very first building ever to be wrapped by Christo. That same year he had presented plans to wrap The Museum of Modern Art in New York, but when the controversial project was curbed by the local fire and police departments and insurance agencies, the museum instead displayed an exhibition of the project itself, illustrated by a large photomontage *200,000 cubic feet package*, nine drawings, and six scale models. In *Wrap in Wrap Out* (1969) Christo wrapped the Museum of Contemporary Art in Chicago. Three sides of the exterior of the building were wrapped in heavy brown tarpaulins, the museum signpost and a 36-foot maple tree were wrapped in semitransparent polythene, and the floor of the lower gallery (roughly 2,500 square feet) was wrapped in used painters' dropcloths. Of these dropcloths museum director Jan van der Marck wrote:

> When he covered the floor of the museum's lower gallery with speckled, grey-beige painters' dropcloths, he could hardly have anticipated the visitors' kindred

reaction. Framed by the glaring emptiness of white walls and ceiling, the gently rippling floorwrap appeared strangely alive. It must have hypnotized the viewers and drawn them to experience it with their bodies, for all day long the gallery was filled with people sitting, crouching, or prostrate in silent contemplation.[10]

Wrapped Coast (1969), *Valley Curtain* (1971–1972), and *Running Fence* (1976) are perhaps Christo's most ambitious, most highly publicized, and best-known projects to date. In *Wrapped Coast* 100 million square feet of polypropylene and 37 miles of rope were used to wrap one mile of 80-foot-high cliffs off Little Bay, Sidney, in what was described as "natural sculpture": "the texture and color of the sand was strangely intensified, and the wind, by swelling and rippling the fabric, introduced movement and became an important adjunct in informing the wrapped coast with a breath of primeval life."[11] In *Valley Curtain* a bright orange, 8,000-pound nylon cur-

4. Christo: *Valley Curtain*. 1971–1972. Nylon polyamide and steel cables, 185′–365′ x 1,250′–1,368′. Grand Hogback, Rifle, Colorado. (Photograph: Shunk-Kender; courtesy the artist)

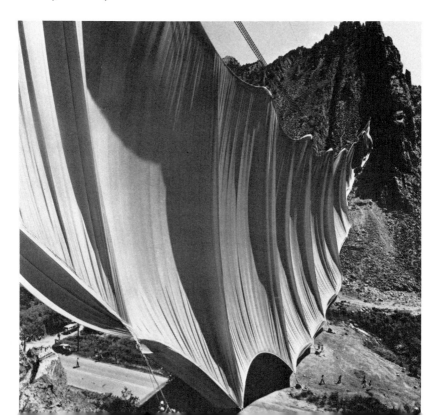

tain was suspended between two slopes, 1,250 feet apart, partitioning Rifle Gap (a valley 200 miles west of Denver, Colorado). *Running Fence* spanned 24½ miles of Northern California. Thought to be inspired partly by the Great Wall of China, it was 18 feet high, made of white nylon fabric, and strung on steel cables between posts set 62 feet apart. Its glowing white color changed according to the time of day, from golden pink at dawn to blue-white under a fall moon. It "could take on the most extraordinary visual drama in the fluctuating energies of wind and light . . . it appeared at times stiff as bone, stretched and spiny as batwings; at others passive, indolent, limp. It seemed alive."[12] All three projects were planned as temporary exhibits; all included plans for returning the land to the way it had been after the projects were taken down.

WALTER DE MARIA

Walter De Maria's first review appeared in 1961 and reported him to be working with plywood to create boxes and an odd assortment of geometric shapes. In 1963 the boxes were still appearing, along with some new plywood objects. In one exhibit he showed such pieces as a "statue" of John Cage: eight tall dowels were made into a cage. *Ball Boxes* was a long, rectangular solid, 4 inches deep, with two small windows. A wooden ball, dropped into the top windows, rolled down a zigzag ramp to the bottom window. At the same show he exhibited *Pointer Board,* a piece of plywood with twenty-five holes in it accompanied by a pointer. Jill Johnston's comment on the work was, "De Maria's pieces are pure and simple as a statement of personal removal." [13]

De Maria held a 1965 show titled "The Columns, The Arch, The Gold Frame and The Silver Frame, The Invisible Drawings, Her Beautiful Lips." The columns and the arch, cut from unfinished plywood, stood at the gallery entrance, giving it the feel of a temple. The main room contained barely visible pencil drawings in thin silver and gold frames. "Otherwise there is nothing but the proprietress of the gallery circulating among her clients, conversation, pleasant ambiguities—for those in the mood."[14] His work took something of a turn in 1966, however, when he showed such pieces as *Elle,* in which a steel ball wobbled down an L-shaped groove. Another piece in the same show had a chair perched on top of a black aluminum pyramid, inviting the viewer to have a seat had not the steps been too narrow to climb. "Step-pyramids evoke Babylon with its brick Ziggurats while steel and

aluminum recall New York, the New Babylon, a city of frustrations and illusions."[15]

His work with metals continued into 1968. That year he showed a flattened, stainless steel sculpture in the shape of a swastika with a round object resting near the center of it. He also made grids of steel spikes and called them *Spike Beds* in 1968. *Mile-Long Drawing* appeared that year, too. It was two parallel lines of chalk, 12 feet apart, drawn for a mile in the Mohave Desert.

In 1969, when the execution of monumental, remote earthworks was at a zenith, De Maria went into Desert Valley, Nevada, ninety-five miles northeast of Las Vegas, to do *Las Vegas Piece*. Described as "an extensive linear work on a vast, flat valley floor," *Las Vegas Piece* consisted of two one-mile lines, which were cut 8 feet wide into the earth with a bulldozer, forming a shallow tract. The two lines met to form a right angle. In 1974 De Maria set

5. Walter De Maria: *Mile-Long Drawing* (detail). 1968. Two chalk lines, 4″ x 1 mile, 12′ apart. El Mirage Dry Lake, Mojave Desert, California. (Photograph: Dia Art Foundation; copyright © 1980 by Dia Art Foundation)

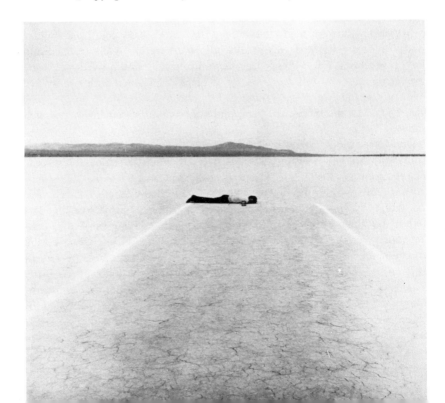

up a test field for *The Lightning Field,* which was permanently installed in New Mexico in 1977. In this smaller version of *The Lightning Field* he used a grid of 18-foot-high stainless steel poles pointed at the tips and spaced 200 feet apart. As pictures have shown, the poles in the field did act as lightning rods and, during a storm, drew many flashes of lightning.

In 1977 De Maria showed his *New York Earth Room,* similar to the *Munich Earth Room* of 1968. By collecting tons of earth, bringing it into a New York gallery sponsored by the Dia Art Foundation, and dumping it, De Maria succeeded in taking land art away from the earth and bringing it indoors; the room was sealed off at the entrance with glass. ''After all the strivings that art has made to create a sense of place for itself, to clear a space, to construct an edifice, to come upon Walter De Maria's *New York Earth Room* is to experience a feeling of collapse, a release of effort . . . ''[16] *Broken Kilometer* was done the next year, in 1978. Brass strips, that when joined together would

6. Walter De Maria: *The Lightning Field.* 1974–1977. Four hundred stainless steel poles (H. 18′) in a rectangular grid spaced 200′ apart over an area of 1 mile by 1 kilometer. (Photograph: John Cliett; courtesy Dia Art Foundation; copyright © 1980 by Dia Art Foundation)

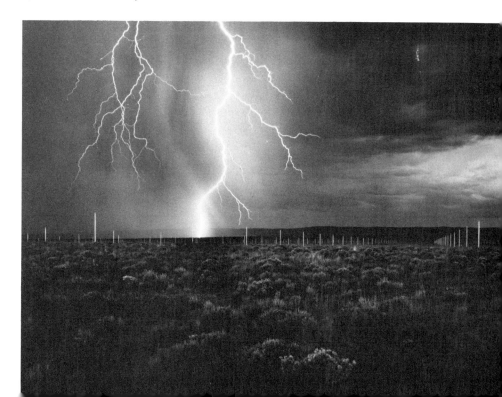

equal a kilometer in length, fill the entire floor of a gallery sponsored by the Dia Art Foundation and named The Broken Kilometer (after the artwork).

De Maria's work has always been in step with shifts in contemporary art and, so, at times a unifying thread has seemed elusive. A predominant characteristic throughout has been the importance his rather conceptual work placed on its materials. During his somewhat eclectic career he did do some work on outdoor pieces in which nature, the land, was an integral part. His work has always shown more of an interest in space concepts than in the land.

JAN DIBBETS

Jan Dibbets was a painter until 1967, after which he began to transfer the Minimal imagery of his canvases onto actual objects. For a time he stacked unpainted, stretched canvases, and even began to cut out squares of turf and stack them into similar arrangements. After 1967 he turned to photography and, using unusual camera angles and varying degrees of daylight, made perception the object of his attention. He has been "concerned with how what he sees is altered as our relationship to it changes, and with how the devices we employ to apprehend objects—the camera, in this case—impose their own order on perception."[17]

In 1968 and 1969 Dibbets did what are known as his *Perspective Corrections*. Many of these were done out of doors, yet they really use nature only as a backdrop. The *Perspective Corrections* were "a defiance of normal illusionistic perspective and a reversal of the usual situation of the illusion of perspective."[18] Dibbets would lay a rope shaped into a rectangle on the ground and, by adjusting his camera angle, shoot it to look like a square—a reversal of Renaissance perspective. Along the same line, he also did *A Trace in the Woods in the Form of a Line of Trees Painted White* (1969). To refute accepted notions of perspective, he painted the bases of a row of trees white, progressively increasing the width of the white bands so that a horizontal line was formed when the viewer looked down the row. This effect was created despite the obvious fact that the line moved away from the viewer.

For a time, in 1969, Dibbets used a combination of maps, texts, and photographs as his work for pieces such as *Five Islands Trip, Three Lines,* and *Study for Afsluitdijk—10km,* which existed only conceptually. From 1969 to 1971 he did his three indoor photographic pieces. *Shadows* and *Shutterspeed* involved the effects and interaction of time and light on photographs of the same image. *Numbers on the Wall,* which consisted of pictures of an empty

gallery that were combined to form a miniature version of the whole room, led into Dibbets's *Panoramas* of 1971.

The *Panoramas of Dutch Mountains,* for example, were simply composites of photographs taken by rotating the camera horizontally on its tripod thirty degrees for each shot. Twelve photographs describe a complete circle around the tripod.

Placing the 12 photos in sequence end to end yields the complete panorama, a composite photograph which is, in a sense, 360 degrees long and 30 degrees high. . . . In the normal panorama, the axis of rotation is vertical and the plane on which the camera rotates is horizontal. In Dibbets' "Panoramas" the axis and plane of rotation are on a tilt off the vertical and horizontal; this means the

7. Jan Dibbets: *Dutch Mountain—Sea II.* 1971. Twelve black-and-white photographs, twelve color photographs, and pencil on paper, 29½″ x 40″. (Photograph: Eric Pollitzer; courtesy Leo Castelli Gallery)

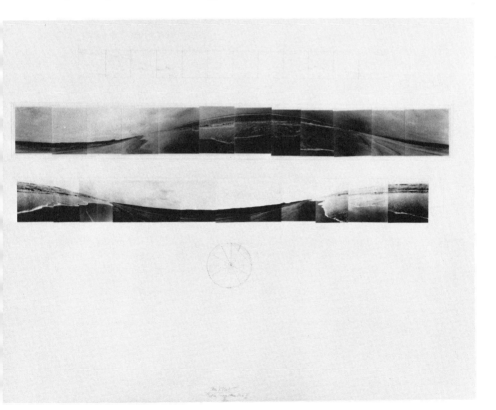

horizon line, instead of remaining horizontal and a constant distance from the top and bottom of each photograph, is on a diagonal across some photographs in the sequence, and altogether missing from those depicting only horizonless sky or ground.[19]

The *Dutch Mountains* were created by an angling of a camera lens. Without moving an ounce of dirt or changing the real landscape in any way, Dibbets created earth art.

In 1974 he did *Structure Study*, a sequence of photographs of flowers, grasses, and shrubs. Subtle changes in focus, perspective, and lighting occurred from picture to picture. In 1977 he did *Water Structure: Study for Monet's Dream* and shot the same scene from slightly different perspectives, combining them into "compositions reminiscent of the more controlled abstract expressionistic paintings of [Mark] Tobey or [Jackson] Pollack."[20] Although he used an outdoor setting for his work, his subjects for his photographs had begun to turn to man-made objects and indoor scenes.

Jan Dibbets's work can be likened to some of Peter Hutchinson's shaped

8. Jan Dibbets: *Invitation Card Piece 3.* 1973. Collage and pencil on paper, 30″ x 40″. (Photograph: Eric Pollitzer; courtesy Leo Castelli Gallery)

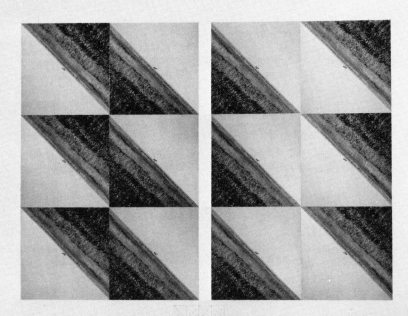

composite photographic pieces, *Horseshoe Piece* (1970), for instance. However, in most of his work there is much less direct contact with nature. Dibbets's work has been less about the perception of the environment or landscape it uses, than about perception itself. *Reflection Study* (1975) was composed of photographs of trees combined to look like inkblot tests; the basic image is always secondary to his manipulation of it. Unlike the photographs of the work of a Hutchinson or a Heizer, Dibbets's photographs were not used to document any other work. They were the works themselves.

HELEN AND NEWTON HARRISON

Beginning as a sculptor in the 1950s, moving on to painting by the 1960s, Newton Harrison became interested in "technological" art by the late 1960s. His later work would incorporate aspects of all three areas, as well as allow him to develop his changing concept of time. A review of his paintings shown in 1963 signaled some of the changes that were ahead for his work: "He . . . carries over the sculptor's reverence for materials. In his current work enormous canvas sheets are free from the restraint of stretchers and hang between two weights which vary in function from piece to piece. The

9. Helen and Newton Harrison: *Portable Fish Farm.* 1971. Tanks holding catfish at each stage of their life cycle. Hayward Gallery, London. (Photograph: Ronald Feldman Fine Arts Inc.)

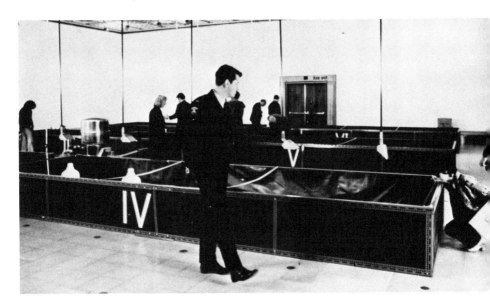

initial reaction is of traffic lights... in totem arrangement.... By using a relatively fresh concept of space, Harrison hopes also to control time by regulating the fixed shapes, their separations... ''[21]

By the end of the 1960s he had begun to do technological art and through it to explore his interest in the natural environment. At one point he did a series of "glow discharge tubes" which he proposed to use in order to create various atmospheric effects at high altitudes; however, this last stage of the project was never carried out by Harrison. His technological art soon changed and entered the realm of land art. In 1971 he showed a piece called *Air, Earth, Water Interface.* Seeds were planted in an 8-by-6-foot box in a gallery, the progress of their growth being duly observed during the show and constituting the artwork. That same year he did a piece called *Brine Shrimp Farm* and set up a tank of brine shrimp in a gallery. "Harrison believes that effective ritual stems from homage to our life-support systems."[22]

10. Helen and Newton Harrison: *Portable Farm: Survival Piece No. 6.* 1972. Plants and trees exhibited in containers to suggest future sources of food. Contemporary Arts Museum, Houston. (Photograph: Ronald Feldman Fine Arts Inc.)

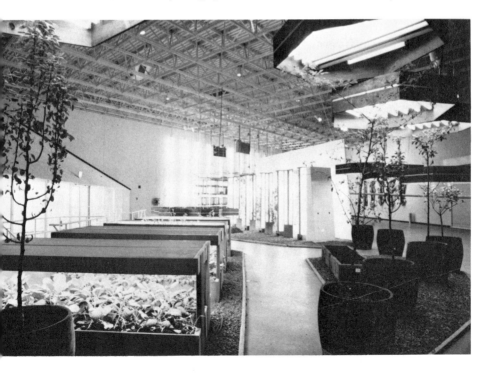

In 1971 he also constructed his controversial *Portable Fish Farm,* which consisted of steel tanks that were filled with catfish at each stage of their life cycle. An uproar occurred when it was announced that the fish in the farm were to be publicly killed, then served at the opening. When the furor showed no signs of abating, Harrison agreed to have the fish killed privately.

In 1972 Helen Harrison began to collaborate with her husband, Newton. *The Lagoon Cycle* was the first project both husband and wife worked on collectively and shared the credit, but from then on all projects were conceived and produced by the Harrisons as a team. *The Lagoon Cycle* was a massive research project in which they observed and experimented with *Scylla serrata* lagoon crabs. The work involved transferring the crabs from their natural habitat, lagoons in Sri Lanka, to the Harrisons' Pepper Canyon Laboratory on the University of California, San Diego, campus. There tank systems were designed to simulate lagoon conditions as much as possible, and included mudsuckers, mangrove seeds, bottom mud, and *Mugil cephalus* all sent to them from Sri Lanka. When the Harrisons noticed the crabs were acting "depressed," they produced a man-made monsoon using fresh water from a hose. "We wondered what might make a crab depressed and suspected something from their well being was missing . . . "[23] That "something" was a monsoon. The Harrisons wrote about this incident in *The Book of the Crab,* saying, "We found that no researchers before had succeeded in getting *Scylla* to mate in the laboratory—when we repeated the monsoon we found out how to duplicate the conditions necessary for mating to occur."[24]

In 1974 they applied for and received a Sea Grant from the Institute of Marine Resources in order to study the breeding cycle of the *Scylla serrata* crab and develop an inexpensive and technologically simple aquaculture system. This system, they hoped, could be developed into a commercially viable farming system. Of this proposal the Harrisons wrote: "The scientists themselves wondered about us and were somewhat amused by the exotic interests of artists but we received the grant (June 1974)."[25] The Sea Grant Research was published in 1974.

In 1977 the Harrisons began working with maps, making them a central part of their expression. *Wherein the Appetite Is Discovered to Be Endless* is a huge wall map showing a proposed sectioning of the oceans according to the richness of their various seabeds and how they would be divided up among nations. Considerable attention was devoted to color interactions on the map. "The art hides itself but is not absent."[26] Other map works done around this time, all dealing with man's ecological and political impact on specific sites or areas, included *Sacramento Meditation, Meditation on the Great Lakes of North America,* and *Horton Plaza Redevelopment. Geo Icon: New York as the*

Center of the World questions the notion that our cities are looked on as the centers of our world.

In the spring of 1980 the Harrisons again brought live creatures back into the gallery for their public showing of *The Lagoon Cycle*. The *Scylla serrata* crabs were displayed in the gallery inside a tank in which they lived, thereby demonstrating their life cycle to the gallery-going public. "Eventually Harrison and his wife want to reintroduce the utilitarian into art at an extremely refined level. And in the process they hope to provide an antidote for the prevailing cynicism of the Art World by making art the non-verbal teaching system it once was."[27]

MICHAEL HEIZER

By 1967 Michael Heizer, previously a painter, had begun to produce the desert sculptures that would be the trademark of his work for at least ten years. He moved from the studio to the desert and used the earth itself as his medium to produce pieces that were not open to the public at first. That changed, but the locations of his works remained virtually inaccessible for some time, reviews and published photographs frequently being the only sources of information about them.

Heizer did a number of works in 1968 that received critical attention. *Dissipate* is a series of five rectangular trenches dug in random order into the soil of the Black Rock Desert in Nevada. Unlike most of his other work that year, *Dissipate* was intended to be permanent, and Heizer lined the sides of the trenches with steel. Much of the other 1968 work was not reinforced for posterity and has disappeared. *Foot Kicked Gesture* was a 12-by-15-foot cross that Heizer kicked into the soil, and *Ground Incision/Loop Drawing* is a series of eight groups of circular tracks driven into the ground by automobile tires. Heizer was also commissioned to dig a 120-foot trench in Nevada's Massacre Lake. The trench, called *Isolated Mass/Circumflex,* forms a loop, isolating the encircled piece of ground. It was not intended to be permanent but to change and disappear. "It is being photographed throughout its disintegration,"[28] Heizer commented. When asked why he makes one of his trenches or diggings, Heizer responded:

> I'm mainly concerned with physical properties, with density, volume, mass, and space. For instance, I find an eighteen-foot-square granite boulder. That's mass—It's already a piece of sculpture. But as an artist it's not enough for me to

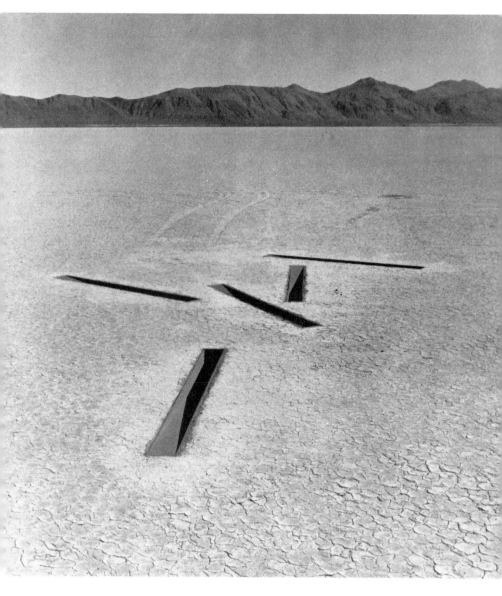

11. Michael Heizer: *Dissipate.* 1968. Wood and steel, 40′ x 50′, each trench 12′ x 1′ x 1′. Black Rock Desert, Nevada. (Collection of Robert Scull; photograph: Xavier Fourcade, Inc.)

say that, so I mess with it. I defile . . . if you're a naturalist you'd say I defiled it, otherwise you'd say I responded in my own manner.[29]

One critic accused Heizer of going into "the primeval wilderness to leave monuments of his manhood there."[30]

Five Conic Displacements (1969) took the form of five expressionistic designs made by the displacement of 150 to 200 total tons of earth. Another work done that year in the same vein was *Double Negative,* a huge composition (1,100 by 42 by 30 feet) that could only be seen in its entirety from a helicopter because its canvases were the sides of two facing cliffs. The work itself involved Heizer in the gouging out of 240,000 tons of earth from the cliffsides. An untitled piece done in 1970 consisted of Heizer and crew carving a large trench into a mountain. By virtue of the inaccessibility of the site, few members of the gallery-going public had an opportunity to see it firsthand. Heizer did, however, have a gallery showing of photographs of the work. One critic wrote of them as

a great adventure in the American mythologyland out West. We follow our artist-pioneer in slides and photographs as he supervises the digging of a deepcut trench on the top of an isolated plateau out there where there is nobody, but lots of nature. The trench running through the top of a low mountain photographs well, looks a little like some ancient ruin, Mayan or even Mycenaean, and really gives you that sense of isolation you all crave. The city dwellers . . . no doubt catch their breaths to see the natural vastness sullied by one puny man. It would be better to be the man, of course . . . in fact you *could* be the man if you had the money, since this mountain was bought by the acre . . .[31]

From 1972 to 1976 he worked at erecting another permanent piece, *Complex One/City,* a 24-by-110-by-140-foot optical illusion in the desert. This huge earth, concrete, and steel structure appears, at a distance, to be a solid rectangle with steel bands bordering a concrete block. From the side, the bands are actually seen to be segmented and placed yards apart, although from the front they seem to form continuous lines of steel.

During most of his desert work, Heizer had been represented by a gallery. Even though his works were inaccessible, photographs of them were duly displayed by his gallery. He assumed something of an antigallery stance for a time, having said, "one aspect of earth orientation (earth art) is that the works circumvent the galleries and the artist has no sense of the commercial or the utilitarian."[32] By 1974 he again began to create works that could be displayed in galleries. *Windows* was created in that year and consisted of

seven panes of glass (each 6 by 7 feet) on which calligraphic marks were etched.

Another work emerged in 1976. *Adjacent, Against, Upon* was a collection of geometric granite and concrete forms arranged adjacent to, against, and upon each other. In 1977 Heizer produced *East India,* in which the artist cut four different kinds of wood into circles of varying sizes. The circles were then sectioned and arranged in configurations around one large, intact circle. *East India* is composed of precisely cut, finished, and polished pieces of wood. This evidenced a change in Heizer's original feeling of "opposition to the kind of sculpture which involves rigidly forming, welding, scaling, perfecting the surface of a piece of material."[33]

Throughout his involvement with the land Heizer's interest seems to have been primarily in its available scale, which gave monumentality to simple forms and gestures.

NANCY HOLT

Beginning as a photographer in the 1960s and having moved on to video by the early 1970s, Nancy Holt's ideas did not really encompass aspects of the natural environment until 1972. Around this time she began making her "locators," which were something like a periscope, each a piece of pipe put in a specific location and fixed into one position to command only a narrow view.

In 1972 she constructed *Views Through a Sand Dune* on the coast of Rhode Island. The work is simply a concrete pipe set into a sand dune. The viewer is afforded a limited vision of sand, water, sky, and sun. In 1973 she produced a gallery piece called *Locator with Sunlight and Spotlight.* This indoor piece involved the projection of two ovals of light, one a spotlight and the other an oval of sunlight, onto two separate walls. Between the two lights a T-shaped pipe stood, each end affording a view of one of the ovals.

That same year Holt began one of her most notable outdoor works. On land she owns near the Great Salt Lake Desert she placed four large concrete pipes in an open X formation. The pipes are positioned to mark the solstitial sunrises and sunsets and are large enough to walk through. In the top half of each tunnel holes have been cut in the exact configuration of one of four constellations (Draco, Perseus, Columba, or Capricorn), allowing spots of sunlight into the pipes.

Holt's interest in astronomy took another form in 1974 when she installed a piece called *Hydra's Head* in Artpark in Lewiston, New York. Six small circular pipes, none over 4 feet in diameter, were inserted into the soil until they

were level with the ground and filled with water. The reflecting pools, situated next to a precipice, were placed in the configuration of the head of the constellation Hydra.

She did another outdoor piece at Artpark in 1975, this one involving no direct manipulation of the environment. Holt made a 16mm color film of Niagara Falls, which she described:

> ...I filmed the waters of the Niagara glistening, shimmering, sparkling, flowing, rippling, foaming, falling, waving, crashing, spattering, splashing, swelling, dripping, cascading, swirling, reflecting, circling, whirling, tumbling, flooding, engulfing, gushing, streaming, pouring, spouting, dropping, spraying, misting, trickling, pooling, bubbling.[34]

Nancy Holt's work has continued to deal with perceptions of nature.

12. Nancy Holt: *Views Through a Sand Dune*. 1972. Cement-asbestos pipe and sand, 108″ x 66″. Narragansett Beach, Rhode Island. (Photograph courtesy the artist)

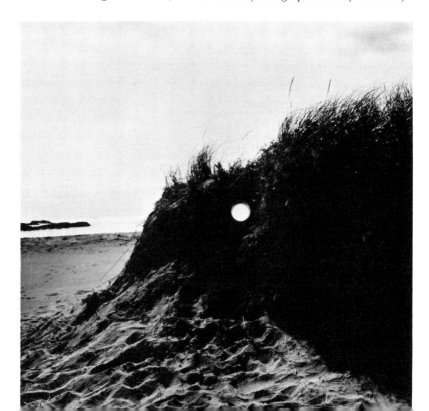

PETER HUTCHINSON

Peter Hutchinson, who originally studied to be a plant geneticist, has remained interested throughout his career in the manipulation of nature by culture.

In 1968 he completed *Grand Canyon Project,* in which filled glass vials were exhibited in front of photographs of the canyon's landscape. To illustrate his conviction that the organic and the inorganic are intertwined, he juxtaposed test tubes filled with organic cultures with infertile sites and inorganic cultures with hospitable sites, or a combination of both.

The idea of time has always been an important part of Hutchinson's work and thinking. He views time as part of nature and has said of his work, "The essence of the work is actually about the present, the timeless present . . ."[35] A project he did off the island of Tobago, *Threaded Calabash* (1969), demonstrates the inescapability of change and, in this case, decomposition. Five calabash fruit were strung on 12 feet of rope with the ends secured underwater. As the fruit began to rise, they formed an arc in the water that Hutchinson photographed. "A further aspect of the piece would be its struc-

13. Peter Hutchinson: *Threaded Calabash.* 1969. Five calabash fruit threaded on a rope and anchored to coral in 30′ of seawater. Tobago, West Indies. (Photograph courtesy the artist)

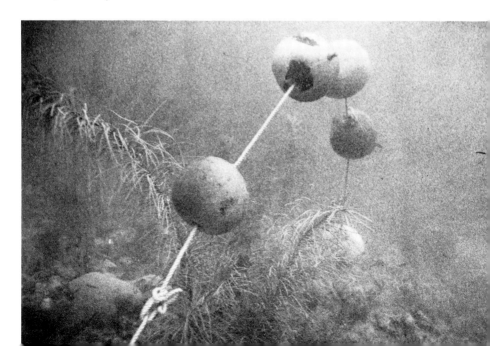

tural disintegration as the pieces of fruit gradually become waterlogged and slowly collapse to the ocean floor.''[36]

Beach Line (1969) was a 200-foot wavy line sprinkled above the tide line, which was photographed as the tide covered and ''reclaimed''[37] it and exhibited with a descriptive text. *Beach Line* lasted fewer than twenty-four hours. For another work he dammed up an underwater canyon with twelve 150-pound sandbags. He explained the outcome of his work: ''I made a change in the pattern of water flow, and fish now have to swim over the top.''[38]

Photography, used as the documentation of his work, plays an increasingly important role in Hutchinson's work. Speaking of *Threaded Calabash,* he said, ''This piece represented to me the use of . . . large color photos as a record and proof that the work was really completed. Looking back I find that it was the photograph that was important.''[39]

In 1970 Hutchinson went to Mexico to complete *Paricutín Project.* He laid a 100-yard-long line of bread along faults at the edge of the volcano's crater;

14. Peter Hutchinson: *Paricutín Project.* 1970. A 300′-long line of bread placed on fault lines at the lip of a crater in Mexico. Heat from the volcano accelerated the formation of mold, changing the color of the bread from white to orange. (Photograph courtesy the artist)

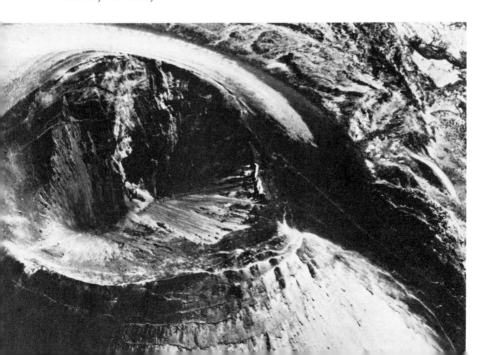

the bread being distinct enough to show up in his aerial photographs. During the six days the project lasted, the bread grew moldy and turned from white to orange. "This work is important to me as a physical/psychological breakthrough in that I did something very risky (physically and aesthetically), difficult and arduous—none of which comes easily."[40]

Hutchinson laid out *Apple Triangle* (1970) near the Mexican volcano he had visited in 1968. The work was a 6-foot triangle of yellow crab apples set in the black lava dust. *Apple Triangle* was spontaneous, lyrical in a way, quickly accomplished, and colorful. "It was, by comparison, so easy to do that I didn't show it for several years, maybe thinking it didn't contain enough 'angst.' "[41] *Horseshoe Piece* (1970) was a purely photographic piece: pictures of single rows of flowers were taken and then mounted and shown as a montage in the shape of a horseshoe. "*Horseshoe Piece* is important to me now as a step from using the photo as a reporting medium to using it actually in a way not limited by what was 'set up' in the original view. That is, original things can be done with the photo after it is taken."[42]

Hutchinson and an assistant took a six-day hike in Colorado in 1971, keeping a journal along the way and taking photographs of the trip. The journey, whose products are called *Foraging,* was done "deliberately as a work of art" to "bring this exhausting journey into a current art context."[43] *Thrown Rope* (1972) proved to be much less arduous: Hutchinson simply planted a row of hyacinths following the configuration of a rope he had thrown.

Words and pictures form the thread that runs through all of Hutchinson's work. Nature, to him, is something that must be overcome or tamed, or used as a canvas for his work, whereas words and pictures are an intrinsic part of his art. In 1973 he did a number of pieces that centered on photographs or texts or both. *White Voodoo* was presented as a text along with some coins glued to a piece of paper, and the writing explained how he found the coins. *Two Tuesdays* traces a trip around the world Hutchinson took when he was twenty-one, re-creating the trip with a display of photographs and a globe. The project's title came from the fact that one week had two Tuesdays owing to his crossing of the international date line. *The End of Letters* is a photographic record of his creation and destruction of all letters in *THE END*. *Breaking In* consists of captioned photographs telling of a day when his apartment was burglarized. Hutchinson said of his work: "The texts were not descriptions of the photos, neither were the photos illustrations of the texts. Each element added information and radically altered the idea that photo or text might suggest alone."[44]

Alphabet Series (1974) removed Hutchinson from the natural environment and committed him even more to the use of words and photographs alone.

This piece dealt with words and pictures that related to every letter in the alphabet. Each displayed letter was made from materials whose names began with that same letter. *The Anarchist's Story* (1975) was a continuation of his interest in series. Black-and-white and color photographs, texts, and mixed-media letters were combined to tell the story. *God Saw I Was Dog* (1976) uses photographs and the palindrome (a group of words that can be read both forward and backward) of the title to make a visual pun. *Man's Condition* (1977) was described in thirteen sets of photographs accompanied by a single word for each. The thirteen words combined to form a poem.

The words and photographs of Hutchinson's later works deal more specifically with the problems people face within their own culture. It is his early work in which nature plays the most dominant role. It documents the uneasy coexistence of the natural environment and human culture.

RICHARD LONG

In 1969, Richard Long held an exhibition consisting of pencil-length pine needles laid end to end in nearly parallel lines that stretched from one end of the gallery to the other. The lines narrowed imperceptibly as they receded to the far end of the gallery, confusing the viewer as to the real length of the room.

That same year, though, he held something of a retrospective in which he showed photographs documenting his work as an earth artist. The photographs covered his outdoor work from its beginnings in 1963 and documented such projects as sod removals, the making of geometrical cuts in the land, and the bicycling of his portable sculptures around the British countryside and anonymous placement of them. One work was the making of a path in a field of grass by walking back and forth for several hours, another consisted of snipping off the heads of flowers in a meadow, thus inscribing a giant X.

... several years before the practice became universal, Long started making his marks on nature: negotiating rights of way, picking patterns in fields by removing swaths of daisies, or walking for a hundred miles in seven days around a fixed point in Dartmoor. These together with beachcombing exercises—tidying seaweed into spirals or rearranging pebbles in a riverbed—are not so much marches stolen on nature ... as circles drawn around standard sculptural conventions ... Long's operations on the face of nature, his incisions, tattooings, and bruisings were, in their time, a breakthrough.[45]

Two such works were *England* (1967) and *A Ten-Mile Walk Done on November 1* (1968). *England* was done outdoors in a park where Long erected a large, freestanding rectangle and, some distance away, a circle lying on the ground. A viewer moving through the landscape would see these two figures change in relationship. At one position the circle would appear to be drawn within the rectangle. *A Ten-Mile Walk Done on November 1* was just that, a walk that the artist had illustrated and documented by tracing the path he took on a map.

A show in 1970 contained a trail of Long's footprints that spiraled to fill the gallery. It referred to an actual landmark, Silbury Hill, a prehistoric hill that is the largest man-made hill in England but whose purpose and origins are unknown. Work that appeared in two separate shows in 1972 was similar. Of the first April Kingsley, a critic, wrote:

> . . . seven concentric rectangles of red mud on the floor of a small gallery relate directly . . . to the surrounding architectural space . . . As his various Xs, spirals, and rectangles "walked into" the landscape over the years seem to indicate, it appears that Long wants to defy Picasso's dictum that "Art is what nature isn't" by fusing art and nature much like the builders of Stonehenge, though far less permanently.[46]

The other show contained an arrangement of concentric stone circles in the gallery.

A Rolling Stone, Resting Places Along a Journey, exhibited in 1974, consisted of ten photographs. Each photo was of a configuration of stones that were laid out on either a slope or flat ground between two mountains. In most of the shots the grouping of the stones is irregular. The stones stand "as discrete signs of passing." The last photograph, however, shows a circle of rocks on a slope and, by virtue of the circle's being a closed shape, suggests completion.

Andrew Causey wrote an article in 1977 in which earth art and Richard Long were discussed:

> Land art takes certain disparate forms which are linked by their being progressive abstractions from the continuity of nature, distilling and compressing the artist's experience without losing in the process the human value of the initial response. A land art work might consist simply of a geometrical arrangement in a natural setting; generally it is easily removable or naturally short lived, designed to be gradually filled by the action of the wind, washed away by rain or tide, terminated by the natural process of growth and decay as in the case of Long's cross formed by picking daisies in a field . . .

Alternatively an area of ground might be recorded in a series of photographs taken at specific intervals, diagrammatically summarized in lines drawn on a map, or represented by analogues, a walking-stick notched to represent miles travelled and days passed, or a length of rope knotted once at the end of each day's walk. In the final stage, typical of Long's work, the work is brought into the gallery . . . [47]

In 1978 he did more walks and documented them with photographs. Early in 1980 Richard Long showed the results of two walks he took, the results being merely a piece of paper containing brief observations made during the walk, the work's title and description of it, where it took place and when, the date, and a description of the walk. *Pico de Orizaba* is described as "a 5½ day walk from Tlachichuca to the summit at 18,885 feet and back" and was done in Mexico in 1979. Terse observations are listed: "Snow . . . warm gravel . . . snow . . . stone . . . rocks . . . dust . . . pine needles . . . powder

15. Richard Long: *Milestones: 229 Stones at 229 Miles* (detail). 1978. Photograph taken during a 300-mile walk from Tipperary to Sligo, Ireland, placing five piles of stones along the way. (Photograph courtesy the artist)

dust . . . grit.'' The other walk, *Two Straight Twelve-Mile Walks on Dartmoor,* is described as ''Parallel . . . a ½ mile apart . . . out and back.''

MARY MISS

In 1967 Mary Miss erected a 13-by-5-foot, freestanding V-shaped screen out of doors. The intricately constructed screen was meant to make the viewer appreciate his or her surroundings, which were temporarily blocked from sight by the screen. Miss's work has often been aimed at sharpening or testing the viewer's perception, and that has sometimes led her to use the natural environment as the site for her projects.

After 1968 she did a number of fence structures indoors; they were repetitious, blocking the viewer's path and forcing ''her audience to deal with the space.''[48] Her method of creating some sort of path then obstructing it as a way to deal with perception led to *Vs in a Field* (1969). This was a series of

16. Mary Miss: *Sunken Pool.* 1974. Wood, steel, and water, 13' x 20'. Greenwich, Connecticut. (Photograph courtesy the artist)

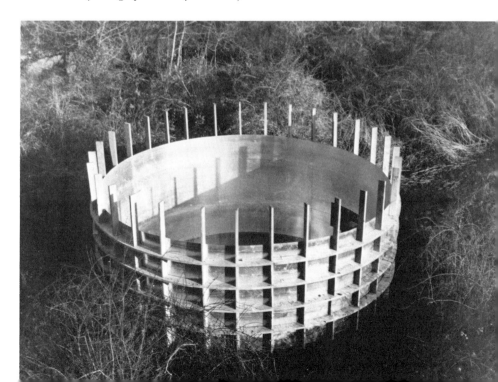

2½-foot wooden **V**s, separated by 75-foot intervals. A 1973 landfill sculpture in Manhattan consisted of five thick plank walls arranged in a row at 50-foot intervals. Each wall had a large hole cut into it, all holes were centered with respect to the sides, but varied in placement from the top to the bottom.

Sunken Pool (1974) was a walled metal cylinder built on an overgrown path. All of the work of the artists discussed in this anthology is Conceptual to one degree or another. Miss's is no exception, but her work has a more ''psychological'' content than many. With *Sunken Pool* she moves further in that direction by displaying an interest in spaces that act as sanctuaries or refuges. This contribution to an outdoor group show was a circular pit, 8 feet deep and 140 feet across, of steel and crushed stone. The steel was used to make three concentric bands set into the ground to contain three concentric circles of gravel, the smallest being the 8-foot-deep pit. Connected to the outer edges of the biggest circles and forming a perfect square were four long troughs gouged into the earth. Miss describes her work:

17. Mary Miss: *Staged Gates*. 1979. Wood, 12' x 50' x 120' to the last structure at the top of the hill. Dayton, Ohio. (Photograph courtesy the artist)

Standing in the center of the piece, everything is cut off from view except the sky. Rising slowly, you passed the marked layers, bands of steel, as though coming up through layers (strata) of the earth—like rising out of the center of a crater. There are four notches in the top layer and it is by sighting down these long troughs that the outside landscape is first revealed over the rim. Continuing the vertical rise from the center, this circular pit with crossed arms becomes a target, a marker on the landscape.[49]

Two things Miss hopes to evoke with many of her pieces are "perceptions of space and conceptions of remembered images."[50] *Perimeters/Pavilions/Decoys* (1978) had three elements: a 5-foot-high semicircular embankment of dirt, wood and screen towers of various sizes, and a square hole or pit dug into the earth. The edges of the pit also form the edges of an overhang, the structure of the pit is formed and supported with wooden beams. The towers had an oriental look, and the underground opening looked like a Pueblo dwelling.

Like many of the other artists in this anthology, she is interested in the perception of space and environment. Her work incorporates the use of natural sites and materials when the expression of her ideas calls for it, but it is not centered on the notion of being land art.

ROBERT MORRIS

Since his work first attracted notice in the mid-1950s, Robert Morris has produced an extremely varied body of artwork. In 1961 he produced lead casts of his own body, arches, columns, and boxes. *Litanies* (1963) was a relief of keys and a key ring acccompanied by a notarized statement withdrawing all aesthetic qualities from the work. *Fountain* (1963) consisted of an empty pail hanging from a hook and inside a recording of running water played. The mid-1960s saw him working frequently with slabs or large blocks, arranging and rearranging them into various patterns during his shows. In 1967, "Robert Morris had not one show but several. His sixteen or so modules were variously combined depending on when you went to the gallery."[51]

Not until 1967 did Morris do any environmental art actually having to do with the Earth. That year he did his first steam pieces, examples of "air art." One was an untitled outdoor work, a large square of ground Morris had prepared to produce a cloud of steam continually.

Steam Piece was also done in 1967 but took place indoors; it was a room filled with steam. Morris felt that steam was a material he could use to deal with the inward regions of sculpture as well as its outward relations to space.

That same year he produced *264 Pieces of Felt,* an arranged pile of felt strips. He followed that up in 1968 with *100 Pieces of Metal,* in which he spread scraps of metal over the gallery floor. Also in 1968 he created a felt "painting," in which eight large squares of felt were stacked on top of each other, then mounted on a wall. Horizontal rows were cut into the material so that bowed ribbons of felt drooped gracefully in the center of the square.

Morris showed three large but varied pieces in 1969. One was a drawing of ten girders, laid out to form a grid. Another consisted of sheets and strips of metal, rubber, and felt scattered about in the corner of a gallery room. The colors of the materials, oranges, tans, grays, and browns, were "unified" by bits of floor showing through. The third piece "ranged from the floor to wall to overhead girder, and was changed daily. It is composed of splashy chunks of clay, a square of clay-juice broomed onto the wall, chassis grease dropped

18. Robert Morris: *Untitled (Steam Piece)* (detail). 1967–1973. Steam vents placed at the four corners of a 25'-square site fill the area with steam. Bellingham, Washington. (Collection of University of Washington, Bellingham; photograph: Leo Castelli Gallery)

or squeegee'd, little bunches of scrap thread, hoe, shovel, broom and miscellaneous spare materials.''[52]

Morris worked both in and out of doors in 1970. For one of his indoor pieces "he set up a revolving camera to photograph photographs and their reflections in mirrors, and then, as the finale, set up a revolving projector which projects the filming of the photographs and their mirror images on the very walls which once held them.''[53]

His 1970 outdoor pieces were, characteristically, dissimilar. One, a proposal for a West Coast show on art and technology, proved unfeasible and was never actually constructed. The proposal suggested that an unpopulated square mile be set aside for an extensive ecological survey. The amount of rainfall over a period of time, weather changes, types of plants, and their growth periods would be among the observations made during the survey. According to the dictates of the survey, several high-output heaters and air-conditioning units (such as are already in use in "aerospace ground support systems") would be installed and operated on this outdoor square. Some units were to be aboveground and some below with fiber-glass rocks, plastic crevasses, camouflaged conduits in the trees, and so forth, providing an in-

19. Robert Morris: *Grand Rapids Project.* 1974. Two asphalt ramps, each 18' wide, cross at the central platform. Grand Rapids, Michigan. (Photograph: Leo Castelli Gallery)

20. Robert Morris: *Untitled (Documenta 6).* 1977. Five basalt granite components in a field. Kassel, West Germany. (Photograph: Leo Castelli Gallery)

terface between nature and technology. In another 1970 outdoor piece he stacked hunks of an old highway bridge.

Hearing (1972) consisted of an over life-size copper chair, a leaden bed, and an aluminum table. The bed and the chair were connected by six wet-cell storage batteries with signs warning viewers not to touch the live furniture. In 1974 he took part in a group show with drawings that used words as part of their visual makeup. The written part of Morris's *Three Rectangles* reads:

> With eyes closed and estimating a lapsed time of sixty seconds, both hands work to blacken a rectangular bar at the top of the page. Eyes are opened and this is studied for sixty seconds and the figure covered. Then with eyes open both eyes attempt to remember and reproduce the first figure in the middle of the page within a time duration of sixty seconds. At the bottom of the page both hands work with eyes open for sixty seconds to produce a rectangle to which the upper two figures should have conformed had the skill been sufficient . . .

Morris, in 1976, produced drawings of labyrinths described by one

21. Robert Morris: *Untitled (Johnson Pit # 30)*. 1979. A former strip-mine site south of Seattle, 3½ acres. The sculpture entailed terracing, preserving tree stumps with tar, and seeding grass. Commissioned by King County Arts Commission, Washington. (Photograph: Leo Castelli Gallery)

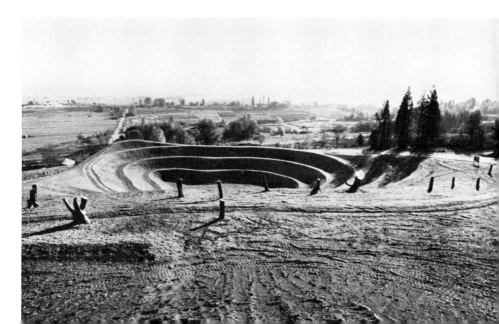

reviewer as "admittedly striking at first glance."[54] In two other shows that Morris appeared in, he exhibited slabs that, when hung from the ceiling, called for the viewer to stand in front of them to get a flat, tunnellike view. A reviewer commented on these pieces, saying:

> To some, these works' resistance to analysis might be considered a virtue . . . I have no quarrel with those who find these works rich and self-sustaining. . . . Elaborate technological process and weighty, elegant materials are employed to demonstrate that objects can be arranged in space to reduce their three dimensionality, that odd things can be done with mirrors.[55]

He produced more work done with felt in 1977.

Some of the artists mentioned in this anthology are motivated primarily by ideas of time or ritual or regard for the land. In contrast, Robert Morris's work is rich and varied, concurrently touching on many important aspects of the contemporary meaning of art.

DENNIS OPPENHEIM

The early part of Dennis Oppenheim's career veered into the realm of earth art. Near the end of the 1960s Oppenheim was involved with other artists who, through their work, were investigating the gallery system and the whole binding cycle of artist-gallery-art. In 1967 he showed *Viewing System for Gallery Space*, a model of a gallery in which bleacherlike seats had been erected. The work intended to make viewers view each other and the gallery's artwork simultaneously.

An extremely prolific and rather eclectic artist, his work has been capable of going off in several directions at once. He did a number of varied works in 1968. For instance, in *Gallery Decomposition* the materials the gallery is made of were collected and put into layers. The layers formed mounds shaped like pyramids and were stacked in the order of what percentage of them was used in the building's overall makeup. *Time Line* was another 1968 project and, using a 2-mile-long pattern plowed into the snow of the St. John River (between Fort Kent, Maine, and Clair, New Brunswick), symbolized the international date line. There was also *Migratory Alteration of Time Zones*, in which three maps of the United States demonstrated how Mountain, Central, and Eastern time zones would change according to summer/winter bird migration patterns. There was still more 1968 work, a show whose review read: "Dennis Oppenheim shows scale models of sculpture, configurations im-

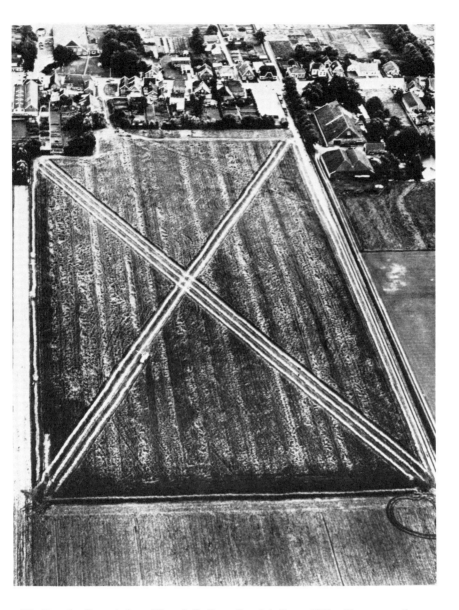

22. Dennis Oppenheim: *Directed Seeding—Canceled Crop.* 1969. The route from Finsterwolde (location of the wheat field) to Nieuwe Schans (location of the storage silo) was reduced by a factor of 6 and plotted on a 422′ x 709′ field. The field was harvested in the shape of an **X** whose arms were 825′ long. The grain was isolated in its raw state and there was no further processing. (Photograph courtesy the artist)

posed on huge areas of earth surface using trenches, pipes, culverts, water, pumping systems, and vegetation."[56] In 1968 he also oversaw the harvest of a 300-by-900-foot oat field in Pennsylvania.

Nineteen sixty-nine was an equally busy and diverse year. *Removal Transplant: New York Stock Exchange* began with Oppenheim's collecting of tapes and litter from the floor of the exchange after one day's trading. In an attempt to evoke the sense of a place through its garbage, he moved all of this trash to the roof of a midtown Manhattan building and left it there. *Time Pocket* referred back to the date-line idea of 1968. This piece was located on a frozen lake in Connecticut, however, and was a 2-mile-long, 8-foot-wide swath cut into the ice with a chain saw. *Branded Mountain* and *Branded Hillside* involved branding the 35-foot-diameter sites by pouring hot tar on them in the shape of a circle with an *X* in the center of it. He intended it to draw attention to the similarities between branding cattle and branding the land they grazed. For *Typhoid* he buried a 15-by-15-foot swath of grass in California. In 1969 he also did a forest floor "removal" and "transplant," as well as *Directed Seeding—Canceled Crop.* Done in Holland, an *X* with 825-foot-long arms was plowed into a 422-by-709-foot grainfield. Oppenheim said of the project: "Planting and cultivating my own material is like mining one's own pigment . . . I can direct the later stages of development at will. In this case the material is planted and cultivated for the sole purpose of withholding it from a product-oriented system."[57] In southern France he did *Reverse Processing,* in which the end product of a calcium mine (white powdered zinc) was returned to the original site of extraction in the form of an arrow.

He also traveled to Tobago in 1969 to execute several works. Among these were *Trap Piece,* in which a wooden box, with one end propped up on a stick, was set near the water's edge on a beach and left to be toppled and carried away by the rising tide. *Blanket Piece* was even more involved with and dependent on the sea for its artistic life. A blanket was placed in the water, and its changing space was photographed as it drifted to the ocean floor. The photographs of this and other Tobago works became the works of art themselves. Oppenheim went underwater to plan cornstalks on the ocean floor for *Cornfield Transplant.* For *Wrist* he carved furrows into the shoreline, patterning his marks after the veins he observed standing out in his own arm when he clenched his fist. As the fist unclenches, the veins disappear, as did the carved veins with the incoming tide. *Route 20 Transfer* had Oppenheim out in a motorboat pouring gasoline onto the surface of the water. To symbolize the horror of traffic accidents, he lit the gas he had spread and photographed its burning.

By 1970, just one year later, Oppenheim's work had begun to lean in

another direction. He did several pieces whose creation was documented on 8mm film and whose content had changed from that of a year earlier. In *Rocked Hand* one hand slowly covered the other with rocks, pressing them down into the ground. The hand "split" and then became invisible as it became part of its rocky surroundings. *Stills from Stomach X Ray* was a thirty-minute film. With his hands pressing on his ribcage, Oppenheim moved his stomach about. "The stomach becomes an exploratory surface given to releasing sensations of what it 'feels like to be formed.'"[58] His hands pushed in and tried to "enter" his chest cavity. For *Rocks in Navel* a film was made of rocks being popped out of Oppenheim's navel by his sharp stomach jerks. *Backtrack* was a film he made of himself being dragged across a sandy beach, facedown, using his body to etch a gesture. In 1970 he also did *Nail Sharpening*, a work in which "the traditional act of depleting a surface (sanding) engages one in a ritual of self-reduction."[59] In *Gingerbread Man* a series of gingerbread men were eaten by the artist. "The cookies were pushed into his mouth rapidly without being swallowed and frequently emerged from his mouth. Eventually they were swallowed, passed through his stomach and intestines, and excreted. The work's final form was a video tape of the fecal-smear slide that was made."[60]

His work moved farther away from land art in general after 1970, but in 1974 he returned to natural sites to do a number of pieces. *Identity Stretch* con-

23. Dennis Oppenheim: *Identity Stretch.* 1970–1975. Hot sprayed tar, 300' x 1,000'. Oppenheim printed his thumb (right) and his son, Eric's (left), on elastic material, which he then stretched to the maximum, photographed, and reproduced (1974) at Artpark, Lewiston, New York. (Photograph courtesy the artist)

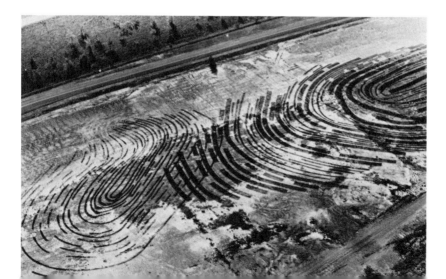

sisted of spraying hot tar in the shape of two thumbprints on a site at Art-
park. He also made several fireworks signs that, when lit simultaneously,
spelled out various phrases. Using letters 4 feet high, he briefly stated such
ideas as: "Avoid the Issues," "Radicality," "Pretty Ideas," and "Mindless
Less Mind."

Oppenheim's work has continued to change and has gone on to touch on
various other ideas central to the art world of the 1970s. His approach to his
work, which only briefly fell into the land art category, can perhaps best be
described by critic Jonathan Crary: "There is an excessiveness—a
mania—supporting Oppenheim's aspirations, an insistence on the tangibility
of everything: a practice that assumes all systems and materials, whether
global or microscopic, institutional or anatomical, are subject to his interven-
tion and modification."[61]

MICHAEL SINGER

Michael Singer's work is relatively recent and does not bring with it the
carry-overs from the 1960s that much of the work of the more veteran artists
discussed here does. From the beginning of his carrier his work has reflected
his concern with two central ideas: "a veneration of nature and a commit-
ment to transience."[62] He moved his work out of doors with his *Situation
Balances* (1971–1973), pieces oriented to the characteristics of their natural site
and did not return to an indoor gallery setting until 1977.

His works done in the early 1970s were made from marsh grass, bamboo,
or reeds and resembled latticework in their construction. The linear nature of
his loosely constructed sculptures gave them the look of line drawings done in
air. One 1973 piece supposedly covered 100 acres, with the work spread out
in sections known as "phragmites." In 1975 he covered 700 feet of an open
glade with sections of bamboo and reed. These early outdoor pieces were
perishable, intended to change with the changes in the environment. "Singer
deliberately blurs the boundaries between the work of art and its surround-
ings. His idea of the function of art is primevally spiritual."[63]

His *Situation Balances* and *Lily Pond Ritual Series* (1975) were impermanent
works that pointed to nature's delicacy and changeability. They were made
from wood and projected a mirror image of curving latticework by being
suspended over water, "the medium which made these effects possible in the
first place. Further, the oak strips made reference to the . . . landscaped hills
and meadows surrounding the work and the pond."[64] Nature is not inac-
cessible, however, and until around 1977 Singer's remote sites were for the

majority of the viewing public. Ironically, these sites are out in the middle of unspoiled nowhere and would surely be ruined if the usual flock of gallery patrons trooped out en masse to view the works.

In 1977 he erected two indoor constructions—a departure from his previous work. Whereas his outdoor sculpture of just two years before was described as a "complex mesh of curved horizontals," a reviewer noted a difference in the 1977 work: "a radical change in the new indoor sculpture is the totemic quality that the artist has introduced into the vertical elements."[65]

In 1979 Singer had a gallery show in which he displayed his latest work, drawings done with charcoal, chalk, and collage. The drawings have a similar scratchy, linear feel to them that his sculptures do, but as they do not have to support their own weight, they are more freely constructed, lines and smudges often floating independently of each other on the page. Done in a different medium from his sculpture, the drawings do reflect Singer's central themes of change and motion within nature.

ROBERT SMITHSON

The bigness of a natural setting and its constant reminders of things primeval undoubtedly appealed to Robert Smithson and were in line with the expressionistic qualities of his work. By 1962 he had moved from the surreal painting/collages done in 1959 to single-line drawings that dealt with stream-of-consciousness images. An outward looseness of style was being established that would comfortably carry him into the outdoor arena and on to his earthworks. Also in 1962, he was working with oils on paper and large canvases, producing imagery compared to "aerial views of modern plowing techniques; or the Venice canal system crammed into the 59th St. subway station and then cross-sectioned."[66]

In 1964 he exhibited a piece in the Finch College Museum, New York, called *Enantiomorphic Chambers,* a construction using mirrors and accompanied by drawings. According to one review it demonstrated "the gap between seeing and knowing."[67] That same year he wrote an article, "Quasi-infinities and the Waning of Space," in which he quotes George Kubler to help him explain his own idea of time: "Actuality is ... the interchronic pause when nothing is happening. It is the void between events." Later in the same article he wrote, "Most notions of time (Progress, Evolution, Avant-garde) are put in terms of biology. Analogies are drawn between organic biology and technology ... the nervous system is extended into elec-

tronics, and the muscular system is extended into mechanics . . . the meta-
phors of anatomical and biological science linger in the minds of some of our
most abstract artists.''[68] *Plunge* (1966) is a line of ten separate rectangular
units painted black and decreasing in size across the gallery floor. Each
module consisted of four cubes that were piled like empty boxes. Smithson
moved the positions of the boxes four times during the show in order to make
a statement about time. In 1968 he showed *Gyrostasis,* a standing triangulated
spiral inspired by gyrostasis, the branch of physics dealing with the tendency
of rotating bodies to maintain their equilibrium. The 73-inch-high painted
steel sculpture resembles the curl in the raised tail of a scorpion.

In 1968 Smithson also began doing his ''nonsites,'' usually rocks and dirt
in a bin that were taken from a specific site indicated by maps and aerial
photographs. He described them as ''a fragment of a greater fragmenta-
tion.'' Among these 1968 nonsites was *Site Uncertain—Nonsite* in which seven
V-shaped coal-filled steel bins were lined up in order of decreasing size.
Another was *Nonsite, Franklin, New Jersey,* made with earth and rocks in bins
and illustrated with maps and photographs relating to the original site.

Central to all of Smithson's work is the concept of *entropy,* the natural
tendency toward chaos. ''A sense of both the creative and destructive aspects
of nature informs the best of Smithson's art. The creative aspect finds expres-
sion in Smithson's sensitivity to the variety and magnificence of natural
materials. Less common in art is a sense of the destructive potential of
nature.''[69] In 1969 he proposed the work *Mudslide,* related to the actually
completed *Asphalt Rundown,* done near Rome that same year, in which he had
a truckload of asphalt poured down the side of a quarry. He proposed *Texas
Overflow* in 1970. It was to involve natural materials, black asphalt and sulfur,
that were to be subjected to entropic forces. The yellowish sulfur was to have
been formed into a ring with hot asphalt poured into the center of it and
allowed to seep out.

Spiral Jetty, Smithson's best-known work, was begun on the northeastern
shore of the Great Salt Lake in April 1970. It snakes out into lake water that
has a reddish tint owing to algae; Smithson located the jetty there to counter
the site's desolation and forbidding appearance. Shaped like a large spiral,
the jetty was originally 1,500 feet long and about 15 feet wide. It is composed
of 6,650 tons of black basalt, limestone, and earth. Nineteen seventy-one saw
the production of *Broken Circle* and *Spiral Hill.* The first is an almost complete
circle of land (140 feet in diameter) extending from the edge of a large pond.
A half-circle of the whole has been removed, leaving only that part's outer
edge. In the center of the remaining whole half-circle stands a large boulder.
Spiral Hill is a conical hill made of earth with a white-sand path cut into the

hill and spiraling to the top. The hill is 75 feet in diameter at its base and overlooks *Broken Circle*.

Beginning in 1971 Smithson made attempts to contact industries that used or had an impact on the environment, notably mining companies. He recommended projects of his as a way for them to reclaim their own devastated sites and sketched several proposals for one Colorado mining company that expressed interest. *Projects for Tailings* would have involved the use of the solid waste, or tailings, that remains after ore is removed from rock. The tailings would have been used to build several earthworks, a number of which were terrace-shaped. His thought was that by planning in advance for land reuse, unnecessary devastation could be prevented.

Smithson worked on the 396-foot-long *Amarillo Ramp*, a curved, slowly rising jetty done in Amarillo, Texas, in 1973. The jetty, which rose to a maximum height of 12 feet, formed an open circle 150 feet in diameter and was made from red shale and earth. Smithson was killed in an airplane crash in the summer of 1973 during work on *Amarillo Ramp* and the piece was finished by his wife, Nancy Holt, and friends.

Robert Smithson's work fell somewhere in between the land artists whose

24. Robert Smithson: *Spiral Hill.* 1971. Earth and white sand, diam. 75' at base. The white-sand path is cut into the hill and spirals to the top. Emmen, Holland. (Photograph: John Weber Gallery)

work basically consisted of moving around huge quantites of earth and those whose work was concerned with saying something about the natural environment. He did his share of earth moving, but unlike some other monumental builders, he often pitted one element against another. Smithson was interested in saying something about his concept of entropy, which, depending on the effectiveness of each piece, says something about nature, as well.

ALAN SONFIST

In contrast to many other artists dealing with the land, Alan Sonfist did not switch from another artistic interest to a concern with nature. His artwork has always dealt directly and exclusively with nature. Having grown up near a native hemlock forest in the Bronx, New York, he infuses his work with symbols of his childhood relationship with that forest. In 1965 he began the first in a series of forest reconstructions in which he transplanted a small section of this Bronx forest, then being destroyed by vandals, to a site in Illinois. He also did *Element Selections,* artworks in which he carefully stepped through a natural area choosing elements unique to that area on which to focus viewer awareness. Some twigs, leaves, rocks, and seeds were left on raw canvas within the area, to decompose and merge back into the environment. Others were taken indoors and their spatial relationships reconstructed. Other chosen elements were put into containers to form *Gene Banks* for future generations to reconstruct.

In 1969 he put a mound of seeds in Central Park of species native to the city, allowing them to be displaced into the planned environment of the park and city by the wind. That year he began negotiations with Tom Hoving, Director of The Metropolitan Museum of Art, concerning another forest transplant, *Time Landscape,* as part of the museum. The museum site was one part of his proposal for sculpture based on historic nature to be created in sites all over New York City.

On Earth Day in 1970 he planted plastic and real flowers together in a park to test the public's judgment of real and artificial nature. In a gallery exhibit that year Sonfist's announcement was a voice print of himself saying *Retrospective.*[70] He showed an array of artwork done in previous years. Together they established the basic themes of his work. As the artist said in an interview about the exhibition, ''I want to make visible the invisible phenomena of the universe.''[71]

One artwork, *Microorganism Enclosure,* was a horizontal sculpture in which the visual patterns of the life and death of colonies of microorganisms could

25. Alan Sonfist: *Crystal Monument*. 1966–1972. Lucite globe containing crystals that change form and location continually in response to the temperature and air currents in the surrounding atmosphere. (Photograph courtesy the artist)

be looked down upon. *Daphnia* was a sculpture consisting of a series of clear enclosures whose color changes were determined by the rise and fall of the population of small living organisms inhabiting the enclosures. He also exhibited several large *Crystal Monument* sculptures (1966–1972) showing the changing cycle of crystal growth. A critic remarked, "Sonfist deliberately containerizes these miniature systems in order to draw an analogy between them and the larger ecological system we think of as our earth."[72]

In 1971 Sonfist installed a *Crystal Monument* as a wall of the Boston Museum of Fine Arts for an exhibition titled "The Elements: Earth Air Fire Water." He also had an exhibition at the Institute of Contemporary Art in London. The curator wrote, "His work is in the tradition of contemplative art." He compared Sonfist's art to "John Donne and other seventeenth-century poets with their frequent allusions to consonance between microcosm and macrocosm."[73]

In 1972, Sonfist exhibited *Earth Monument,* the history of an area written visually in rock: he displayed a 30-foot core of earth in the Akron Art Institute, Ohio, showing the colors and textures of the land beneath the city. He also did sculptures by casting the form of cavities caused by erosion on hillsides. Also in 1972, Sonfist did another transplant artwork, this time of a living society. *Army Ants: Patterns and Structures* involved the temporary relocation of a colony of army ants. The ants were the social ordering or microcosm within the macrocosm of the urban environment. The movement of gallery visitors mirrored the movement of the ants within the artwork. That year Sonfist visited sites painted by an early American artist to do an "Element Selection" titled *Dreams with Asher B. Durand.*

Sonfist often works with scientists to create practical solutions for his contemplative ideas. In 1973 he worked on a marsh reconstruction for the city of Cambridge, Massachusetts. With a team of Massachusetts Institute of Technology and Harvard researchers, he studied the feasibility of bringing back the native fauna and flora to renew animal and bird life. He exhibited the resulting piece at the Center for Advanced Visual Studies.

In 1975 in consultation with geologists and ecologists, he drew up a plan for converting a chemical-waste dump into a forest of native plants and trees. Typical of his use of poetic metaphor, he began the piece with *Pool of Earth,* a rock-ringed circle of virgin soil to give birth to a forest through seeds carried in by wind and animals.

In 1977, for a one-man exhibition at the Boston Museum of Fine Arts, Sonfist created a 20-foot-high public artwork, *Tower of Leaves,* using fallen leaves from the site. That year he began to construct one section of his plan for New York—a hemlock forest in the Bronx. Having searched for several

different sites besides The Metropolitan Museum since 1969 and having obtained the necessary legal permissions and raised the necessary funds, *Time Landscape* was finally dedicated by public officials in New York City in 1978. A 9,000-square-foot site was reconstructed as a pre-Colonial forest. Sonfist planted a meadow and a young oak forest, composing it by combining parts of his many *Element Selections* artworks. *Sun Monument* was also created in 1978 in Kingston, Rhode Island, by angling several hills according to the position of the sun for each month of the year.

Sonfist's work is distinguished by his use of natural materials as media. He makes artworks that reveal through reconstruction the structuring of these natural elements and their poetic implications.

GEORGE TRAKAS

If a main theme must be looked for in an artist's work, then George Trakas's motivating impulse must be his idea of how the human body affects the human being's perspective on the world. What is important to him is not the body itself, its functions and malfunctions, so much as its place, its position, even its height and weight with regard to its immediate environment. Trakas can be called an earth artist in that, like so many other earth artists, the outdoors has, from time to time, been the only place to accommodate some of his ideas.

After doing ↓↑ in 1970, he built structures in 1971 that a reviewer described as follows:

Tabernacle-like structures are formed of metal girders and rough wooden beams. The walls are often fragile panes of glass. These transparent, glistening elements are so fixed as to support on their thin edges the massive weights of metal beams and telephone-pole-like shafts somewhat rigidly fixed in place by gravitational tugs, knottings and settings which occasionally suggest delineations of "eaves." Thus, the support is in the "wrong" place—instead of being ground-borne, the supports are formed of what can be viewed as the "spines" of these boothlike structures. What is unexpectedly tested . . . is the structural integrity of the elements associated with crisp fragility.[74]

Passage (1972) was an actual bridge constructed in a gallery. Viewers were encouraged to walk across it to experience their passage through this environment more fully. Trakas went outside to build *Union Station* (1975), a piece that consisted of two bridges, one of wood and one of steel, that extended

26. George Trakas: *Rock River Union* (detail). 1976. Steel and wood, 360′ x 102′.
Artpark, Lewiston, New York. (Photograph courtesy the artist)

from an elevated road into a marshy field. The bridges, looking like elevated railroad tracks, followed a line that would have had them intersecting had not Trakas blown them up at that point. Described by the critic Roberta Smith as looking like the scene of an accident,[75] the wooden bridge splintered, and the steel bridge bent back upon itself.

In 1976 Trakas took part in an outdoor group show in Lewiston, New York, where he built *Rock River Union*. It was a steel bridge built down the side of a cliff, enabling viewers to look at rock formations and a concrete, steel, and wood stair cascade that went down to the Niagara River.

Back inside in 1977 he built *Columnar Pass* in a gallery at the Philadelphia College of Art. The construction was a crisscrossing of steel and wood weaving by the object of the "pass"—a column in the middle of the gallery. It was low to the ground and suggested itself as a footpath to the viewer. He built another outdoor bridge in late 1977.

The 160-foot bridge emerged from an embankment, angled over the uncovered foundation of the old Minneapolis Armory, and terminated at the stump of an ancient elm. Arching over the bridge where it crossed the Armory foundation was a steel framework that suggested a simple house. The spectator had to walk along the bridge and into the landscape to really experience the work.[76]

Trakas's work is concerned with the environment, but more with the environment as experience, as idea, than with environment as a part of nature. Like many other artists mentioned who have built constructions outdoors, his objective seems to be for the viewer to experience the environment not necessarily as it is but as he wants it to be seen.

NOTES

1. "Reviews and Previews: New Names This Month," *ARTnews* 58, no. 6 (October 1959), p. 18.

2. Roberta Smith, "Reviews: 112 Greene Street," *Artforum* 12, no. 1 (September 1974), p. 71.

3. *Ibid.*

4. "British Artists at the Biennale des Jeunes in Paris: Statements by the Artists," *Studio International* 176, no. 892 (September 1967), pp. 92–93.

5. Charles McCorquodale, "London," *Art International* 22, no. 1 (January 1978), p. 83.

6. Lawrence Alloway, "Christo," *Studio International* 181, no. 931 (March 1971), p. 97.

7. Lawrence Campbell, "Reviews and Previews," *ARTnews* 63, no. 4 (Summer 1964), p. 15.

8. Robert Melville, "Gallery: Stars and Parcels," *The Architectural Review* 150, no. 893 (July 1971), p. 57.

9. Jan van der Marck, "Why Pack a Museum?" *Artscanada* 26, no. 136/137 (October 1969), pp. 34–35.

10. *Ibid.*, p. 35.

11. Alan McCullogh, "Letter from Australia," *Art International* 14 (January 1970), p. 71.

12. Beth Coffelt, "Running Fence: A Drama in Wind and Light," *ARTnews* 75, no. 9 (November 1976), p. 85.

13. Jill Johnston, "Reviews and Previews: New Names This Month," *ARTnews* 61, no. 10 (February 1963), p. 19.

14. Thomas Neumann, "Reviews and Previews," *ARTnews* 63, no. 10 (February 1965), p. 16.

15. Nicolas Calas, "Reviews: In the Galleries," *Arts* 41, no. 3 (December 1966–January 1967), p. 70.

16. Valentin Tatransky, "Reviews," *Arts* 52, no. 4 (December 1977), p. 16.

17. Douglas Crimp, "Reviews and Previews," *ARTnews* 72, no. 4 (April 1973), p. 82.

18. Bruce Boice, "Jan Dibbets: The Photograph and the Photographed," *Artforum* 11, no. 8 (April 1973), p. 45.

19. *Ibid.*, p. 47.

20. Hugh Adams, "Jan Dibbets and Richard Long," *Studio International* 193, no. 985 (January–February 1977), p. 68.

21. Ti-Grace Sharpless, "Reviews and Previews," *ARTnews* 61, no. 9 (January 1963), p. 15.

22. Jack Burnham, "Contemporary Ritual: A Search for Meaning in Post-Historical Terms," *Arts* 47, no. 5 (March 1973), p. 40.

23. Helen Mayer Harrison and Newton Harrison, *Dialogue Discourse Research* (Santa Barbara, Calif.: Santa Barbara Museum of Art, 1972), p. H-13.

24. *Ibid.*, p. H-20.

25. *Ibid.*, p. H-21.

26. Kim Levin, "Helen and Newton Harrison: New Grounds for Arts," *Arts* 52, no. 6 (February 1978), p. 127.

27. Burnham, "Contemporary Ritual," p. 41.

28. Michael Heizer, "The Art of Michael Heizer," *Artforum* 8, no. 4 (December 1969), p. 32.

29. "Discussions with Heizer, Oppenheim, Smithson," *Avalanche* no. 1 (Fall 1970), p. 70.

30. Dore Ashton, "New York Commentary," *Studio International* 179, no. 920 (March 1970), p. 119.

31. *Ibid.*

32. "Discussions with Heizer, Oppenheim, Smithson," p. 62.

33. *Ibid.*, p. 70.

34. Sharon Edelman, ed., *Artpark: The Program in Visual Arts* (Buffalo, N.Y.: Buffalo University Press, 1976), p. 79.

35. Peter Hutchinson, "Earth in Upheaval," *Arts* 43, no. 2 (November 1968), p. 19.

36. William Johnson, "Scuba Sculpture," *ARTnews* 68, no. 7 (November 1969), p. 53.

37. Peter Hutchinson, *Peter Hutchinson Selected Works: 1968–1977* (New York: John Gibson Gallery, 1977), unpaged.

38. *Ibid.*

39. *Ibid.*

40. *Ibid.*

41. *Ibid.*

42. *Ibid.*

43. *Ibid.*

44. *Ibid.*

45. William Feaver, "London Letter: Summer," *Art International* 16, no. 9 (November 1972), p. 38.

46. April Kingsley, "Reviews and Previews," *ARTnews* 71, no. 3 (May 1972), p. 52.

47. Andrew Causey, "Space and Time in British Land Art," *Studio International* 193, no. 986 (March–April 1977), p. 128.

48. Ronald J. Onorato, "Illusive Spaces: The Art of Mary Miss," *Artforum* 17, no. 4 (December 1978), p. 28.

49. Edelman, *Artpark,* p. 160.

50. Onorato, "Illusive Spaces," p. 160.

51. Scott Burton, "Reviews and Previews," *ARTnews* 66, no. 22 (April 1967), p. 14.

52. Al Brunelle, "Reviews and Previews," *ARTnews* 68, no. 2 (April 1969), p. 20.

53. Dore Ashton, "New York Commentary," *Studio International* 179, no. 920 (March 1970), p. 119.

54. Ronald J. Onorato, "The Modern Maze," *Art International* 20, nos. 4–5 (April–May 1976), p. 22.

55. Carter Ratcliff, "Reviews: New York," *Artforum* 15, no. 2 (October 1976), p. 65.

56. Al Brunelle, "Reviews and Previews," *ARTnews* 67, no. 4 (Summer 1968), p. 17.

57. Jack Burnham, "Dennis Oppenheim: Catalyst 1967–1970," *Artscanada* 27, no. 4 (August 1970), pp. 29–36.

58. Dennis Oppenheim, "Interactions: Form—Energy—Subject," *Arts* 46, no. 5 (March 1972), p. 37.

59. *Ibid.*

60. *Ibid.*

61. Jonathan Crary, "Dennis Oppenheim's Delirious Operations," *Artforum* 17, no. 3 (November 1978), p. 37.

62. Margaret Sheffield, "Natural Structures: Michael Singer's Sculptures and Drawings," *Artforum* 17, no. 6 (February 1979), p. 49.

63. *Ibid.*

64. Carter Ratcliff, "Reviews," *Artforum* 18, no. 2 (October 1979), p. 49.

65. Sheffield, "Natural Structures," p. 49.

66. Valerie Peterson, "Reviews and Previews," *ARTnews* 61, no. 2 (April 1962), p. 58.

67. Mel Bochner, "Art in Progress—Structures," *Arts* 40, no. 9 (September–October 1966), p. 39.

68. Robert Smithson, "Quasi-infinities and the Waning of Space," *Arts Magazine* 41 (November 1964), pp. 8–9.

69. John Beardsley, *Probing the Earth: Comtemporary Land Projects* (Washington, D.C.: Smithsonian Institution Press, 1977), p. 83.

70. Lawrence Alloway, Introduction to *Autobiography of Alan Sonfist* (Ithaca, N.Y.: Cornell University, Herbert F. Johnson Museum of Art, 1975), p. 3.

71. Grace Glueck, "Nature's Boy," *The New York Times,* November 15, 1970.

72. Cindy Nemser, "The Alchemist and the Phenomenologist," *Art in America* 59 (March 1971), pp. 100–103.

73. Jonathan Benthall, *Alan Sonfist* (London: Institute of Contemporary Art, 1971), p. 10.

74. Robert Pincus-Witten, "Reviews," *Artforum* 13 (Summer 1975), p. 67.

75. Roberta Smith, "Reviews," *Artforum* 14 (December 1975), p. 69.

76. William Hegeman, "Sculpture to Walk Through," *ARTnews* 77, no. 1 (January 1978), p. 115.

MARK ROSENTHAL

Some Attitudes of Earth Art: From Competition to Adoration

Mark Rosenthal, Curator of Collections of the Berkeley University Art Museum, has grouped artists into five main categories that typify different approaches to the environment. Certain artists mount something of an assault on nature while others merely "touch" the landscape lightly to produce their art. Does earth art have to give heavy-handed evidence of a human presence on the landscape to be effective, or can the artist subtly redirect nature and allow it to make its own statement? Rosenthal's essay discusses the work of several artists, but, specifically, he compares the attitudes of Robert Smithson and Alan Sonfist toward the environment they work in and on.

> Nature exists to be raped![1]
> —Pablo Picasso

Picasso's declaration represents in exaggerated form the attitude of those early twentieth-century artists who insisted on the expressive power to assault and manipulate the most fundamental subject matter of art: nature. By contrast, the passionate embrace of nature by earth artists reflects a renewed faith in this primary source of artistic inspiration. That nature can inspire such diametrically opposed reactions, in the same century, indicates its steadfast position as a testing ground of artistic ambitions. Within the bounds of earth art, however, there is a diverse range of attitudes toward nature. To some extent, the attitudes overlap, but important distinctions do emerge. My purpose in this essay is to explore and compare some of these attitudes, without necessarily surveying and/or mentioning every figure identified with earth art, or establishing the definitive history of this tendency up to the present, or delving into all the precedents and significant parallels.

27. Michael Heizer: *Five Conic Displacements*. 1969. Excavations 800' x 15' x 4' 6" in Coyote Dry Lake, Nevada. (Photograph: Xavier Fourcade, Inc.)

GESTURES IN THE LANDSCAPE

The prototypical earth artists are Walter De Maria, Michael Heizer, Dennis Oppenheim, and Robert Smithson. The term *earth art* was initially applied to these artists in particular, and the assignment of one term for the four remains a reasonably accurate indicator of the fact that they share certain characteristics. While there was an urge to reject the gallery system, an urge that by implication evoked the positive and romantic values of the land, De Maria, Heizer, Oppenheim, and Smithson grandiloquently marked the land with their presence. Their work arises from Minimalism, yet may be said, stylistically, to be a merger of that tendency with Abstract Expressionism. De Maria's *Las Vegas Piece* (1969), Heizer's *Double Negative* (1969–1971), Oppenheim's *Branded Hillside* (1969), and Smithson's *Spiral Jetty* (1970) utilize the geometric, hard-edge style of Minimalism but also evoke the pronounced gestural qualities associated with the Abstract Expressionists. If the canvases

28. Dennis Oppenheim: *Pretty Ideas.* 1974. Red, yellow, and green strontium nitrate flares, 15′ x 100′. Long Island, New York. (Photograph courtesy the artist)

29. Robert Morris: *Observatory.* 1971. Earth, timber, granite, steel, and water, diam. 230'. First version created for Sonsbeek 71, Ijmuiden, Holland; now destroyed. (Photograph: Leo Castelli Gallery)

30. Robert Morris: *Observatory.* 1971–1977. Earth, wood, and granite, diam. 298' 6". Permanent installation in Oostelijk Flevoland, Holland. (Photograph: Leo Castelli Gallery)

of the latter were among the largest of the country, De Maria, Heizer, Oppenheim, and Smithson went a step further in placing their marks on a scale best viewed and photographed from the air.

Site-specificness is an almost incidental result of the physical size of these pieces. Although the works are physically inseparable from the locales, space, as in Dan Flavin and Carl Andre, is a generic or conceptual matter. That is, the formally discrete composition of De Maria's pair of lines forming a T, Heizer's negative voids, Oppenheim's X within a circle, and Smithson's spiral might have been placed at any number of locations. These forms establish an engagement with space,[2] much as do unintended aesthetic phenomena, such as hedgerows and jetties.[3]

The actions of these artists in the landscape retain some of the impetus suggested by Picasso's metaphor of the rape. Landscape is bulldozed and penetrated for the purpose of incising a visual statement. Smithson notes that heavy construction has a "primordial grandeur," and views the "*disruption* of the earth's crust" as "compelling."[4] Finally, Smithson's principal interest is art: ". . . there's no need to refer to nature anymore. I'm totally concerned with making art."[5] While De Maria, Heizer, Oppenheim, and Smithson may enjoy nature in some transcendent sense, their work is not concerned with revealing such emotions. Rather they approach nature utilizing the vernacular of the modern world.

ENCLOSURES IN THE LANDSCAPE

Michael Heizer's *Complex One/City* (1972–1976), Robert Morris's *Observatory* (1971–1977), and Robert Smithson's *Broken Circle—Spiral Hill* (1971) extend the central premises of the works described as "gestures in the landscape." There remains a strong emphasis on ambitious, large-scale, geometrically composed structures that are united with their specific sites primarily because of scale. These quasi-architectural structures support comparison with ancient and tribal monuments that seek accommodation with, signify worship of, or aspire to protection from natural deities. Whether the contemporary artists share these motives is ambiguous, but their works do partake of the dramatic formal vocabulary, the iconic appearance, and the mysteriousness of earlier prototypes.

In these pieces, as well as many by Alice Aycock (for example, *Circular Building with Narrow Ledges for Walking,* 1976), Richard Fleishner (*Untitled,* at Artpark, 1976), and Mary Miss (*Sunken Pool,* 1974), a powerful suggestion of an interior space exists. Whether or not one does, this suggestion qualifies the

bold, uncompromising quality of the "gesture in the landscape." Instead of simply viewing a wonder of human achievement, the viewer is enticed to approach and explore a space that is indicated structurally but hidden from view. The implication and then discovery of this space, if it exists, isolate the structure from its setting to some extent, for the space is largely separate from the surroundings. Moreover, once inside, the spectator is secluded, or perhaps protected, from the adjacent landscape.

Many of the works by Aycock, Fleishner, and Miss present a vertical profile juxtaposed with the horizontal ground plane. (In several instances, the vertical is inverted into the earth.) This verticality produces an effect of visual independence of the pieces from their settings. The works, in general,

31. Alice Aycock: *Circular Building with Narrow Ledges for Walking.* 1976. Reinforced concrete, cast in place, rising 13' above ground and extending 4' below. The exterior diameter is 12', and the three interior concentric ledges have diameters of 10' 8", 9' 4", and 8'. The ledges are placed so that one must walk around the entire ledge before descending to the next level. Silver Spring, Pennsylvania. (Photograph: John Weber Gallery)

have the quality of a large-scale object that shapes space, placed in a landscape context. Morris says of *Observatory,* specifically, "it lies in between sculpture and architecture."[6]

MODEST GESTURES IN THE LANDSCAPE

Richard Long and Michael Singer "touch" the landscape in a very delicate, unobtrusive manner. Long usually creates a small geometrical or loosely geometrical pattern of stones or branches. In this aspect he joins the artists described in the previous two sections; all seem intent on juxtaposing the human invention of geometry with nature's chaotic composition. But Long's actions are of the utmost modesty. Similarly, Singer bundles reeds, branches, or bamboo stalks and places them in marshy areas. So slight are his actions, as are Long's, that it may be difficult to discern the artwork.

As opposed to the example set by Smithson, Long and Singer concede

32. Richard Long: *Circle in the Andes.* 1972. Photograph of site installation. (Photograph courtesy the artist)

precedence to the landscape. Both view their works as ritualistic responses to the site with which they are interacting. Their largely horizontal gestures acquiesce in and complement the landscape. That these quiet gestures will be quickly erased is part of the modest ambitions of the artists when they work in nature.

NATURE FOR ITSELF

In the late 1960s numerous artists began to exhibit processes found in nature with little or no literal touch of their own hand. De Maria's *Earth Room* and Smithson's "nonsites" (both 1968) are key monuments, for each brings

33. Walter De Maria: *The New York Earth Room.* 1977. Earth, peat, and bark, 22″ x 3,600′ sq. New York City. (Photograph: John Cliett; courtesy Dia Art Foundation; copyright © 1980 by Dia Art Foundation)

nature into the gallery in a raw, unmodified fashion. Other examples include Hans Haacke's *Ten Turtles Set Free* (1970), Newton and Helen Harrison's *Slow Growth and Death of a Lily Cell* (1967), Neil Jenney's sculptures made of branches (1968), Morris's greenhouse of fir-tree seedlings (1969), and Oppenheim's cultivation and harvesting projects (1969). In all of these there is an emphasis on natural process occurring in real time, very nearly to the exclusion of "art" concerns. Indeed, nature's compositional and aesthetic qualities substitute for those created by an artist in an artwork. The effect in many cases is a kind of *memento mori*, in that the viewer is presented with birth, growth, regeneration, and decay, themes that can easily be construed as pointed parallels to the human condition. As opposed to the earlier discussed works, these pieces banish the artist's heroic or even modest independence, and give absolute priority to nature.

IDEALIZED LANDSCAPE

Hamish Fulton and Alan Sonfist also eliminate the gesture of the artist while paying obeisance to nature. Fulton exhibits photographs taken on long walks in countrysides throughout the world. Beneath these are expressionless descriptions of the locales and the distance of the walks. Although often associated with Richard Long, Fulton does not "touch" the landscape directly; only the border of the photograph indicates that he was even present in the landscape. Sonfist is known for a variety of objects, including rubbings made from trees and didactic presentations in which the gene composition of a leaf is shown. Sonfist's *chef d'oeuvre* is *Time Landscape* (1965–1978), a parcel of earth on West Broadway (1978) in New York City on which are planted the trees and shrubbery that would have been found in the pre-Colonial forests of the city. Like the work of the preceding group, *Time Landscape* presents nature in an unadulterated, unmodified state as the fundamental content of the work. The fact that this portion of nature is contained and bound up by a fence and located a few hundred feet from the center of SoHo reflects Smithson's influential "nonsites," in which raw nature is contained for presentation in an art context. One might also mention in this category of works Frank Gillette's *Aransas* (1979), an eight-channel video installation. The eight video tapes are shown simultaneously, without programmatic coordination. The natural events at the Aransas Pass nature preserve in Texas are recorded.

Fulton, Gillette, and Sonfist do not generalize about landscape or space. Whatever the place, its qualities and aspects are of the greatest significance,

34. Alan Sonfist: *Time Landscape.* 1978. Trees and shrubbery, 9,000′ sq. Re-creation of a pre-Colonial forest. Red Hook, Brooklyn. (Photograph courtesy the artist)

35. Robert Smithson: *Spiral Jetty.* 1970. Black rock, salt crystals, earth, and red water (algae) composing a coil 1,500′ x 15′. Great Salt Lake, Utah. (Photograph: Gianfranco Gorgoni; courtesy John Weber Gallery)

determining most if not all aesthetic decisions. Their veneration of nature is such that there is a corresponding diminishment of formal concerns. Rather, the effects of nature and the site predominate, as if an Impressionist were at work. Moreover, in comparison to Smithson's choosing degraded sites, these artists always present picturesque views in which human beings are absent.

The various attitudes considered here can be summarized by comparing perhaps the archetypal earthwork, Smithson's *Spiral Jetty*, to what may become a second, revisionist archetype, Sonfist's *Time Landscape*. Certainly there are areas of common concern, qualities that demonstrate the joint participation of Smithson and Sonfist in the confraternity of earth artists. Both have an outlook that is characteristic of the recent past's ecological preoccupations. That is, Smithson seeks to recycle a landscape site that reveals a "succession of man-made systems mired in abandoned hopes,"[7] and Sonfist wants to rejuvenate a bit of natural history. Reinforcing their romantic outlooks is, in varying degrees, a concern with site-specificness, a concern that places the values and processes of nature in a significant position. *Spiral Jetty* is, in part, about entropy, the force of degeneration and decay; in *Time Landscape* the viewer can observe the growth of trees. Both sequences of events require significant periods of time. Finally, and perhaps crucially, the artist's literal interaction with nature is fundamental to both Smithson and Sonfist. It is perhaps this interaction and its prominence in the artwork that epitomizes earthwork generally, rather than whether earth is used as a medium or the work is present on the land. Notwithstanding these comparisons, *Time Landscape* is a radical departure from *Spiral Jetty*.

In *Spiral Jetty* Smithson utilizes a signature form—the spiral. It is a specific, repeatable form that creates a dialogue with place. Although *Spiral Jetty* is sufficiently of its locale to be immovable, it is, nevertheless, a rapprochement between an element of the artist's vocabulary and a site. By contrast, Sonfist implacably restates the nature that was once there. *Time Landscape* is completely site-specific in all of its aspects, although it is in reality a memory of the site.

One might ask where the "art" is in *Time Landscape*, that is, where is the formal composition in this ostensibly formless environment. In contrast, Smithson creates a very powerful, formal geometrical composition. His spiral is clearly an addition, a human gesture, made to the site. He maintains the importance of art, or perhaps his own self-importance, whereas Sonfist immerses art and himself in the site. This is not to say that Sonfist's work, unlike Smithson's, is passive and unprovocative. His work creates a dialogue between abandoned and current values, between concerns for the land and the priorities of an urban landscape.

Whereas Smithson pushes and manipulates earth to form his signature, Sonfist cultivates a garden. Smithson represents the heroic individual confronting nature with his tools, and Sonfist symbolizes the ecological servant of nature. Smithson attacked those seeking an "absolute garden," saying they naïvely seek a return to a place from which humanity has not yet fallen;[8] this for Smithson is a "jejune Eden."[9] For him, at least in his most strident moments, earth is merely a medium of his art. But the Earth is sacred to Sonfist. He epitomizes the attitude ridiculed by Smithson, for he does aspire to those gardens that existed before the Fall, in this case of Manhattan.

While Smithson's disavowal of the biblical garden is emphatic, he too revels in a seemingly biblical state, after the Fall. He writes didactically of entropy, but then rhapsodizes on these moments of dissolution and destruction. For instance, after having incised his line, he speaks of becoming engulfed in the scarlet reflection of the sun there: "My eyes became combustion chambers churning orbs of blood blazing by the light of the sun. All was enveloped in a flaming chromosphere; I thought of Jackson Pollock's *Eyes in the Heat.*"[10] With this comparison, Smithson gives to his action in the landscape a certain life-enhancing/life-consuming power, similar to Pollock's mythic struggle on canvas.

Smithson was clearly aggressive with his subject matter. His joy in the "disruption of the Earth's crust" very nearly equals Picasso's strident pleasure in making nature submit. It is not surprising that Smithson was accused, in one review, of raping the earth.[11] He even wrote that "nature has no morality."[12] However, he defended himself against the accusation of rape by saying that "sex isn't all a series of rapes." Through congress with nature he believed he was asserting his own naturalness.[13] If Picasso believed in the rape of nature, one might suggest that Smithson believed in physical, ostensibly nonromantic, intercourse with nature.

Sonfist carries the sexual metaphor further in his photograph titled *Myself Wrapping the Tree* (1972). He too feels exalted by his contact with nature. And although his love is also physical, it is impossible to imagine Sonfist agreeing with Smithson that nature is without a morality. On the contrary, *Time Landscape* reminds the beleaguered city dweller of the moral and upright place from which he or she has departed. To pursue the sexual metaphor a step further, Sonfist places nature on a pedestal before making love to it.

Many earth artists have expressed the fervent desire to assert their own naturalness, and acting vis-à-vis nature is their means to achieve the goal. In some cases these efforts are viewed, with German Romantic optimism, as analogies to the activities of nature itself. But this heroic attitude has begun to give way or to exist side by side with a more modest view. Instead of an im-

plied competition, the more tentative earthworkers produce homages that have little touch of the artist's hand. The distinction is between those with technological confidence and those with none. The former seek equality with nature by integrating their efforts in the landscape. The latter submit entirely to the site, producing ritualistic responses. The comparison recalls Wilhelm Worringer's polarity between cultures that are comfortable with themselves and their human powers and those that fear the unknown energies of nature.[14]

NOTES

1. André Malraux, *Picasso's Mask,* trans. June Guicharnaud and Jacques Guicharnaud (New York: Holt, Rinehart & Winston, 1976), p. 55.

2. "John Beardsley Discusses the Way Land Works: 'Engage the Landscape,'" *Probing the Earth: Contemporary Land Projects* (Washington, D.C.: Smithsonian Institution Press, 1977), p. 9.

3. Marcel Trieb, "Traces upon the Land: The Formalistic Landscape," *Architectural Association Quarterly* (England), no. 4 (1979), pp. 28–29.

4. Robert Smithson, *The Writings of Robert Smithson,* ed. Nancy Holt (New York: New York University Press, 1979), p. 83.

5. *Ibid.,* p. 174.

6. *Het Observatorium van Robert Morris in Oostelijk Flevoland* (Amsterdam: Stedelijk Museum, 1977), unpaged.

7. *Smithson,* p. 111.

8. *Ibid.,* p. 191.

9. *Ibid.,* p. 85.

10. *Ibid.,* p. 113.

11. *Ibid.,* pp. 112–123.

12. *Ibid.,* p. 154.

13. *Ibid.,* pp. 123–124.

14. Wilhelm Worringer, *Abstraction and Empathy,* trans. Michael Bullock (New York: International Universities Press, 1953).

ELIZABETH C. BAKER

Artworks

on

the Land

Why do Michael Heizer, Robert Smithson, and Walter De Maria opt for remote sites far away from cities, galleries, and the public eye to erect their work? And what is the relationship of this art to the landscape of which it is now a part? In "Artworks on the Land" Elizabeth C. Baker, editor of Art in America, *discusses these works and suggests ways in which they might be interpreted should one surmount the difficulties of traveling to their isolated sites. Baker also presents her opinions about the effect these artworks may have on the ecology of these sites and discusses what relation this type of artwork may have to everyday life.*

Since the late 1960s artists have been making art on the land. Some of their work has been ephemeral, some permanent (or intended to be). Some of it has been in urban or semiurban settings, some in leftover industrial waste areas, some on private domestic grounds, or in various kinds of ordinary countryside. Some was made expressly to be documented, and the documentary residue *is* the work. A few artists, however—Michael Heizer, Robert Smithson, and Walter De Maria—have sought out remote sites in the West, isolated stretches of empty land, often arid semidesert unmarked by man. The grandly physical works they have made there (there are only a few) form a particular category among earthworks, and certainly the most paradigmatic one for the medium. These works have a complete clarity of impact, unconfused by any accidental environmental factors. All sorts of outdoor land pieces and site pieces located in settled areas incorporate into their content the way they interact with daily life, with circumstance, with other man-made forms, and the way they declare themselves art in such contexts. The desert pieces are interesting for the very reason that they do not do any of these things; rather, they present art in a very clear polarity with nature.

These pieces come about slowly: the hunt for appropriate and available land is usually complicated, and funding and logistics difficult. However, they continue to be made. From 1967 on Heizer has put a number of pieces, both large and small, in various parts of the desert. Best known and largest is his *Double Negative* (1969–1971), a deep, majestic double cut in the edge of a mesa near the town of Overton, Nevada. Also near Overton is Walter De Maria's *Las Vegas Piece* (1969), an extensive linear work on a vast, flat valley floor. Smithson's *Spiral Jetty* (1970) in the Great Salt Lake (the subject of a film that has been fairly widely disseminated) is probably the best-known earthwork, although it is at present temporarily submerged because of a change in water level. Smithson was killed in a plane crash while surveying for *Amarillo Ramp* (1973), a smaller earth spiral in Texas, completed posthumously. He left plans for a number of works that may someday be built, some of the most interesting of which involve man-made wastelands. A few other artists, among them James Turrell and Nancy Holt, have projects for Western land pieces too.

Two new works at different stages of completion, by Heizer and De Maria, add considerably to the range of what has been done: Heizer is just finishing *Complex One* (1972–1976), a pyramidlike sculpture that initiates a projected group. And Walter De Maria is preparing a new piece, *The Lightning Field* [completed 1977], in the Southwest; it will be a mile-square grid of widely spaced steel poles. I shall discuss the new Heizer piece in the greatest detail here, as it is complete in all its essential elements.

The status of all these works is peculiar. They are not easily visited, and for most people knowledge of them is necessarily filtered through secondhand sources: photographs, posters, articles, diagrams, films, video tapes, whatever. It is ironic that such works, originally motivated partly by the desire to find a way of making art outside the art world's gallery and museum system, end up largely dependent on that system's mechanisms for dissemination. But this is a side issue, for if getting out of the system has proved a practical impossibility (and if the earthwork artists never really stopped making gallery art or exhibiting in museums), the historical shift that took them to the desert produced a new context for the geometrical Minimalist mode in which they were all (to one degree or another) working. This move changes, or at least extends, the meaning of style. Indoors, Minimalism inevitably conducts a dialogue with the architecture, sometimes incorporating it directly. It may or may not aspire to a strongly architectural character, but it is in any case constrained, literally and psychologically, by the real architectural spaces in which it is housed. Outdoors, Minimalism, with its intrinsic drive to large size and to real space, is the antithesis of the accidental, free, organic

shapes of nature; it is the essence of the artificial—of art. As the mark of rational, arbitrary, man-made order interposed in nature, such forms take on a good deal of added resonance.

These works have an ambiguous relationship with the land they occupy. While invariably dramatically sited, they are certainly not involved with "landscape" in any pictorial sense: rather, they stem from self-reflexive sculptural sensibilities preoccupied with structure, materials, scale. Also primary, of course, is their relation to the space around them, but this has very little to do with the specifics of "view." A romantic, "scenic" reading is clearly all wrong. In fact, none of these three artists has opted for sites that are conventionally scenic; their spaces tend to be rather neutral, although very vast.

The land, nevertheless, becomes a strong countertheme to the work's formal properties, both in an obvious and in a subtle way. It is obvious that the choice of site is crucial. Particular works have particular requirements: the right amount of space, the presence or lack of specific natural features, the right kind of grade, the right density and hardness of rock, for example. On a more subtle level, the works conceptually affect the land. The sites become places as vivid as the works themselves—they become concretized, identifiable, specific locales. Unmarked land is undifferentiated, whatever its beauty; it is something you pass through. If *landscape* as an entity does not exist—if it is in all cases a mental construct—then these earthworks are, among other things, the means of re-presenting a particular place. The appearance of that place becomes a part of the content of the work, whether in photographs or in reality, and whether the artists intend it fully, partially, or not at all.

The artists undoubtedly harbor a degree of romanticism about place, space, loneliness, the elements, hard work, and a certain danger inherent in the choice of such places. The drama of the locales is inseparable from extremes of climate, heat, cold, storms, and spectacular light and weather changes. So one must suspect at least a hint of an acceptably modified, appropriately toned-down *frisson* of the old American sublime. But what really counts is much more specific: particular places engender particular types of perceptions, and these perceptions play a role in determining the nature of the works. These works are not only inseparable from their sites—they are not really definable at all apart from them.

Heizer has been building *Complex One* since 1972, working at first from an improvised campsite/construction site in a wide-open, extremely remote, high desert plateau, ringed on the horizon by mountains that are too distant

to provide any shelter. At present, his house and sheds and trucks and his sculpture are the only signs of human occupation, except for a dirt road. He owns or controls nearly all the land in sight, to prevent alien visual intrusions. The piece has been almost finished for nearly a year now, waiting only for some final concrete facing.

Complex One is a long pyramidlike mound made of earth; it has a rectangular base and the long sides slant backward; the ends are trapezoidal. It is somewhat related in shape to *Double Negative:* both are long geometric slivers cutting across the land, but only *Complex One* is built up on it, not cut into it. One might almost say that *Complex One* is *Double Negative* made positive.

It is very different, however, in having many parts: the mound is framed by a set of vertical and horizontal concrete "columns" on its long western face. The piece is oriented to the sun in a general way—empirically, not

36. Michael Heizer: *Complex One/City.* 1972–1976. Cement, steel, and earth, 24′ x 110′ x 140′. South-central Nevada. (Collection of Virginia Dwan and Michael Heizer; photograph: Gianfranco Gorgoni; courtesy Xavier Fourcade, Inc.)

scientifically; it faces the median point of the sun's yearlong swing so as to receive maximum light. Light and shadow are important factors. This face of the work is mainly what counts: its back is and will remain unfinished.

When seen from a distance—half a mile away or farther, say—the work appears to be a rectangular plane standing straight up, framed by bands of concrete. As you go closer, the rectangular framing quite literally comes apart: light starts to slip between different segments of the horizontal and vertical parts, and between column sections and the main mound. What appear at a distance to be continuous bands are seen to consist of a number of thick elements positioned at different and surprising intervals from the mound and from each other. Close up, the real positioning and relative sizes of all the elements become clear.

37. Michael Heizer: *Double Negative* (detail). 1969–1971. Two cuts in the Virgin River Mesa, Nevada, displacing 240,000 tons of rhyolite and sandstone to create a negative structure 50′ x 30′ x 1,500′. (Photograph: Xavier Fourcade, Inc.)

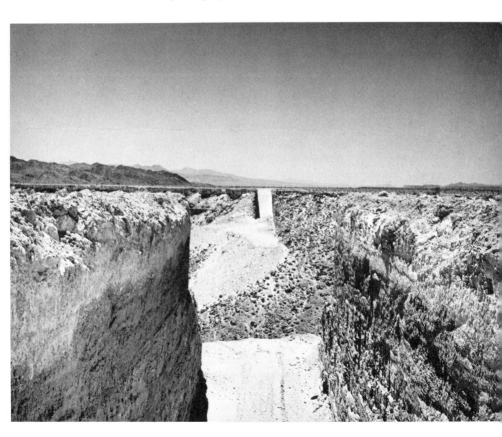

Three kinds of readings present themselves: far off, the work is essentially pictorial, a big, apparently two-dimensional rectangle, its "picture" shape and proportions reinforced by the frame; in the middle distance, it is perceived as a solid, buildinglike form with the various frame or columnar elements reading like beams, walls, other structural members; close up, the parts interact sculpturally with one another and with the viewer in a "normal" sculptural way.

The piece is large but does not seem particularly to aspire to the monumental; it is not calculated to overwhelm. It sits rather modestly in the huge sweep of the terrain. There is a matter-of-fact quality about its scale, which is comprehensibly human—like any medium-size low Western building, perhaps. This goes with the viewpoint to which the piece is oriented: it is meant to be seen from a person's eye level, and if one stands at any distance at all, it does not disturb the line of the mountains behind it. Very horizontal, it nicely includes hugging the ground in its range of more declarative effects.

Some dimensions will help clarify this: the mound is 20 feet high and 140 feet long. The front face is inclined backward at a forty-five-degree angle. The end trapezoids have 60-foot bases. The columns are all 3½ feet wide; most are also 3½ feet thick, but a few vary somewhat in thickness. Including the columns, the overall height of the work is 24 feet. All the columns have faces perpendicular to the ground except the one that forms the right-hand side of the rectangle as you face it; this one is attached to the face of the mound and follows its angle back. (This is why it often catches the light differently.) There are two cantilevered sections of concrete: a T-shaped overhang that juts out 30 feet and has a 30-foot crosspiece, and an inverted-L column, 24 feet high with a 40-foot extension, that stands at the extreme left. The T-form casts a shadow (usually diagonal), which moves as the sun moves, across the face of the piece. A full day is required to see the piece in all its aspects, leaving aside the fact that the shadow's position also changes according to the time of year.

Heizer explains that his sources are the Egyptian mastaba for the general form of the mound and the snake bands bordering the ball court at Chichén Itzá for the framing elements. The projecting stone rings of the same ball court, as well as other Mayan stone overhangs that cast long raking shadows, also come to mind. He likes to tie his work to the past with references like this, and the connections, especially to the mastaba form, are obviously valid. He is well versed in archaeological lore, and conversant with the monumental vocabularies of various ancient and primitive cultures. But this does not begin to explain the odd particularities of his own work or to characterize

it in any way other than the most general. Its references may be partly an-
cient, but they are much more densely contemporary. There is considerable
interplay with Heizer's own paintings—banded geometric forms, often inter-
rupted by cuts or with parts sprung free. Often the bands of color in his
paintings seem to correspond to bands of shadow in the outdoor works.[1] The
complex spatial relationships (one wonders if the title has any punning intent)
in *Complex One*—the integration-disintegration-reintegration of parts in
space, the assured fusion of painting, sculpture, and architecture ideas—all
reflect an artist confidently manipulating what he knows about contemporary
art.

There are plenty of other allusions too: modern industrial echoes are as
much a factor as primitive, archaeological ones. The work is as much like a
billboard in proportions (Heizer sometimes refers to it as a "sign") as it is
like the "big American painting" in format. The overhanging and project-
ing elements are themselves a lot like signs—or lighting fixtures, or ex-
pressway markers. (Interestingly, Heizer calls them "gingerbreads.") The
form may also suggest a motel or low factory sooner than an ancient tomb.

Both perceptually and theoretically, what is most peculiar and original
about the work is the outright split between form and face, for principally,
despite its emphatic three-dimensionality, it is involved with the complexities
of facade. One recalls elaborate, dominant classical porticoes intended for
frontal consumption only—as well as the false-front buildings of old Western
towns. This seems to be a very Nevada-type piece, redolent both of Las
Vegas (cf. the Venturi and Scott-Brown book, *Learning from Las Vegas,* 1972,
for certain architectural and sign-system analogies) and of ghost towns.

The frontality of *Complex One* can be seen as projecting a curiously pic-
torializing effect on a portion of the landscape: it is not just that the presence
of the piece re-presents or differentiates this particular place; it is also that as
a distant, planar, picturelike entity the work tends to crystallize and make a
panorama of a certain lateral sweep of land that frames the frame of the
piece.

Heizer plans to build a second piece facing this one at a considerable
distance, perhaps half a mile. (The full title of the present work is *Complex
One/City,* implying more to follow.) One wonders what this face-off between
the two works will do to the intervening as well as the surrounding space.
There is a likelihood that there will exist a sort of overscaled common or
plaza.

Much writing on earthworks gets rather effusive. The experience of
visiting the works is a complicated one, no small part of which is the difficulty

of getting there and the exoticism of locale and life-style. Things can become intensely anecdotal: you learn about local economics, land purchasing in the West, enormous government land reserves, atomic test sites, snakes, trucks, and desert climates. All this, especially in the course of short visits, tends to overwhelm, so at a certain point it becomes necessary to separate the art experience from the general experience. One of the ways to do this is to compare some of these works, in order to get a clearer sense of the possibilities of personal style. Heizer, Smithson, and De Maria have all done more than one major earthwork, and one can begin to see a developing consistency of style and attitude for each of them—toward form, toward use of land and space, even toward the preferred *kind* of land.

It is instructive to compare De Maria's two earth pieces—*Las Vegas Piece* and *The Lightning Field*—with Heizer's. Both are, from one point of view, much larger than any of Heizer's. *Las Vegas Piece* is a linear work that "covers" several miles of a broad, very faintly inclined piece of flat land. But unlike Heizer's massive displacements, it barely disturbs the surface of the ground. Consisting simply of a right angle with both sides a mile long with a smaller (half-size) right angle set into it, it is a shallow track in the earth the width of a bulldozer's blade (about 8 feet), and only a few inches deep. Six years old and only slightly eroded, the cut appears freshly "drawn."

This piece requires that you walk it. At ground level (it is a clear form seen from the air) knee-high scrub growth hides it unless one is right on it—its track is shallower than all sorts of natural washes and holes. Ground-level perception seems essential to its full meaning. It provides a four-mile walk and an experience of specific place, random apprehension of surroundings, and an intensified sense of self that seem to transcend visual apprehension alone. Its shape becomes known indelibly as a mental visual form, however, during the time it takes to pace it.

The Lightning Field [in 1976] is a work in progress. What exists at present is a small "test field," a 7-by-5-foot unit grid of 18-foot-high stainless steel poles, pointed at the tip, set at one-acre intervals. The test field is about fifty miles outside Flagstaff, Arizona. The finished mile-square field will consist of 640 poles (instead of 35), and will occupy a different, yet undetermined site.

The tenuous physicality of both *Las Vegas Piece* and *The Lightning Field* imposes considerable anticipatory anxiety on the viewer. For both, you walk off the road for quite a long time before seeing anything. Doubt mounts long before you find them; relief and surprise mingle with the experience of the works when you do find them. *The Lightning Field* is slowly grasped, too, but in a different way from *Las Vegas Piece*. The present test field is physically extensive enough to be taken in much as the larger one will be, at least in terms

of sight. Perceptually, it strains your attention, your sense of intervals; its boundaries are not clear once you are more than one or two units inside it. The distance between poles is so great you strain to locate the next one—and especially the one beyond that. But psychological and supraperceptual factors seem crucial here, and knowing you are in a mile-square aggregation will be very different from the present experience.

Formally, *The Lightning Field* relates to De Maria's number permutation sculptures (1965), grids with upright members packed closely, and his steel *Spike Beds* (1968), grids with viciously pointed uprights (just as *Las Vegas Piece* has analogies with his geometrically channeled sculpture objects). *The Lightning Field* implies, if only in name, some menacing overtones too, but the points of the widely spaced poles are not a physical threat: they seem more metaphorical, more formal, even, than functional either as skewers or as lightning rods. Several may have been struck by lightning, however. A degree of danger exists, according to De Maria, during the June-to-

38. Walter De Maria: *Las Vegas Piece.* 1969. Bulldozer cuts into Desert Valley (95 miles northeast of Las Vegas), Nevada, 8′ wide, consisting of two 1-mile-long lines and two ½-mile-long lines. (Photograph: Dia Art Foundation)

September lightning season, when lightning occurs in the late afternoon at least every other day. The piece may yield some useful scientific observations over a period of time. The possibility of lightning is not, however, a necessary component of the work, which retains its validity at those times of year when visiting it presents no danger. (Various plans are under consideration for preventing accidents, which I shall not go into here.)

Seeing the work at high noon, any threat, electrical or otherwise, seems nonexistent. Instead, one feels oneself in a transparent structure that measures out a certain portion of otherwise indeterminate space; one also feels perceptually stretched. Simultaneously cold/precise/industrial and fragile/lyrical/meditation-inducing, De Maria's visually unemphatic, psychologically loaded landworks are ultimately intensely compelling to the imagination.

Smithson had another sensibility entirely. *Spiral Jetty* has been widely published. *Amarillo Ramp* has also been discussed extensively,[2] so these works

39. Robert Smithson: *Amarillo Ramp.* 1973. Red shale and earth, H. 0'-14', L. 396'. Amarillo, Texas. (Collection of Stanley Marsh; photograph: Nancy Holt)

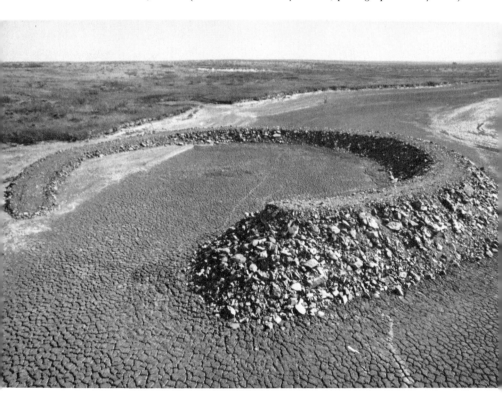

need not be described in detail here. But they make a strong counterstatement to both Heizer and De Maria. Heizer's materials—his rock, gravel, concrete, or plain earth—speak as physical substance, but they usually involve shape, more than color and texture. He is generally involved with rather precise, large-scale shapes and general effects. His style is clear, forthright, aggressive, dramatic. It has obviously involved massive amounts of work with heavy machinery, and big displacements of earth, presumably permanent (this is true of Smithson too). De Maria tends toward dematerialization in favor of heightened mental/psychological content. Both Heizer and De Maria like clear rectilinear geometric structures. Smithson's sense of form is less orderly, more baroque; and although his spirals should imply a kinship with organic form, his constructs seem the most elaborately artificial of all. His choice of materials is also very different; ranging from his grubby, black-and-red asphalt pour to the incredibly hard, heavy, fractured basalt of *Spiral Jetty* encrusted with multicolored algae and salts, to the red rubble of *Amarillo Ramp,* they are highly colored, rugged, and expressionistic. Smithson's earth pieces have all been additive; Heizer has only now made his first additive work. De Maria works minimum physical transformation, instead superimposing a permeable scheme. Although *Double Negative* occupies the edge of a mesa, Heizer and De Maria right now seek flat, rather featureless ground; Smithson, on the other hand, has opted for graded sites. It could be argued that for *Spiral Jetty* and *Amarillo Ramp* the surface of the water provides the planar surface on which he makes a graphic statement—a surface akin to flat desert—but water's complicated reflectiveness is typically Smithsonian. And finally, it is well known that Smithson had a propensity for "distressed" land areas rather than unsullied virgin land.

Earthworks sometimes generate vehement negative responses, part defensive, part sentimental, on the part of programmatic nature lovers. Yet none of these three artists' works is large enough to have any significant impact on the ecology; indeed, someday these works, in their capacity as Art, may have a preservational effect. Making art on the land that will be seen by the very few is also sometimes considered a bizarre, even suspect pursuit. There is certainly a curious mixture of self-removal and self-aggrandizement involved. However, there is also a certain naturalness to this work: primitive cultures appeal to all of these artists, and all are rather knowledgeable in Indian lore. And in the West the supposedly empty land is surprisingly replete with prehistoric marks, notations, and drawings of all sorts. Given this context, it is hard to escape the rather straightforward conclusion that the Earth, stretched flat and flawlessly horizontal, might be an inviting place to work.

A much more enigmatic, practical consideration is the relationship of con-temporary earthworks to the real world of today. One of the striking things about visiting these works (I have seen all the ones mentioned in detail here except *Spiral Jetty*) is the unexpected sense one gets of their connection with ordinary, everyday life. It is one thing to go into a teamwork factory situation and fabricate a sculpture, that is difficult enough; but to put together the technological, social, and quasi-political arrangements necessary to build large works on the land involves a series of encounters that goes well beyond a normal patronage situation—encounters at every level of society, with federal and state land officials through local industrialists, ranch owners, and bankers, to suppliers of all kinds, technicians, workmen, and even watch-men. From case to case all of this is managed with one degree of success or another. But the fact that it is possible to realize an earthwork at all seems to indicate that the profession of avant-garde artist and the idea of the making of art in nontraditional forms have percolated into the culture to such a degree that they now have at least a marginal acceptability, even respectability. It seems inconceivable that works on this scale, in these semipublic (un-protected) circumstances, requiring, after all, a very considerable degree of social cooperation, could have been done more than, say, fifteen years ago. It is fascinating and ironic to consider this side of the matter, for work like Heizer's, De Maria's, or Smithson's can also be seen as a very extreme form of artistic individualism, and its isolation in the desert as the apotheosis of the privileged setting—of the ultimate studio situation.

America has always thought it had limitless wilderness. But it is increas-ingly clear that from the beginning we have also had a national attitude that the land was there to be *used*. So perhaps it does not seem strange to Americans perfectly accustomed to altering the landscape endlessly, usually for an economic motive, that other Americans, even artists, should also wish to do something to the face of the Earth.

NOTES

1. See Hayden Herrera, "Michael Heizer Paints a Picture," *Art in America* 62, no. 6 (November–December 1974), pp. 92–94.

2. See John Coplans, "Robert Smithson, the 'Amarillo Ramp,'" *Artforum* 12, no. 8 (April 1974), pp. 36–45.

JEFFREY DEITCH

The New Economics of Environmental Art

Both nineteenth- and twentieth-century art have dealt with the environment. Jeffrey Deitch, financial art consultant for Citibank, concerns himself in this essay with the changing effects, from one century to the next, of this type of art on the art world. How has the economic basis of nature-oriented art shifted in a century? When art is "group produced," how are its price and the economy of the art world affected? The artworks of Christo and Robert Smithson serve as excellent examples of this twentieth-century development in artmaking. Deitch also discusses the changed role of art-as-collectible and the role of the gallery in this different art scene.

The move by nineteenth-century vanguard artists from the studio to the open air had a profound impact on the history of art, altering the subject, the structure, and the economic meaning of works of art. The move by certain vanguard artists of the 1960s and 1970s from the studio and gallery out into the social and natural environment may have an equally profound effect, even though at the present time this tendency may appear to be only another extension of "art pluralism." As Gustave Courbet and his fellow travelers broke through the confines of the Academy, artists like Andy Warhol, Christo, Dennis Oppenheim, and Robert Smithson ventured beyond the somewhat hermetic world of late Modernism to engage the world at large.

But the contemporary environment is, of course, drastically different from that of Europe in the infancy of industrial society. Henri Toulouse-Lautrec's commercial posters celebrating luminaries of the dance halls and cabarets seem exceedingly civilized compared to Warhol's cheery endorsements of consumer products and his forays into the mass media. The plein-air paintings of the Barbizon and Impressionist painters seem quaint compared to Smithson's projects for airports and strip mines.

Both of these tendencies, 100 years apart, took artists out of the studios and away from the more esteemed subjects and forms that were deemed by those of the academic persuasion to be the true domain of serious art. Both of these out-of-the-studio movements have involved an exploration and sometimes a celebration of the artist's relationship to the environment. The nineteenth-century artist could commune with nature on traditional-size canvases with ordinary artists' materials. But the contemporary environment is so multifaceted and the individual's relationship to the social and natural landscape is so complex that the traditional economic units of art production seem anachronistic and inadequate as modes of art expression.

When the bulk of agricultural production came from individual farmers tilling small plots of land surrounding their homes, and when commerce was dominated by family-owned firms, a human-scale painting or sculpture would have been an appropriate response to the environment. Today, when man's relationship to the environment is orchestrated by immense bureaucracies and multinational corporations, a studio-size painting or a discrete piece of public sculpture seems to pale beside these powerful sponsors of environmental intervention. In an age of organization some of the most interesting vanguard artists have chosen to build their own organizations in order to structure a meaningful interaction with the environment. One of the most significant differences between the early Modern and the contemporary manifestations of environmental art is the shift in the economic basis of the work, a shift that begins to parallel the evolution of small proprietorships into complex corporations.

In the social sphere such organizations as the Yippies, which merged art and politics, and Warhol's family of enterprises have had a much larger impact on contemporary culture than any individual's paintings or posters. Both of these organizations continue to provide fodder for the media and outlets for those on the creative fringe. While Warhol recovered from the attempt made on his life, his organization continued to feed the culture with films and other material; and Abbie Hoffman's network kept both him and his spirit alive during his years as a fugitive.

An organizational rather than an individual approach has made possible many of the past decade's more significant artistic interactions with the natural environment. Smithson's *Spiral Jetty* (1970) involved the leasing of land, elaborate financing, construction crews, photography, magazine articles, a film, and a network of galleries to screen it. Christo's projects, such as the *Running Fence* (1972–1976), involve most of these elements and more. Hundreds of drawings must be sold to finance his projects, which involve lengthy negotiations with governmental agencies, landowners, banks, and

community groups. *Running Fence* was approached in much the same way as a highway authority would approach building a road or a developer would plan an industrial park. Thousands of hours had to be spent structuring the financing, preparing Environmental Impact reports, and testifying before zoning boards. *Running Fence* was of such a scale that it became news as well as art, with the project's various stages reported worldwide in print and on television.

The expense of this huge organizational effort, which amounted to more than $3,200,000 according to Christo's records (see table 1), outraged some observers who contended that a more productive use could have been found for all that capital. Actually, the $3,200,000 spent on the piece was probably multiplied into some $9,000,000 of economic benefits as the workers, contractors, pilots, filmmakers, photographers, and others who worked on the piece spent the money they earned and developed their own projects out of it. Christo's money may have gone a lot further than the capital invested in a typical film project or a sports promotion. The project was not only economically complex but economically productive.

Even the sculptor who wants to install a modestly scaled traditional piece in a public park must now go through the rounds of presentations and negotiations that parallel a real estate developer's struggle to win a zoning variance. George Segal's *In Memory of May 4, 1972, Kent State: Abraham and Isaac* (1979) for Kent State University in Ohio and his *Gay Liberation* (1980) for Sheridan Square in New York City are examples of proposals that became victims of this process. Pushing pieces like these through to final approval involves the orchestration of a sophisticated public-relations campaign to win the needed backing from the press and from neighborhood interest groups.

With the exception of artists like Richard Long, whose gentle interactions with isolated environments are quite beyond the reach of public authorities, the environmental artist is no longer a simple economic entity producing discrete works that can be neatly sold, with custody transferred to the buyer. The artist is becoming more like a developer, conceiving of a project, hustling for the financing, securing the site, supervising the construction, and arranging public access when the project is completed. In addition, provisions must be made to maintain the piece into the future. Like Hollywood film directors, artists are becoming deal makers.

Alan Sonfist's New York City–wide *Time Landscape* (1965–1978), most visible to the art world in its segment at the corner of La Guardia Place and Houston Street (1978), is an example of the artwork as a major urban-design plan. This ambitious and carefully researched undertaking consists of a network of sites throughout New York City's five boroughs, where sections of

TABLE 1

Running Fence Corporation Schedule of Expenses

Expenses	1972[1]	1973	1974	1975	1976	1977[1]
Engineering & surveying	$ 8,776.94	$11,311.43	$ 45,779.30	$ 53,939.00	$ 36,985.21	$ 20,000.00
Fabric	9,609.22		143,048.59	6,432.25		
Construction	15,000.00	882.00	333,016.27	392,728.77	940,162.46	85,000.00
Documentation/advertising/ promotion	2,500.00	10,439.18	51,550.30	36,085.15	41,972.50	130,000.+
Travel		12,566.92	29,611.15	36,120.69	35,689.00	
Shipping & storage	300.00	3,360.99	4,240.00	3,258.34	6,950.92	16,000.00
Framing			3,349.52	7,948.49	17,459.00	20,000.00
Fees (secretarial & project management)			13,121.01	15,062.00	3,215.05	15,000.00
Telephone		83.46	1,444.80	7,647.33	6,995.49	
Legal & accounting		5,211.52	19,716.63	115,560.17	42,655.23	50,000.00
Rent (to ranchers)			7,540.80	10,050.00	49,931.03	
Interest & bank charges	742.77	2,681.98	462.96	3,496.26	2,905.82	40,000.00
Taxes				6,135.12	875.03	
Miscellaneous (includes permits & insurance)		375.55	21,584.35	47,586.65	87,850.41	
Settlement of 2 lawsuits						62,000.00
Totals	$36,928.93	$46,913.03	$674,465.68	$742,050.22	$1,273,647.15	$438,000.00

Grand total: $3,212,005.01

[1]Partial figures for 1972. It is difficult to separate expenses for *Running Fence* from expenses for the completion of the *Valley Curtain* project. For 1977, it is equally difficult to separate *Running Fence* expenses from those of the Kansas City *Wrapped Walkways* project. All 1977 figures are approximate.

land have been restored to the way they might have appeared in the seventeenth century, before the advent of urbanization. Sonfist spent over ten years developing the project and finally pushing it to fruition. To complete the La Guardia Place site, he had to weave his way through community groups, local politicians, real estate interests, several arms of city government, art patrons, and their lawyers. It was only after shaping alliances with influential neighborhood politicians and agreeing to important compromises with community groups that Sonfist finally brought *Time Landscape* to completion. Even in the final stages, as the ''sculpture'' was being constructed, problems that developed with a tree supplier were almost enough to quash the piece. As table 2 shows, the piece has so far cost $74,700 to build and maintain. Sonfist managed all of this without a patron or a sponsoring organization.

Artists like Walter De Maria, who have been lucky enough to find patrons for their environmental pieces, have an easier time on the fund-raising side, but the execution of the project can be just as complex. De Maria's *Lightning Field* (1977) in New Mexico is a project on the scale of a major ranching development and involves a full-time administrator and archivist, a photographer, a busy guest lodge, a communications system, and maintenance personnel. The Dia Art Foundation, which also sponsors De Maria's *New York Earth Room* (1977), has picked up the cost, unofficially estimated at about $1,000,000 so far.

Another economic approach is being explored by Nancy Holt, who is currently working with a county planning commission and a real estate developer in the Washington, D.C., area to create an environmental sculpture that will be a park as well as an artwork, expanding the concept of *sculptor* into *site planning consultant.* This type of project represents a major shift in the artist's economic stance because the modern artist has traditionally been economically responsible only to him- or herself. Whereas a Christo project has no *traditional* economic purpose, despite the benefits that it feeds back into the economy, Holt's site planning piece does. It can be viewed as a symbiotic relationship between an artist and a businessperson. The real estate venture makes possible an interesting and challenging work of art, and the art may add to the commercial success of the development. In actually designing the site as an artwork, Holt is going much further than the traditional public sculptor who constructs a work of art to be placed by the architect. Holt's type of project opens the door to an art that deals with the economic system on its own terms rather than insulating itself in the simple shadow economy of the art world.

It is not surprising to note that Christo, Holt, and several of the other

TABLE 2

ALAN SONFIST, TIME LANDSCAPE, 1965–1978

Expenses

Botanical research	$ 5,000	
Historical research	5,000	
Legal fees	1,700	
Artist fee	10,000	
Presentation, fund raising	2,000	
Presentation, community models	500	
Clearing site	1,500	
Topsoil	5,500	
Iron fence (required by community)	18,000	
Painting of fence	1,000	
Trees & plants	12,000	purchased
	6,000	donated
Stabilization of forest		
(hiring person for 2 years)	6,000	
Miscellaneous, electricity, & telephone	500	
Total	$74,700	

prominent environmental artists have chosen not to be represented by galleries. They prefer to manage their own affairs, working with galleries on an ad hoc basis only when it suits them. The traditional gallery is still essentially a nineteenth-century institution, offering expensive artworks to a small wealthy clientele. The function of the better galleries has been expanded to encompass museumlike documentation and public information services in addition to the presentation of professionally curated exhibitions. But even the most advanced and successful galleries are still far removed from the sophisticated marketing of the film, broadcast, and publishing companies that merchandise other forms of culture. In shifting the economic basis of the artwork, the recent generation of environmental artists has outgrown the gallery and has pointed out the importance of developing an alternative form of art distribution.

In addition to challenging the structure of the gallery, the new environmental work also challenges the economic role of the museum. As a conservator and promoter of the art of this generation, the museum will have to devise new approaches in order to deal with environmental pieces. The Dia Art Foundation, which sponsors permanent installations of environmental art in unusual locations, is moving to fill the vacuum, but its model projects only begin to point toward a solution.

Beyond the problems it presents for museums and galleries, the altered economic basis of recent environmental art underlines the opportunity that artists have to shape a new social role for themselves. An emerging generation of artists will, one hopes, not just make objects for cultural consumption but become active in the process by which society shapes its environment.

MICHAEL AUPING

Earth Art:
A Study in Ecological
Politics

Opening with a description of the environmental ramifications and problems that had to be considered by Christo in the building of his Running Fence, *Michael Auping's essay deals with the "ecological politics" that must go into the construction of an earthwork. Auping, the curator of the John and Mable Ringling Museum of Art in Sarasota, Florida, says, "Since the nineteenth century, man has shared in landscape formation at a scale approaching that of the geological process." How much concern do artists like Michael Heizer and Robert Smithson show for the ecology as opposed to artists like Michael Singer and Alan Sonfist?*

In 1972 the Bulgarian artist Christo proposed to finance and build an 18-foot-high curtainlike fence that would meander 24 miles through the rolling hills of California's Sonoma and Marin counties and into the ocean. The *Running Fence* was to remain standing for two weeks. It was to be built on private land, the owners of which consented to the project. Construction of the *Fence*, however, was halted by local environmentalists who feared that Christo's fence would disrupt the patterns of animal movement in the area as well as devastate the lush ground cover of the area both through construction of the work and by attracting masses of tourists out onto the hills. The artist was asked to file an Environmental Impact Report, which he did. Christo worked closely with local environmentalists to arrive at some acceptable compromises: Areas in the fence would be left open for animal movement and tourists would be restricted to viewing the *Fence* from paved roads. Also, Christo's original proposal had the *Fence* trail some distance into the ocean and disappear. Feeling that the ecology of the coastline would definitely be disturbed by such an action, the authorities forbade Christo from extending the *Fence* into the ocean. Christo agreed. As the project got under way, how-

92

ever, Christo decided that this aspect of the project was an integral part of his vision. Consequently, he built his *Fence* into the ocean (1976). A controversy ensued, with demands that Christo be prosecuted for his action.

One of the dominant literary and political themes of the 1970s was ecology. Our increased awareness of the Earth's finite resources, combined with an increasing number of factions in society claiming control over those resources, had reached the point at which ecology became a very hot political issue. Ecological politics has filtered into every level of society.

Since the mid-1960s increasing numbers of artists had been moving their

40. Christo: *Wrapped Coast—Little Bay—One Million Square Feet.* 1969. The wrapped 1-million-square-foot section of coastline at Little Bay, Australia. Project coordinator: John Kaldor. (Photograph: Shunk-Kender; courtesy the artist)

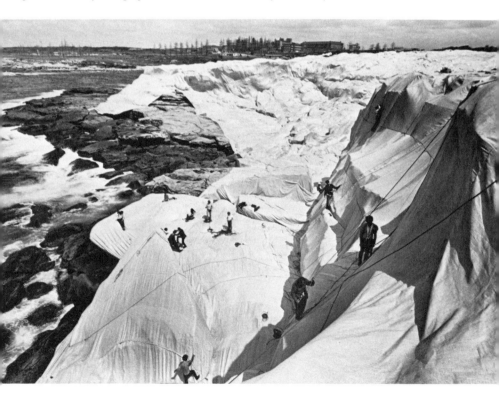

work out of urban studios and into the landscape. Collectively labeled *earth art,* these works neither depicted the landscape nor simply incorporated it as a backdrop for a self-contained sculptural object. Rather, they actually engaged it as sculptural material.

Insofar as earth art physically interacts with the landscape, it cannot be ecologically neutral. Ecological politics is thus an inherent aspect of earth art. Over the past decade or so artists have developed a variety of means of engaging the landscape, which represent, by intention or effect, a mix of attitudes ranging from ecological indifference to ecological activism.

Michael Heizer has been one of the most aggressive and prolific of the "first-generation" earth artists. Using a modern vocabulary of forms, Heizer literally carves the landscape to form an aesthetic vision, replacing the hammer and the chisel with pneumatic drills, earthmovers, and explosives.

41. Michael Heizer: *Displaced-Replaced Mass.* 1969. Fifty-two-ton granite mass placed in a depression. Silver Springs, Nevada. (Photograph: Xavier Fourcade, Inc.)

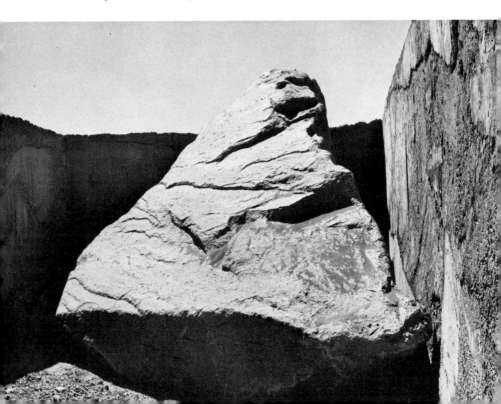

Among his works are *Double Negative* (1969–1971), consisting of two mammoth trenches executed by carving 240,000 tons of earth with explosives and heavy machinery in two facing cliffs in Nevada; *Munich Depression* (1969), in which 1,000 tons of earth were excavated; *Displaced-Replaced Mass* (1969), in which three blocks of 30, 52, and 70 tons of solid rock were moved by crane and transported a distance of sixty miles; *Detroit Drag Mass Displacement* (1971), in which 30 tons of rock were dragged by cables until a 100-foot-long, 2-foot-deep depression was formed displacing 300 tons of earth.

The son of the late Robert Heizer, a distinguished archaeologist specializing in the study of pre-Columbian cultures, Heizer is essentially reviving an ancient tradition of monumental earthworks. Heizer, like his predecessors the Egyptians, the Mayans, the Aztecs, the Zapotecs, and others, is creating monuments that will likely outlast the culture in which they were made. Speaking of *Complex One/City* (a recent project, 1972–1976, consisting of a large pseudo-architectural structure of concrete and earth), Heizer remarked, "When that final blast comes, a work like *Complex One* will be your artifact. It's going to be your art, because it's accurate and it's going to represent you. *Complex One* is designed to deflect enormous heat and enormous shock. It's very much about the atomic age."[1] *Complex One* is the first in a projected *City* of such structures to be built by Heizer in south-central Nevada.

Heizer's grim futuristic view would understandably render ecological considerations mute. The criticisms that many of his works aggressively rearrange natural formations that have taken millennia to develop and destroy the subtle life systems that inhabit his seemingly barren sites would appear to be of little concern to Heizer. Heizer has often argued that it is naïve to criticize his work from an ecological standpoint, given the fact that modern industry is rearranging the landscape on a scale that dwarfs any of his endeavors. One senses in Heizer's works a fascination, even a competition, with the scale of modern industry. The artist has remarked, "The work I'm doing *has* to be done, and *somebody* has to do it. Where in the hell are all the artists? I mean we live in an age of obligation. We live in an age of the 747 aircraft, the moon rocket . . . so you must make a certain type of art."[2] In the same interview, Heizer went on to say, "You might say I'm in the construction business . . . To begin with, I have a tremendous real estate file on every available piece of property in six western states. I look for climate and material in the ground. When I find the right spot, I buy it."[3]

Along similar lines, the late Robert Smithson spoke of heavy construction as having "primordial grandeur" and the "disruption of the earth's crust"

as being "compelling."[4] In 1969 Smithson executed *Asphalt Rundown*, in which a truckload of asphalt was poured down the side of a hill. The same year he was prevented from dropping broken glass on an island in Vancouver by environmentalists fearful that it would harm the birdlife of that area. In 1970 Smithson executed his *Spiral Jetty*, a huge spiral formation made of black asphalt, limestone rocks, and earth scraped from the surrounding shoreline of the Great Salt Lake.

Toward the end of his brief career, however, Smithson appears to have become more concerned about the ecological implication of working on such a grand scale in a dwindling virgin landscape. He visited several strip-mined

42. Robert Smithson: *Asphalt Rundown.* 1969. Commissioned by L'Attica, Rome. (Photograph: John Weber Gallery)

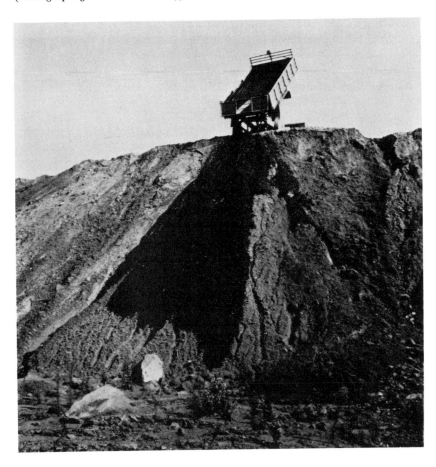

sites, proposing that the mining companies allow him to use such land for large-scale earthworks, as a way of recycling the land for aesthetic purposes. He spoke of his art as a resource that mediated between ecology and industry. Smithson's proposed *Projects for Tailings* (1971) was an effort to realize such a vision. The Minerals Engineering Company of Denver was enthusiastic about Smithson's proposal for a "tailings" earthwork at one of their mines. Tailings are the solid waste that remains after ore is chemically extracted from rock. Smithson envisioned a variety of forms built up over the years with some 9 million tons of tailings.

In essence, however, Smithson was not really mediating between ecology and industry, but was simply hiring himself out to decorate an area of landscape the mining company had exploited.

At a recent symposium for the Seattle Arts Commission's project "Earthworks: Land Reclamation as Sculpture," the artist Robert Morris voiced his concern in this regard.

> The most significant implication of art as land reclamation is that art can and should be used to wipe away technological guilt. Will it be a little easier in the future to rip up the landscape for one last shovelful of a nonrenewable energy source if an artist can be found—cheap, mind you—to transform the devastation into an inspiring and modern work of art?[5]

Like Heizer, Smithson was essentially indifferent to notions of environmental protection. To varying degrees each saw his work in the landscape as part of an aesthetic evolution.[6] "The ecology thing," stated Smithson, "has a kind of religious, ethical undertone to it. It's like the official religion now, but I think a lot of it is based on a kind of late nineteenth-century, puritanical view of nature. In the puritan ethic, there's no need to refer to nature anymore. I'm totally concerned with making art."[7]

On the other side of the ecological-political fence, as it were, are a number of artists working in the landscape whose approach is diametrically opposed to that represented by Smithson and Heizer. Their art, in a broad sense, proposes exchanging an attitude of ecological indifference for one involving great respect for natural features and systems.

Michael Singer's sculpture reflects a philosophy of extreme restraint and discretion toward the landscape. Singer's works are often so subtly embedded in the landscape that one senses them as much as sees them. An airy structure of marsh reeds at the Smithsonian Institution's Chesapeake Bay Center for Environmental Studies was clearly distinct from its surroundings only

during a certain time of day when the angle of the sun was such that the minimal surfaces of the reeds were clearly lit up.

Gently tying, balancing, and bending the natural materials found in the beaver bogs, marshes, ponds, evergreen woods, and bamboo stands where he works, Singer creates incredibly fragile and transitory works. The physical and visual structure of the works flex with the condition of the environment. Singer continually returns to the site of his works, adjusting them to accent fully the new character of the landscape. Singer often refers to his work as "research" in the form of a continuous dialogue with the natural process. After extensively photographing his sculptures, Singer either dismantles them or allows them to decompose into the landscape.

The extraordinary rapport Singer effects with outdoor spaces has prompted environmentalists to support Singer's work as complementary to their concerns. Recognizing an unequivocal respect for the landscape as be-

43. Michael Singer: *First Gate Ritual Series* (detail). 1976. Oak and stone, 80'. Balanced oak and stone structure floating on the surface of a pond at the Nassau County Museum of Fine Arts, Roslyn, New York. (Photograph: Sperone Westwater Fischer Inc.)

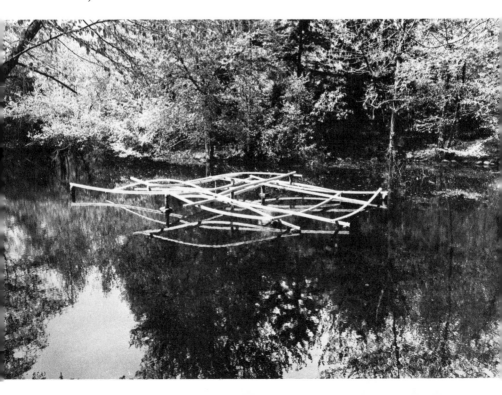

ing central to his work, the United States Department of the Interior and the Smithsonian Institution have sponsored major outdoor projects by Singer.

Hamish Fulton's sculpture relates to walking. His art consists of large landscape photographs taken by the artist while hiking through various regions of the world. Beneath each of Fulton's photographs is a precisely chosen and arranged group of words that acts as a kind of haiku response for the emotional experience the walk held for the artist. The words do not describe the photographs, and the photographs do not illustrate the words. Rather, they are a tightly choreographed metaphor for Fulton's interaction with the landscape.

Walking represents a sculptural experience for Fulton. He has remarked, "No walk—no work."[8] The character of the terrain dictates the lengths of Fulton's walks. Fulton's work is about being *in* the landscape and responding to it on its own terms, without rearranging it.

Fulton's photographs do not reflect a picture-postcard aesthetic, but rather an ambition to understand and help communicate the natural narrative qualities of landscape. His distillations of different walks vary from spectacular vistas to seemingly featureless terrain or sky. To Fulton, both viewpoints are beautiful in that they impart integral facets of a larger totality that is nature.

Fulton's work extends a tradition peculiar to his homeland. In nineteenth-century England walking was synonymous with an appreciation of nature. A walk in the countryside represented a kind of communion with the fundamental entities of nature.

Ecological awareness and research are the very subjects of the work of Helen and Newton Harrison. Since 1970 the Harrisons have been conducting quasi-scientific research into various environmental disturbances in California. These extended projects, often in progress for a year or more, have focused on such ecological matters as the relationship between commercial fishing and seabed resources, the impact of agribusiness on the California desert, the potential effects of damming the Colorado River system, and the problem of sulfuric acid rain because of increased air pollution. Their art takes the form of mural-size canvases, photographs, models, and other visual material combined with extended texts that isolate an environmental problem and propose a solution.

Indifferent to the social and aesthetic boundaries of the "art world," the Harrisons are aware of current technological and scientific research in ecology. In 1974 Newton Harrison was awarded a Sea Grant by the Institute

of Marine Resources to fund one of his art projects. The Harrisons view their art as an instrument for social transformation. Their work is both a form of social realism and ecological criticism. Newton Harrison said, "We've been very alienated from our resources, but our time of grace is over. The idea that technology is able to buy us out of our problems is an illusion. We are going to have to make vast changes in our consciousness and behavioral patterns, because if we don't, we won't be here."[9]

Alan Sonfist's art is similarly broad based. In response to a question regarding his level of contact with the art world, Sonfist remarked, "At this time of society, the important thing is survival. The balance of a whole mechanism is threatened. The art world is a narrow world. To understand Einstein's world, for example, is far more important."[10]

The impetus behind Sonfist's art is an acute fascination with living things and their processes of survival. Among his works are paintings in which the image is randomly created by wetting the canvas and allowing mildew to grow on the linen surface; containers of microorganisms in which fungi and

44. Helen and Newton Harrison: *The Fourth Lagoon.* 1974. Sketch for the central panel. (Photograph: D. James Dee; courtesy Ronald Feldman Fine Arts Inc.)

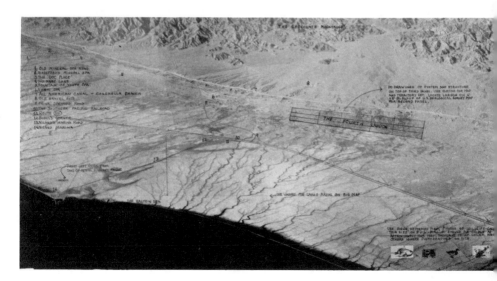

bacteria generate changing forms; a colony of army ants housed in a transparent container for the period of an exhibition; wall hangings made of leaves allowed to fall randomly on a cloth support at various stages in a tree's yearly cycle; a detailed and ongoing master autobiography of the artist's life that begins with the entry "1946 May 26 at 10:00 P.M.: my first experience was air"; and photographic documentation of a ritualistic performance in the landscape in which Sonfist assumed an animistic identity. In his *Will and Testament* (1972), Sonfist has offered his bodily remains to The Museum of Modern Art. He stated, "Because the decay and growth of my body will represent the continuation of my art work, I bequeath my body in a sealed transparent enclosure to The Museum of Modern Art, New York City, to be kept as a work of art accessible to the public."

Sonfist is an adamant protector of the natural landscape, for personal and nostalgic reasons, as well as aesthetic ones. In one interview he remarked,

> I grew up in the south Bronx next to a municipal area called "The Hemlock Forest," one of the last virgin forests of New York City. . . . Growing up as I did in the streets of one of the most violent areas of the city—which it still is—I took refuge in the forest and often spent the whole day there without seeing a single person. It was a magical environment and I created childhood experiences with the natural objects in the forest, actually playing with the rocks, twigs, and so on. They became my close friends. I found that what they had to offer me was much more suited to my personality than the violence of the streets . . . somehow I intuitively felt that this environment of trees had some sort of symbolic meaning for me. For some subjective reason I was directed toward the trees or they toward me. I was really trying to set up a direct level of communication with rocks, trees, twigs . . . [11]

Such sentiments have led Sonfist to the idea of "natural phenomena as public monuments," in which Sonfist suggests dedicating civic monuments to nature. Sonfist's most ambitious project to date demonstrating this concept is *Time Landscape*. Located between Houston Street and La Guardia Place in downtown Manhattan, *Time Landscape* (1978) is a contemporary re-creation of the pre-Colonial forest that once existed on this site. Sonfist views *Time Landscape* as renewing the city's natural environment as architects renew its architecture. The work is a pilot project, which he hopes will lead to this kind of reconstruction at various sites throughout Manhattan.

Since the nineteenth century man has shared in landscape formation at a scale approaching that of the geological process. The development of cities and industries with their attendant pollution has produced changes at a

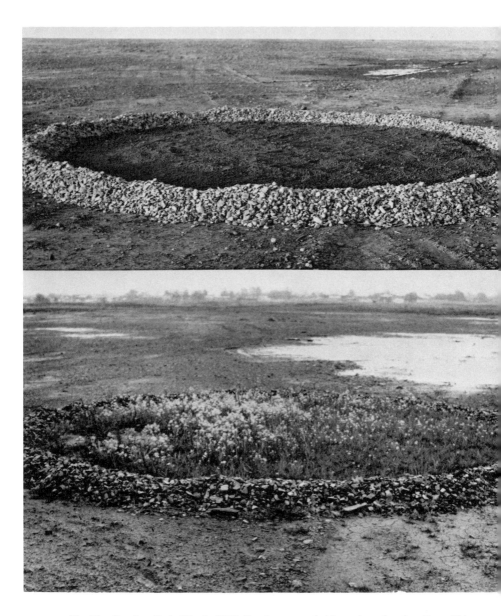

45. Alan Sonfist: *Pool of Earth.* 1975. Earth surrounded by a ring of rocks, diam. 50'. In the middle of a chemical-waste dump a circle of soil was placed to catch drifting seeds and begin the rebirth of the original forest. Artpark, Lewiston, New York. (Photograph courtesy the artist)

magnitude similar to that of nature's. Sonfist and the Harrisons would share in forming the landscape from the standpoint of nature itself. The aesthetic and philosophical content of their works is nature in its broadest sense: as visual inspiration and as a complex organism vital to the biological well-being of the planet. Sonfist remarked, "I am trying to bring forth meaningful metaphors that show that we are only one of many internal structures that exist in nature."[12]

The works of Sonfist, the Harrisons, Fulton, and Singer all, directly or indirectly, reflect the concerns of increasing numbers of biologists, ecologists, and legislators attempting to develop a legal ethic that addresses man's relationship to the land; an ethic that views natural objects such as trees, mountains, rivers, and lakes as having a legal right to existence. Through their delicate and considered approach to the landscape these artists point to the idea that nature be politically, as well as aesthetically integrated into society. Newton Harrison views many earthworks, such as those by Heizer and Smithson, as simply one-sided aesthetic impositions upon nature. "Think of the vast energy put into big cuts and shapes in the desert that are inherently gestural, simply primary structures in another context. They are transactional with museum spaces, not with the earth. They are involved primarily with forms."[13]

It would seem appropriate that earth art has emerged in conjunction with a broad reevaluation of society's relationship to the natural environment. To the extent that artists condition our vision of the world, earth artists also participate in forming our approach to a future utilization of the landscape. Over its brief period of development, earth art has offered us a variety of models in this respect. From the standpoint of environmental protection, it has been both a liability and an asset.

NOTES

1. John Gruen, "Michael Heizer: 'You Might Say I'm in the Construction Business,'" *ARTnews* 76, no. 10 (December 1977), p. 99.

2. *Ibid.,* p. 98.

3. *Ibid.*

4. Robert Smithson, *The Writings of Robert Smithson,* ed. Nancy Holt (New York: New York University Press, 1979), p. 83.

5. Judith L. Dunham, "Artists Reclaim the Land," *Artweek* 10, no. 29 (September 15, 1979), p. 1.

6. Calvin Tomkins, "Maybe a Quantum Leap," *The Scene* (New York: The Viking Press, 1970), p. 144.

7. Smithson, *Writings,* p. 174.

8. David Brown, "Some Aspects of British Art Today," *Europe in the Seventies* (Chicago: The Art Institute of Chicago, 1977), p. 18.

9. Grace Glueck, "Art People: 'The Earth Is Their Palette,'" *The New York Times*, April 4, 1980, p. C24.

10. Peter Birmingham, *Alan Sonfist/Trees* (Washington, D.C.: Smithsonian Institution Press, 1978), unpaged.

11. *Ibid.*

12. *Ibid.*

13. Glueck, "Art People: 'The Earth Is Their Palette.'"

JACK BURNHAM

Hans Haacke—
Wind and Water
Sculpture

Hans Haacke's work now deals largely with sociopolitical concerns, but for the better part of the 1960s he worked in the realm of nature. According to Jack Burnham, art critic and author of several books on contemporary sculpture, his intent was to convey as simply yet as penetratingly as possible singular observations about the natural world around us. In this essay Burnham offers the reader Haacke's "manifesto": his motivation is to increase the depth of a spectator's observation. Can Haacke's simple works, which encourage "relaxed observation," still find a place in the thinking of the 1980s? The essay dips into the career of one environmental artist yet brings up several ideas that are applicable to most of the artists in this anthology. Burnham poses one question in the text that could indeed be asked of these artists as a group: they all are people who work with nature by choice and accept its changes, even if it destroys the original appearance of their work. "How can an artist demand so much and at the same time be content with the inevitable?"

I [Burnham] wrote this essay during the summer and fall of 1965 but it was not published until a year and a half later because of editorial delays at Tri-Quarterly *magazine. In the light of present-day outdoor environmental and ecological art it is difficult to remember what a novelty it was, just fifteen years ago, to write about an artist dealing directly with the forces of nature. From 1967 until 1970 Hans Haacke went on to create a number of large-scale ecological works, notably at Coney Island, New York, in 1968, for the "Earth Art" exhibition at Cornell in 1969, and for the Foundation Maeght Museum at St. Paul de Vence, France, in 1970.*

A question often asked is why did Haacke forsake ecological art for the types of political art pioneered by him during the 1970s? As explained in the monograph Hans Haacke: Framing and Being Framed—7 Works 1970–75, *Haacke's focus during the late 1960s was the interaction between natural and human systems. Increasingly he felt that very few "natural systems" tend in any true sense of the word to remain* natural. *They are invariably modified by human interests. Gradually he realized that these interests are largely controlled by military, governmental, and corporate concerns. Thus, his art moved in the direction of actively researching the political and economic motives of those in power.*

Haacke found himself facing another dilemma encountered by artists working within the context of natural systems. Many of his early ideas for the "waves," "weather boxes," and bubble

pieces found their way into the department stores in cheap variations, as novelty art, produced by manufacturers with an eye for the disco trade. Also at the time few foundations or arts councils sponsored outdoor environmental art. But more to the point, Haacke drew back from the temptation to produce large-scale outdoor pieces that more or less appeared to be expanded sculpture. Somehow the irony of representing socioeconomic conditions with dry sarcasm in a commercial gallery seemed a more pressing and valuable contribution to society.

SOME BIOGRAPHICAL FRAGMENTS

Hans Haacke was born in 1936 and grew up outside the city of Cologne in West Germany. Most of his early training was in painting and graphics. After receiving a master's degree in fine arts from the Staatliche Hochschule für Bildende Künste in Kassel, he moved to Paris in 1960 to study under the English printmaker Stanley Hayter at the Atelier 17. Here he completed optical prints (inkless intaglios), optical paintings (yellow dots on white), and reflecting reliefs on aluminum foil—three years before *optical* became a dirty word. A year later he left for the United States and Temple University sponsored by a Fulbright grant.

Haacke's water constructions first appeared in 1963 and were neither understood nor well received by the powers that run galleries or control museum shows. Among individuals there were a few encouraging exceptions. Like some Alice-in-Wonderland timetable, kinetic art as a popular manifestation was several years off according to the New York dealers. So for this and personal reasons Haacke, by the end of that year, decided to return to Cologne. In Europe enthusiastic collectors of younger artists' works were sparse compared to what one finds in the States (in fact, some of the best museum directors in West Germany were under local pressure to show more conservative art), but there was already a certain established sympathy among the more knowledgeable dealers over the kinetic movement.

Haacke, like many other artists, both European and American, has acutely felt that the times demanded an art form that expressed itself through motion. As in certain other segments of the European avant-garde his work seems to have moved toward an unlikely marriage of ultracool technology (granted, on a primitive level) and Dada perversity. His 1960 to 1961 stay in Paris made him knowledgeable about the activities of both Takis and Yves Klein. Both men, for Haacke, were artists who dared to think and engage in nonremunerative projects, works that because of their transitory nature had no sale value but, nevertheless, represented the realization of ambitious dreams in the round.

Near Haacke's home in Cologne, Otto Piene, Heinz Mack, and Günther Uecker had already begun Group Zero in Düsseldorf, an association close in many particulars to the ideals of the two Paris-based artists. Zero tried in many respects to sever itself from the past of nonobjective art: both in the artistic posture that it assumed and the problems it raised. In Uecker's work Haacke had a basis for his early stainless steel field reliefs. Something of Mack's pliant use of reflectivity in aluminum is also in evidence in Haacke's thinking; while the freedom of Piene's *Light Ballet* (1959) has figured heavily in the phenomenological characteristics of his art. At any rate the debt of the Zero influence figures critically in Haacke's art, and since 1962 he has shown frequently with them.

My own thinking was swayed not a little by my visit to Haacke's studio in Cologne during the summer of 1964. It was situated in a less than prosperous

46. Hans Haacke: *Spray of Ithaca Falls Freezing and Melting on Rope* (detail). 1969. Ithaca, New York. (Photograph courtesy the artist)

neighborhood a few blocks west of the Cologne Radio Station and the state-subsidized electronic music laboratories under the direction of Stockhausen and Eimert. Located on the top floor of a prewar building, Haacke's studio consisted of a cavernous central room where the results of World War II bombing raids were keenly evident. In an age when so much creativity has its origins in destruction, perhaps it is fitting that structures such as these, their business respectability lost, became the low-rent salvation of less affluent German artists. There within a shell of missing masonry and blackened roof timbers, visitors came across a new world in incubation—one fragile and alive—like the blades of grass that work their way up between the cracks in a sidewalk.

Standing on trestle tables and boxes were many plastic structures. On closer inspection these turned out to be precision-made Plexiglas containers fully and partially filled with liquids. Haacke put some of these into operation, which meant turning them upside down or switching on a small motor. In some cases I was asked only to look, as a box would do its "work" with no human intervention. Baudelaire had mentioned several times in his notebooks that the shimmering symmetry of the main crystal chandelier at the opera often diverted his attention for half the evening. And I must admit, in such surroundings, these transparent constructions did the same thing for me. They acted as lures for the spirit and perhaps if they had been viewed under more mundane circumstances, they would have, at first, looked like remnants of a biology supply house or an appliance repair shop.

Although the atmosphere of the place had a certain unworldly fantasy to it, Haacke had more than his share of practical problems. He spoke of the cost of materials and of not being able to get the right apparatus for a certain "wind" construction. Interested chemists and engineers would stop by to give advice on technical problems, but for some projects Haacke needed more solid help. Perhaps there was a certain poetic justice to the fact that at the time Haacke was teaching art and costume history at a nearby girls' school of fashion. I think for an artist working so far outside the scope of traditional art history, the need to prepare lectures on the Renaissance acted as a salutary reminder of what art was about in the past.

During the early 1960s he was included in important "New Tendency" shows in Ulm, London, Amsterdam, Berlin, Gelsenkirchen, Venice, and ironically after earlier rejection in the States, in shows in Washington, D.C., and Philadelphia. The Zero show late in 1964 at the Institute of Contemporary Art in Philadelphia was the first time the participants were received as a group in the United States.

A comprehensive NUL (Dutch Zero group) show was sponsored by the

Stedelijk Museum in Amsterdam in the spring of 1965. Here all the Zero-allied tendencies of the world were assembled for the first time. Haacke felt particularly sympathetic to Japan's Gutai group with its spirit of direct involvement with the forces of nature. In particular he wrote of the room-spanning hammocks of water by Sadamasa Motonaga. Also, he felt it unfortunate that meaningful communication with the Japanese group was nearly impossible, being reduced to a few polite exchanges over lunch.

On the strength of some financial and critical success in Europe, Haacke, now with an American wife, set out again for New York in the fall of 1965. Once there, he prepared for a January show at the Howard Wise Gallery. This time more people were ready to accept the water and air constructions in the spirit in which they were conceived. There were those critics who called it "high-class gadgetry," but there were others who realized the mechanical simplicity of the wind and water constructions and were willing to accept them on the sensuousness of their phenomenal attainments alone.

Currently Haacke lives in Manhattan and teaches in Philadelphia. Making a type of art that is incredibly romantic and nature-oriented, he feels he needs the abrasiveness and intellectual provocation of the world's most art-conscious city. Haacke is recognized now as one of the more lyrical talents of the recent kinetic generation. *Time* magazine's caption "The Kinetic Kraze" hardly applies to an artistic sensibility that has been slowly gathering momentum for the past fifty years, and certainly not to the kind of slow meditative awareness Haacke is trying to induce.

HAACKE'S USE OF NATURAL MEDIUMS

Haacke's water boxes have a kind of maddening ambiguity. On the one hand he fusses with their shapes, demanding both very precise Archimedean proportions and technical perfection, while on the other he encourages the semirandom activity that pervades the boxes' inside activity. How can an artist demand so much and at the same time be content with the inevitable? It is typical that he refuses to use screws, stainless steel braces, or gaskets to put his plastic boxes together, but at the same time he constantly searches for new degrees of freedom.

I can remember when Haacke took me to see an example of his first water boxes (spring 1962), then in the rental collection of The Museum of Modern Art in New York. A secretary commented that museum personnel had been playing with it for days—it seemed to have caused more joyful curiosity than any number of "sculptures"—for that reason the museum never thought

seriously of buying it as a "work of art." For those who watched the water box, the aggregate emotion was that of delight and perplexity.

Most saw the water box as essentially frivolous, lacking the mystery, restraint, impact, technical bravura, cruelty, wit, and optical salience that went into the games of other currently successful artists. Here was an art of essential phenomenalism where the obligation to *see* was passed on to the spectator. The artist had structured the events—take it or leave it—the rest was up to the dimmed memory of the viewer: to remember what he had forgotten since childhood about the intimate effects of wind and water.

In this respect, Haacke has spoken several times of the Japanese mode of making precise but informal art and gave me some examples from the seventeen-syllable haiku poems: short, terse fragments that are really tiny universes of sensibility. The water boxes in their own way are encapsulated forms of the poetic condition.

> Spring rain
> Conveyed under the trees
> In drops.

Just as within the Plexiglas container, this poem makes the discovery that the same source of water, when altered by an obstacle, can change in consistency and texture. Large irregular drops from the branches of a tree fall on the haiku poet as he stands underneath peering at the fine fabric of spring rain. This is precisely the condition of the gravity-controlled water boxes, where water becomes one thing, then another—always varied to the senses and changing form as it meets new forms of material opposition. Haacke cited another example:

> The dew of the rouge-flower
> When spilled
> Is simply water.

We see only what we want to see and the hardest thing to see is what is nonliterary in origin, in fact, what is with us from the moment we first open our eyes. Thousands of times I have discharged the contents of a washbasin or have swallowed liquid with the purpose of removing the contents from the cavity of the glass into the cavity created by my digestive system. Few times have I exerted what Husserl calls "reduction" in isolating either the motions of my body in receiving the water or the actions of the water leaving the glass. This last is what Haacke is about, and its full import only came to me after my visit to his studio in Cologne.

All the containers strewn about his studio may have looked similar, but were in essential ways different from each other. In a typical one water flowed from an uppermost level through a partition with tiny holes to the bottom, creating as it fell a tapestry of small whirlpools and drops. Another container divided water into converging zigzag streams running along transparent sides of the box.

In some cases, not just form and partitioning, but physical principles determine the dynamics of the water boxes. As one cylindrical vessel is inverted, colored solutions merge, flatten, and distend against each other, as Haacke's wife, Linda, remarked, like a Sam Francis painting in slow motion. Later, this idea was incorporated into a series of flat, panellike constructions having partial plastic walls. Colored liquids would partition into bubble

47. Hans Haacke: *Double-Decker Rain.* 1963. Acrylic and water, $4^{11}/_{16}''$ x 14" x 14". (Photograph courtesy the artist)

structures on their journey to the top of the piece, slowly forming and re-
forming as they rose upward.

More and more I began to sense that the quality that unified these con-
structions was their ability to transcend merely mechanical operation and to
assume some of the pattern inherent in life processes. In the translational mo-
tion of regular water currents, say through a pipe, the water remains un-
changed at each segment of the pipe. In contrast, liquids moving through an
organic system or digestive tract constantly change in chemical structure as
they move in space. Ideally, Haacke would like something like that if it were
feasible. The partitions and other deterrents in his constructions are the
closest that he can come in this direction.

Through the anonymity of Plexiglas with liquid passing from level to level,
he is trying perhaps to get at the clockwork of the human body's own
chemistry. There is a sense of immanent completion with the further
knowledge that the cycle will begin all over again. One apparatus could be
said to simulate cell duplication; with the aid of a small hand pump a
chemical engenders overflowing mounds of foam. Soap particles dissolve as
they spread out. Not all the action is so apparent. At one window of the
studio a large transparent box stood in the sunlight regenerating cycle after
cycle of condensation. With slow, endless variation the transparent sides of
the box were patterned with beads of moisture only to turn into rivulets of
water as they became too heavy to remain drops. In the sun a fine haze of
vapor appears near the top of the construction, then drops and tiny trickles
along the sides, with pools of water along the bottom.

Haacke had some interesting comments about this last piece. This is one
work that did not need to be turned over by the viewer, yet in exhibitions its
subtle action is not enough for some people and they *want* to set it on its top.
Of course, this just erases the pattern established on the plastic, and the slow
process of building up condensation must begin again. Haacke claims that
only the most perceptive and sensitive viewers ever like his condensation box.
For most observers its rate of change is too slow to sustain any attention. All
of which suggests to Haacke that the quieter and simpler phenomena of
nature are no match today for what people expect out of life. For the sensitive
kinetic artist time scales are an important element—and particularly as they
are juxtaposed in mechanical and organic systems.

In relation to this he gave me his own short manifesto.

> . . . make something which experiences, reacts to its environment, changes, is
> nonstable . . .

...make something indeterminate, that always looks different, the shape of which cannot be predicted precisely...

...make something that cannot "perform" without the assistance of its environment...

...make something sensitive to light and temperature changes, that is subject to air currents and depends, in its functioning, on the forces of gravity...

...make something the spectator handles, an object to be played with and thus animated...

...make something that lives in time and makes the "spectator" experience time...

...articulate something natural...

> Hans Haacke
> Cologne, January 1965

Haacke's statement brought to mind the closing efforts of Leonardo da Vinci and his thousands of notations on the nature and substance of air and water; of his lust to comprehend the currents, whorls, and eddies; of his plans in old age for miniature experimental water works; of his notebook sketches, which sought to link up relationships between the circulation of water in the earth, in the cells of plants, and the blood pumping through the arteries of the human body, of an instinct that anticipated the statistical mechanics of modern physics by four centuries, and not least of all, the great *Deluge* drawings that tried to capture the violent patterns of wind and water as they destroyed all man-made activity.

Comparisons tend to have their invidious aspects, yet the parallels that run between Hans Haacke's sculpture and the scientific reveries of Leonardo are not irrelevant. In no way is this meant to equate Haacke with the greatest mind of the Renaissance, but it does suggest that the same prescientific poetry that permeated the meditations and observations of Leonardo is, after a lapse of 450 years, actively alive in the minds of a few contemporary artists. Leonardo's science was the art of using the eye observantly; his art was based on the science of careful visual analysis. This analytical inclination in both men stems from an inherent fascination with the dynamics of natural systems, not just depicted as a wind storm or a full tide but as fluid motion in *actual* operation. Above all, Leonardo was an analogy-forming creature in his grasp of constant change and effect. The Earth, its oceans of air and water, its underground turbulences, its animal and vegetal balances, its armies of

political systems, and not least of all, the anatomical functioning of its human inhabitants—all involve dynamic complexes that that artist-scientist never ceased comparing to each other.

It is this sensibility, still scientifically accurate in its broader respects, that speaks to an artist such as Haacke and permits him to say, "I am doing what artists have always done—that is, extending the boundaries of visual awareness."

Gradually Haacke has moved from the water pieces to a more encompassing determination of the full scope of his work. All usable, flexible forces have become the means for remaking tiny bits of the world into boundless, playful systems. These feats with air drafts and blower systems could be termed *weather events*. In this respect some of Haacke's recent *Sail* (1965) constructions were accompanied by a statement that echoed familiarly of Leonardo.

48. Hans Haacke: *Circulation*. 1969. Vinyl hoses of three different diameters, Y-connectors, and a circulating pump with an electric motor. Installation, Museum of Fine Arts, Boston. (Photograph courtesy the artist)

If wind blows into a light piece of material, it flutters like a flag or it swells like a sail, depending on the way in which it is suspended. The direction of the stream of air as well as its intensity also determine the movements. None of these movements is without an influence from all the others. A common pulse goes through the membrane. The swelling on one side makes the other side recede; tensions arise and decrease. The sensitive fabric reacts to the slightest changes of air conditions. A gentle draft makes it swing lightly, a strong air current makes it swell almost to the bursting point or pulls so that it furiously twists itself about. Since many factors are involved, no movement can be precisely predicted. The wind-driven fabric behaves like a living organism, all parts of which are constantly influencing one another. The unfolding of the organism in a harmonious manner depends on the intuitiveness and skill of the "wind player." His means to reach the essential character of the material are manipulations of the wind sources and the shape and method of suspending the fabric. His materials are

49. Hans Haacke: *Blue Sail.* 1965. Blue chiffon, nylon thread, weights, and oscillating fan, 84″ x 84″. Installation, Howard Wise Gallery, New York. (Photograph courtesy the artist)

wind and flexible fabric, his tools are the laws of nature. The sensitivity of the
wind player determines whether the fabric is given life and breathes.

Today in the engineering of complex systems the problem is to make the
man-machine relationship as smoothly functional as possible. The more
variables present and the faster the machine components must make deci-
sions and transmit actions the less opportunity remains for the human
operator to assert his own degree of autonomous control. For this
reason—and for more practical ones—Haacke's devices are purposely kept
simple and technically unelaborate. He is not after the usual passive knob-
pressing kinetic art; neither is the viewer in complete control of the situation,
instead, at best, a mutual interaction between viewer and sail system is en-
couraged. This is a level of authentic sensual involvement that Haacke senses
the world has less time for today. Art is natural medicine.

This was apparent the summer before last [1963] when Gerd Winkler of
the Hessische Rundfunk, a television station in Frankfurt, made a film in

50. Hans Haacke: *Sky Line.* 1967. A line of helium-filled balloons connected by a
nylon string. Central Park, New York City. (Photograph courtesy the artist)

Haacke's studio. One sequence was devoted to the uninhibited play of several children around a group of balloons suspended on a column of air—the children understood the point perfectly of knocking the balloons off the column of air, whereas grown-ups photographed doing the same thing usually felt a bit self-conscious. Certainly Haacke's experimentation begins with the same playful intensity as the early Dadaists, although in spirit it is less attuned to alienation and therapeutic destruction.

One senses an innate distrust by Haacke of complicated machines and electronic equipment, basically on the grounds that they are nonvisual and tend to break down. "The simpler the better" is his sentiment, "like the standing egg of Columbus. It is best to get along with unmechanical sources of energy." On a monumental scale he would invent new forms of windmills and sail constructions—"driven and blown by naturally existing winds."

In his January 1966 show two "air events" were set up: a 7-by-7-foot chiffon sail suspended loosely parallel to the floor and kept swinging above an oscillating fan, and the other a large, white rubber balloon balanced on an air jet. A number of times I've questioned Haacke on the salability of such works. After all they are fragile *systems* not stable *objects*. His reply is that he is fortunate to have a gallery that can understand the importance of nonsalable works, and that they have to be made in spite of what happens to them later.

More basic than the category of kineticism or mechanics is the fact that the artist is trying to manipulate purely invisible forces, a strictly nonpalpable art, in which effects and interaction count for more than physical durability. This outlook is somehow reminiscent of that of Roger Ascham, tutor to Elizabeth I of England, who wrote in his *Toxophilus: The Schole of Shooting,* "To see the wind with a man his eyes it is impossible, the nature of it is so fine and subtle." After this Ascham proceeds to deduce the consistency of the wind from the effects that it has on certain light and flexible objects—grass, snow, dust, and other carriers of the invisible forces of hot and cold in reaction to each other.

"Hath the rain a father? Or who hath the drops of dew?" reads the Bible. Still, similar questions can be formed about the origins of the wind. The Earth itself can be looked on as a great wind-making device, forming patterns of evaporation, rain, and humidity over its surface as a kind of enormous condensation container. Haacke's interest in the invisible mechanics of nature is like all meaningful art; it is a reevocation of what was always known about existence, but forgotten at one time or another.

The water constructions are less easy to describe in words because they embody a "program" directed by gravity and composed of a number of

parts. It was originally the discovery that water is the most living of inorganic substances that brought Haacke to his personal work. I talked to him about this problem of trying to describe what is in fact only moving reflection. Literary illusion and hyperbole seemed to fade in the face of something so completely phenomenal. His retort was that even photographs give a very incomplete impression and that, at the risk of boredom, accurate, extensive descriptions have to be made "like a police report."

So then, *process* is the word that describes the procession of hydrodynamical events that permit water to move in one of these boxes from a higher to a lower level. In the simpler containers this is a matter of about five minutes. Each sequence of events is, in effect, a unified visual statement.

At the inception of these hydrodynamic activities the water dimples as the first set of drops begins to pass through the tiny drilled openings of the interior partition. From that point onward animation increases with the more rapid passage of water. Soon the surface of the upper body of water tightens into a relatively stable pattern of vortices. Light reflected from the ridges of the wavelets on the surface becomes the visual means by which liquid flow and drop agitation are observed. This results in a kind of loose network of reflections, seemingly random but statistically determinate. A secondary webbing of light lines is brought to focus on the pedestal surface beneath the water box itself. This is the result of convergent light rays through the lens-simulating contours of the waves above. With exquisite precision the water-drop and its sheath, repeated countless times over the entire surface of the partitions, become a field of repeating miniature fountains in conjunction with the body of water below.

Seen from outside the box, these layers of activity superimpose and assume an interwoven complexity. To the casual observer this description may belabor the actual occurrence—with so much happening so quickly. But Haacke's intention is not to catch each action discretely and precisely as I have described it, it is geared instead toward a mode of relaxed observation. This is a kind of *letting-go* process in which phenomena become secondary to an intuition about the nature of sequential events.

Actually, after watching one of the water boxes, or "drippers" as Haacke calls them, on a mat, stark white plastic tabletop, I thought I had the answer to what he was aiming at: an extremely old and visceral form of beauty, something, perhaps, fading from contemporary consciousness.

I could picture Thoreau lying on his stomach on the western slopes above Walden Pond watching the surface disturbances on the water: birds, fish, grass, breezes, water bugs—almost like a fireworks display. Here, I remember, was a man who harbored no wishful illusions about the deadening

effects of technology, who knew what he was after. At that, a passage from Thoreau's *Journal* came to mind: "A long soaking rain, the drops trickling down the stubble . . . To watch this crystal globe just sent from heaven to associate with me [a raindrop], while these clouds and this somber drizzling weather shut all in, we two draw nearer and know one another."

There is a kind of pantheistic union between living and nonliving matter in which both assume an organic rapport. I asked Haacke about this in a letter and his answer was something of a shock.

"Good old Thoreau," was his reply, "romanticism is not really my cup of tea, although I don't deny that there's some of it in me. However, I hate the nineteenth-century idyllic nature-loving act. I'm for what the large cities have to offer, the possibilities of technology and the urban mentality. Plexiglas, on the other hand, is artificial and strongly resists either tactile sensuality or the 'personal touch.' Plexiglas, mass-production—Thoreau—they don't really fit together."

For some, including myself, there seems to be a tug-of-war, a tremendous ambiguity in Haacke's efforts. It is as if he is willing to accept the phenomenal forces of nature, but only as long as they are hermetically sealed in a kind of artificial laboratory—not lake water, but the chemist's distilled H_2O.

At the same time, Haacke is for the mass production of his works with some kind of royalty arrangement for their distribution, a working relationship not uncommon among young artists today. Perhaps in the long run such a method of distribution would make art a little less like the motion-picture-star casting system with its aura of "autographed" pieces. But then there are always "stars" in life, and economic manipulation has rarely been the forte of the artist.

Perhaps this is a mark of the times, but increasingly one runs across the desire among younger constructionists to make not "environmental sculpture" but a kind of expansive, almost landscape art. Such ideas have been around for some time, although there are signs that they will not always be manifesto rhetoric. For Haacke's friends the Zeroists, financial obstacles have resulted in frustrations similar to those experienced by the Constructivists three and four decades ago.

In the 1920s and 1930s Gabo and Pevsner made dozens of scale models for monumental sculpture. Not until the 1950s did any substantial commissions come their way.

During the spring of 1966 Haacke felt that a prime opportunity for such a monumental undertaking was at hand. A "Zero on the Sea" festival, all ex-

penses paid, was to be sponsored at Scheveningen, Holland, by the local tourist agency. In a letter from just before the trip Haacke wrote in great excitement of some of his proposed undertakings out on the Scheveningen pier.

> I plan to have 60 foot nylon strips, white, being blown out over the sea from flagpoles on the pier—which are closely grouped together so that a constant flicker can be created. And a 150 foot plastic hose, tightly inflated with helium, will fly high above the beach or sea.... And also, I would like to lure 1,000 seagulls to a certain spot (in the air) by some delicious food so as to construct an air sculpture from their combined mass.

Haacke felt that the entire undertaking was too good to be true, and rightly enough, two weeks before it was to commence, the sponsors called it off for lack of funds.

Nevertheless, he feels that with the elements of his work—wind and water—large scale is an inevitability, although a self-perpetuating source of frustration. Survival in art, as in all other realms of life, is contingent on material adjustment. One begins to embrace, if not see as a positive advantage, those limitations that currently define salable gallery art. In a letter Haacke wrote, "... in spite of all my environmental and monumental thinking I am still fascinated by the nearly magic, self-contained quality of objects. My water levels, waves, and condensation boxes are unthinkable without this physical separation from their surroundings."

Mechanization is another problem for an artist in Haacke's position. With all of his espousal of the city and the values of mechanization, there is a deep underlying suspicion of the active effect of machines on his art. This is not a rejection of machines per se, but of their tendency to dominate in any relationship with man or the elements. If he has an aversion to the use of motors to pump liquids or to keep one of his systems in motion, it has much to do with the proportional size of the motor to the construction and of the quality of the motion generated. In a small construction most motors would be disproportionately large, and electric wiring would deprive the piece of its autonomy and power as a self-sufficient object. There is also the visual irrationality of power apparatus and the lifeless motion that it usually generates. "Forced" motion has none of the give-and-take and inevitability that characterizes Haacke's method. No such inhibitions exist for a work installed in a large architectural setting. Here the scale "naturalizes" motor-driven motion. Being incorporated into the architecture, there is no need for isolation as in a small, freestanding work. Of course, with the smaller constructions, the observer is the prime source of power—pushing, shaking, and

51. Hans Haacke: *Fog, Swamping, Erosion.* 1969. Water, hoses, and spray nozzles. University of Washington, Seattle. (Photograph courtesy the artist)

52. Hans Haacke: *Beach Pollution*. 1970. Six hundred feet of beach cleared of debris. Carboneras, Spain. (Photograph courtesy the artist)

turning the box over. Haacke considers this role of the observer as a motive force to be of prime importance, no casual push-button affair. He has also commented that because this relationship is a physically sensitive one, there are "good" and "bad" generators among spectators.

Slowly the line between stable objects that sit passively waiting to be wrapped up and shipped off to some customer's home and the new projects demanding participation and unlimited space seems to be forming. The sense of ownership seems to vaporize from such conceptions as Haacke presents, instead they present the urge to move out into space like so much smoke. What Haacke is doing implies both great economic and material disruptions in the handling of art. But as Takis, the Greek kineticist, has said about the economic fallibilities of artists: "So, unconsciously perhaps, they

53. Hans Haacke: *Rhine Water Purification Plant.* 1972. Water from the Rhine River is trucked to the gallery and then passed through chemicals, sand, and charcoal filters into a large enclosure containing live goldfish. The water overflow is carried by a hose under the gallery floor to the garden outside. Installation, Museum Haus Lange, Krefeld, West Germany. (Photograph courtesy the artist)

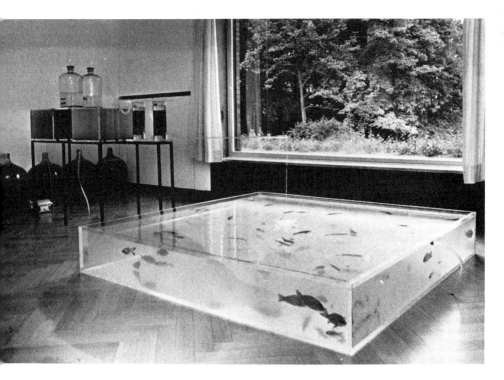

establish one of their discoveries, and then become known. Now that they are known, they are afraid to continue their search into the unknown for fear of disestablishing their known work—all this perhaps unconsciously."

So far, Haacke has avoided this pitfall and his creations have been event-oriented, not object-directed. Whatever direction he now chooses to travel, his momentum has not abated. He seems to be entering more dangerous altitudes as he flies straight for the clouds, but perhaps, more lucky than Icarus, he will avoid the sun.

LAWRENCE ALLOWAY

Robert Smithson's Development

Robert Smithson's work contains inherent ambiguities. Its implications are often complex yet its forms are simple. New York art critic Lawrence Alloway discusses such things as Smithson's ideas of entropy with regard to nature, humanity, and his art. Did he view the concept of entropy as a way to demonstrate essences and inevitabilities, or did he, to quote Alloway, see it as the "clash of uncoordinated orders"? And what is Smithson's relation to Minimalism? By focusing mainly on the work done from 1966 to 1969, Lawrence Alloway covers Smithson's important pieces as well as the thoughts behind their production.

Smithson's sculpture of 1964 to 1968 is regarded as belonging to Minimal art, but this view needs qualification, partly because of the way in which his later development throws retroactive light on earlier pieces. The reason for linking him with Minimal art is not hard to find: he made the connection himself. In an article of 1966, for example, he wrote particularly about Dan Flavin, Donald Judd, Sol LeWitt, and Robert Morris[1] and in 1968 discussed the writings of Carl Andre, Flavin, Judd, LeWitt, Morris and Ad Reinhardt.[2] These names do not exhaust his references, but they amount to a primary emphasis. Aside from the evidence of his interests and associates, what about the style of his work in relation to the requirements of Minimal art? The canon certainly required a sculpture of neutral units, either modular or monolithic. Another expectation was inertness, a denial of visual animation and contrast. A third factor, proposed by Lucy Lippard, was the desire of the artists to "compete visually with their nonart surroundings" by means of "projects that would in fact create a new landscape made of sculpture rather than decorated by sculpture."[3] Whether this environmental impulse belongs properly to Minimal art can be contested if, as Lippard sug-

gests, it begins with "Tony Smith's long visualized 'artificial landscapes without cultural precedent.' "[4] Actually Smith makes big sculptures, sometimes at architectural scale, but their solid fabrication separates them fundamentally from the concept of a "landscape made of sculpture." Lippard's extrapolation of Minimal art to earthworks is problematic in another way, inasmuch as she assumes Minimal art to be a fundamental stylistic entity. It is true that artists who were called Minimal produced earthworks in and after 1968, but this does not make the later work dependent on Minimalism. What happened with Minimal art is that the very general reductive impulses of a period were consolidated and appropriated for a few artists. At any rate, what is clear on rereading contemporary criticism is that Smithson presented a problem to the critics who supported Minimal art as a movement. Typically, in Lippard's text quoted above, the main reference to Smithson concerns his article "Entropy and the New Monuments" and not his sculpture.

What aspect of Smithson's sculpture relates most closely to Minimal art? Obviously it is the use of modules to control repetitive arrays of forms. Although some of Smithson's pieces employ an extendable module of fixed dimension, like LeWitt's or Judd's, the direction of his development is toward progressions with expanding sequences. The morphological difference between seriality and progression is considerable. The steps of these sequences are systematic but their complexity is in excess of the tolerances of Minimal art. Consider Smithson's long steplike sculptures, such as *Plunge* (1966): the intricacy of the units, ten of them expanding along the row at the rate of half an inch each time, deliberately opposes the notion of all-at-once graspability typical of the Minimalist application of Gestalt theory. It is true that LeWitt's grids, as the parts become numerous, propose a visual display of overlapping partial and oblique views different from the given module in effect. The divergence of recipe and object is of course intentional, but can this be linked to Smithson's interests? LeWitt's precisely defined and repeatable ambiguities are easily learnable and, as such, have a kinship with Renaissance rational-perspective platforms. Smithson, on the contrary, has a sense of collapsing systems, which has far-reaching implications for his art. A clue to his attitude is contained in the title *Alogon 1* (1966). This is a Pythagorean term for mathematical incommensurables, meaning the "unnamable" or "unutterable"; these were unaccountable imperfections in the numerical fabric of the universe, not mysteries, which is why they were not to be named or discussed.[5] Jo Baer (who studied Greek) prepared a lexical note for Smithson on *alogon:* its senses include inexpressive, irrational, and unexpected, as well as incommensurable. *Alogon 1* has regular forms but

the interplay of actual diminishment and the perspectival effect of tapering in the side views produce a sense of dislocated systems. Its cantilevered bulk resembles a massive corbel table, but with nothing to support, and the black mat paint, by reducing perceptible light changes, can be said to "slow" the light. The formality of the sculpture, therefore, confirms the title's pessimistic reference to the limits of knowledge or to a system's weak points.

Smithson's intricacy and suspension of definite closure seem to me decisive separations from what Minimal art was supposed to be. In 1967 and 1968 the tendency to complexity reached a climax in Smithson's sculpture. One example is the project for the Dallas–Fort Worth Regional Airport, a large spiral constructed of triangular concrete segments, flat on the ground, viewable as a whole form only from airborne planes. The spiral motif is developed three-dimensionally in *Gyrostasis* (1968), in which twelve joined blocks, triangular in section, rise from the largest step, which is also the base of the sculpture, and diminish to form a suspended half-circle at the top. Here the tapering progression is not simply stretched in one direction, as in *Plunge* and *Alogon 1,* but made into a complex freestanding object: each straight-edged step is clearly articulated and each is an episode along the flow of the spiral. The source of the spiral is in crystallography, as Smithson's early sculpture *Enantiomorphic Chambers* (1964) proves. An enantiotropic system is one for which "changes are completely reversible,"[6] as in "a substance [which] when heated changes from form A to form B, the reverse change taking place on cooling."[7] In the sculpture two identical but reversed chambers are placed side by side with internal mirrors to double up the symmetry. The translation of a concept from crystallography to the structure of a work of art is typical of Smithson's interest in the relationships of art and the world as opposed to an art isolated by its internal relationships. In this case he applies the reversible forms and the mirrors to a refutation of "the illusionistic plane of focus sometimes called the 'picture plane.'"[8]

Coincident with his sculpture Smithson began a series of trips into the country in December 1966, which he documented photographically. The first was to Great Notch Quarry, near Paterson, the visual record is of a desolate New Jersey landscape. Smithson has commented on his fondness for "sites that had been in some way disrupted or pulverized."[9] This means, as his practice from this time on confirms, that he is attending to landscape not only in terms of natural process but in terms of human intervention as well. Since the nineteenth century man has shared in landscape formation at a scale comparable to that of geological process. The development of cities and industries with their attendant pollution has produced changes of the same order of magnitude as nature's. Indeed it is no longer possible to separate

man from nature, and New Jersey, the California of the East, is one of the places where the geological network of faults and the human network of waste penetrate each other to form a solitary landscape. On an earlier trip to the quarry with Donald Judd, based on their "mutual interest in geology and mineralogy," he wrote of its walls: "fragmentation, corrosion, decomposition, disintegration, rock creep, debris slides, mud flow, avalanche were everywhere in evidence."[10] The fullness with which Smithson describes these traces of change is typical of his mesh of collapsing systems. In fact, what he sees out there is related to the interpreting brain, which, Smithson stresses, governs perception: "slump, debris slides, avalanches all take place within the cracking limits of the brain."[11] He does not tolerate ideas of man and nature in separation; his interest is in systems that contain both.

In April 1966 he made a "site selection trip" to the Pine Barrens Plains with Robert Morris, Carl Andre, Nancy Holt, and Virginia Dwan that culminated in the first nonsite. They subsequently tried to buy some land for an earthwork exhibition there. In May 1968 he wrote: "If one travels to southern New Jersey in order to see the origin of the nonsite, one may look around and say 'Is this all there is?' The Pine Barrens Plains are not much to look at. And the hexagonal map with its 30 subdivisions surrounding a hexagonal airfield may leave the participator wondering."[12] It is no accident that the cue for this first nonsite was an airfield. Since July 1966 Smithson had been an artist-consultant to Tippets-Abbett-McCarthy-Stratton (engineers and architects) on their projected Dallas–Fort Worth Regional Airport. To quote from his report: "The straight lines of landing fields and runways bring into existence a perception of 'perspective' that evades all our conceptions of nature."[13] "The landscape begins to look more like a three-dimensional map rather than a rustic garden."[14] Thus there is a reference to a real but artificial object at the center of the hexagonal map. It is not only a question of real site and artificial nonsite; we must take into account the artificiality of the signified site as well as the concreteness of the soil samples in the Minimal art containers.

Nonsite, 1 (1967) was originally described as *A Nonsite (indoor earthwork).* Smithson was interested in the scale change, as between a signifier and the signified. A stubborn sculptural sense has always kept him aware of the mass and volume of absent signifieds; it is a sculpture of absence. The contraction of the world into more or less arbitrary designations led him to the concept of the "indoor earthwork" but his immediate revision of this paradox to a dialectic strengthened his position immensely. He equalized the ambiguities of both site and nonsite, nature and its analogue, presuming a common spectrum of artifice and abstraction. Site and nonsite constitute a collection of

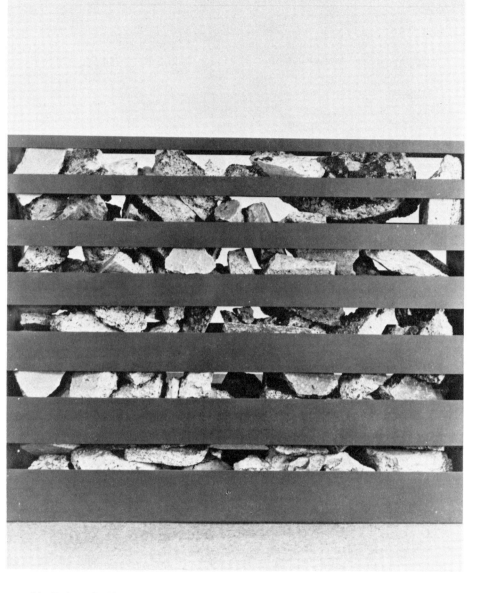

54. Robert Smithson: *Nonsite, Line of Wreckage, Bayonne, New Jersey* (detail). 1968. Purple-painted steel bin holding broken cement, 59″ x 70″ x 12½″. The complete work includes maps and snapshots of the site. (Photograph: John Weber Gallery)

relationships among variables. The site is identified by information supplied by the artist in the form of maps, photographs, analogical objects (bins and trays cued by the original lay of the land), rock samples, and verbal captions. The nonsite, by this accumulation of references, acts as the signifier of the absent site. What has happened is that the modules of Smithson's abstract sculpture have been turned into maps. The coordinates of cartographical grids have replaced the ideal geometry of modular sculpture. This can be put another way, inasmuch as Smithson rejects Wilhelm Worringer's dualistic system of abstraction and empathy. "Geometry strikes me as a 'rendering' of inanimate matter. What are the lattices and grids of pure abstraction if not renderings and representations of a reduced order of nature?"[15] Thus the significative role of the grid in the nonsites can be taken as a linguistic extension of the modules of Minimal art. Smithson defines the relation of site and nonsite as dialectical, affirming its basis in "a changing reality with a material basis" (*The Random House Dictionary of the English Language*). Here is the artist's list of the two terms:

Site	*Nonsite*
1. Open limits	Closed limits
2. A series of points	An array of matter
3. Outer coordinates	Inner coordinates
4. Subtraction	Addition
5. Indeterminate certainty	Determinate uncertainty
6. Scattered information	Contained information
7. Reflection	Mirror
8. Edge	Center
9. Some place (physical)	No place (abstract)
10. Many	One[16]

The names of several of the sites are evocatively *entropic*, to use a word that Smithson brought into the literature of art. *Pine Barrens, Line of Wreckage, Edgewater Mono Lake*. This is in line with his skeptical view of the optimistic technology of twentieth-century modernists, such as David Smith; Smithson proposes rust as "the fundamental property of steel."[17] This is an acknowledgment of the inevitability of decay and of change; the sites/nonsites are a meditation on the connection of these states to everything in the world. *Site/Nonsite "Line of Wreckage," Bayonne, New Jersey* (1968) refers to a crumbling shoreline in New Jersey that was being stabilized by clean fill. Smithson subtracted some of the broken concrete being used for this for the nonsite. It

was characteristically a desolate place to be "redefined in terms of art," to quote the artist. The Jersey swamps are here, masses of reeds that grow high enough to make the space they enclose indeterminate; the turnpike is close by, but it is hard to enter if you are off it; and the buildings are, Smithson observes, "essentially anonymous." On a later visit Smithson discovered that the landscape had radically changed, with factories built out to the line of the recently completed fill. A part of what he likes about New Jersey is the fact that it is a "landscape in transition." As the sites change, his nonsites increasingly take on the character of memorials to dead cities (or hypothetical continents). The nonsite system of references always has the possibility of canceling itself out.

The original location of *Site/Nonsite: Edgewater, the Palisades* (1968) was discovered in a book on the geology of New York City by Christopher J. Schuberth. He discusses layers of sandstone, "the oldest exposed strata of the Newark series," and basalt in the cliff face of the Palisades and describes "the right of way of the old trolley that connected the amusement park with the Edgewater–125th Street ferry until August 5, 1938."[18] The trolley bed climbs the cliff, through choking vegetation; it has become the corroded track of an occasional stream, littered with junk that has come down from adult discards to children's playthings. There is a "large open clearing. . .where the trolley made a hairpin turn," to quote Schuberth, now a clearing for nothing except a spectacular view over the suburban roofs of Edgewater across the Hudson River, to Manhattan. The site is a coalition of indeterminate time rates. There is a piece of nineteenth-century engineering almost effaced; by comparison the ancient and complex geology is intact. The prehistoric asserts its newness against old technology, for it is compared to the twentieth-century buildings in view across the river, and from which we come. Smithson's photographs of the site record objects and spaces in trajectories of change.

The contrast of sense perception, on site, and abstraction, at the nonsite, is stretched further in *Six Stops on a Section* (1968). To quote Smithson: "the section line is a 142-degree angle on an 1874 map of northern New Jersey, showing iron and limestone districts. Covering about sixty-three miles." Along this line he selected the following sites, each characterized geologically: (1) Bergen Hill (gravel); (2) Second Mountain (stones); (3) Morris Plains (stones and sand); (4) Mount Hope (rocks and stones); (5) Lafayette (gravel); and (6) Dingman's Ferry (slate). The first stop, also known as Laurel Hill, is a high outcrop of ancient traprock, which is being quarried on one side for gravel. It sticks up rawly from the flat swamps; from the top is a view of the Newark skyline and a sight of the second stop. The quarrying operations have a long way to go before the outcrop is consumed, but the machines are

munching away steadily. In *Passaic Trip 1* (1967) Smithson made twenty-four photographs of a construction site along the river (published with six photographs in *Artforum* as "The Monuments of Passaic").[19] The "monuments" have not survived to 1972, except for the bridge and *The Sand-Box Monument* (also called *The Desert*) in Taras Shevchenko Park, Passaic, which has been newly painted blue, orange, and gray. The sites/nonsites are not a dualistic system, such as, nature and art, true and false. On the contrary the same unstoppable rate of change and threat of entropy permeates both terms: "it is the back-and-forth thing," as Smithson has observed.[20] Neither site nor nonsite is a reliable source of fixed value, neither completely elucidates the other.

"On Saturday, September 30, 1967, I went to the Port Authority Building on 41st Street and Eighth Avenue. I brought a copy of *The New York Times* and a Signet paperback called *Earthworks* by Brian W. Aldiss."[21] Then he took the bus to New Jersey on the excursion described in "The Monuments of Passaic." In the proposals to Tippets-Abbett-McCarthy-Stratton, Smithson had already used the term: "on the boundaries of the taxiways, runways, and approach 'clear zones' we might construct 'earthworks' or grid type frameworks close to the ground level."[22] In the fall of 1968 a group exhibition at the Dwan Gallery was called "Earthworks," and it was clear that a new tendency had been named. It was the large spaces around the airport that forced Smithson's attention to a new scale of operation, eliciting the idea of an art of expanding thresholds. Returning to the bus: from *The New York Times* Smithson quotes a series of inanities about works of art, including the headline "Moving a 1,000 Pound Sculpture Can Be a Fine Work of Art, Too." From this it is a logical step to interpret the construction site as a series of monuments, such as *Monuments with Pontoons: the Pumping Derrick,* and *The Fountain Monument.* This monumentalizing of the quotidian relates to a basic turn of Smithson's mind. He is not taking the Dada tradition of the found object and applying it to the newspaper and the construction site equally, but it is an anticipation of Conceptual art's play with naming. It has more to do with the overlap of systems that, in one way or another, recurs through his work. The article is a documented inventory but Smithson imposes a convention on the data that we do not anticipate. It is, to use the original title, a "Guide to the Monuments of Passaic" and follows the perambulatory form of a guidebook, including meditations on time and monuments. "Has Passaic replaced Rome as the eternal City? If certain cities of the world were placed end to end in a straight line according to size, starting with Rome, where would Passaic be in that impossible progression?"[23] This is *Six Stops on a Section* translated into the city-mobility and contracted time of science

fiction. The guide is a fictionalized documentary, with a nitty-gritty iconography amplified into the grandeur of monumentality and ancient cities. The fluctuations and intersections of the two conventions seem closer to the way one handles the input of the world than any single-valued interpretation of data would be.

Smithson is a brilliant writer with a vocabulary that includes knotty technical terms, adjectival largesse, broad references, and serpentine arguments. It is I think indicative that his spell of maximum writing (1966–1969) coincides with the period when he was moving from sculpture to earthworks, from an art of autonomous objects to an art penetrating the world and penetrated by sign systems. However, as pointed out earlier, his sculpture was prone to demonstrate complexity and artificiality, rather than summary wholeness and supposed inevitability (an illusory quality, in fact). Thus he seems always to have resisted the reductive and essentializing moves begun in the 1950s, and continued through the 1960s. He wrote mainly for two editors, Phil Leider of *Artforum*, five articles, and Sam Edwards of *Arts* and *Art Voices,* four articles. The central subject is his art or at least the ideas that inhabit and direct his art. He wrote about the Hayden Planetarium and science fiction, Art Deco and New Jersey, the writings of his fellow artists and art as a linguistic system, geology and Mexican mythology. To indicate both the specificity of his data and their discursive routes, I shall quote from the "Cretaceous" section of *Strata* (1967):

> Globigerina ooze and the blueish muds. *Creta* the Latin word for chalk (the chalk age). An article called *Grottoes, Geology and the Gothic Revival. Philosophic Romances.* Greensands accumulated over wide areas in shallow water. Upraised plateaux in Australia. Sediment samples. Conifers. Remains of a flightless bird discovered in a chalk pit. Causes of extinction unknown. The fabulous sea serpent. The classical attitude toward mountains is gloomy.[24]

By means of the sites/nonsites Smithson established a dialectic between outdoor and indoor locations. He was able to use the gallery not simply as a container for preexisting objects but brought it into a complex allusive relation to the absent site. Earthworks depended for their financing and for the distribution of information concerning them on the traditional resources of art dealers, but only Smithson figured out a way to use the support system as part of the meaning of the work. By comparison Michael Heizer, when he shows blown-up or small photographs in galleries, is settling for the simple situation of signaling an absent original by means of confirmatory documents. His photographs, as it were, say, yes there is a hill or a cut out

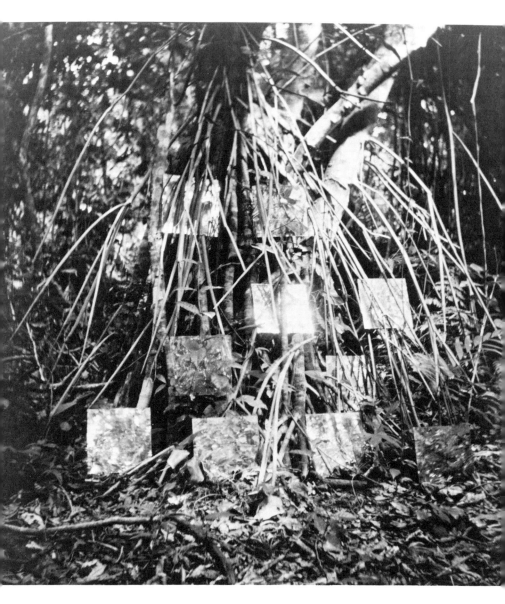

55. Robert Smithson: *The Seventh Mirror Displacement* (detail from "Incidents of Mirror-Travel in the Yucatán"). 1969. Mirrors temporarily installed in the foliage of a tree. Yucatán, Mexico. (Photograph: Nancy Holt; courtesy John Weber Gallery)

there in a positivistic sense, whereas Smithson's nonsite is epistemological. The mirror displacements, begun in the salt mine at Cayuga Lake, New York, in 1969, climaxed later that year in the *Yucatán* series; here the problematics of the nonsite are carried into the site itself. A dozen mirrors, each twelve inches square, were arranged in various places, such as a field of ashes ("The people in this region clear land by burning it out"),[25] a quarry, the seashore, the jungle. The manufactured twentieth-century artifacts are not only set *against* the landscape, the images in the mirrors are of the environments, but displaced by reflections. The reflections bring in the theme of duplication, a kind of mapping, but the reflections of light are endless and unpredictable; to quote the artist, they "evade measure." The scattering of modular plates in the organic environment also has the effect of mixing the ordered and the unexpected. The mirrors act like the elements of the nonsite in their allusive signification.

Entropy is a loaded term in Smithson's vocabulary. (It customarily means decreasing organization and, along with that, loss of distinctiveness.) Here are some examples from his writings that, because they come from the same source as his art, may be considered to provide information about the art. Referring to the construction site in Passaic, he observed: "That zero panorama seemed to contain *ruins in reverse,* that is—all the new construction that would eventually be built."[26] In his original article on entropy he stated, "falseness, as an ultimate, is inextricably a part of entropy, and this falseness is devoid of moral implications."[27] Thus all systems of communication, to the extent that they are not one-to-one, have a false and indistinct aspect. Smithson applies the idea to time, as in his characterization of "the obsolete future of H. G. Wells's *The Shape of Things to Come* (1938)."[28] "The Jersey Swamps—a good location for a movie about life on Mars."[29] Basically Smithson's idea of entropy concerns not only the deterioration of order, although he observes it attentively, "but rather the clash of uncoordinated orders," to quote a formulation of Rudolf Arnheim.[30]

There is a shift in Smithson's work to outdoor sites solely, large in scale, freed of significative bonds, which is marked by his *Partially Buried Woodshed* (1970) at Kent State University, Ohio. The measurements of the shed are 45 feet by 18 feet 6 inches by 10 feet 2 inches high, but these figures do not describe the limits of Smithson's work, only what was given. His original intention was to subject an existing hill to the pressure of a mud flow, but sub-zero temperatures defeated the plan. He had already used a truck in *Asphalt Rundown* (1969) the year before and now he used a backhoe on a tractor to pile dirt onto the shed until the central beam cracked. (In Smithson's mind,

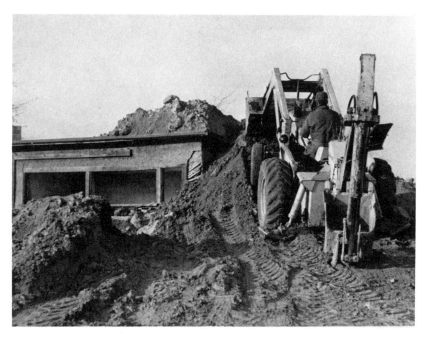

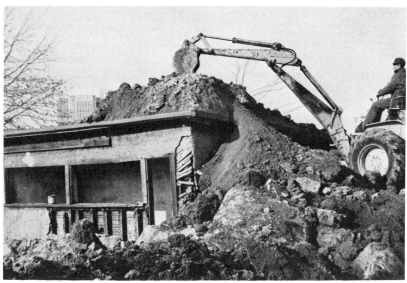

56. Robert Smithson: *Partially Buried Woodshed* (2 views). 1970. Shed, 45′ x 18′ 6″ x 10′ 2″. Kent State University, Ohio. (Photographs: John Weber Gallery)

among other things, as he set up this piece, were those science-fiction movies in which amorphous beings inundate known structures and incorporate people, such as the *The Blob*.) The man-made (in terms of structure and right-angles) and the inchoate (masses of soil) were brought together to create a stress situation: the work was finished when the beam broke, so that the timing of collapse is, in a sense, the work's subject. Hence Smithson's instructions when he donated the work to the university: "everything in the shed is part of the art and should not be removed. The entire work of art is subject to weathering and should be considered part of the work."[31]

The *Spiral Jetty* (1970; see fig. 35, p. 69), built on the north shore of the Great Salt Lake, is an expansion to literal scale of the capacious sign systems that Smithson had been dealing with since 1968. It is a move into logistic complexity and an expanded technology. It can be described as a "post-studio" system of operation. After he had located the site, Smithson took specifications for the job to a number of contractors, none of whom was willing to run the risk of moving heavy earthmoving equipment out into the shallows of the lake. Finally Parsons Asphalt Inc., Ogden, took the job because of the personal interest of Robert Phillips in the problems it presented; the company had worked in the lake before, building straight and square dikes, but this was the first time they had had to construct curved embankments into the water. The working procedure on what was called Job No. 73 was as follows. Front-end loaders (Michigan Model 175) were used to dig out rocks and to collect sand on the shore. Ten-wheeler dump trucks carried the load to the lake, backed out along the coil, and tipped it off the end. Here truck loaders (Caterpillar Model 955) placed the dumped rocks and tamped them down within the narrow limits set up by the guidelines placed by Smithson. The technical difficulties were considerable and called on all the skills of the drivers, including the operational hunch that tells when the ground is too soft and therefore likely to subside. The drivers, far from being ironic about a nonutilitarian project, appreciated the task as a challenge and brought their families out to the site for picnics at which they were able to demonstrate their virtuosity. The machines tipped and jostled their way along the spiral as the new embankments grew. A crucial figure in the work was the foreman, Grant Boosenbarck, who responded to the problems of the unprecedented structure with canny skill and maintained the concentration of the workmen by his leadership.

The dimensions of Smithson's work had been increasing since *Asphalt Run-down,* in which he tipped asphalt down the side of a quarry near Rome, Italy. The use of this sluggish material picks up an earlier theme, stated in the *Tar Pool Project* (1966) and expanded conceptually in 1969 as *Earth Map of Sulphur*

and Tar (Cambrian Period), a proposal for a model of the earth with (yellow) sulfur continents and (black) tar oceans to be constructed on a long axis of 400 feet. The viscous mud-asphalt theme is also present in *Texas Overflow* (1970), in which a plateau paved in asphalt is ringed by broken chunks of sulfur. When he came to operate in enlarged dimensions, the conditions of Smithson's work changed drastically. He found himself out of the studio and no longer dependent on middlemen for the handling of his work. With the earth as his medium he had to deal directly with contractors, engineers, realtors, executives, and civic officials. This was true for both *Spiral Jetty* and *Spiral Hill* and *Broken Circle* (1971) at Emmen, Holland, and for a group of pending projects. For the Salton Sea, California, he has a proposal he has been discussing with city authorities for a work called *Coastal Crescent* (1972, unrealized) to measure 750 feet across. For Egypt Valley, Ohio, there is a proposal (*Lake Edge Crescents,* October 1972, unrealized) under discussion with the Hanna Coal Company for reclamation of a 1,000-acre tract of strip-mined country. The work is a jetty that combines elements of both a spiral (a hornlike curve of beach) and a circle (an arm of earth carried out into a lake). It is an expansion of ideas given in *Broken Circle—Spiral Hill.* Smithson wrote in 1971: "Across the country there are many mining areas, disused quarries, and polluted lakes and rivers. One practical solution for the utilization of such devastated places would be land and water re-cycling in terms of 'Earth Art.' ... Economics, when abstracted from the world, is blind to natural processes."[32] Thus, as his works have expanded, as the contacts that make them possible have diversified, he has reached the point at which he can manipulate directly the large-scale natural and man-made forces of which he has always been aware. Accompanying this expansion of operations, the view he takes of galleries and museums has hardened, from the subtle accommodations of the site-nonsite relationship to what Smithson has described nicely as "a more succinct disclosure of limits." In "Cultural Confinement" he emphasizes the limits of architectural display in terms of privations rather than conventions.[33]

To return to the *Spiral Jetty:* approaching it from the land, you crest a low ridge and there, in front of and below you, is the spiral, spun out into the flat reddish water. It is securely locked to the shore, both materially and morphologically. It is 1,500 feet from the top of the ridge out to the tip of the coil, which measures about 15 feet across, just enough to support the trucks. The fill is made up of 3,500 cubic yards of boulders and earth; each cubic yard weighs 3,800 pounds, which means that a total of 6,650 tons was moved to constitute the embankment. These statistics, which should be read as the equivalent of a technical description, such as oil on canvas or watercolor on

paper, indicate scale. Walking along the spiral lifts one out into the water into a breathless experience of horizontality. The lake stretches away, until finally there is a ripple of distant mountains and close around one the shore crumbles down into the water, echoing the mountains. From this point of view the spiral is a low trail of stones and rocks resting on the water like a leaf on a stream. It is a moist and earthy causeway with salt caking on the rocks and on the visitor. The landscape is openly geologic, evoking past time with placid insistence.

Concurrently with the earthwork, Smithson made a film that shows its construction and, after completion, its vertiginous relation to water and sun. The film is both a record and a representative work by Smithson. The sculpture and the film are related in the same way as site and nonsite, although with a new amplitude of resources and references. "The sites in films are not to be located or trusted," Smithson has observed.[34] In the film he declines to use the horizontal expanse of the site. As in his still photography he likes low-profile imagery. The typical camera angle is, so to say, slightly stooped, with little sky visible, or close up. The machines are mostly shot in close-up, looming on the screen, biting earth, emitting rocks; they are compared to prehistoric animals in a technological-prehistorical analogy. In various ways the theme of time runs through the film. The present acts of construction (earthmoving) are compared to the Earth's past. The ancient geological formations constitute a time-bound present and the sequence in the Hall of the Late Dinosaurs in The American Museum of Natural History in New York implies futurity. The sequence was shot with a red filter to suggest an entropic equalization of energy. "Nothing has ever changed since I have been here," says Smithson of the sound track, matching the drained images to Samuel Beckett's *The Unnamable* (Alogon). Thus the photographic record of present activity, the building of the jetty, is set into a context of great duration. The long final sequence, photographed from a helicopter, abolishes the low-keyed style that the film maintains until this point. The climactic sequence fuses water and sun as the camera picks up the sun's reflections in the lake and in the channels of water that infiltrate the spiral to its center. Here the reflected solar imagery, an enormous "displacement," produces an exhilarating world picture. The sound track at this point includes a quotation from *The Time Stream* by John Taine referring to "a vast spiral nebula of innumerable suns."[35] The quotation is apt but it is typical of Smithson's double-takes, his sense of perpetual reservation, that the story should be old-fashioned science fiction, published originally in 1932. In an early sequence, establishing the ubiquity of spirals and "introducing" the sun, the sound track records the wheezes of the bag of a respirator machine.

It is as if to say the sun is burning up but it is still alive. At the close of the film, after the solar and water spectacular (a planetary amplification of Smithson's original Dallas–Fort Worth Airport ideas), Smithson himself appears running into the spiral, pursued by the helicopter, although it is only there for the purpose of photographing him. When he gets to the center he pauses, then starts to walk back, a factual, deflationary detail, typical of Smithson's laconic but undeviating anti-idealism.

What is remarkable about Smithson's work in the past ten years is the distance of ground covered in his move from sculpture to earthworks without any break in the continuity of his generating ideas. He has a built-in sense of permeability, possibly parallel to his interest in geology, the subject of which is matter in perpetual stress, overlapping, and penetration. The ways in which modules turned into mapping and mapping into sites are examples of the course of one idea into and through another. To this can be added the diffusion of his early experiences in New Jersey, where he was born and raised, into his later investigations of the same landscape. The Pine Barrens, for instance, was an area he had frequented long before he brought it into the area of art. "Since I was a kid," Smithson remembers, he had been interested in crystals after an uncle, who worked for the Hammond Map Company, gave him a quartz crystal. The point is that the landscape and its systems of ordering have been familiar to Smithson most of his life and their presence can be felt on every level of his art and thought. He is not building barriers around fragments of personality or stylistic innovation, as happened with a good deal of art in the 1960s. He does not attempt to fix reality in a permanent form by means of art, but demonstrates a sustained and interlocked view of a permeant reality.

NOTES

1. Robert Smithson, "Entropy and the New Monuments," *Artforum* 4, no. 10 (June 1966), pp. 26–31.

2. Robert Smithson, "A Museum of Language in the Vicinity of Art," *Art International* 12, no.3 (March 1968), pp. 21–27.

3. Lucy Lippard, "10 Structurists in 20 Paragraphs," *Minimal Art* (The Hague: Haags Gemeentemuseum, 1968), p. 30.

4. *Ibid.*

5. Tobias Dantzig, *Number: The Language of Science,* 4th ed., rev. and enl. (New York: The Macmillan Co., 1954), p. 103. (All books cited herein were in Smithson's possession.)

6. Ajit Ram Verma and Padmanabhan Krishna, *Polymorphism and Polytypism in Crystals* (New York: John Wiley & Sons, 1966), pp. 20–21.

7. *Ibid.,* p. 10.

8. Robert Smithson, unpublished typescript, 1967.

9. "Discussions with Heizer, Oppenheim and Smithson," *Avalanche* 1 (Fall 1970), p. 52.

10. Robert Smithson, "The Crystal Land," *Harper's Bazaar*, no. 3054 (May 1966), p. 73.

11. Robert Smithson, "A Sedimentation of the Mind: Earth Projects," *Artforum* 7, no. 1 (September 1968), p. 45.

12. Robert Smithson, "Participation Degree Zero," typescript, 1968.

13. Robert Smithson, "Aerial Art," *Studio International* 177, no. 910 (April 1969), p. 180. (Smithson invited the collaboration of Andre, LeWitt, and Morris.)

14. *Ibid.*

15. Robert Smithson, "Nature and Abstraction," typescript, 1971. Cf. "Language to Be Looked at and/or Things to Be Read," press release, Dwan Gallery, New York, 1967. (Smithson used the pseudonym Eton Corrasable.) Reprinted in *The Writings of Robert Smithson*, ed. Nancy Holt (New York: New York University Press, 1979), pp. 219, 104, respectively.

16. Robert Smithson, "Dialectic of Site and Nonsite," in Gerry Schum, *Land Art* (Berlin 1969), unpaged.

17. Smithson, "A Sedimentation of the Mind," p. 46.

18. Christopher J. Schuberth, *The Geology of New York City and Environs* (New York: Natural History Press, 1968), pp. 232–236.

19. Robert Smithson, "The Monuments of Passaic," *Artforum* 6, no. 4 (December 1967), pp. 48–51.

20. Robert Smithson *et al.*, "Symposium," *Earth Art* (catalogue) (Ithaca, N.Y.: Andrew Dickinson White Museum of Art, Cornell University, 1970), unpaged.

21. Smithson, "The Monuments of Passaic," p. 48.

22. Smithson, "Aerial Art," p. 180.

23. Smithson, "The Monuments of Passaic," p. 51

24. Robert Smithson, "Strata: A Geophotographic Fiction," *Aspen Review* 8 (Fall/Winter 1967). Reprinted in *The Writings of Robert Smithson*, pp. 129–131.

25. Robert Smithson, "Incidents of Mirror-Travel in the Yucatán," *Artforum* 8, no. 1 (September 1969), p. 28. (The title of course reminds one of the brilliant travel book by John L. Stephens, *Incidents of Travel in Yucatán*.)

26. Smithson, "The Monuments of Passaic," p. 50.

27. Smithson, "Entropy and the New Monuments," p. 29.

28. Robert Smithson, "Ultramoderne," *Arts* 42, no. 1 (September–October 1967), p. 32.

29. Smithson, "The Crystal Land," p. 73.

30. Rudolf Arnheim, *Entropy and Art* (Berkeley: University of California Press, 1971), p. 15.

31. Robert Smithson, typescript, 1970.

32. Robert Smithson, proposal, 1972. Printed in *The Writings of Robert Smithson,* p. 220.

33. Robert Smithson, "Cultural Confinement," *Artforum* 11, no. 2 (October 1972), p. 39.

34. Robert Smithson, "A Cinematic Atopia," *Artforum* 10, no. 1 (September 1971), p. 53.

35. John Taine, *Three Science Fiction Novels* (New York: Dover Publications, 1964). (Includes *Time Stream.*)

JONATHAN CARPENTER

Alan Sonfist's
Public Sculptures

Recent monumental art has not only involved remote sites and massive intrusions into the Earth.
Alan Sonfist's large-scale land art reverses these conditions. His sculptures use the land within
urban centers. Rather than making marks into the Earth, Sonfist selectively brings together the
elements of the Earth from past times. Jonathan Carpenter, a free-lance writer, discusses the
various large-scale artworks by Alan Sonfist and the answers they propose about the meaning of
contemporary art.

To review the public sculptures of Alan Sonfist since the 1960s is to witness
the reemergence of the socially aware artist. These sculptures reassert the
historic role of the artist as an active initiator of ideas within society. Inherent
in each of his artworks are fundamental redefinitions of what sculpture is,
who the artist is, and how art should function for its public.

Sonfist's artworks establish new relationships between public sculpture and
its site. In *Atlanta Earth Wall,* a relief sculpture that encompasses the entire
wall of a building, layers of earth from beneath the site are the media: the red
topsoil, the buried old city, the sand, the granite bedrock. In the exhibition
catalogue for the project, the critic Carter Ratcliff discusses this artwork in
terms that apply to Sonfist's art in general.

> Alan Sonfist's *Atlanta Earth Wall* is a public monument of a new kind. Briefly,
> it takes its form and its meaning from a direct reference to its site . . . Most public
> artworks are large abstract sculptures in styles that have found approval within

the world of avant-garde art and art criticism. Their appearance is thus a displacement of very specialized tastes and values from the art world into the public realm. In other words, what makes sense to an aesthetic elite is suddenly offered to the general public in a way that doesn't permit it much recourse. . . . In order to make sense out of the usual public monument one must take an imaginative leap out of its setting. That is because the work's meanings have been developed elsewhere, not at the center of contemporary life but at the art-world periphery. By contrast, the meanings of Sonfist's *Atlanta Earth Wall*

57. Alan Sonfist: *Wall of Earth.* 1965. A relief composed of earth cores from Macomb, Illinois; some from 50′ below ground. (Photograph courtesy the artist)

derive from the site itself . . . It gives the individual a very strong sense of being precisely where he or she is here and now . . . This is an artwork that leaps over the boundaries of art-world specialization to become part of the environment. In doing so, it reveals the environment to us at a time when such revelations are essential for survival on the imaginative plane and also on the plane of the absolutely real—on earth itself.[1]

Sonfist's concept of public sculpture can be clarified by contrasting his *Earth Monument* (1971) with Walter De Maria's *Broken Kilometer* (1979). Both artworks are based on measure. Sonfist's sculpture, exhibited in 1972 at the Akron Art Institute in Ohio, laid out in the gallery rods from a land coring 100 feet long. Encoded in the variations of color and texture of the rock were events in the history of that land during millions of years. Length was equal to time; material changes were equal to events on that site. De Maria's sculpture, also of rods lying on a gallery floor, was made of bronze fabricated in uniform lengths. Together they equaled an abstract unit of measurement, one kilometer. When De Maria utilized the idea of drilling in the earth for *Vertical Earth Kilometer* (1977) in Kassel, Germany, the distinction between his art and Sonfist's is again clear. Whereas Sonfist's sculpture emphasized every visual detail of the local earth, De Maria discarded the earth displaced by his drilling of the site and inserted a brass rod.

Sonfist described the way he thinks artwork should function as public sculpture:

Public monuments traditionally have celebrated events in human history—acts or humans of importance to the whole community. In the twentieth century, as we perceive our dependence on nature, the concept of community expands to include nonhuman elements, and civic monuments should honor and celebrate life and acts of another part of the community: natural phenomena. Within the city, public monuments should recapture and revitalize the history of the environment natural to that location.[2]

The art critic Lawrence Alloway summarizes the innovation of Sonfist's sculpture, its unique revelation of its site and the social implications of his vision: "Sonfist's interest in monumental art . . . rests on a revision of the idea of public sculpture, carrying it in the direction of both topicality and ethics."[3]

Rock Monument of Buffalo, the largest version of Sonfist's *Element Selections* artworks of the 1960s, was installed at the Albright-Knox Art Gallery in 1978. It is a sculpture that takes its materials and composition from the site, thereby enhancing the individual's relationship to the land he inhabits.

Through an article in a Buffalo newspaper, Sonfist explained the objective of the artwork and asked people to seek rocks in their area. Each rock was selected by Sonfist for aesthetic power and verified for historical significance by a local geologist. Sonfist's composition of selected rocks embedded to scale in a 25-foot area on the museum lawn compressed a 50-mile area of the city.

The actual geology is like a book unfolding itself below the city; my art deals with creating and revealing aesthetic experiences that are . . . normally inaccessi-

58. Alan Sonfist: *Rock Monument of Buffalo*. 1965–1978. 25′ x 25′. Rocks selected from the Buffalo, New York, area and positioned in the same relationship as that in which they were originally found. (Collection of Albright-Knox Art Gallery; photograph courtesy the artist)

ble to people, either hidden under the ground, or under roads and buildings, or inaccessible because the relationships exist in such large scale that they cannot be perceived or coherently related. My sculpture reveals what is below the surface and by collapsing the scale makes clear in one experience the geology of the entire area. The public monument for Buffalo can never be duplicated because it takes its form from the specific characteristics of its location.[4]

Sonfist selected a site to bring together different times: the twentieth-century museum, its Greek-inspired portico, evoking the art styles of thousands of years, and the rocks formed during millions of years. Each rock's contrasting color and texture reveal its individual history. The tilt, reflecting its original position in the ground, gives each rock the sensation of reach, as if it were emerging from its past into the present moment. Although faithful to the nature of the material, Sonfist's work is, in the end, evocative and poetic.

This vision becomes clearer through comparison with other recent sculpture built with boulders. In Michael Heizer's sculpture *Adjacent, Against, Upon* (1976) huge boulders are stacked to illustrate propositional alternatives. In Carl Andre's *Stone Field Sculpture* (1977), Hartford, Connecticut, boulders are lined up in rows increasing in size, while decreasing in number and spacing within a triangular site. Sonfist's sculpture does not refer the viewer's awareness to language or numerical relations. *Rock Monument of Buffalo* refers to the immediate context of the viewer, placing people in space and time and in relationship with nature.

Each artist who began to build art with nature in the 1960s approached its use from a different philosophical basis. Hans Haacke's interest in systems led him to present natural systems, such as water, and later led him into examining the social system in which art exists. Robert Smithson's interest in myths, in ideas of order and entropy, led to his building natural materials into symbolic shapes, such as the spiral, and his intention to let them decay eventually. Sonfist's aesthetic philosophy is the positive interdependence of humans and nature. His youthful experience in a natural city park shaped his attitude toward nature as an isolated realm within an industrialized environment. When he made *Element Selections* from this threatened natural forest and transported part of it to a safer environment in 1965, he was establishing the basic theme of his art. This personal image has proved to have wider validity as a metaphor for the new relationship of society and the natural world that is unique to the twentieth century. Sonfist's art represents the meeting of personal myth and cultural need.

59. Alan Sonfist: *Element Selections.* 1965– . *(Top)* In each environment Sonfist searches the area until he finds some symbol with which to begin. He unrolls canvas and places things from the landscape on the canvas in the same relationship as that in which they were found. The canvas remains in the environment to be modified by the elements and eventually submerged into nature. *(Bottom)* Or the canvas can be brought into a museum to represent a fixed monument in time. (Collection of Wallraf-Richartz Ludwig Museum, Cologne; photograph courtesy the artist)

Up to the present time, the Earth could be pictured as a vast natural system with tiny isolated areas of human culture. However, human activity has been altering the globe as radically as have the Ice Ages or continental drift. Now, cultural areas have spread so much that the Earth has become a broad field of cultivated lands and chemically altered air and sea within which exist only a few patches of untouched nature. Sonfist's awareness of this vast change, which defines the modern condition, has led him to rethink what art should be.

Art and other products of human culture used to be rare items in a natural world. Now, objects of human creation are the norm, and products of unadulterated natural production are rare. The scarcity of nature makes it occupy the position that culture once did: it is becoming something of a rare collectible. This radically revised relationship of art and nature has inspired Sonfist's art.

In the 1960s Sonfist made sculptures enclosing colonies of microorganisms. People looked down on the red, green, black, and yellow shapes of these creatures spreading over the surface as they would later look at themselves on Earth from the moon. Sonfist brought from Panama a colony of army ants that lived in a gallery space. The winding paths in which they followed each other created a graceful drawing showing the patterns and structures of an entire society functioning within and sometimes mirroring a complex urban society. These artworks embody the vast perspective that characterizes Sonfist's work. He sees the Earth as a whole and the human being's place in it. He sees society as a whole and the artist's place in it. He sees time in its vast scale and the human being's place in it.

His largest work in actual scale is *Time Landscape* (1965–1978). Historical nature from past centuries is the medium for a series of sculptures on sites dotting the entire city of New York. *Time Landscape* is built of trees and shrubs and grasses. The species chosen were present in the vast time before human intervention. As each area had a different natural past, Sonfist utilized distinct materials and compositions in each *Time Landscape.* In the Bronx he used the dense verticality of native hemlocks. In Brooklyn his sculptural materials were free-flowing sand and vines and grasses. In Manhattan his materials were the contrast of cedars in a low grass meadow and the sparse mass of a young oak forest. In Wave Hill a 10-acre site will have sculptures constructed of material from a succession of uses of the land over a 300-year period.

Another large-scale project is the *Monument to Texas* being developed with the Museum of Fine Arts in Dallas. On a series of islands isolated by the Trinity River, which runs through Dallas, Sonfist has designed sculptures us-

ing the elements of each of the natural ecologies of Texas. As the critic Ron Onorato has said, "Sonfist is an artist-historian, not of past civilizations, but of the earth itself."[5]

Sonfist designs these sculptures through study, selection, and reintegration. Many observations are recorded; together these observations form a new totality while retaining their exact reference to the original site. Like the nineteenth-century Hudson River painter Asher B. Durand, whom he admires, Sonfist journeys to remaining untouched forests to study the visual relationships of a real natural forest. Thousands of observations are collected (he calls them "Element Selections") in the forms of drawings, photographs, and actual elements taken from the site. Nuances of difference in the position of rock to twig, of tree trunk to bush, are studied. Together, exhibited in museums and galleries, they describe the formal visual vocabulary of a natural forest. To create each *Time Landscape,* Sonfist combines these studies into his own composition.

Sonfist's method is clarified by comparison with Richard Long. Sonfist's movements through nature are not predetermined in shape or length; when recorded after a trip, they have an irregular shape formed by his own response to the forest: "As I followed the surface of the pine needles, it led me to observe a whitish hue . . . " In a museum Long's collected rocks are arranged in geometric configurations, their particular order unspecified. Retaining no visual clues of their relationship to the environment, Long's shaped paths and rocks refer the viewer away from the site. In contrast, Sonfist's artistic transformation of materials is a visual, contextual one; the act of pulling relationships out of the field of the forest floor isolates them, allowing new relationships among these collected perceptions to occur. An elegant calligraphy is created that was present but unseen because of other dominant relationships in the original environment. From a material standpoint the site has been faithfully recorded; from a visual standpoint a new entity has been created. Sonfist has simultaneously recorded and transformed the site.

Since the 1960s many artists have dealt with the land. Because the land has a potent meaning in America, carrying the myth of the frontier and the fruitful promised land, one cannot avoid the issue of the meaning of that use. Most of the artists who worked with the land continued the historic American push to the natural frontier. They claimed land much as settlers did: their sculpture was like territorial markings on land inaccessible to or remote from human contact. Seen in this way, these monoliths and markings appear as nostalgic references to a long-vanished era in American history. Sonfist's art

deals with the present reality in which the unexplored frontier is only a myth: the reality is industrialized America from coast to coast. Sonfist's daring move has been to reverse the movement and bring the American frontier back to claim the urban context. When Sonfist uses natural materials from the site itself to make his public sculpture, he brings the city into a complex interaction with his art. The natural materials contrast vividly with the fabricated environment, yet are not alien to it. They actually preceded the structures on their own sites. Sonfist's sculptures act like a perspective point

60. Alan Sonfist: *Time Landscape.* 1965–1978. 200′ x 40′. The re-creation of a pre-Colonial forest by planting the site with native species of trees that will grow as they did before the settlement of North America by Europeans. La Guardia Place, Manhattan, New York. (Photograph courtesy the artist)

that allows people to see the present as part of a larger, vaster stretch of time. Natural monuments like *Time Landscape* become identifiable symbols for the city; an awareness of natural origins becomes part of the population's everyday consciousness. In Sonfist's work nature is given a new identity. It is not a competitor to be fought: humans against nature. It is not a backdrop for human recreation: humans using nature. Nature asserts itself as itself. It exists alongside people, occupying space with the same legal status as they do: humans and nature together equally.

People's response to *Time Landscape* has been enthusiastic. One segment of *Time Landscape*, considered by the board of The Metropolitan Museum of Art in 1969 as an outdoor work within the museum complex, was finally completed in 1978 on a 9,000-square-foot lot in Greenwich Village.

An editorial in *The Villager* newspaper expressed the reaction of the community to the new sculpture:

> Here in New York . . . many of our residents never have the chance to hear the message in the murmuring of pines and hemlocks. It is for this reason we are delighted that artist Alan Sonfist's proposal to create a "forest" in a 200 foot by 45 foot strip of land . . . is about to become a reality. That it would be filled with the types of trees and vegetation that existed here before the area was colonized 300 years ago is a great idea, especially to show those of our number who seldom see or hear a forest that New York was not always concrete and steel.[6]

The reaction of public officials was also positive. Mayor Edward Koch wrote on April 18, 1978,

> I am delighted that the long-awaited "Time Landscape" project is being dedicated this morning in La Guardia Place . . . The concept of a year-round, natural microcosmic forest which would contain plants and trees indigenous to pre-Colonial New York is fresh and intriguing.[7]

Benjamin Paterson, the Assistant Director of Cultural Affairs, noted that "the fragility and vulnerability of this living and exposed site cannot help but magnify for the public at large the urban ecological concerns of the 1970s, 1980s and 1990s.[8]

Immaterial forces of nature such as light, heat, wind, and growth have also been the subject of Sonfist's art. In attempting to visualize these processes, Sonfist has redefined the use of fabricated materials in public art. Bronze or steel is commonly used to create a form that is then placed in a natural site. Such sculptures are regarded as environmental. In reality these sculptures

have nothing to do with the environment. Nature functions as if it were a traditional pedestal: it is used to isolate the artistic object from other objects, to create a context of different materials in order to enhance the impact and drama of the composed form. Any spatial extension of materials different from the sculpture would serve the same function.

Sonfist's attitude toward fabricated materials is different: his materials exist to make visible the natural elements of the site. The form of steel is decided not in reference to artistic styles, but for its appropriateness in interpreting natural forces. Nature is the subject of his work, not merely used as its context. He has used steel, copper, bronze, and Lucite—all to focus attention on some aspect of natural elements. *Crystal Monument* (1966–1972), for example, consisted of a transparent column that contained natural crystals ranging in size from microscopic to one foot. Installed in Dayton, Ohio, in 1972, the crystals regroup and shift position continually, responding to the surrounding temperature, illumination, and air currents. The column isolates and frames the crystals, providing a field on which to visualize patterns of changes in the environment. Jack Burnham, writing about *Crystal Monument* in the *Britannica Yearbook of Science and the Future* in 1973, said of Sonfist, "He sees 'sculpture' in the ecological exchanges that occur every day and believes that man-nature stability will come only when we have become acutely sensitive to the natural changes around us."[9]

Such a natural change is growth occurring imperceptibly over long periods of time. In Louisville, Kentucky, Sonfist has constructed *Towers of Growth* (1981), a 21-foot cubic sculpture constructed of sixteen stainless steel columns in groups of four, each surrounding a native tree. Each column is of a dissimilar height and thickness that correspond to the growth pattern of the four different native trees, each representing the tree's life at ten, fifteen, twenty, and twenty-five years. Typically, Sonfist's sculpture situates the viewer in the present, reflecting on the past and future. At first the columns are predictive; as the trees grow, the columns will increasingly reflect their past life.

To bring vast natural changes to a human scale, Sonfist is building *Four Points of the Sun for Philadelphia* (1972–), a stainless steel sculpture. Open pyramids on the wall of a medical building will be completed by the sun's rays during different solar events in the year. In *Sun Movement for Rhode Island* (1972–1975) the sun flows down steel bands once a year when the sun moves parallel to them.

Wind Fountain for New Orleans (proposed in 1973) also makes natural forces visible. Made of steel forms built to catch the breezes, the sculpture will generate enough power to light itself. The brightness of its glow will indicate

wind currents. For his exhibition at the Museum of Fine Arts in Boston, Sonfist built *Tower of Leaves* (1976–1977), a poetic sculpture in which fallen leaves were stacked up between four steel columns until they reached the height of the tree from which they fell.

When man-made materials are not used to frame nature, they are used to emphasize their own natural qualities. The innate physical structure of a material and its response to the environment are evoked by Sonfist. In *Bending Columns* (proposed in 1973) Sonfist fused dissimilar metals into 20-foot rods. Because each metal responds differently to temperature changes, the columns twist in changing configurations that make visible the flux of the weather. In *Time Enclosure* (1981) for the John and Mable Ringling Museum of Art, Sarasota, Florida, Sonfist made the largest version of his *Gene Bank* pieces of the 1960s by enclosing seeds from five different environments of Florida in five hollow squares built of brass, copper, aluminum, steel, and stainless steel. Partially embedded in the earth, the sculptural forms will decay at different rates owing to the different structures of the metals, releasing their seeds in succession in the future to reestablish the native vegetation of the area, which is being replaced by cultivated plants.

Again in distinction to sculptures that use traditional sculptural materials, Sonfist uses twentieth-century materials freely if they can help make visible natural forces. He is working with a computer corporation to use their resources to create *Tidal Fountain*. Parts of that sculpture will simulate tidal movements with contained water to create wave patterns and variable volumes rather than the usual cascades. He is also using the technological resources of a rigging company in Morgan City, Louisiana, to build a large sculpture. Walkways will spiral around a coring of earth, allowing visitors to pass by thousands of years with each step. Beginning with the limited view of their environment from the ground, they will ascend the tower, going backward in time to the Earth's formation but seeing greater and greater vistas of their own present-day environment.

The steel rods and planes that litter city plazas derive from an artistic vocabulary developed at the turn of the century in Europe and in its massive form, in early twentieth-century Russia. The failure of this sculptural tradition to become symbolic for people is clear. The term *postmodern* signals its passage into history even within the artistic elite. As the public reaction to *Time Landscape* indicates, Sonfist's achievement has been to find a new universal content that can regenerate public sculpture and make it once again artistically and culturally significant.

NOTES

1. Carter Ratcliff, *Atlanta Earth Wall* (Atlanta: The High Museum of Art, 1979), p. 2.

2. Alan Sonfist, *Natural Phenomena as Public Monuments* (Purchase, N.Y.: Neuberger Museum, 1978), p. 2.

3. Lawrence Alloway, "Time and Nature in Sonfist's Work," *Alan Sonfist* (Boston: Museum of Fine Arts, 1977).

4. *Rock Monument of Buffalo* (Buffalo, N.Y.: Albright-Knox Art Gallery, 1979).

5. Ronald Onorato, "Alan Sonfist, Museum of Fine Arts, Boston," *Artforum* 16, no. 5 (January 1978), pp. 74–75.

6. "Artist Gets Seed Money to Plant La Guardia Place Forest," *The Villager,* March 23, 1978, p. 2.

7. Unpublished letter from Mayor Edward Koch to Alan Sonfist, April 25, 1977.

8. Unpublished letter from Benjamin Paterson to Alan Sonfist, March 10, 1977.

9. Jack Burnham, "Art and Technology," *Britannica Yearbook of Science and the Future* (Chicago: William Benton, 1973), p. 351.

PIERRE RESTANY

Christo:
Running Fence

In 1976 the American sculptor Christo erected his 24-mile-long Running Fence *in California. Pierre Restany, author and art critic for* Domus, *discusses Christo's monumental outdoor work in this essay.*

The site: straddling the counties of Marin and Sonoma, in California, to the north of San Francisco. Twenty-four miles of white nylon undulating through fields, hills, and vales. A few "holes" to afford space for a freeway, main and secondary roads, cattle tracks, or to avoid invading a village post office. One hundred and sixty-five thousand yards of nylon supported by more than 2,000 metal posts and fastened to hundreds of thousands of hooks. The anchoring infrastructure was entrusted to sixty-five skilled workers who spent months on it, while the laying of the plastic fabric was carried out in three days by 350 students. This, then, is the *Running Fence*. Starting from the heart of Petaluma country to plunge into the ocean from the heights of Bodega Bay.

It is Christo's most complex and most poetic project. Its combined sources seem to be the Great Wall of China (it is a disturbing coincidence that Mao died on the day the *Running Fence* was born), the silkworm, and the butterfly's wing. Certain sections of it take one's breath away. It is hard to say which prevails: the dazzling beauty or the fascinating mystery of the fence. The culminating points and the most intense moment of excitement are afforded by the tangential view of the work from Freeway 101 or from the sheer drop into the sea at Bodega Bay. It is an ambiguous scheme, there being no possible view of it as a whole. From close up the fence itself makes a cliff. From a

distance and seen from the air, the *Running Fence* becomes abstract: the ribbon becomes a line, a Kafkaesque frontier, both inexplicable and receding. There is in these 24 miles of fence a sort of visual panorama of all of Christo's work to date. The plastic is laid, not assembled, in *packages* beside the posts; when unfolded, the fabric wraps up the students' bodies as they put it in position; the part by the sea evokes memories of the *Wrapped Coast–Little Bay–One Million Square Feet* project of 1969 on the Australian coast; some stretches along the hollows in the little valleys are in themselves mini *Valley Curtains* (1971–1972); the post enclosure stops at the roadsides remind one of *Storefronts* (1964/1968).

One would be tempted to think that a work so different in its unitary coherence, so strongly stated in its typology, might be the last—illustrating the sum total of a language and the synthesis of a method of action, constituting an *ante litteram* formal and spiritual testament. But that would be to overlook the artist's immense vitality and imaginative power, the extraor-

61. Christo: *Running Fence.* 1972–1976. 18 ' x 24 miles. A white nylon curtain running across Sonoma and Marin counties, California, for two weeks. (Photograph: Wolfgang Volz; courtesy the artist)

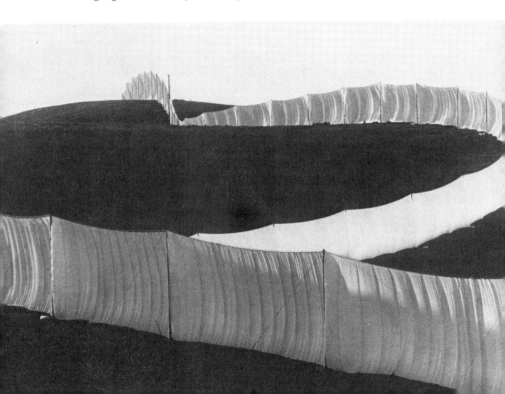

dinary energy and rare determination of the Christo plus Jeanne-Claude couple.

For when all is said and done, the most uplifting thing about the whole enterprise is its human side. Yes, "The Christos" financed this $2 million operation themselves. The money is theirs; they got it by means of an ingenious and by now classic financing system based on cash shares staked on Christo's works. They succeeded in finding sponsors, keen and loyal shareholders whose faith is sustained by the ceaselessly mounting echo of documentation gathered on the previous projects, plans, photographs, books, and films exhibited, sold, and shown in the four corners of the world. They kept up a legal battle that has lasted for three years; they submitted to every smallest technical exigency of a meddlesome bureaucracy unrivaled anywhere else in the world for its ruthless attention to trifling details. They contrived to break down the reticence of the private owners concerned and even turned them into supporters and friends; they surmounted the latent opposition of local opinion that was hostile in principle to any kind of

62. Christo: *Running Fence.* 1972–1976. (Photograph: Wolfgang Volz; courtesy the artist)

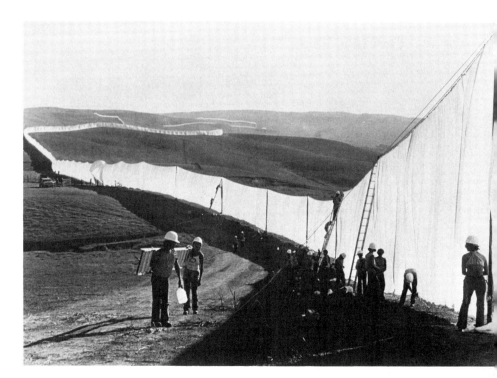

manifestation outside the conventional bounds of habit and further reinforced in its instinctive distrust by the venomous and incessant action of a petty faction of ineffective subintellectuals and bitter pseudo-ecologists. They had to guard against defections, last-minute legal hitches, alternating tensions, and the discouragements of their huge final working team.

One has to have lived as I did, in the company of some fifty or so specialists, free-lance writers, and other witnesses from all over the world, in the atmosphere of the Petaluma motel, of the headquarters at Valley Ford, and of the operation in situ, to grasp the decisive importance of the human factor in an adventure of this magnitude. The *Running Fence* has been conceived and realized thanks to Christo's remarkable faith in man; a faith that elsewhere moves mountains and here runs, up hill and down dale, from the prairie to the sea.

DONALD B. KUSPIT

Charles Ross:
Light's Measure

Donald B. Kuspit, critic and professor of art history at State University of New York at Stony Brook, notes in this essay that Charles Ross occupies a place somewhere between science and mysticism. Ross's work has always been about the properties and effects of light, but, as he himself admits, it is not founded on scientific observation. Rather, as Kuspit describes, he is fascinated by the way that humans observe light and incorporate its significance, or imagined significance, into their psyche. How has this idea appeared consistently throughout the development of an artist whose work has taken a number of forms, from light-catching prisms to a pattern of solar burns on paper? And how does Kuspit ultimately categorize Ross, an artist who focuses on such elusive themes as light and time, as a realist?

Prisms, solar burns, now star maps—all artfully demonstrating the "dimensions" of light. Ross gives us light, not so much analyzed as acknowledged, much as Robert Morris's felt pieces acknowledge gravity (another imponderable), metaphorically bowing in homage to it. Ross sees freshly what lets us see, making us conscious of what we unthinkingly take for granted: the universal medium of our existence and perception, the light which gives us life as well as vision and to which we open and close as much as any plant.

The very act of showing light's workings—bending and "breaking" sunlight in a prism, letting the sun deliberately mark or burn a material, or displaying a photographic negative of starlight as a map (as though it were an odalisque whose voluptuous radiance would blind if it were not veiled and viewed indirectly)—mystically celebrates it. Ross puts light through its paces like a ringmaster making an animal perform, always aware of its ultimately uncontrollable, recalcitrant—alien, mysterious—character, which can seemingly at will break the bonds of the art that controls or "negates" its nature.

159

Ross's works of art do not look like we expect works of art to look but, rather, like tools with no known use. That is, without their "regulation" of the play of light—their dispassionate handling of that seemingly impassioned substance—Ross's works lack those signs of sensuous spontaneity and expressive play of personality that we superficially identify with art and look like so many different versions of the same obsolete astrolabe.

As he himself acknowledges, Ross stands at the crossroads of science and mysticism, where he thinks much art exists (Pointillism, for example). However, he is quick to acknowledge that his work is not scientifically credible, in that it does not prove any hypothesis or demonstrate any principle: it is not experimental in the scientific sense. Nonetheless, he shares with such

63. Charles Ross: *Broken Pyramid.* 1968. Plexiglas prisms, 17½" x 35" x 17½". Prisms installed as an outdoor sculpture interact with sunlight, sky, and clouds. New York. (Photograph courtesy the artist)

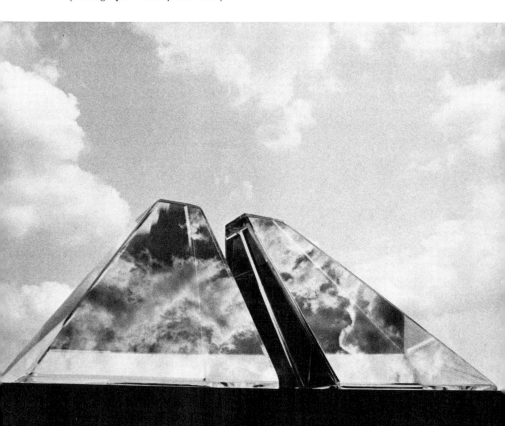

artists as Victor Vasarely the belief that "the great adventure today is science." Art's role in this adventure is to help us experience personally and concretely what science demonstrates impersonally and abstractly. Art gives particular, moving form to universal truth, not so much verifying as vivifying it. In other words art helps us intuit scientific ideas by giving them aesthetic effect; art's "beauty" is in this sense a display of "truth." In Ross's case scientific method is mimicked aesthetically, the work of art becoming a "recollection" of a scientifically mediated reality.

Such conceptually oriented art, with its scientific/intellectual ideals, is not new; science sustains much traditional art. Many Renaissance pictures were *dimostrazione* of mathematically constructed perspective space, before they were pictures of anything. That is, their concept of space is logically prior to what they show inhabiting "actual" space. Similarly, Ross's star maps are mathematically constructed images whose spacelessness—collapsed perspective, neither empirical nor mathematical—is emblematic of the logic of time that operates in and takes over outer space, a logic prior to the particular stars that are the source of the light that shows this logic. But Ross is involved in a modern version of the old ideal; he is dealing with a more complex reality—time/light—than visual space, and science itself has become more self-conscious, as art itself must become if it is to participate in the great adventure.

The new scientific art is not simply illustrative of scientific law or logic like the old one, but must now make clear the point of view or conceptual attitude, with all its subjective as well as objective complications and nuances, that underlies and conditions the scientific understanding of reality. As Ross makes clear, this attitude unavoidably mythologizes as well as rationalizes that reality: mediates it for subjective satisfaction as well as objective understanding. These conflicting demands infect one another and interpenetrate, so that objective understanding takes on mythical connotations, and subjective satisfaction imagines it is objectively reasoning. Ross is not simply illustrating the indisputable, primordial reality of light. Rather, he is coming to grips with the point of view that finds it necessary to grapple with light: he is trying to discover the rationale for this necessity, which originates in the situation of the terrestrial, all too human observer. It is this observer that is the ultimate limiting condition on the understanding of light, and Ross's art is finally about the compulsive self-projection of this observer on cosmic light in his effort to "comprehend" it.

This projection is psychomythical as well as technological. It is not just the telescope neutrally viewing the stars, but the religious mythmaker giving them a form and meaning familiar to man. The age-old zodiac constella-

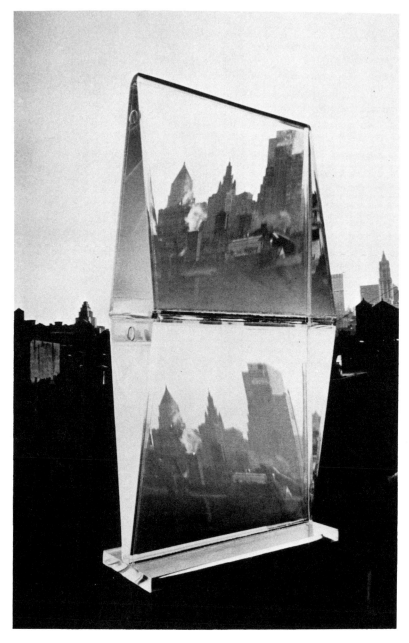

64. Charles Ross: *Double Wedge.* 1969. Plexiglas wedges, 100″ x 50″ x 24″. The wedges are joined to reflect and double the skyline. New York. (Photograph: John Weber Gallery)

tions—an integral part of the earliest sky maps (and a more secretive yet equally essential part of Ross's)—structure the stars and impose a psychically habitable framework on them.

Ross's development shows him realizing his purpose with increasing clarity and subtlety. The prisms and solar burns show light narrating its own condition, as it were. The star maps show it directly bound to the condition of human observation. That is, the mediating conditions—the psychology of mythical projection, in which man sees signs of his own destiny in the stars, and the technology of astronomy, involving telescope and camera —themselves become the subject of attention in the star maps. These instruments not only are responsible for what one sees but become signs of the point of view, the condition, of the viewer. With the prisms this is not the case: the transformation of white sunlight into a large multicolored spectrum, which advances as the sun passes across the sky, seems more significant than

65. Charles Ross: *Sunlight Convergence/Solar Burn*. 1971–1972. Three hundred sixty-six planks, each 60″ x 12″. Installation, John Weber Gallery, New York. (Photograph: John Weber Gallery)

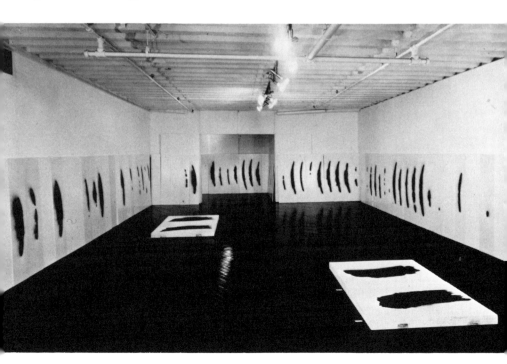

the prism that effects the transformation. This is also the case with the solar burns, created by placing a wooden plank at the focus of a large stationary lens. This was done every day for a year. "As the sun passed across the sky, the concentrated power of its rays burned the day's signature along the plank" (subject to atmospheric conditions, overcast days produced blank boards). But in the case of the star maps the instrumentation (camera, telescope), less obviously present than a prism or even a stationary lens, produces a more durable documentation of light. The instrumentation calls greater attention to itself, however indirectly, and has greater significance than in the cases of the prism and the lens. It accomplishes more, gives greater accuracy and comprehensiveness, and satisfies a great ambition.

In the star maps, which Ross began in 1974, not only is his implicit ideal of documentation—getting light on record—realized but so is his explicit ideal of articulating the temporal characteristics of light. As Ross notes, over the course of a year the sun's path forms a double spiral, which reverses direction from winter to summer. This figure eight—the analemma, double helix, or infinity sign that appears in the star maps and is responsible for the overall structure of the solar burns—quickly loses its mystical connotations when one recognizes that it reflects, in Ross's words, "a combination of terrestrial and celestial forces acting in different dimensions of time."

The effort to capture light-years by mediating them with mythology and technology (by way of astrology and astronomy) is really an effort to combine discrepant experiences of time in one conceptual continuum. Light generalizes time, makes it selfsame throughout the cosmos—a uniformity reflected in the nonillusionism of Ross's maps (they are too flat to give us the illusion that we are actually looking at stars). But the instruments that grapple with this light-time are symbolic extensions of man into the cosmos, and their meaning resides less in what they discover than in their demonstration of man's general attitude toward it.

Mythology and photography both bring the sky down to earth, as it were, and focus time and light, making them, if not familiar, then less uncanny. Yet time and light clearly transcend these instruments and the humans who use them—who are left "lost" in the seemingly infinite space-time heralded by the stars. The instruments seem as much an effort to preclude a terrifying numinous experience of infinite space-time or time-light as to make finite the infinite.

Now Ross's maps, which are determined by alternate axes—the sun's path, through the zodiac and the Milky Way—are essentially abstract. But the comfort the maps' abstract design gives us is quickly lost the moment we

try to make sense of the relations between the stars depicted. Then the chaos of celestial space-time becomes evident, and we are completely dislocated in and by it. All of Ross's art is a disguise of, a frame for, an effort to soften the impact of this dramatic experience of the stars—this experience of becoming lost in the stars, consumed by and converted into light. It is this terrible experience that has been called "mythical."

Ross's maps do not guarantee this experience, but we can talk a little more about them as art. They are at once open and closed constructions. They are constituted by 428 photographic negatives from the Falkau astronomical atlas (begun in the 1950s) by Hans Vehrenberg. The atlas shows stars to the thirteenth magnitude, considerably beyond our boundary of vision at the sixth magnitude (the dimmest stars visible to the naked eye). The negatives from the atlas have been arranged to cover the entire celestial sphere from pole to pole; the viewpoint is that of an observer at the center of the earth. The maps are *cuts* of the sphere, necessary in transferring it to a flat surface. One cut breaks up the sphere into intervals that correspond to ten degrees of earth latitude on star space (Ross calls this the *earth-space cut*); another cut is determined by the boundaries of the same constellations, as established by an international meeting of astronomers in the 1920s (*mind-space cut*); and a third cut breaks the sphere into long points like triangles, each of which represents the stars that would pass a fixed point in the period of an hour (*earth-time cut*). In each case the earth becomes in a sense the measure of the universe.

The background/support for each of the maps is painted in a different shade of acrylic gray, subjectively chosen as responsive to light. For me, the gray casts a nostalgic pall on the maps, compromising their objectivity. It interferes with their apparent literalness by metaphorically suggesting the passage of time that is in fact involved in the movement of light. The gray also seems to symbolize an indeterminate realm of transition between daylight and dark light. This curious mix of subjective and objective is also apparent in the fact that the maps are photographic negatives. (As in the atlas, the stars become black and the night sky white, so that the stars and especially the relations between them—their grouping into constellations—are more easily readable.)

A ritual approach seems to give us the best hold on Ross's art. This ritual approach—symbolized explicitly in Ross's systematic unfolding of the cosmic sphere into a procession of stately curves—is the residue of a sacramental attitude. The skin of the sky is at once flayed and hung as a trophy in the semisacred space of the art gallery, as though the sky had been sacrificed by man for his own edification. The artistic form that results is as important as

the sky content itself for Ross, as its overall symmetry—achieved by "slight trimming," without significant loss of information—makes clear. In these works a sliver of the cosmic sphere, of cosmic space, is sacrificed for the sake of art.

It should also be noted that the overall abstract pattern of Ross's star maps is essentially Minimalist, in both theoretical point and visual effect. It is impersonal (nonintimate), while reminding us of and in a sense throwing us back on the conditions of our consciousness, as well as obviously revealing those of its own making. It is interesting to realize that in one of his earliest exhibitions, at the Dwan Gallery in 1968, Ross showed, in a four-part series, a five-part rotation of a cube into a half-cube. (They were made of the same transparent plastic of which the prisms were later made.) Here we see Ross's interest in "primary structures," an interest refined in the star maps, and moved from the three- to the two-dimensional. Ross is still preoccupied with the tensions and transference between dimensions, although now primarily temporal rather than spatial.

This neo-Minimalist, renunciatory aesthetic becomes evident in comparing Ross's star maps with the "literalist" maps of Jasper Johns and the "spiritualist" ones of the Abstract Expressionist painters, both of which have more in common with each other than either with Ross's maps. A particularly pointed comparison is with John's *Map (Based on Buckminster Fuller's Dymaxion Air-Ocean World,* 1967), where the global order is littered with seemingly arbitrary painterly touches, signs of the artist's ambiguous, affectionately mocking, personal investment in it. This both trivializes and subjectivizes—our world's map is now another beat-up, used stage prop in the artist's bag of tricks. Ross makes no comparable attempt personally to appropriate his cosmic maps—to stamp the stars with his "mark"—however much his use of photographs, whose major importance is that they are indirectly about time, is a half-poetic, half matter-of-fact appropriation of the time that is the essence of light.

The painterly fields of Barnett Newman, Mark Rothko, and Clyfford Still are metaphors for a personal psychic terrain, in which the artists search for the holy grail of their own spirituality. (They charge the whole field with the energy of their search, which is too often mistaken for spiritual energy.) They are poetic idealists looking for the dregs of their spirituality—an archaic spirituality—in the ruins of traditional space. By contrast, Ross's space is nonmetaphoric and more literalist, to the extent cosmic space-time can be made literal and immediate. There is nothing sublime about Ross's space, however infinite it seems. The density of the stars shows it to be possessed, despite its apparent relative emptiness, of a *horror vacui.* Its infinity is strictly

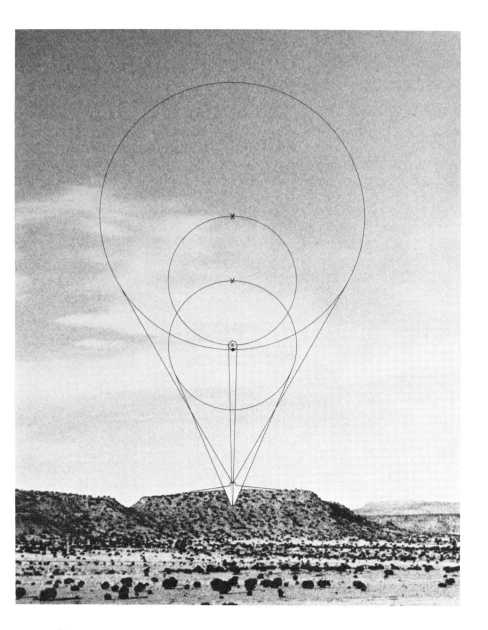

66. Charles Ross: *Star Axis* (project). 1979. A conical space hewn in a mesa in New Mexico to frame the 26,000-year cycle of the wobble of the Earth's axis. The smallest circle (with an *X* in the center of it) represents the daily orbit of Polaris in A.D. 2067; the largest circle the orbit of Polaris in 11,000 B.C. and A.D. 15,000. (Photograph courtesy the artist)

empirical or realistic. In this sense Ross's art is as descriptive as it is construc-
tive, as realistic as it is ritualistic, and the "transcendental" experience of
disorientation in infinite space-time to which it can give rise has its basis in
the facts of the human condition insofar as it is understood to be cosmically
situated, rather than in the aspirations of spiritual yearning or pretensions of
metaphysical absoluteness. The abstract look of Ross's maps does nothing to
contradict this realism, but rather confirms that reality itself, consciously and
relationally experienced, is abstract.

DIANA SHAFFER

Nancy Holt:
Spaces for Reflections
or Projections

In this essay Diana Shaffer, an artist herself, discusses major works in Nancy Holt's career. Frequent reference has been made to the fact that Holt began as a photographer, but this essay discusses how her work goes beyond its photographic allusions. For example, how is her art related to architecture? And how does her work respond to the vastness and timelessness of the desert landscape to which she is drawn?

In the mid-1960s Nancy Holt was known in New York City as a photographer, a filmmaker, and a concrete poet. In 1968 she took her first trip West with Robert Smithson and Michael Heizer and felt an immediate empathy with the broad open spaces and rugged existence she experienced there. From 1969 to 1971 she created *Buried Poems* in specific outdoor sites, and in 1972 two sculptures in the landscape, *Views Through a Sand Dune* and *Missoula Ranch Locators.* Her major sculpture, *Sun Tunnels,* was completed in the Utah desert in 1976, and *Stone Enclosure: Rock Rings* was executed in 1978 in Bellingham, Washington.

Views Through a Sand Dune, created in Narragansett, Rhode Island, consists of a cement pipe, 5 ½ feet long and 8 inches in diameter, carefully embedded at eye level in an irregularly sloping sand dune. The peninsula where the dune is located is flanked on one side by the Atlantic Ocean and on the other by the Narragansett River. The embedded pipe concentrates attention on the congregation of land, sky, and sea at this particular location and provides a fixed point of observation among the varied natural conditions. The pipe exposes views that the dune previously obscured, which, being at the end of a long tube, appear strongly focused and strangely detached and unreal.

Missoula Ranch Locators, created on a private ranch in Missoula, Montana, consists of eight steel-pipe structures forming a 40-foot-diameter circle in an open field. They are aligned with the compass points and correspond roughly to North, South, East, and West and the four intermediary positions. Each locator consists of a 12-inch-long, 2-inch-diameter galvanized-steel pipe, welded perpendicularly to a vertical steel pipe at approximately eye level. The locators allow the viewer to peer either inward, toward the center of the circle, a view that includes the opposite locator, or outward, toward eight distinct views of the vast Montana terrain. The site was chosen for the variety of images that could be seen around the circle, including a mountain, a tree, a flat plain, and a ranch house. In perceiving the sculpture the viewer's eye and body function like a revolving lens, while the locators act as tripods, "bringing the vast space back to human scale, and making the viewer the center of things."[1]

67. Nancy Holt: *Sun Tunnels.* 1973–1976. Four cast-concrete tunnels, each 18′. The open ends are aligned with the position of the rising and setting sun at the solstices; there are holes with diameters of 7″ to 10″ in the patterns of the four constellations, Capricorn, Draco, Columba, and Perseus, penetrating the walls of the tunnels. Utah. (Photograph courtesy the artist)

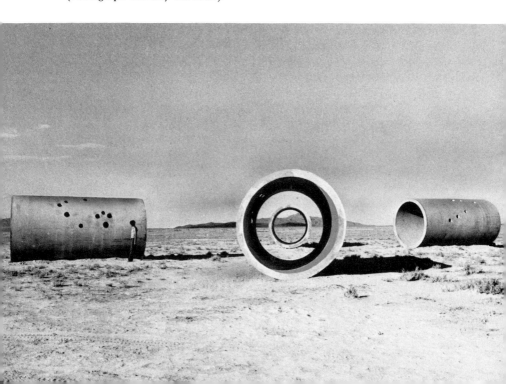

Holt created *Sun Tunnels* in the Utah desert between 1973 and 1976. She describes her long search for an appropriate site for the work and claims that the work evolved out of her experience of the Western desert and can exist only in that particular place.[2] *Sun Tunnels* consists of four cast-concrete cylinders, or tunnels, each 18 feet long with inside diameters of 8 feet, lying horizontally on the land, and paired in two straight lines, so that their four open ends frame the points on the horizon where the sun rises and sets at the summer and winter solstices. The tunnels visually capture the rising and setting sun on these dates and make it available to the viewer. Holt states that the idea for the *Sun Tunnels* became clear to her while she was in the desert watching the run rising and setting, keeping the time of the Earth.[3] A small, circular concrete core sunk flush with the ground marks the exact center of the four radiating tunnels and the intersection of the two sight lines created by their cross-shaped configuration. The 7-inch-thick walls of the tunnels are pierced by smaller holes, 7, 8, 9, and 10 inches in diameter, in the patterns of the four constellations, Capricorn, Draco, Columba, and Perseus. The sun filtering through these holes creates shifting circular and elliptical patterns of light in the tunnels' dark inner cavity. Holt discusses working with a model, a helioscope, and a camera to predict the changing light patterns that would be created by the finished sculpture. She also uses a photographic vocabulary to describe the dynamics of the finished *Sun Tunnels:* ''The panoramic view of the landscape is too overwhelming to take in without visual reference points. The view blurs out rather than sharpens. Through the Tunnels, parts of the landscape are framed and come into focus.''[4]

In her early interior installations Holt worked with themes of illumination and reflection by projecting circles and ellipses of light onto blank gallery walls, sometimes reflecting them backward with mirrors. In 1974 she developed these themes in a site-specific sculpture, *Hydra's Head,* created for Artpark, in Lewiston, New York. *Hydra's Head* consists of six still pools of water, sunk 3 feet into the ground and varying in diameter from 2 to 4 feet. The configuration of the pools is based on the positions of the six stars in the head of the constellation Hydra, and their diameters differ relative to the magnitude of each star. The form of the sculpture is contingent not only on the form of the constellation but also on the physical, cultural, and historical characteristics of the specific site chosen for the work. Holt refers to an old Indian legend, which observes that '' 'pools of water are the eyes of the earth.' At night the pools of Hydra's head 'see' the stars brought down into their circumferences, by day they catch in their 'view' sky, clouds, sun, and a bird or two. The moon is seen moving from pool to pool . . . 'a continuous recurrence of light encircled.' ''[5]

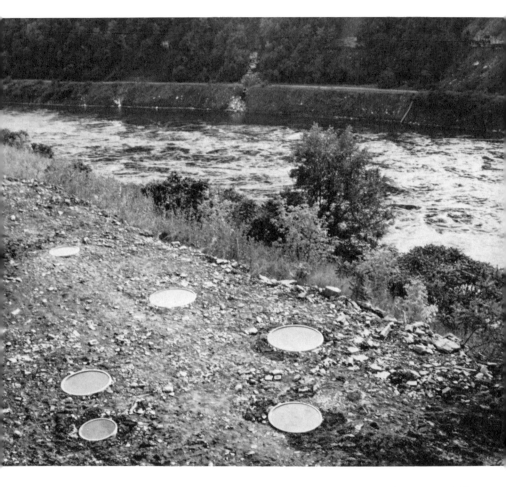

68. Nancy Holt: *Hydra's Head.* 1974. Six concrete-lined pools covering an area 28' x 62'. The pools range from 2' to 4' in diameter and are 3' deep. Their positions and sizes correspond to the stars in the head of the constellation Hydra. Artpark, Lewiston, New York. (Photograph courtesy the artist)

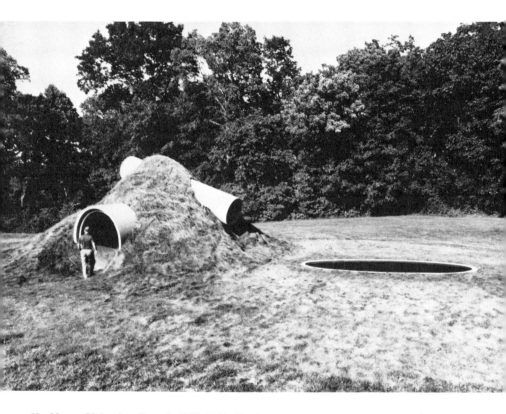

69. Nancy Holt: *Star-Crossed.* 1979–1981. Earth, concrete, water, and grass, 14′ x 40′ overall. The oval pool fits exactly into the field of vision framed by the small tunnel and it appears to be circular. Looking up through the small tunnel the other way, a circle of sky is seen, which is also reflected into the pool. Miami University Art Museum, Oxford, Ohio. (Photograph courtesy the artist)

Between 1977 and 1978 Holt created another major sculpture, *Stone Enclosure: Rock Rings,* on the campus of Western Washington University in Bellingham, Washington. The sculpture consists of two circular concentric stone walls, a tubular volume, or space, delimited by the inner circle and the curving path, or corridor, formed between the two. The outside diameter of the inner ring is 20 feet and the outer one is 40 feet. Both are 2 feet thick and 10 feet high, constructed out of schist stone, concrete, and mortar. The circular walls are pierced by four arches, 8 feet high by 4½ feet wide, aligned North-South by the North Star, and twelve circular holes, 3 feet 4 inches in diameter, aligned so that they form NEWS, NE, SE, SW, and NW lines of sight, or axes, cutting diagonally across, or through, the masonry walls. The centers of the holes are at eye level. Holt discusses shooting Polaroid photographs of the views through metal hoops of various diameters and alignments in order to determine the final diameter of the circular holes and the final placement of the *Rock Rings,* according to what would be seen through each opening in the sculpture.

Holt has repeatedly used the device of implied and explicit diagonals radiating out from circular centers to lead into the landscape in opposing directions. Holt's structures are always roofless and penetrated, open to the sky and the horizon. They are focal points as well as enclosures and seem to penetrate rather than sit passively within the landscape. They create a sense of space that has been described in the following ways by Blaise Pascal and Gaston Bachelard: ''Nature is an infinite sphere, whose center is everywhere and whose circumference is nowhere''—Pascal[6] and ''Every object invested with intimate space becomes the center of all space. For each object, distance is the present, the horizon exists as much as the center''—Bachelard.[7]

The experience of Holt's sculpture is both visual and kinesthetic. It involves first a movement from the broad environmental context in toward the center of the form, then, inversely, from its demarcated center out toward an expanding horizon. The viewer actually enters the form to become its literal center, penetrate its internal dynamics, and become its focal point. From this vantage the viewer explores himself in relation to an expanded environmental field. The viewer not only is encompassed by the structure but also becomes its psychological center.

At this point several themes emerge from Holt's work. One is the theme of site-specific sculpture, in which the work is a combination of a form the artist creates and the environment in which that form is placed. The work of art is contingent not only on the artist's ideas but also on the physical, cultural, and historical characteristics of a specific site. Thus, the combination of the site

and the artist's concept forms the complete piece, and it is only at one particular site that the completed work can exist.

A second theme is the influence of the camera on Holt's creative process. The tubular or cylindrical forms of Holt's sculptures and the prevalence of circular openings or eyeholes visually resemble optical instruments, like large telescopes or lenses. In addition, they seem to have a voyeuristic function within the landscape. They function to frame or isolate distant views and make them available to the viewer for observation. On another level, however, the work posits analogues for vision that are highly subjective and related to discoveries in contemporary perceptual psychology and epistemology. The sculpture's cutout windows or holes project onto and mirror and reflect the environment. They act in a reciprocal or reflexive fashion as recipients of information about the external world and as projectors of a structured vision back onto it. The perceiver of the sculpture must peer both inward, and outward. Vision is presented as the active re-creation of each individual, not as the passive receiving, or recording, of information about the external world. We are reminded of the phenomenological ideal of the eye that could see itself seeing more than a camera or a telescope.

Holt's sculptures also suggest several romantic metaphors. The entire symbolism of eye, sun, landscape, water, and dramatic lighting connects her work to the American luminist painters and the New England Transcendentalists, who used similar visual devices to express their philosophy that man's spiritual depth develops along with his understanding that his spirit partakes of and is reflected in the world of nature. Her concentration on illumination drawn from the sun down into a form, then radiating out from that form, makes her sculpture a visual expression of Yeats's beautiful poetic metaphor: "It must go further still: that soul must become its own betrayer, its own deliverer, the one activity, the mirror turn lamp."[8]

A third theme that dominates Holt's work is time. Holt's sculpture is built of materials suggested by each site. She writes of the *Sun Tunnels*, "the color and substance of the *Sun Tunnels* is the same as the land they are part of," and the 230-million-year-old schist stone of *Stone Enclosure: Rock Rings* is indigenous to its region. The fact that the materials of Holt's sculpture blend into their sites gives the impression that they have always been there and belong to a span of geologic time that is longer than the span of human history. The sculptures' alignment with the North Star and their circular forms allude to primitive instruments for measuring the position of the Earth in relation to the fixed sun and universe. Their raw, elemental quality is reminiscent of sites like Stonehenge and Nazca, which exist to express basis existential dilemmas.

Although Holt's sculpture speaks of the timeless, it speaks perhaps even more eloquently of the ephemeral. The architectural identity of arches, corridors, tunnels, and windows suggests themes of passage, or transience. The natural sunlight filtering through the circular openings in the walls of *Sun Tunnels* and *Rock Rings* creates protean elliptical patterns, which constantly change as the Earth rotates. The viewer immerses himself in the perceptual experience of the unique moment, then allows that moment to dissolve and merge into the next. The viewer becomes acutely aware that at any single moment he sees only a shimmering fragment of Holt's sculpture, the total structure of which unfolds slowly over time. Holt's sculpture thus

70. Nancy Holt: *Inside Out.* 1980. Wrought iron and beds planted with seasonal flowers, 14' x 12'. Commissioned for the International Sculpture Conference. Presidential Park, Washington, D.C. (Photograph courtesy the artist)

simultaneously expresses the paradox of the finite instant and the infinite passage of time and becomes a potent visual symbol for the paradox of perceived time.

Holt relies on empirical observation and building rituals to create sculpture that expresses an aura of both matter-of-fact analysis and romantic mysticism. The work evidences strong sources in perceptual psychology, epistemology, and phenomenology. Although the work utilizes architectural form as a strategy to revive a metaphoric and symbolic content for sculpture, its attitude toward the traditional functions of shelter and protection is ambivalent. Creating partial enclosure rather than contained interior space, Holt's sculpture is structured so that its intricate internal workings correlate form to environmental context, interior to exterior space, and individual perception to structural facts. On one level Holt's art is about the impact of immediate, all-encompassing experience in contradistinction to a more abstract or conceptual mode of knowing. On a more profound level it is about the notion that perceptual experience gives us the passage from one moment to the next and thus helps us realize the unity of time.

NOTES

1. Nancy Holt, "Sun Tunnels," *Artforum* 6, no. 8 (April 1977), p. 34.
2. *Ibid.*, p. 37.
3. *Ibid.*
4. *Ibid.*, p. 50.
5. Nancy Holt, "Hydra's Head," *Arts Magazine* 49, no. 5 (January 1975), p. 59. Reprinted in Sharon Edelman, ed., *Artpark: The Program in the Visual Arts* (Lewiston, N.Y.: Artpark, 1976), p. 22.
6. Quoted in Mel Bochner and Robert Smithson, "The Domain of the Great Bear," in Nancy Holt, ed., *The Writings of Robert Smithson* (New York: New York University Press, 1979), p. 25.
7. Gaston Bachelard, *Poetics of Space,* trans. Maria Joles (Boston: Beacon, 1969), p. 203.
8. Quoted in M. H. Morams, *The Mirror and the Lamp* (Oxford: Oxford University Press, 1953), preface.

GRACE GLUECK

The Earth
Is Their Palette
(Helen and Newton Harrison)

Grace Glueck is an art critic for The New York Times. *In this essay she discusses the work of Helen and Newton Harrison, paying special attention to their latest project,* The Lagoon Cycle. *The Harrisons, who have been working together since 1971, stand in opposition to other artists who seem to ignore the ecology of the environment they use for their work.*

"Suddenly, the crabs began to act strangely," Helen and Newton Harrison write in their newly published *The Book of the Crab.* "They stopped eating our food. They stopped eating each other. They even stopped moving around much. We wondered what might make a crab depressed and suspected something necessary to their well-being was missing."

The Harrisons, a two-artist team based at the University of California in San Diego, finally realized that the crabs, imported from Sri Lanka and kept in a specially designed laboratory tank at the university, missed the monsoons that hit their native shores, changing their food supply. With a hose, they created an artificial monsoon, and soon the crabs were deep in amorous dalliance. The Harrisons' discovery of the mating patterns of *Scylla serrata,* as the fierce but edible Sri Lanka crab is called, made enough of an impression on scientists at the nearby Scripps Institute of Oceanography for the Harrisons to be given a "sea grant" of some $20,000 to support further study.

The crab project began with a "survival" piece, initiated by Newton Harrison, which dealt with life cycles. Looking for a hardy creature that could survive museum conditions, the Harrisons heard about the redoubtable *Scylla serrata,* and through friends had live samples sent from Sri Lanka. Their interest in the crabs later led them to Sri Lanka itself, where they began (in

178

1972) a ten-year project, *The Lagoon Cycle,* which, starting with the ecology of lagoons, questions the nature and uses of technology itself. "We've been very alienated from our resources," says Mr. Harrison, "but our time of grace is over. The idea that technology is able to buy us out of our problems is an illusion. We are going to have to make vast changes in our consciousness and behavioral patterns, because if we don't, we won't be here."

The Harrisons, as you may gather, are something different from the conventional run of artists, even the California variety. Working together, they produce projects of cosmic scope that deal in story form with such ecological matters as seabed resources and fishing, the impact of big agriculture on the California desert, the damming of the Colorado River system, the possibility of glacial melt, the plethora of sulfuric acid rain.

71. Helen and Newton Harrison: *Crab Project.* 1974. Installed at Ronald Feldman Fine Arts Inc., New York. (Photograph: Ronald Feldman Fine Arts Inc.)

OK, but why are the Harrisons calling their projects art? "When you read Dostoevsky, why aren't you calling it social science?" asks Mr. Harrison, who started out as a conventional sculptor and is now a professor in San Diego's department of visual arts. "He took his own transactions with the world and transposed them into images and stories. We do the same. The best description we can make of ourselves is as storytellers of a sort. We are artists who put one foot in front of another, and when it doesn't look right, we do it again."

The team takes a dim view of the "earth art" made by less socially

72. Helen and Newton Harrison: *Hartley's Lagoon.* 1974. Concrete, wood, gravel, saltwater, biological filter covering bottom of pool, and 163 juvenile crabs, 40' x 8'-12' x 2'-5'. Working model for *The Third Lagoon.* Hollywood Hills, California. (Photograph: Helen Harrison; courtesy Ronald Feldman Fine Arts Inc.)

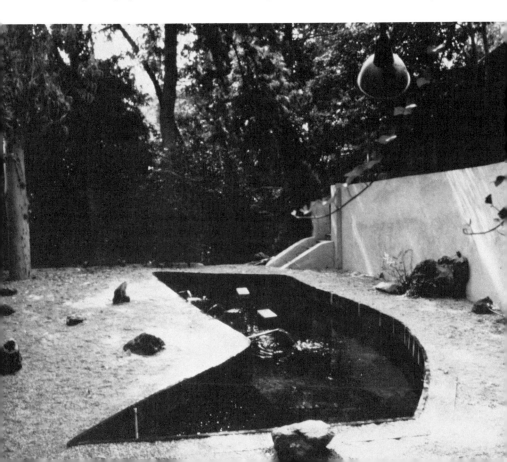

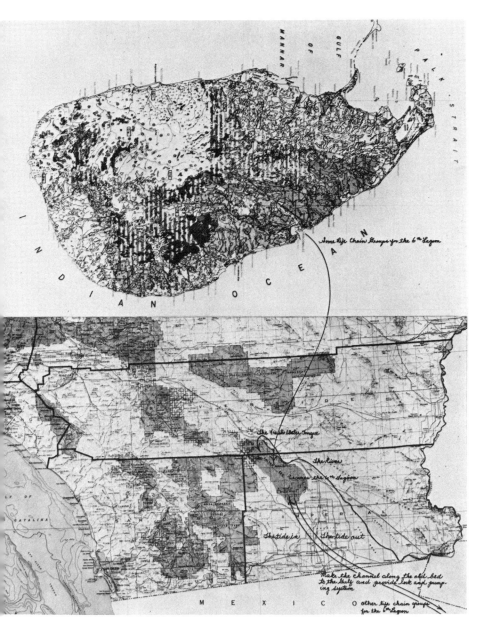

73. Helen and Newton Harrison: *From Trincomalee to the Salton Sea, from the Salton Sea to the Gulf.* 1974. Photographs, ink, and crayon, 25″ x 20″. Sketch for *The Sixth Lagoon.* (Photograph: eeva-inkeri; courtesy Ronald Feldman Fine Arts Inc.)

motivated artists. "Think of the vast energy put into big cuts and shapes in the desert that are inherently gestural," says Mr. Harrison, "simply primary structures in another context. They are transactional with museum space, not with the earth. They are involved primarily with forms."

The two, who have found time to produce four children, have been working together since 1971. "Newton began a piece on extinct animals for a fur and feathers show put on by the World Wildlife Society," says Mrs. Harrison, who painted and was director of the education program for the University of California Extension, "but he bit off more than he could chew. I pitched in, and I realized I was more interested in doing what Newton was doing than in my own work. And that's how it all began."

74. Newton Harrison: *La Jolla Promenade, Survival Piece No. 4.* 1971. Installed at "Animal, Vegetable, and Mineral Show," La Jolla Museum of Contemporary Art, California. (Photograph: Ronald Feldman Fine Arts Inc.)

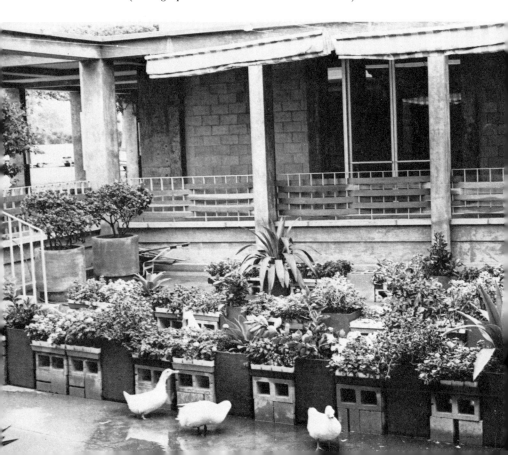

KATE LINKER

Michael Singer:
A Position In, and On,
Nature

Kate Linker's essay traces the development of Michael Singer's work to the point that discussions of this artist's environmental work often incorporated the word ritual *in their descriptions of it. With regard to this idea, Linker brings up his works' relation to oriental art and philosophy. Does Singer's work diverge from what could be considered to be the mainstream of environmental art? Linker, a critic for art publications, shed light on an artist who can be seen to be suggesting a new attitude for the "return to nature."*

Kassel, Germany: the time, a warm midafternoon in late June; the place, a small pond framed by foliage a good two miles' walk from the main Documenta site. No viewers grace the benches scattered around the water's edge. Only the rustling motions of an occasional swan fracture the pastoral calm. On the waters two low-lying lattice structures by Michael Singer seem to hover, unmoored, over the smooth surface; unmoored, as their anchoring armatures go unnoticed in the water's calm. The sculptures function as reflectors. Over the central curves of pine, rendered golden by bright light, the elaborate greenery finds its image mirrored in the surface of the pond. It is reflected on other levels, with long fingers of pines and a willow's density translating into sculptural form. Sighted from the end of an embankment, the sculptures create a gateway, their forms aligned with a clearing in the trees leading to a larger clearing up the hill. In the clear sun they form a strik-ing accent, glistening under the intensity of the light, but their appearance alters with the approaching storm. I watch as raindrops rupture the water's surface, as the sky darkens, and the golden pine moves through levels of gray in the rhythms of subsiding light.

So distant was Singer's sculpture from the central activity that few people actually saw it. In its isolation, reached only with effort and repeated glancings at a map, it formed a contrast to the bustle of the sculpture park and its welter of conflicting works. Singer planned it that way—as a statement of the approach shaping outdoor projects and indoor installations from recent years. Secluded from diversions and uniquely sensitive to its site, the piece acted as an instrument by which each detail of the area might be signal, might register tellingly on its observer.

Singer's sculptures work as optics. Like prisms, microscopes, monocles, they magnify observed objects until the visual fields develop in distance, depth, and meaning. This analogy with optical devices is more than a metaphor; it suggests a mode of thinking in which the landscape is rendered visible by objects. One is reminded of Marcel Proust's use of windows and magic lanterns for points of view—lenses, or transparencies, through which reality is refracted and revealed. In Singer's art, the focusing of the environment is intimately related to the viability of form. The keenness of the vision is rendered through the clarity of the lens.

Singer's use of sculpture, like its inherent realism, provides a counterforce to the studio aesthetic behind much "environmental" art of the past few years. This aesthetic, in its broadest lines, developed with the nineteenth-century intensity of city life, reflecting the "nature" artist's isolation from his chosen subject. Ensconced within the city, his response to nature's absence was appropriation; abstract ruminations were shaped into symbols referring to a reality eternally removed. Gradually, a point was reached in this symbolic investment of objects at which the works merely illustrated studio-developed notions, or displayed facts of perception, psychology, and so forth, through experience of the actual sites. A host of mental mirrors grew up in the boneyards of tangible space. While not meaning to imply that these works are not site-specific, scaled to particular locations, the major problem for contemporary sculptors has often been finding locations adequate for studio-composed ideas. *Site,* for them, denotes a generalized space, whether clearing or glade, forest or field, requiring comparable modulations in scale.

Singer's sculptures, in contrast, whether indoors or out, are rooted in the primitive character of his encounters with place. His oeuvre is all of a piece and intimately connected, deriving from early experiences out of doors. Singer's earliest works were heavy constructions of steel and milled woods but by 1971, at age twenty-five, he had already discovered the woods. Called *Situation Balances* (1971–1973)—the name itself is telling—these early outdoor works involve entries in the shifting equilibrium of the environment. Formed by rearranging wind-felled logs, and sensitive to the elements, they

developed through precarious balancings by nature and man. The largest work (which took three years to "complete") finally disappeared along with the broken dam into the surrounding beaver bog. Although rough-hewn and massive, reflecting their setting, these networks of tenuously posed trees, buttressed by stumps, already presaged the compositions of succeeding years. In a piece at Harriman State Park (*Lily Pond Ritual Series,* early 1975) fragility is emphasized in the wispy, near-formless reed tracery grazing the surface of the pond. Line, in this work, evaporates in the suggestion of space as triads and long, loping textures of reeds curve delicately in the fluctuations of weight. A short vertical bends to horizontal, extending, as if pointing, to an ambiguous end; moving from aqueous origin to aerated end, rhythms extend

75. Michael Singer: *First Gate Ritual Series 7/78.* 1978. White pine, stones, and phragmites, 9′ x 14′ 17′. (Collection of Fort Worth Art Museum; courtesy Sperone Westwater Fischer Inc.)

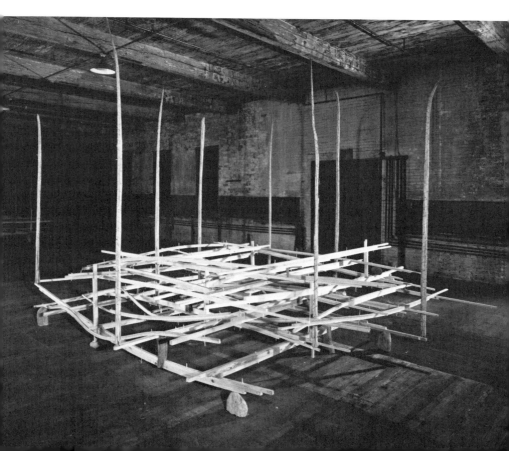

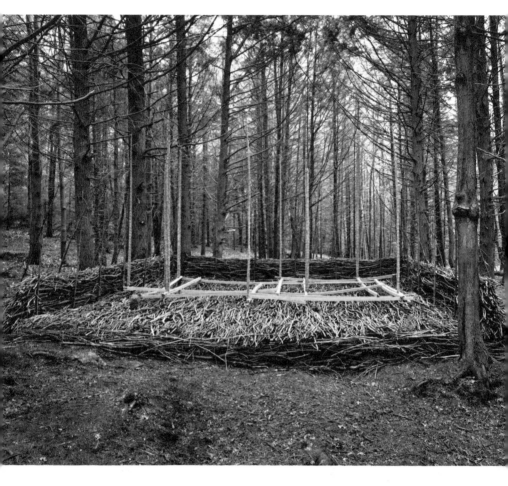

76. Michael Singer: *First Gate Ritual Series 7/79.* 1979. Spruce twigs, pine, phrag-
mites, and rock, approx. 6′ x 13′ 10″ x 13′ 10″. Wilmington, Vermont. (Photograph:
Sperone Westwater Fischer Inc.)

through the length of the site. Here, poised amid this watery world, Singer makes much of reflection—of refraction—and of the double, distended time of light.

Lily Pond Ritual Series is one of the first pieces to receive a title characteristic of Singer's work. Much has been made of his reverence for nature, and of its constancy, but the ritual aspect goes deeper. Singer, without being consciously primitivizing, has a primitive motive for making objects based in his outlook on the specifics of place. Ritual rests on the notion that space is not homogeneous for the perceiving man, but that certain areas have unique power to position him in the landscape, to orient him in his environment. Like magical ceremonies, they function as adjusters, keeping balance within

77. Michael Singer: *Ritual Series 80/81.* 1980–1981. Wood and rock, 4' 10½" x 17' 3" x 18' 1". (Collection of The Solomon R. Guggenheim Museum; courtesy Sperone Westwater Fischer Inc.)

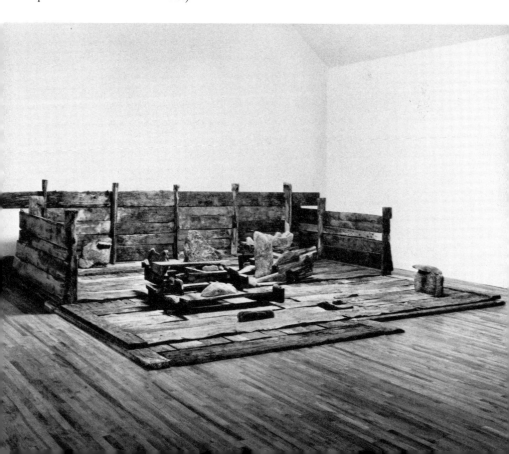

the total milieu. Singer's interventions in the environment are continuous. His actions and evolution's course comprise a system in time, linking human and natural time, without any overload of the "organic." In the largest sense they are ecological, dealing with interpenetrating systems—with man's continuity with nature's flow and his position in its web. His own words reinforce this ordering imperative. He speaks of "building an apparatus to see more of what I am, where I am," describing his works as "clues" to his environment. His attention to the siting process—the intricacies of its selection, the long periods of contemplation before building itself—bears this concern out. *Sangam Ritual Series,* moreover (built in 1976, and installed at the Wadsworth Atheneum), takes its name from an Indian site at the junction of rivers that provides a location for a spiritual shrine.

Nature, in Singer's sculptures, can be viewed as a process whose patterns are made visible—in curves and countercurves, networks of forces held, although precariously, in static modes. In works like those at Roslyn, Documenta, or in recent indoor shows, this rhythm is accorded tangible form. The main vehicle for Singer's content is a flexible structure made of slender woven woods, the joins secured with dowels. Although these forms work a primitive grid, the balance achieved is the opposite of regularity. No unit is repeated. The variations in rhythms are endless. We move through rocking rhythms, lilting curves, and slow, ponderous waves according to the bend or brawn of wood. A line may move slowly, luxuriously, flowing upward in a capacious vault or dart quickly around the structure like a stone over the surface of a pond. These differences are not fortuitous, but responses to exigencies of setting—to spaces, broad and narrow, the intense compression of low-hanging foliage or the buoyancy of lofty heights. Singer shapes these contents pointedly, and continually, building meaning into intervals like a Japanese playing his *ma.*

The references to the Orient in these works are larger still. Oriental art has always been a major influence both on Singer's art and on his way of life. The visible tensions of his work can be likened to a basic Chinese rhythm, the yin-yang dualism of reverse curves, concave and convex, that forms the elemental rhythm of nature. This cadence, the most abstract and fluid, is also the most tangible. It forms a rhythm basic to growth, embodied in reflections in water, in clouds, in branches shaped by responding curves. Because the pattern is fluent and endless, it expresses wholeness, but it is also infinitely flexible, permitting a pliant framework for commentary on the singularities of specific sites.

Observation of natural laws, we are told in Chinese teaching, leads directly to communion. The special merit of the Chinese, as George Rowley states in

Principles of Chinese Painting (1959), was their feeling that nature could be understood only on its own terms. Singer's intuitions of nature's fusions of forces are incorporated in a dialogue based on ever-altering balance. In this colloquy the sense of form's mutability in nature, of elemental flux, is pervasive. Singer is constantly adjusting his sculptures to respond to variations in environmental conditions. "Every moment is different," he says, noting changes in wind and water, in clouds and shadows and light. (These changes, moreover, are photographed constantly, as with the 1,000 slides recording the progress of westward-moving light over a marshland construction from 1975.) The fragility of his materials shapes an analogue to nature's subtlety in its exiguous balancing of flood and flow. This metaphor is developed throughout all his indoor works, where the wooden networks, often with thin, bound vertical poles, are balanced vertiginously on judiciously placed stones. Such works exist in, and imply, time. Their precarious poise evokes nature's processes, both as change and as accommodation. Here the ritual element, blended with the idea of balance, provides the key to total harmony. If nature is grasped as a process rather than as an object, then the work's shifting definition within the equilibrium of atmosphere provides a means of being part of it, linking man and environment through the action of making. And from the early *Situation Balances* to the indoor environments of recent years there is no deviation. At Documenta, dialogues of tree to tree, wood to water, and man to environment are measured to the dominant balance of light as changes in its wavering levels translate into wood's shifting tones.

In confined spaces this oscillation is refined and filtered as the clouds, storms, and shadows registered through windows reap changes in internal hues. These indoor works, constructed largely for museums during the past two years, are as sensitive to their sites as the outdooor ones, but the terms of the balance are altered with exchanged locales. On one level, they structure sharply specific spaces that function metaphorically, evolving parallels between bogs, clearings, forests, and swamps, and the currents of internal realms. Space, in these works, is quickly transformed into place, as a host of allusions cluster about the characteristics of a work.

But on another level the relation is fluid, freer, as these open linear structures delineate the lineaments of rooms. In a two-part installation at the Smith College Museum of Art (Northampton, Massachusetts, 1977) a shallow structure occupied a low-ceilinged gallery while an airy lattice, topped by seven phragmite poles, articulated the emptiness of a vault. These and other works scale the extensions and limits of space; with their latitudinal and longitudinal poles, beams, and sills, they evoke archetypes of built forms. More important, however, the structures function as optics, refracting

spaces against the airy, hemp-bound poles and the openings between the woods. The keys to this process are the easy relations between the articulated interior structure and the related space of the surround. Through this connection internal rhythms are extended, so that the quivering equilibrium is echoed throughout the surrounding space. Singer's vantage, in this dynamic unfolding of space, is a freely moving eye. One moves around, scrutinizing from varied angles, or looks downward through the flattening structure of the web. The poles work in and out in shifting configurations, developing the tensions between verticals and horizontals, altering areas of space. Space becomes sensitized—moves and expands to its fullest sensed dimensions—and we are far from the geometer's static cube.

In his latest installation (1977) at the Neuberger Museum in Purchase, New York, Singer's deliberations ring clearer than ever before. A single sculpture, nearly 40 feet long and almost half as wide, fills the enormity of a cavernous space. Because Singer places the work at a distance, in the farthest reach of the room, we are drawn *through* space *to* space by a path of paradoxes uniquely addressed to the eye. The image, viewed from the distance, is of tremulous stasis, with boundaries defined by edges, corners, and the neat lines of vertical poles. Where form ends, we see a neutral void, extending to gallery walls; within are thickets and massings of interwoven wood. The work evokes the bog, with its slow, stately majesty, but on closer view, images of rapids, of rushing waters, well out. Now the density of the meshwork distends into space as the airiness among the individual elements becomes pronounced. These strokes, worked with slipped levels of many-layered woods, curve in and out in a variety of contradictory rhythms. Some seem violent; others, snaky and sinuous; still others begin in narrow rocking rhythms to finish with rapid thrusts. Like the bamboo poles, they measure and dilate inner space as the eye scans a variety of disparate views. Moving around the work thus becomes kaleidoscopic, owing to the shifting formations of space. One can sight a faraway pole, the most distant: around the narrow flow of absolute line the fullness of space collects. Because the poles are fashioned in different heights and with differing thicknesses, no boundaries mark off the surrounding air. External and interior spaces move in and out through the structure, communicating in a rhythmic flow. This quickening of space, through interpretation of place, has ultimately much to do with man's position as he views the process unfold. "Working" the structure from many angles, watching nature's rhythms expand, he becomes explicitly, as well as implicitly, a part.

HAROLD ROSENBERG

Time and Space Concepts
in Environmental Art

Harold Rosenberg was an art critic for The New Yorker *as well as many art journals and the author of numerous books. In this essay, a transcript of a panel discussion Mr. Rosenberg moderated, several important issues and their relation to environmental art are touched on. What role does the gallery play in this "nongallery" art? What role should the artist play in relation to society and what purpose should contemporary art serve? Art as reality and art versus reality are topics of conversation, as well as how the artist's works interact with the communities in which they are placed.*

HAROLD ROSENBERG: We have the whole team here, including an added starter, Alan Sonfist, who is to my left here. The others are all familiar to you, or should be. Mr. Christo, to my right, Les Levine beyond him, and Dennis Oppenheim. Now the subject is part of the general series which have been conducted here with the name of "Time and Space Concepts." This is number four in the series and this one is devoted to environmental art. In other words, if you put this together with the general thesis, you have "Time and Space Concepts in Environmental Art." Now, to me, this idea of time and space concepts is a rather limiting one, but I don't know if my colleagues here have the same impression. I would think that with these highly different artists who are on the panel today, it would be more rewarding to speak concretely about their works as individuals rather than about time and space concepts in environmental art, but maybe they disagree with me. And there's no reason why they shouldn't. So I'll ask them the first question, which is, do you approve of the concept of *environmental art*? Does any of you have a notion about, what do you mean by environmental art? Or maybe you don't want to talk about it at all? Any response to that? No? Well you've

191

got to have a response because you either agree with this or you don't. So come on, one by one. Christo, come on, speak up. What do you think about environmental art? Or time and space concepts?

CHRISTO: I don't know.

HR: Are you embarrassed by this question?

C: No, no, no, since you ask that question. But if they, the organizers, think that this is the best way to set that lecture or that problem, then it's OK. I don't know. It perhaps can be part of some problem——

HR: You mustn't show that much faith in organizers. Now, come on, you know that. You ought to be in revolt against people who organize things.

C: No, but really, I don't think we should lose time to discuss the title of the meeting today. I think perhaps it's better to try some questions and ignore that title.

HR: Ignore that title. OK. Do you agree we ought to ignore the title and talk about something else?

DENNIS OPPENHEIM: Yeah, if somebody would like to start it.

HR: Nobody wants to. Does anyone? Well, you're not going to get me ——

QUESTION: I don't agree that we should ignore the title.

HR: Ah, good. Now we have a clashing of horns, right? What do you think we should do if we don't ignore the title? All right, let's talk about something else. I guess we'd better do that. It doesn't seem to fill anybody with enthusiasm one way or the other. Now, let's see—Levine, Les Levine and Dennis Oppenheim, do you have some kind of idea of public participation in your work in the sense that Christo has? Or, if you're going to talk about environments at all, I think the thing to keep in mind is that an environment includes a human environment. It's not simply that you go out and find a site somewheres and put rocks in there or take them out. It's a human environment that's included, and Mr. Christo, I'm not going to give a lecture on his work, because he's here, but he makes the physical environment part of what you might call a social and human environment by implicating a lot of people in his projects. And the way those people are drawn into the project is part of the project or work itself. Now I'll ask Mr. Levine first: do you have any such feeling about your projects and how they differ, say, from his?

LES LEVINE: What kind of feeling was it?

HR: What?

LL: I have an idea about time, and space. I think time is equivalent to form. That time represents form. That that's its meaning essentially. For instance, something that is machine-made will look quick, something that is handmade will look slow. So essentially, time defines form for me. Space equals Air, Air equals Mind, Mind equals Idea, Idea equals Territory. This

is my idea, my territory. You stay off my territory. I don't know about public involvement in my work. I would hate it if there was no public involved with it. But I don't know to what degree I want them involved.

HR: Yes, that's what we're talking about really, because he wants them involved.

LL: I think I want them involved, too. I think it's more up to them in what way they want to be involved. You can't make art without somebody to look at it.

HR: Yes, well that's different. I mean, that would be true about a painting, too. You don't have to get them to help you paint it, but you expect somebody to look at it. But Christo—now stop me if I misrepresent you—regards the world, and that is the social world, as potentially part of the work itself. Isn't it correct?

C: Yes.

HR: So it isn't just that somebody comes around and looks at it but they're part, you might say, of the physical being of the work itself since it includes records that are made, lawsuits, all kinds of stuff like that, which normally is not part of a work of art. How about you, Oppenheim?

DO: Well, let me see, I think discussing public art at this point is a rather rich area. I think it's beginning to open up. I mean work that does exist in environment. And there are some questions about it that hadn't surfaced years ago. One is the relationship to the spectator in a different sense. And we've explained some, you know, some recent works which have raised this question quite a bit. The exterior, the alternative to the gallery, is a very interesting topic too. And I would say that's one of the things I like about the work that Christo does is that it counters it, in a sense. It is an alternative to it and I think it's a positive one. And, I think we're quite often problemmed by the commercial gallery and museum circuit and some of these problems affect our works. And so I think—you know, I'm just stating things that we all know about the fact that there are other uses of art and as they expand outside these known perimeters, they become vital and they become new and they can effect a new stimulus. Other ways in which we do this seems to be something that we can discuss more specifically.

HR: Well, go ahead. For one thing, you know, actually all of you guys have a gallery, so it's not an alternative to galleries. It's a question of what part the gallery plays in these works. I think it's a very complex one. It's not, by any means, a mere alternative. You know that if you have some part of the work that's sold in the galleries, you then have the gallery acting as a representative of the artist and the promotion of the cost of production, and all sorts of stuff like that. So that while it's not a piece itself sold in a gallery, many

aspects of it show up in the gallery and the artist, in a way, is involved with sale, even though he's not involved with exhibiting the work in a gallery. So that you have a complex relationship there which I think you fellows already discussed. Of course, you're the ones most able to discuss this question of what the role of the gallery continues to be in this nongallery art.

DO: Well I think we would want it to be less of an instrument. My impression of *Running Fence* was that it circumvented the gallery in its physical substance. That is the way that it communicated out in a certain region. You weren't impressed by the way it related to the museums or that it was contained by one. It didn't function in the way that a retrospective would in a large museum, where you understand being in a place, and it would have identified with that place. It had a certain freedom that I think is healthy. When works can address themselves to land, and to the environment, without these impinging art-related factions, I think that it's encourageable.

LL: But Dennis, don't you think that the essential role of art galleries in these things is packaging? They package the project, they package the funding. They package its display to the public in one form or another. And so their role isn't changed that much. When John Gibson was on 67th Street calling himself John Gibson Commissions and hoping to get people projects to do, the general idea was that he would act kind of like an artist's agent for getting these things. Packaging the artist's product to potential investors in the project, and it didn't work, apparently. But I don't see that that role has changed. I don't see anything that implies to me that something else is happening.

DO: Well yes, but I think the work itself can have a life of its own. The fact that it may be backed by the same system, you know, I think we're talking about environmental works which are in rather low-visibility areas. That is not a public sculpture in a park, you know. Which is an interesting thing. I find it very hard to do a work in an extremely public area. You know, I find that if I can think of a work, I would always find other areas that are at least less visible. That are just more, kind of, energized. That's what I do.

LL: Then how are you going to bring that to the public? So you do it through an art magazine or you do it through an art gallery. The system hasn't changed. The location of the activity has changed, but the sociological development that might be occurring is the same. Exactly.

DO: Well, yes. But I think it's very nice to see art that isn't directly pinned to these classical housings, the museums and things, although it might be indirectly related. I think there's something very nice to experience some of these large works that read as relating to their own kind of instruments, and having the artist control them is another thing that is, I think, an advantage.

LL: I would agree with that. I agree with what you're saying right now. I think it's very advantageous that the artist undertake projects that are larger than the space that can be provided by galleries or museums. And they're larger in concept, larger in physical space, whatever. But I still feel that Harold's question was how's it attached to the gallery and my feeling is that it still is.

HR: Well, you have another possibility. Do you want to say anything about this right now, because you haven't said anything. Go ahead. We'll stay and wait.

ALAN SONFIST: Well, if you want me to, I'll start.

HR: By all means, I want everybody to talk as much as possible, but not at the same time.

78. Dennis Oppenheim: *Cobalt Vectors—An Invasion.* 1978. Asphalt primer and cobalt blue dry pigment, 2,000′. El Mirage Dry Lake, California. (Photograph courtesy the artist)

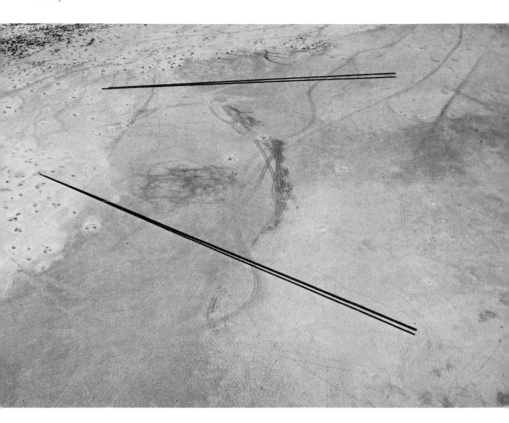

AS: Well, I really feel that art should have a moral responsibility to our society and I really feel that—you know, related to your question, I think too much of art that's being produced for galleries has become art just dealing with interior decoration. And just dealing with the idea of gallery structures but not looking at society as a whole. We really have to broaden the spectrum of what an artist is about or else we'll be just totally eliminated and become interior decorators. And I think this is up to each artist as an individual. The defining factor of us being artists is that we are able to project visions into our society. I've been criticized in the early part of my career for being involved in social issues. I'm particularly interested in environmental conditions and I feel that for us to survive we have to, as individuals, deal with these as a major problem. Obviously it cannot be something just superficial because it's a topic that's concerning civilization, but it has to come from your own internal convictions. I don't think any art is created out of any, quote, topical, you know, topic of the moment. It should really involve your own internal psyche and it has to come from you as an individual.

I've been working on a project to re-create a forest for the City of New York, through the city, working with the communities and trying to create a very positive force. It's going to be done in Greenwich Village. I don't know if you're familiar with the project or not; it's been going on through many stages of frustration, working with the city, working with the community people, and trying to explain to them what is art, and how this relates to their lives.

This is one of the things that's lacking in a gallery structure. The art world, for its survival, must take a more active role in the community as a whole. Art traditionally is about trying to deal with people and their environment. We as artists are the leaders of our society and this is how we should view ourselves. But that's not the role realized by most artists at this moment.

DO: Well, I think as vital as the conditions can be outside or as the alternatives to the gallery situation are, it doesn't preempt the fact that lots of good work can be directed within a confine which includes, you know, the gallery. Actually, it doesn't really make any difference. In other words, the works that occur outside don't read as having configurations that are particularly different from those, than the kinds of ideas that can be manifested by artists who work in more traditional, if you will, conditions.

LL: I'd like to say that the issue seems to be about art's use. What are you going to use art for? What do you think art is to be used for? I don't necessarily think that artists are the leaders of society. I think they're in the same position as anybody else is. They have dreams and ambitions of doing

certain things and somewhere along the line those ambitions get subverted by the system they attach themselves to. So art that is in galleries is very often used to continue the economic support of the gallery. In the past it used to be the major issue. How are you going to keep them making art? But the issue now, in many situations, particularly in this moment of economic conservatism, is how are you going to keep the galleries open? And I think that much of what we see in galleries today has become more conservative, let's say, than three or four years ago because of that.

HR: Well, let me sum up a few of these points. You could say that an art gallery is the environment of works of art. And also the preferred environment of the art world. That is the people who are interested in art. Well, we can prove that by just sitting here, in an art gallery. I mean this is where the art discussion and artworks are likely to wind up. In other words, this is the environment of art. Now you can say the gallery has certain limits. It's limited in size, therefore you can't put a mountain in here if your purpose is to do something to a mountain. And then, besides being too small for certain things, it's also limited in time. That is to say, if you do a work which has to vanish after fifteen minutes or fifteen days, it's not a good thing to expect galleries to have these things around. That is, the transitory nature of certain types of works makes them inexpedient for the gallery. Size makes them inexpedient. In which case they're usually by-products; we have all agreed they go into the galleries, like the sketches of Christo or the sketches of Oppenheim. As a matter of fact, I've seen works by Oppenheim in movies of the works and they weren't accessible at all any other way. You have that problem. That's to say, the gallery, in the case of environmental works, in quotes, they, the gallery, is replaced by media. That is, the works don't really take place in the social mind. They take place in the media first. That is, you have movies of them, like Christo's movie and his [Oppenheim's] movie. He had a movie, for example, in which they took a lot of stuff, a whole day's product, paper products of the stock market, you remember that one? They carried it in bags to the top of a roof somewhere. It got to be about three feet deep if I'm not mistaken. Then they danced around on it and the wind blew it away and all this time it was being filmed. So this is a terrific environment of the displaced floor of the stock market. But nobody invited me to go there and be there. On the other hand, I could see the movie. So, I got a secondhand environment. And that's what you usually get. Very few people, I'm sure, in this room have seen Christo's *Running Fence* or his *Packaged Cliff [Wrapped Coast]* in Australia. But we've all seen——

LL: I think that that's good. Secondhand is as good as firsthand. Everything in the newspaper is secondhand, and you believe it. When we go

into a certain country and shoot down a number of people, you don't pick up the newspaper and say they didn't do that.

HR: That's right. Very good. Let's concentrate on that. An environment is not an environment, usually. What the environment is, is actually a reproduction in one form or another. Either in film, or——

LL: We're used to getting information that way. As a matter of fact, people, for all they complain about video art as being boring, they still look at it for longer than they would look at a static object. They still manage to be able to spend more time looking at it than they would have. Then they even say that's boring. But it doesn't matter, because if you want to be bored it's OK. Go ahead and be bored. I think that images that are reproduced in society, let's say, of an ice cream cone, or a Polaroid camera, or a dress, or the President of the United States, or whatever, aren't believable.

HR: Yes, that's true. Not only that, they're more believable than reality. A favorite illustration is that people run across the street to buy a newspaper to find out how cold it is.

LL: But when you have a situation where a person does an action and makes a film or a photograph of it, it isn't that much different from a politician sending out a press release and setting up all the photographers over there because he knows that's his best side. And giving the speech from this direction and then when all the photographs come out, they all are shot from his best side.

HR: I said, is that good or bad? I mean, you would normally expect an artist to go around to the other side.

LL: It's not good or bad, it's a matter of time and space. It's a matter of there's not a lot of physical space and everybody can't be in it.

HR: It's not a matter of time and space, it's a matter of choice on the part of the politician who wants his good side to appear. It's not just time and space, it's a matter of how you look at this guy.

LL: But how can you go to everybody in the country? He has to try and reach them all.

HR: He's an artist, right? He's an artist with an ulterior motive, which doesn't mean that he's not a good artist. He's good enough to know which side he's buttered on, and so he gets everybody to see him in that perspective, just as an artist might want to see a landscape or something else in that perspective. But the problem is that what you see is not the reality but a made-up thing, a work of art. And that's all right.

LL: In the media generation, the media is more real than the previous notion of reality.

HR: And we agree about that. Now, the question I'm suggesting is, is that

good or bad? And what should be the position that an artist would take toward this illusory world by which we're all surrounded?

c: I don't think it's an illusory world, you know. I don't think that we can say that American society has the Vietnam war on the photographs only, and we don't have six years of war killing people. When they kill eighty thousand people it's not illusion. They kill eighty thousand people. And of course, you can have documents of eighty thousand bodies, but it's not illusion. And I think it's completely wrong to think that media is illusion. Not at all. We have the misery in Bangladesh, it's not illusion. And some people, some few millions of people are in the flood, and it's not illusion. Perhaps for *The New York Times,* perhaps it's not illusion, but is real life. And I don't think is the moral right to prove. When a man likes to climb the Himalayas, it's not to have a few nice photographs, but he climbed the Himalayas to feel that he climbed a few thousand feet up. And it's something individual which cannot be substituted with anything, if somebody likes to experience that. I think that millions of people like to experience that. And it's not illusion at all. Of course there're some documents, some books, some things like that, but behind this is the great true experience.

hr: You're talking about behind it as if it were a plus.

c: No, the source, the source.

hr: The source is not illusion, but the representation of it is, as he said, you can live with it. If you get the eighty thousand dead in a way that you can live with——

c: I don't think I can bluff with not having the reality and tell there was eighty thousand people who died. That's all. The drama of the human mind is not something that can be done in short matter of a few editorials in *The New York Times.* You know, the people live, you know, the most exciting things despite that the media is very powerful, but is the real things like Sadat was going to Israel. You know, that perhaps can be secreted like fiction, but became real. And the moment when it became real it became powerful. That is the story. If Sadat was not existing, all the beautiful things about Sadat cannot be told. As I am saying, Caesar existed once, we know he did great things.

hr: We know he's alive.

c: We know he was there.

hr: But what was the effect of Sadat going to Israel? Everybody began to wonder what was behind it, including the United States State Department. It was obvious and everyone was trained to realize that the truth of the matter is not what meets the eye.

c: It was the physical action. There was the physical displacement. There

was the motion of physical power of somebody, you know, with enormous tension that displaces and creates an enormous imbalance in the mind of people. Now that can be created completely artificially by the film and the media, but it's not at all the same, reality is much more powerful than any documents, products, you know.

HR: OK. Everybody agree with that?

LL: I think the illusion is very often more powerful than the reality. I think that many illusions that we see in the media are taken to be far more real than reality. You spoke about the Vietnam war, well, ten years of massive media coverage didn't end it one second earlier.

AS: People are relying on art-media illusions to create their realities. We have to try to counterbalance this type of structure. I see in my own personal work the need to deal with direct realities. Through the media other people are creating the images for us to perceive as being our world. Only by going back to the direct sources can we create art situations to make an alternative structure for people to perceive. Eventually, people will start looking at the real world, instead of looking at the media, in order to perceive the world. This is a very crucial issue in our situation, in our society. Has it become more important for us to look at a painting of natural phenomena or can it become more important to us to actually search out that natural phenomena and see it for its own reality? Will we continue to allow these secondary sources to give us the vital information about our survival?

DO: Well, I think part of those conditions were, became content in art. For instance, the fact that some work became less visual, and the apparatus behind the work could be condensed into certain thoughts that could easily be passed through the medias. And I think that's a condition that we experience. I think that did in fact happen and it precipitated all these statements about the cover of *Artforum* being more important than a one-man show and, you know, things like this. So there was this kind of displacement, but I think the origins of it were in the condensation of energy in a translatable substance through the media. I've noticed that; I've looked at the pictures of works and I've gotten the essence of the work. Now I'm sure this doesn't happen across the board but it's partly behind the stress or the weight that is now given to the media in regard to art.

LL: I don't think the media care about art anymore, though. For instance, the remark you made a second ago, about the one-man show being less important than the cover of *Artforum,* I think that might have been true a few years ago. But I think the cover of *Artforum* is not as good as a one-man show today.

AS: We are relying on secondary sources of information. We aren't looking

at the direct sources and this is the problem. We have to start really gong back and looking at the realities of our world. Again, it's that we are not the leaders. It's the packagers who are the leaders at this moment. This is the issue: Is the art world just mimicking the commercial world or are we going to become the leaders of this society?

HR: Well, are you all agreed on something here?

C: We're discussing the consumption of art.

HR: They switched our subject over into the art world. We were talking about reality in a big, solid sense, you know.

C: I was talking about how art is *consumed* (is that the right word in English?) and I'll talk about how the publisher advise like that. This is with all discussion but how we come art, you know. I don't think artists are very much impressed about that. Some perhaps are interested, but basically artists like to look at work and the consumption of art is something else.

HR: It's interesting that you should say that.

C: Yeah, exactly. But we're discussing that.

HR: Well, I would say not only now where we have all these ubiquitous media, but that all times, art, rather let's say, reality and illusion are inseparable. I think everybody would agree that there's never been a time when there was nothing but reality around. I mean, Paul Goodman used to think that would be paradise, you know.

LL: Reality is just a bigger illusion.

HR: Well, at any rate, nobody knows where the line is to be drawn between reality and illusion, but we do have, I think, in regard to art, a special situation in modern times because of the capacity for reproduction. As Benjamin put it, we live in an age of reproduction, which, first of all, does away with the handicrafts as a specific way of satisfying human needs. In other words, you get chairs and tables made in factories. You get shoes made in factories, and therefore the crafts tend to decline and everything comes out as a reproduction. A million copies of this, a million copies of that. And that's what in turn affects art, too. And as the reproductions become more and more effective, that is more and more accurate, you have a strong effect on art, where, for example, the collection of art today becomes a kind of special hobby. It isn't that people need to collect works of art. If they want to decorate their houses, they can get beautiful reproductions and if they were really sincere they wouldn't notice the difference. They only know the difference because of the specialists and connoisseurs, you know, the same type of people who collect stamps. You don't need to have a stamp for that purpose. I mean, you need a stamp at the post office but you can spend three thousand dollars for a stamp. So, the point of that matter is that the reality

and the reproduction have become inseparable and create special problems for art. If anybody up here wants to talk about that, go ahead, otherwise we can regard ourselves as having exhausted the subject.

LL: I don't think it makes any difference. I think you could make an art that has to do with just you having the experience. You can make an art that has to do with reproducing the experience in various grades of degeneration, until you end up just sort of barely touching the paper. I don't think it makes any difference. I think the experience that anybody gets out of a work of art has to do with the experience they get out of being alive.

HR: Then what do they need you for?

LL: They don't need me.

HR: They do. They need you. You got some other ideas. Everybody isn't alive in the same way. So they really need you because you got some other ideas. Why do away with you?

LL: I hope they won't, but what I'm saying is that the big thing people used to say about certain kinds of art was that's just decorative. And that, that was the ultimate put-down. To be said that something's decorative. After a certain amount of time, after you live a little bit longer, you realize that the fact it was decorative maybe kept it around. Those things that weren't even decorative were thrown out. So maybe it's not such a bad thing that it was.

HR: Well, you know, all ideas, no matter how good or how bad, finally get to the point where people get bored with them and begin to advocate the antithesis. So they just said, well——

LL: See, I don't think form of materials is the big issue. I think that if you're going to say a person can produce a thing up at the North Pole or somewhere, but he can't make a photograph of it, or he could produce a photograph but not do it at the North Pole or he couldn't do it by drawing. I think if you're going to make a choice of techniques or how you want to finally present the issue, I don't think that's very exciting—it seems like a waste of time to care.

HR: Yes, that's right. Everybody agree with that? All you guys agree with that? Well, good. Everybody agrees with that. Anybody disagree with that? In the audience? Or didn't you hear it? OK, we have reached—repeat your point, Les.

LL: No. They don't want to go through it again.

HR: He doesn't want to repeat it and I don't blame him. We got a question?

Q: It just seems to me that what most of us came here to talk about, or rather to listen to you talking about, was the concepts that went into the creation of your work rather than the concepts of what goes into the consumption

of it and the purveying of it. I personally am much more interested in knowing what it is that you have in mind that you want to do.

HR: What's that? Say that again.

Q: What I wanted to hear was what you have in mind that you want to create or why it is that you do what you do. And not whether the gallery, or the museum, you know, or other publications are the most effective means of consumption here.

C: No, we were talking about consumption here.

Q: Not about the competitive art-marketing business.

C: We're talking about that instead of talking about our work.

HR: She says no. She says you weren't talking about your work but about consumption.

C: No, no, no, no, the lady was telling, we were discussing in here about how we come to show our work to the people and things like that instead to talk about my work. And I can only talk about my work. I don't know anything about these bullshit galleries and things like that. I can only tell my story.

HR: Go ahead, tell your story. Come on, very good, very good.

C: And we were talking about mechanics——

HR: Go ahead. We were talking about environments but you go talk about your work.

C: Exactly. I talk only about my work. The only way I can talk about work, talking about the project I am working on right now. I am working on that project for two-and-a-half years and what I was trying to do for quite a long time, I was very interested to do an urban project in a very special town in the world somewhere. And I was fascinated for some reason by the East-West relation. You know, I come from the East country, communist country. I think that the value of our twentieth-century world, living apart, separately, measures all existence for the last sixty years and balances the peace and the war, intellectually, philosophically, and perhaps one of the most powerful things of the twentieth century. To align these two worlds together. And the only town where these two relations meet and where the same ethnic type is living together, and separately, is Berlin. Berlin is a big metropolis of some 5 million people divided by the powers of that world, and they live together, and fight and relate and not existing and existing. And of course the only structure in Berlin which is under the jurisdiction of the Soviet Army, of the British Army, of the American, the French, and the German government is the former German parliament, the Reichstag. And of course, I tried to wrap the Reichstag and just now, for the last two-and-a-half years, I talk with the Soviets, with the British, with the Americans, with the French and the Ger-

man government. And I have involved for the first time (at least for my work) values which, if the work is ultimately successful, create some conversation between the Soviets and the British, with the Americans and the French and German government. I am far away to be successful. And now we have big problems, but we are working hard and hopefully, to do that work. Now, through that process of relation, evolved all new type of people, new type of value. I don't know if you're familiar with Berlin. Berlin was almost totally destroyed. One side, on the West Berlin is totally capitalist, urbanist, expansion, and the East Berlin is fantastically totalitarian, empty avenues and high buildings, with fantastic motion of people. And of course that structure, which is almost on the limits of the two sides, can be visible from both sides. And if we're doing that structure, wrap that structure, it will involve that engagement of this two-power systems. I don't know if I'm successful but all my works, they are suicidal in some way. You know, they start their own life, their own reality. And this is beyond my power. You know, it involves people so much more powerful than me, and we only, with Jeanne-Claude from behind, are pumping the work with funds, so that finally we can arrive at the results. And that is something that will make the work exist in the economic sense. That when the work-object will be finished, will be ultimately the end of the work, you know, it will be the end of this two-and-a-half, three, or four, or five years of time, which cannot be repeated. It will be something that will be part of our lives, of my life and Jeanne-Claude's life and some friends, and we'll be going ahead with new projects. And each work is like a new way of living, you know. I will not do another *Running Fence* because for four years I learn so much of American system, of land use, and governmental agency that perhaps no university in the world can teach me like that. For the first time I am involved with international politics. I was never aware of the complexity of dealing with the high, the very cautious, very sensitive relations between East and West. When the Russian general, or the Russian minister, and the different people of the Western power system meet, of course, this is a long process which is extremely refreshing, extremely powerful because it gives new value for my work. This is why I do each time a new work. The new project gives new value to the work I am involved with. That's what I wanted to say. But I can answer more questions about that.

HR: Now, wait a minute, that sounds marvelous. I'm very enthusiastic about your development, but you haven't told us what you're doing.

C: I just told you. The former German parliament, the Reichstag, is a structure built in the late nineteenth century. It was the symbol of the incredible power of the German Bundestag founded by Bismarck, and the

reality of the structure was a continuous metamorphosis all the time. After two hundred entries by several great architects in the late nineteenth century, finally Wallot won the competition and that building was built in a casino-type, ordinary, trivial, huge building, 150 feet high by 600 feet by 400 feet. And it was never used to fulfill its symbolic purpose, you know. Shortly after, during the Weimar Republic it was the symbol of democracy. Hitler hated it and he burnt it. And after setting the fire in 1933, that was a very famous fire which created feelings against all socialist, progressive elements in Germany. That was the famous process of Leipzig in '33. After that he restored it and used it for his own policy. Marshall Zhukov lost two thousand people taking the building in 1945. It seemed completely stupid because the building had no strategic interest except one or two Nazi commandos were defending the building. The building was almost totally destroyed. The federal government of Germany spent seventy-five million dollars to restore the building as a completely new parliament and they cannot use it because the Soviets won't permit that the building be used for parliamentary purposes with the fear that it will be a revival of German Nazi nationalism. The building for the last hundred years was in a continuous metamorphosis. And when I was talking with the opposition, about my wrapping of the building, I was telling the people really all the time the building was changing physically, it can be wrapped for fourteen days and be a work of art. That is not so easy to convince them.

HR: Well, are you wrapping up the parliament? You mean you kept it a secret until this minute?

C: No, I was going to start that in a moment. OK. We have not yet got the permits but we engage all the Bundestag, Parliament, the ministers, five powers (the four allied forces, they have ministers in Berlin). They are not attached to the foreign ministers. They are directly attached to the President of the United States, to the Prime Minister in England, and the President of France. And of course the power is directly represented there. I mean, they are not like the foreign department, and of course that is an extremely touchy situation, because for these people all is related to keep balance of an existing system and cautious how they exchange between East and West through the several checkpoints in Berlin. Now, we are far away to get the permits, hopefully in one year we will succeed to convince.

HR: What if you don't get them?

C: It will be a failure.

HR: The work will be——

C: Will be a failure.

HR: No. No, just——

c: If we do not finish. You know, the important thing is that the work is, it would be a failure, and it would be very good, like a cold shower to my ego. But, you know, it is very important that the goal is set. The work exists outside of my power. And if everybody was doubting that I will put all my energy to arrive to realize object I will never go through that response to that reality that we are facing now. That everybody knows that we do everything ultimately, everything, to get that building wrapped. And that is what gives this fantastic power. That is why *Pravda* just wrote editorial against the project. If I was only talking about wrapping the Reichstag, with no believable means, nobody would be interested. But because everybody was truly, truly interested in that, *Pravda* about a few weeks ago wrote an editorial against the project. Now that is the way one can tell how is important that the establishment and the reality is facing there. When we try to make war, but we really don't make war, nobody would be interested in you. But if it is really the war, it becomes truth.

HR: Well, I think it's marvelous that you're living up to the idea of trying to get to the reality through the media. What you're planning out, nobody knows, because they didn't take the trouble to look. I mean, they just take it for granted what they read in the papers is the state of affairs. Isn't that so? I mean, you're not running into any détente.

c: No.

Q: What is your purpose in wrapping up buildings? Did it start out to be political or did it become political afterwards?

c: No, no. You know, each building, first, this is only third building that I wrap, you know? That's very few buildings I wrapped. But all of us are anxious for many years to be involved with a very public structure. The only buildings I wrapped were the buildings related to the art world. They were museums and, ultimately, you understand that some museum director would permit me to wrap their building. And of course, this is why it took me long years to wrap a building, to negotiate and to go ahead, perhaps do a public work beyond one-to-one situation, one nation situation. This building involve a thousand, a million relation of different people around the world. And of course that gives the value and the power of the project. You know, the project is strong and the reality is a reality with a huge, fertile ground. I don't know what is the project. The project builds its own life. When I started to do the Reichstag, I knew very little about the German ministry or German history. I learned so much and it's so exciting. You know, in a way the project, after we finish, is like for three-and-a-half to four or five years, have its own poetry, own life, and it is produced by the sheer energy that was put to realize that work. It was the same way in California. I was not aware

of the complexity of the land use and legislation of the California state, and of the United States, and that it would have brought problems for the use of land. But through doing that project, we involved this fantastic machine in which the project draws energy. Now, we would be perfectly cheating if I go to some rich friends in South Africa, to my friends and build this fence on fifty or hundred miles of hills. There would be no relation, no relation to the work. The work would be nonexistent, you know. The work arrived to that impact only because it is nourished on the power it carried with itself. The real sources.

HR: I'd just ask you one question now. I think it's a wonderful presentation you've made and everybody ought to know what you're doing. I ask you one question and this is, do you feel that you've adequately conveyed this assembly of experience and information to anybody outside of yourself?

C: Yes.

HR: That's the point.

C: Yes. OK, I tell you. That is it very much because at least for Germany, and England and some people who are very related to the project now, it is very much in a way that the whole German media, all the politicians, and in England, they're involved very much with that. It shows how much the work is related to the people. You know, I talk to the people from the chancellor, to the different politicians because they're crucial and they're the makers of the project, because if you do not convince them, we will never see the project happen. And of course, that very slow involvement of these people, too, and these people [do not become involved], not because they see because I am crazy. No, these people are completely convinced of the polarization of the German opinion, and some part of the British opinion, how that work is going to go ahead. That work involved enormous courage to be defended because conservative people think it can create almost the closing of the East-West border, in Berlin, if we will go ahead with that thing. We create difficulty to their relations. Somebody, like some left group in Germany think that is a very important thing to create a matter of conversation. When the whole German nation and some part of people are related to that building, they help see themselves and discussing something which is not rational, pragmatic, not related to the goods and the salary of the people. Yes?

Q: You've talked about an idea of space and time in your work, the space perhaps being what you're doing with East and West Berlin, this sense of space, of division between the East and West in terms of the powers. That sort of sense of geographical space. And you talked about the sense of time that it takes for you to create a work. It's going to take you two or three years since the initial programming of your thoughts about what you wanted to do.

And I would like to know, what is the relationship, or do you view there's a separation between your personal sense of time, and space, as an individual, as an artist, and that relationship to your . . . how you work. In other words, what the space . . . I'm trying to understand if you have a different set of criteria for space and time in your own life as an artist as opposed to how you view it in relationship to your work.

c: How I sleep? How I wake?

q: No, that's—— It's not clear.

c: No, I perhaps, if I understand, I answer you. Let me answer the question. I was trying to clarify that the work basically exists outside of my (almost) power. You know, when the work is put on the reality of relations it becomes an incredible monster. I don't talk for the physical. The physical object is the end of the work, end of the motions. But when that work starts to build its own identity throughout the spirit of time, making its own identity despite that we have so great advisers and we hire lawyers and professionals, nobody can know where the work is going. You know, because there is no precedent. Each work has this new and new relation. Of course, we know how to build *Running Fence,* but I will never do another *Running Fence.* Now the making of the Reichstag, that is the first time I engage this international relation of the completely different sets of the people, of the value. Especially it involved Eastern world. And of course, that creates a volume of energy, especially people against and for the project. Now that each time the project creates its own power of that momentum because there are so much forces for, also that there are so much forces against. And that really creates the power of the project. Not only in the East. In a country like this, we will never have so much problem as on the conservative part of this side in Western Europe. And of course, what makes the project build in time and relations we cannot predict, because it's almost like the real life. You know, the people who try to do all kinds of things and we cannot know. We can try to understand and can relate to that. My wife would like to . . .

JEANNE-CLAUDE: I think Les Levine explained very clearly that today it's very hard to disassociate time and space, and the proof is that if somebody said at what distance is your house, you answer, fifteen minutes' time. You don't answer in kilometers. Or if somebody says five miles, you say twenty minutes. It's the same thing. So it's more difficult to disassociate time and space than to do what you're trying, to put them together because they really are together.

HR: Wait a minute. I think we, . . . I'll tell you what, I think we're going to run short of time because I want the other three artists to speak, too, about their projects. I'll entertain one brief question addressed to Christo but no

more until everybody else has had a chance to talk. There's one over there. That lady in the back.

Q: What do you think of your . . .

TECHNICIAN: Please use the microphone. We're videotaping it and the machine can't hear you.

Q: While she's getting it, I just noticed that Christo's first statement was two-and-a-half years in terms of his talking about his project. Later on we found out that it was taking a long time and that something might happen, but it was his whole flow that apparently is the project.

HR: Well, what's your point?

Q: Well, time and space.

HR: Well, you guys insist on having those two words in here. I don't think we need those two words around, but anyway, go ahead.

Q: What do you think of the relationship of this prophylactic technique in relation to your power and to cold war politics?

C: No, I don't think art have to do anything with warfare. For art everything is sources. The good weather is good for art like the bad weather, you know. It cannot, when it is raining, is not good for art. When is sun, is good for art. The same thing, everything can be matter of art. I don't see one conservative guy or very reactionary can be not matter of my art like one progressive guy. Everything is subject of art and can be beautiful source of energy. And I don't do good and bad things. I do my work.

HR: Now, no more questions asked until the other artists have had a chance to talk. You want to say something about your work now? I mean, if you feel like it. If you don't feel like it, tell me.

AS: Well, I started off my own talk, I started to talk about the project that I've been working on for the last ten years, to re-create a pre-Colonial forest for the City of New York. And I've run into the bureaucratic problems of going through the administration, trying to talk to people about the idea of re-creating aesthetic environments. One of the issues I'm personally involved in is going back to the origins of art, going back to the idea of cave paintings, where there was the social commitment of the artist involving himself in the society as a whole. And I think that this relationship has been lost—the artist has been limited to producing objects for the gallery context. The traditional purpose of the artist is dealing with a community and seeing how you as an individual can create an aesthetic experience within that community. We have to project ourselves into a larger scope, for us as a society, as a group, as individuals, to survive. If we keep on with this progression of dealing with interior decoration, the art world will become meaningless.

In terms of the personal circumstances of my own evolution, I grew up in

the South Bronx in a very violent area of the city. The specific nature of my own personal psychic involvement with the community comes from that condition. Each individual has their own alternative structure in relation to our society: it's the idea of projecting yourself in that sense, and working with the community. It has taken me many years to work into this project, into the community, and talk to the people about the idea that this is an art project and how it is going to affect their lives, how it is going to increase an aesthetic awareness in their environment.

This project is open also to people in this symposium. It will be started this spring, and if anyone, at the end of this talk, wants to help out in the project, that's great.

HR: Well, what are you doing and where is it?

LL: Line up at the corner there, folks.

AS: Well, I mean, it's just an idea; I'm emphasizing that it is really open, it's not that I'm just *talking* about it, it actually is an open community project.

HR: Where is it?

AS: It's right here on La Guardia Place, between Houston and Bleecker Streets.

HR: And what's going on? You're working there . . . ?

AS: It's going to re-create a pre-Colonial forest, trying to give another aesthetic vision to the city.

HR: Well, that's fine. Anybody want to go and work on a forest right around the corner?

Q: Will people be paying for it?

HR: She wants money.

AS: It's being funded at different levels.

HR: Who's paying for this? The City of New York?

AS: It's a group. It's being privately funded and federally funded.

HR: All right. Very good, any questions?

Q: I think it's rather difficult to project oneself into a community. It seems to me that one would have to be involved with the people of the community to help you work on the project and perhaps even get paid for it, even also getting their views, because even a good architect who works on private projects will be involved in the community and be involved in their ideas.

HR: Are you arguing with him or with Christo? He's in Berlin. This guy comes from here.

AS: I live in the Greenwich Village community. I live there and that's the reason why the project is first being created in Greenwich Village. I am working with the buildings surrounding the project. There's input into the project from the community surrounding it. I'm working with the local plan-

ning board. I'm also working with the local politicians on the project. I'm not just saying, "Here's a sculpture, tough luck if you don't like it," or, "I'm doing an earthwork, and if you don't like it, it's your own problem, because I'm going to stick it in here anyway." This is the typical "man against nature" cliché that many artists are following that I am against.

HR: OK, one more question for Sonfist.

Q: This is a question to Alan Sonfist. If right now we talk about survival, we have, say, the Sahara spreading, we have the Midwest losing half its soil fertility, we have, in New York City, the major toxic input being the automobile engines and carbon monoxide, how will a block of forest in New York City address itself to any of those problems? The general desiccation of the world, for example? With the general pollution in the atmosphere, especially since it would seem to me from elementary ecological analysis that a forest placed on a block in Manhattan would not have any pre-Colonial aspect since the birds that set down there, the insects that set down there . . . what there could be would obviously be tainted by and affected by the surrounding several hundred square miles.

AS: The project is one square block. It's a pilot project. I'm working with the local government about the idea of doing other similar projects. This is a spreading project, not just in New York City but also in other cities. Besides the aesthetic impact on the community, the project will add oxygen to the air and absorb noise. I see this as literally a growing counterforce within the city. I am working with Mayor Ed Koch and a whole series of people who are involved in this area. This project is an event that will continue on.

Q: Well, I'm not quite sure about another part of the question—

AS: There were two parts, I thought, weren't there? A second part?

Q: Well, it strikes me that the matter of survival now is largely a global matter and involves looking at ecological processes as global processes, at least within large bases, and to put a forest in a city where the main ecological problems are, for example, depleting food supplies, because our climate is becoming greatly destabilized and, I think, because there is the internal-combustion engine. All of these, I don't think are being addressed by the forest. I'm not aware that a forest itself would remove the carbon dioxide.

AS: Well, not just one. I'm talking about this as a beginning. It's a pilot project. There are many other empty spaces within the city.

Q: But does that address itself to realizing now that we have oil and gas which are toxic? Does it address itself to——

HR: Aw, come on. You don't expect him to turn the city into a forest?

AS: Everyone here has their own responsibility to their environment. Everyone here has a certain role. I'm not trying to say that everyone should

go out and deal with pollution. I think the issue is to create a more heightened awareness of our circumstances, whether they be political, or social. The forest is one answer of many answers.

Q: So that your forest is not a model.

AS: It's a metaphor and hopefully it will alter people's perceptions of their environment surrounding it.

Q: Have you made any, maybe——

HR: Listen, let's not have a discussion between two people. We have three more, two more artists whom I'm sure you're all going to hear from, and then if there's any time left, which I doubt, we'll have further questions from the audience.

Q: I have formulated a program called Art People for the Environment, for which I wrote an article, and it has to do with what Alan Sonfist is talking about. It's called "Out of the Studio and into the Street." It has to do with public art and a plan for the entire city.

HR: Is it a question?

Q: It has been—— No, I'd like to extend this further.

HR: You want to give a commercial for your project? Wait until the end of the meeting, that's all.

Q: Yes, I do. I feel that it's something that all of us could be involved in and I think that there should be some kind of program.

HR: You want this to be a footnote to what he's been talking about.

Q: Yes, I'd like to extend it so it could be something that more people could be included in and I have, in fact, some typed, some printed matter on that if anyone is interested.

HR: Are you going to circulate this? Go ahead, tell us about what you're up to (*to Oppenheim*).

DO: Well, I prefer just to use the time in allowing a few more people to ask a few more questions. I don't really feel like talking about it.

HR: How about you, Les? You got something going?

LL: I don't think artists should talk about what they're doing really, that much.

HR: Are you criticizing your two predecessors here?

LL: Yes, but in a gentle way. Let's put it this way. I feel artists do their works and if people misunderstand them, that's OK. It doesn't really matter. Explanations won't make them understand it any better, anyway. I'd like to talk about the concept of time and space as it is understood by the medium of television. In television there is a machine called the time-base corrector. What that machine does, it's a new event actually, it's only been in existence about three years. What that machine does is, it takes the specific timing of a

picture, strips it off, and reinserts new timing so that the picture is what we call square. As opposed to tearing, shaking, moving. *Square* means it's absolutely flat and tight on the screen. One of the things we've learned by looking at time-base corrected pictures is that there is some definite relationship between time and perception. The shorter amount of time it takes to see an image, the higher degree of perception exists. So that all badly produced pictures in television are in bad slow timing. Think about that.

HR: Well, you want to say something . . . ?

Q: I'd like to say something about that. Let's see—that's a curious concept. The technological concept, you know, that's an active invention right now. But what about the fact that, well, I'm a painter and usually it works just the opposite. In other words, the human value would indicate that the longer you look at something, it's a good painting, a quality painting. The deeper the experience, the more quality experience. The technological thing has come up with just the opposite kind of impression. So I kind of question that whole thing.

LL: Well, all right, let me talk about that then.

HR: He just gave you a piece of news. He just said there was such a thing. He didn't say it was good or bad.

LL: The fact that there is such a thing implies eventually the idea that time-based art or time-based experience are going to go through a different kind of analysis than they've previously been through. The same thing applies in photography. Out-of-focus pictures generally mean that the photographer and his subject were out of time base. The subject moved. Or the shutter speed was too slow. One or two of the things. The difference in discussing this is that you're talking about a random-access art. You're talking about an art which can be dealt with in terms of random access. But most of what we've been talking about here is not a random-access art but is time-based art. An art that has to be dealt with in terms of time.

Q: What do you mean random-based?

LL: Something you can go into at any position and at any given time. You can retrieve all the information necessary, or holistically all at once.

Q: But why are you putting everything, like in terms of painting, in terms of technological terms, which——

LL: No, they're not technological terms. They're words in the English dictionary.

Q: That doesn't mean that they're not technological, basically.

LL: Well, you know, *paintbrush* is a technological term, *oil paint* is a technological term. It describes a substance. It's just a way of using words that people understand what you're talking about.

HR: Well, I don't know what you guys are arguing about actually. But I would like to note that the two artists who have described their projects seem to be free in their idea of how long it would take; therefore and in that sense they are exactly antithetical to the concerns of television and the media. The media are based on exact measurements to the extent that they can do it. Everything that's shown to people, and that's one of the bases on which they falsify reality in the formal sense. That is, that things don't happen in fifteen-second, in thirty-second commercials, or in half-hour programs. And these artists, without necessarily being concerned with this question at all, just took it for granted that they can go on forever if necessary. One of the characteristics of a work of art is that it makes its own demands on the time and energy of its creator, and the poor guy might suddenly find that he spent ten years doing something that didn't work out at all. And this is one of the glories of being an artist, you see, as Socrates said about the philosopher—he's not in a hurry. He works down, he suddenly sees an idea over there and he meanders off into a path where he finds himself in a dead end. And Christo told you that he could find himself in a dead end and it wouldn't kill him. Just imagine if NBC found itself in a dead end. It would be dead, in other words. Let's see, anybody have any more questions? No, no more questions?

Q: I was wondering whether environmental art, I wanted to carry what Les Levine was talking about, that random-access art, like a painting, is something that you come into and go out of randomly. I'm wondering whether Christo felt what he was doing, or Dennis, or any of the other panelists thought that environmental art is in fact a random-access art.

LL: Now wait a second. Time-based art is time that implicitly is time coded. Video tape is time-based art. What is on the first five inches of the tape is different than what's on the next five inches. You're dealing with essentially the same system as you are with a clock. So that you are dealing with a time-set system. You're dealing with a system that uses the sixty-cycle current in the same way as an electric clock does. And if you try to use it any other way, you can't see anything. It just doesn't work. So I think to talk about time and space is, we're going to get into a discussion of technology because the only decent analysis that has been made of time and space ends up in the technological area. There's been no serious analysis of time and space in painting that I know of.

HR: Well, it's altogether a case of—I think Paul Klee talked about the fact that in the old days, the distinction was between time and space, time being the form in which music and drama took place and the space being the form of architecture, painting, and sculpture because it's static. That was Les-

sing's distinction which lasted for a long time. And then Klee argued that the concept of time applies to painting if you look at it from the point of view of the artist. So he developed a formula that a line is a moving dot. And a plane is a moving line, and a cube is a moving plane. So then, if you begin to see how these things moved around, you were involved with time. So he broke down the distinction at about the same time that the physicists began talking about space-time with a hyphen instead of making a distinction.

LL: However, the important factor in discussing time and space in those terms is that if you get the wrong time, nothing happens. If I look at that painting in the wrong time base, nothing different happens than looking at it in the right time base.

HR: I wouldn't say that. Maybe looking at it as a static object when it shouldn't be seen as a static object.

LL: No, but if you do it with something which actually has a time log in it, you can't see it. It just ends up that you just can't see what's there.

HR: Well, I suppose there's a difference of emphasis. What I was trying to get at is simply that the subject had been discussed in the past, you know, on that basis of time-space.

LL: The same idea of a line being a missile moving through time, right? Is the same idea which all computers use to say that the tape is moving through time. So instead of saying, "Let's find six hundred and forty feet into the tape," they now say, "Find four minutes, three seconds, and eight nanoseconds into the tape" because it's more accurate. When you're dealing with time, it's more accurate to deal directly with time.

Q: I have a question that specifically involves Christo and Alan Sonfist in terms of whether they view dealing with people, in other words, Sonfist dealing with the planning boards and all kinds of frustrations that are going on with the planning boards and Mr. Christo dealing with the governments, painters dealing with people as a painter would deal paint? And do you view it as the same medium? As a process, or something, you know.

C: The people, the board of supervisors, or the ranchers, I think that in a way they know they have the ultimate power in the making of the work. It's not viewing but living with the work, or making the work. In my case, they're artmakers because without them the work will not exist. Without their decisions, without their involvement, without their approval, without their reaction the work cannot be, they will or will not let me do the work.

Q: So these people are your medium?

C: Yes, they're like the friends, in a way. It is impossible to do work without them.

LL: Can I ask Christo a question?

c: Sure.

LL: Do you find that people perform better when raised to the level of an artist?

c: No, not at all. They're only the sources in the way that——

HR: Maybe he doesn't know how to raise them.

c: The question is they are doing different things, you know. The question is that they like to be involved with something irrational and provocative, interact, you know.

HR: Do you have a question?

c: Or answer?

HR: Yes, do you have a question or an answer? Come on.

J-c: Les Levine asked if people perform better when called artists. Well, yes. When Christo, in public, told the opposition which was made up of local artists and who had taken us to court, when Christo told them that they were, whether they liked it or not, part of his work of art, they sure performed much better as an opposition.

HR: Very good. All right, I think we have now reached the end of our needed expenditure of time, so I thank my collaborators here who have done a wonderful job, individually and collectively, and thank you very much.

CHARLES TRAUB

Thoughts on Photography in Conquest of the American Landscape

Charles Traub, photographer, teacher, and former director of Light Gallery in New York, has written an essay that looks at the relationship of art—especially the art of photography—to nature from an unusual vantage point. Why do photographers generally ignore the hostile elements of nature? Nature has usually been represented romantically, softly, especially in photography; why has this been the rule and is it necessarily appropriate? Traub discusses attitudes toward the natural world in terms of the work of such photographers as Carleton Watkins, Alfred Stieglitz, and Ansel Adams, and looks at such phenomena as the Farm Security Administration photographers and the first photographs taken on the moon. It is his contention that most contemporary photographers such as Garry Winogrand and Robert Adams capture a more honest view of the relationship of man to his environment. Is this "honesty" the whole truth, or is there still some validity to the naïveté of the pioneer nineteenth-century photographers?

> "I'm not interested in nature, only my own nature."
> —Aaron Siskind

Photography embraces the pursuit of the natural and the man-made landscape with new objectivity. Since the invention of the camera obscura in the eighteenth century, the landscape has probably been the most recurrent subject of photographic study.

Although painters historically have presented and revealed ominous and malevolent qualities of nature—its fire and ice—photography rarely views the negative side of nature. The leap in the "Brown Decades" (1880–1900) to a technological culture and the spread of urbanization were concurrent with the invention and early development of photography. This youthful medium has primarily witnessed man's encroachment on his natural en-

217

vironment, his gradual dominance of it. Yet for a long time cameramen have portrayed the landscape as a luxurious, welcoming retreat from reality and a spiritually uplifting escape. Alexis de Tocqueville described American civilization as a tribute to "that power God has granted us over nature."[1]

In a recent article for *Esquire* Robert Persig chronicled the experience of sailing around the world and shed some light on man's rather misconceived relationship to nature.[2] For most sailors there is a great dream: to escape the nine-to-five world, to gain control of the helm and mastery of the sail, to be free of decisions except for those made with the winds, the sails, and the sea. Those who venture on this unusual odyssey understand that latent terror provoked by the capricious elements and the loneliness of tending a small craft on the high seas. The physical effort involved in the undertaking outweighs the romance of it. Our subconscious, at least, can recognize the reality Persig describes: we know it through depictions by the nineteenth-century seascape painters, Albert P. Ryder and Winslow Homer.

The same fear compels our self-protective urge to build our city forts, institutionalize our culture, and mold our art to insulate us from the hostile, unpredictable elements. Our art is the tangible manifestation of the nobility of the human will facing the unknown, but inevitable forces of life. The production of art is man's refuge from the primeval forces around him and, indirectly, a means of controlling them.

The growth of camera art is a by-product of a mechanistic age and parallels our culture's use of technology to rule our universe. One must remember that the awe-inspiring NASA photographs are not snapshots taken during sightseeing jaunts into the heavens but scientific maps of a terrain and topography soon to be exploited by the human race. These striking photographs remind us of the technological advances that have been made by man in every field, not the least of which is the advancing technology of camera equipment itself. These pictures, for instance, resulted from equipment that automatically records the comings and goings of all forms of life, whether or not a human is present to operate it. Ten years after the making of the NASA photographs, an exhibition at Light Gallery in New York gave these images a new dimension. After the passage of a decade they could be admitted into the realm of art. They are the freshest and most faithful view the public has had of a yet unspoiled frontier; they resemble newly discovered relics that hint at our origins. The photographs of the green Earth taken from the moon transcend a documentary function, reminding us of the uniqueness of life as we understand it. Viewed from the moon, the Earth seems all the more important because it is the only place we know to be inhabited by living beings.

Art has always evoked our fragility, what is most human in us. Art lives because we see ourselves reflected in it. Thus only after some length of time could we exhibit the NASA pictures in an art gallery. Now that mankind has had enough experience to "know" space, it does not seem so mysterious or impossible to conquer. The space photographs can now be understood in this new context because we can appreciate the conditions of their making. Their very existence is a rarefied reminder of something we have already lost in "anticipation of the triumphant march of civilization."[3]

It is an illusion that our ancestors lived in harmony with their environment. Until the early eighteenth century man was hard put to "civilize" nature and use it for his own enjoyment, artistic or otherwise. The pleasures of real estate were enjoyed only by the gentry, and then only in a relatively controlled, idyllic, pastoral environment. We need only recall the royal forest of England or the great fields of the French châteaus to understand this point. The peasant, on the other hand, was in constant battle with the elements, including the soil itself. The fifteenth-century age of exploration was not undertaken out of a love for nature but rather for financial gain. This spirit of conquest peaked with the "manifest destiny" of nineteenth-century America. Concurrently, the developing photographic medium provided a mirror by which the defoliation of the virgin American landscape could be observed.

Underwritten by the U.S. government in his explorations of the Northwest rivers, the former portrait photographer Carleton Watkins did his greatest work in the 1860s and 1870s. Documenting the unexplored waterways, he suspected, even as he first set out, that the resulting photographs of his subject would surpass in beauty what was to be their official nature.[4] Nature's magnificence transcends the efficient logic of the camera's eye. Although it presumes to capture nature's order, it must ultimately yield to the photographer's need to understand himself, his origins. Watkins clearly found the Northwest Territory and the Yosemite valley places where he could fulfill his creative genius. He also correctly assumed that the marketing of these photographs—views of unknown curiosities of the West—would prove to be a profitable business venture. In another sense his studies surveyed a land soon to be altered by civilization and thus acted as a record of that civilization's reach to date. Landscape as subject matter indicates, in one respect, a culture's expansion. And man is always the narcissistic consumer.

The monumentality of the Western landscape awed nineteenth-century photographers. They frequently included a human figure in their vistas, indicating the scale of the natural wonders encountered. But perhaps these first photographers also used figures to make a symbolic gesture. They saw the sublime in the face of nature, yet they surely foresaw man's inevitable en-

croachment on this untouched, newly documented topography. The explorer-photographer's counterpart, Neil Armstrong, photographed his own footprint with a similar insight as he walked on the moon for the first time. He proclaimed that his footstep was an advancement for mankind, meaning that the moon was now accessible to man. The first closeup views of the moon, the first artifacts from it, and the photographs taken by the astronaut-photographers remain as curiosities. They represent something of a pure, naïve view, unencumbered by the possibility that soon the moon could be overrun by technology and development.

Throughout the late nineteenth century the American landscape increasingly changed as men harvested its resources. At the same time that the remaining monuments of the West became subjects for great photographic art, they became tourist attractions institutionalized by the national park system. Consequently, the "faithful witness" of the undiscovered, the itinerant photographer, turned to social documentation as his mainstay: man as subject matter was unavoidable in this new landscape. Photographs began to focus on its new inhabitants and the civilization they planted on the wilderness.

By the turn of the century artists like Alfred Stieglitz, saddened by this loss of the photograph's "innocence," turned from making a mere record of the landscape to the use of metaphor as a means of documenting it. He recognized that portraying the wilderness with nostalgic and romantic overtones was unacceptable to the mechanized twentieth century; "experiencing the wilderness" now meant savoring it in small bits, or on a jaunt to the nearest national park; or in Stieglitz's case, at his hideaway at Lake George. Stieglitz and other photographers were beginning to be aware that less and less unspoiled, primeval landscape could be found in twentieth-century topography. Edward Weston's famous photograph of the three-dimensional coffee-cup sign monopolizing a Western landscape is an example of the change that was taking place. This image of man and nature juxtaposed against each other was the new vista that posed a problem for photographers to solve harmoniously.

Ansel Adams, a throwback to the nineteenth century, reminds us of the majesty of the few untouched panoramas left in our American landscape. His is a romantic image. The Yosemite pictured in his photographs is a far cry from the reality of travel carts moving thousands of tourists to Bright Angel Falls. But Adams's fellow photographers could not retain that innocent approach. By the 1930s Edward Weston noted that nature's forms, such as the peppers and cacti he photographed, are beautiful "because they are the

ultimate expression of its potentiality."[5] His view was a refined one, recognizing that the photographer could never be quite the detached viewer we had assumed Timothy O'Sullivan or William Henry Jackson to be in their early documentation of the West. As unselfconscious surveyors they gave us specific records for historical, sociological, and scientific use rather than expressive comments on the Western expansion.

By mid-century the more sophisticated photographers were making icons of nature's artifacts. They isolated stones, trees, and fruit, metaphorically alluding to some infinite range of spiritual, mental, or psychic concerns. Paul Caponigro, seeking metaphysical issues in his work, cut an apple in half and photographed its symmetry, feeling that the inner layers would reveal what remained of nature's order, what is invisible in the raw and virgin landscape. This concern is far more self-conscious than those of the early nineteenth-century photographers and is a progression of the vision contained in the work of Weston. (Concurrently scientific use of the medium turned to micro- and macrophotography, which are equally specific in their attention to detail.)

The modern documentary movement in creative photography stems from the photographs commissioned by the Farm Security Administration during the Depression. This attempt to map photographically the movements of hard-hit rural America was spurred by the recurring phenomenon: man's struggle with nature. The work differed greatly from the more cynical approach to the same idea of today's photography; the dignity of man in the face of adverse elements was the major visual and expressive concern. Although the FSA carefully detailed the depressed conditions of rural America, primarily a result of man's own mismanagement of his resources, the individual was seen as heroic and noble in his struggle for survival.

The American Topographical Photographers (a label invented in the mid-1970s) pursue picture making with an attitude that minimizes stylistic concerns. They work without deliberately seeming to frame relationships and try to make pictures devoid of personal style, pictures that seem almost authorless. They hark back to their predecessors in the FSA in an apparent preoccupation with straight subject matter rather than noticeable artifice. Like the second home in the mountains and a house by the sea, our gardens and even the layout of our streets become new symbols of material status: like trained pets they reassure us of our dominant position. These photographers are fully aware of the ironic twists inherent in the civilization process. They seek to recapture the objective stance of their predecessors in the nineteenth

century, but their sensibilities and their work are informed by contemporary ideas ranging from Sigmund Freud, Charles Darwin, Karl Marx, and James Joyce to television.

Garry Winogrand, the seminal figure of the movement, can be seen roving Los Angeles in a battered Cadillac photographing people, distorted architecture, and the convoluted intersections where man meets landscape. He knows full well that man is a reflection of his own beginnings and his own endings. Less classic in his approach, his attempt is almost mannerist. He keeps a watchful eye for man's extravagances, for proof of the wastefulness of our culture, and the overindulgence of our most mundane activities. In our decorative and sartorial guises he sees us often as little more advanced than our primate cousins. His is a consummate document, a compulsive endeavor to leave a record of this culture.

By the 1970s and 1980s the avant-garde photographer knew full well that there remained few concerns for the medium's descriptive capabilities with regard to the natural landscape. A new generation of more cynical artists, like Robert Adams and Joel Sternfeld, became preoccupied with the imposition of suburban America on those once majestic hills of Colorado and California. Others, like Stephen Shore and Doug Baz sought out the place for natural objects in man's civilized landscape. They documented the bushes, the flowers, and the gardens that had been planted in controlled settings and manicured by man in his leisure.

Another group of contemporary photographers is preoccupied with landscapes that the artist constructs himself: John Pfahl, John Baldessari, and John Divola among others. A visual construction is created to be photographed, and a witty allusion or ''sight gag'' that would not exist without the artist's manipulation becomes the content of the picture. John Divola, for example, embellishes or even defaces his landscapes, dramatically drawing attention to the absurdities created by man in his environment and ironically contrasting twentieth-century self-consciousness to the purity of nineteenth-century landscape photography. The contemporary artist is now creating his own artifacts for the landscape, making art itself the subject for reportage. This group of photographers is aligned closely in its concerns and linked to contemporary artists such as Christo and Smithson.

Latent in today's photographic imagery are the seeds of tomorrow's development. Although the photographer is the last to admit to influences on his development, he is both a product of the medium's history and, indeed, the environment he works in, and the pictures he makes reflect both influences. Few creative photographers have deliberately depicted the crag-

giness of the woods, the dirt, or the bugs. No equivalents have been made for the unpleasant experience of passing through the brush and being whipped in the face with a swinging branch.

In his book, *The Unforeseen Wilderness* (1971), Ralph Eugene Meatyard depicts a passage through the Red River Gorge using the harshest of light and the least pleasing of tones in his pictures. In the eroded gorge one feels the portent of an unfavorable passage. Nature has its perverse side, opposing any advancement of technology. Meatyard's Red River Gorge pictures provide a photographic equivalent. Alan Watts, in *Nature, Man, and Woman* (1970), observed that nature is usually seen symbolically as the feminine side of our life. We know a love of nature as a sentimental fascination with beautiful surfaces. But "seagulls do not float in the sky for delight but for watchful hunt of food."[6] Violence is inescapable in the predatory relationship that permeates our life.

The American landscape is more profoundly charged by those buildings that man has built upon it than by natural phenomena. As structures are built, the artist and the photographer contrive new imagery that documents the encroachment of civilization. Today the juncture in photography rests on the fact that man totally dominates the landscape. Nature photography as such can only be a reminder of a forgotten past, a throwback to the dream that no longer exists. No wonder that the recent eruption of Mount Saint Helens attracted thousands of photographers, journalists, and artists who sought to catch a glimpse of Mother Nature storming. Hundreds of picture makers gasped from their jeeps and airplanes at the sight of such primeval activity rarely perceived in their mundane lives. The potential of a volcano's destructive force impresses us, but in our routine life it is inconceivable that this spectacle will harm us. We gawk at the volcano as we might at a freak in a circus.

Few pictures of natural disasters have been made purely for expressive reasons; nature's harshness has been documented but rarely is it used in photographic art as other than a romantic backdrop for some human concern. Even the news pictures of Mount Saint Helens were basically confined to the majestic luster and the silkiness of the dust-laden earth around it. If the subject is repulsive to the viewer, often the photograph of it is seen negatively; the preconditioned reaction to the subject often causes the importance of the artist's attempt to be lost. In the hands of a master photographer even disagreeable subject matter can be made fascinating enough—"acceptable" enough—to impart the aesthetic experience. Such might be the case in the *Coyote* (1941) picture by Frederick Sommer or the bleak desert landscape for

which he is also famous. One can argue that the experience of whether the object photographed is negative or positive is subjective. But it can also be argued that the position and clarity of the technique and the virtuosity of the composition contribute to making an object transcend its origins and its subject matter, and consequently the conditions that make a beautiful object of a photograph are matters for more deliberate judgment and objective observation.

All of these points of view combine to leave us with one dominant concern: the primitive element in man fears the unknown, including the nature that lies just beyond the borders of his civilized world. The camera, faithful as a mirror, only reflects man's impulse and need to control and dominate these natural forces. Without risk of physical harm, photography probes the unknown, helping man understand and conquer the unfathomable.

NOTES

1. Alexis de Tocqueville, *Journey to America* (Garden City, N.Y.: Doubleday Anchor Books, 1971), p. 399.

2. Robert Persig, "Cruising Blues and Their Cure," *Esquire* (May 1979), p. 65.

3. Tocqueville, *Journey to America*, p. 399.

4. Russ Anderson, "Watkins on the Columbia River: An Ascendancy of Abstraction," in *Carleton Watkins: The Photographs of the Columbia River and Oregon* (Carmel, Calif.: The Friends of Photography, 1979).

5. Edward Weston, *Daybooks* (New York: Horizon Press, 1961), p. 221.

6. Alan Watts, *Nature, Man, and Woman* (New York: Vintage Books, 1970), p. 51.

ROBERT ROSENBLUM

Painting America
First

In 1976 the U.S. Department of the Interior commissioned forty-five landscape painters to pro-
duce their versions of outdoor America for what would be a traveling Bicentennial show. The
paintings that emerged stand as modern counterparts to those done roughly one hundred years ago
by such painters as Thomas Moran, Frederic Church, and Albert Bierstadt. How are these con-
temporary landscapes different from those done a century ago and what part of the ''vision'' has
remained intact? This essay by the writer and Henry Ittleson Jr. Professor of Modern European
Art at New York University, Robert Rosenblum, gives an idea of how American painters, as
distinct from the sculptors discussed in this book, are responding to the American environment.

Histories of American painting written after 1976 may provide quite a jolt for
those who thought that Stieglitz and the Armory Show had forever shut and
locked the doors on the nineteenth century. Could 1876 be alive and well in
1976? Can the spirits of Cole and Inness, Kensett and Bierstadt be
resurrected?

These are some of the questions that this exploratory exhibition will trig-
ger, for the pictures here offer a virtual stocktaking of those current styles and
attitudes that, against the grain of abstract art, still want a one-to-one
dialogue between things painted and things seen. Thanks to a happy govern-
mental inspiration, the American artist has once more been wed to the
American scene, confronted here with the surprisingly diverse range of
Americana that falls under the jurisdiction of the Department of the In-
terior—not only the remains of the American wilderness but also the
primeval animal, vegetable, and mineral kingdoms, lumber mills, dams,
forts, Colonial marketplaces, city playgrounds, even trash incinerators.
Choosing their own subjects from this repertory, some forty-five artists were

sent off to look and to paint. Their aesthetic colonization of the fifty states extended from Alaskan mountains to the Everglades, from Hawaiian water gardens to the Cape Cod shore, from Palm Springs to the Appalachian Trail. For some of the artists these commissions were, geographically speaking, unadventurous, involving sites within the familiar territory of their own landscape experience: Jane Freilicher at the Morton Wildlife Refuge in the Hamptons, New York; the late Fairfield Porter on the coast at Acadia National Park, Maine; Neil Welliver at the Moosehorn Wildlife Refuge in the woods of Maine. But for others, the leap from their usual city walls to the unbounded American landscape must have been breathtaking. There was Philip Pearlstein, baking in the sun at the Canyon de Chelly, Arizona; John Button trekking alone for days to get to the giant redwoods; Ben Schonzeit and Lowell Nesbitt together surveying the Continental Divide; Vincent Arcilesi, pitching his easel against the winds in the Grand Canyon. Such peregrinations of artist-explorers stir up American memories of almost exactly a century ago, not only of those painters—Moran, Church, Bierstadt—who tried to contain in rectangular canvases the uncontainable expanses of the West, but also of those intrepid photographers of the 1870s—Jackson, Russell, O'Sullivan, Watkins, Muybridge—who were determined, on their arduous expeditions, to document the Book of Genesis landscape that so challenged inherited European experiences of measurable time and space. And these farflung commissions parallel, at least in impulse, the efforts of our recent earthwork artists—Heizer, Smithson, De Maria—to reestablish connections with the primal American scene.

The insistent fascination of this anthology of a freshly documented America lies in the constant dialogue—at times harmonious, at times discordant—between the past and present, the nineteenth and the twentieth centuries. It is tonic to see revived, while they last, the traditions of recording those indigenous American facts that compelled the attention of so many nineteenth-century artists. Consider, for instance, the show's quartet of American fauna pictures, whose specimens look so refreshingly unlike most of the things artists choose to paint in the 1970s. For one, there is Ellen Lanyon's mural-size reconstruction of wildlife in an Everglades swamp, where wood ibis, water turkey, and alligator in their natural habitat recall Audubon's own close-eyed blend of exacting scientific illustration of textbook accuracy and a patterned linear elegance. Or, choosing a broader style and a more disarming angle, there is Alex Katz's alternately heroic and comic rear-end view of a Maine moose staring insouciantly from the sprawling landscape at the curious spectator. Another tradition of zoological description is revived in the profile rendering on white ground of other threatened native

species: Don Nice's hair-by-hair account of a buffalo in South Dakota (coincidentally, the emblem of the Department of the Interior) or William Allan's scale-by-scale rendering of a sockeye salmon in Alaska. These records of what was here before the Europeans include even the American Indian population (the Bureau of Indian Affairs is part of the Department of the Interior), with results—Fritz Scholder's Indian chief, Willard Midgette's Navaho powwow—that extend into the 1970s an American pictorial ancestry that goes back to George Catlin in the nineteenth century or, for that matter, to the first documentation of Indian life by John White in Virginia in the 1580s.

But it is above all landscape that dominates the show. Today, of course, the concept of *landscape* may even include the technological wonders, especially the dams that, within the cntext of rock and river, can often transform the West into an American version of the Valley of the Kings. Thus, both George Nick and Robert Birmelin view dams along the Columbia River in a two-part sequence—morning and evening—that weds these hydroelectric wonders to the dawn-to-dusk cycles of American nature as indissolubly as Monet fuses Rouen Cathedral with the changing light of France. And John Button, in his crushing view from below of the Shasta Dam spillway, recreates technology as almost an American antiquity, the California equivalent of a pre-Columbian pyramid looming against a limpid blue sky. It is this numbing scale, whether in dams or in still virgin landscape, that is reaffirmed throughout the show, the scale we already know both in the nineteenth-century terms of Church and his contemporaries and in the twentieth-century translations of Marin, O'Keeffe, and Hartley. These traditions are overtly perpetuated in the abundance of Sublime views: Lowell Nesbitt's four-part Cinemascope discovery of Shangri-La purity at the Continental Divide; Johan Sellenraad's panoramic vista of Tanguy-like canyonlands in Utah; Susan Shatter's giant watercolor recording of another science-fiction vista along the Colorado River; Vincent Arcilesi's bird's-eye surveys of the Grand Canyon; Roy Schnackenberg's mountain-climber triumph atop Mountain Brooks, Alaska. Even Wayne Thiebaud's more casual view of literally cliff-hanging trees at Yosemite has a sublime scale, as if the ghost of Bierstadt were haunting the California Pop scene. These are all works that stun the urban spectator with a rush of sheer vastness and unpolluted air.

In most of these works, the mood is one of exhilarating adventure and head-clearing oxygenation; but some explore more brooding mysteries. Mountains yield to sky in William Allan's moody immersion in the uncharted fluidities of darkening cloud formations, as they do in Alfred Leslie's

79. Philip Pearlstein: *White House Ruin, Canyon de Chelly—Afternoon.* 1975. Oil on canvas, 60″ x 60″. (Photograph: eeva-inkeri; courtesy Frumkin Gallery)

menacing invasion of fog and cloud at the edge of a western Massachusetts abyss that engulfs a tiny airplane, shaking our belief in the primacy of gravity and terrestrial matter. There are works, too, that confront one more quietly with the facts of New World time. John Button's uncannily still, giant redwoods only slowly reveal their scale vis-à-vis the minuscule streambed below, finally disclosing their identity as awesome relics of a prehistoric age. Similarly, Philip Pearlstein's records of the ruins of cliff dwellers in the Canyon de Chelly create, in their slow and painstaking description of the accumulation of rock and clay, an equally strange sense of American prehistory, where geological and troglodytic ghosts conjure up a mythic world of elementary power. And Vija Celmins's exquisitely detailed and mysterious document of the relics of tidewater glaciers both rises and falls, in its four-part presentation, with the slow and haunting tempo of Ice Age time.

But not all of these landscapes are so frighteningly primeval in their grandeur. Many, in fact, seem inhabited by the spirits of our nineteenth-century ancestors who began to tame these virgin forests. Fairfield Porter's idyll of Maine sea and rock may be savage, but it is still hospitable enough to include the human figure (as is also often the case in Winslow Homer's interpretations of the same coastal sites). Daniel Lang's hushed contemplations of the Columbia River Valley in Washington or Robert Jordan's corners and heights of the Appalachian Trail in New Hampshire project a luminous, thoroughly habitable Eden, in which the serenely pervasive light of a Kensett or a Fitz Hugh Lane seems to have survived the rigors of the twentieth century. And in Neil Welliver's light-flecked immersion in the dense woods of a Maine wildlife refuge or in Jane Freilicher's comfortably domesticated and sun-dappled union of Long Island's low sky, flat horizon, and wet and verdant earth, the ideals of American Impressionism still look worth pursuing. Rackstraw Downes also perpetuates the nineteenth century in his Romantic view of the cokeworks in the riverbed near Pittsburgh, which recaptures the gloom of early industrial blight: framed in a landscape as pastoral as a Constable is a view of what Blake called "Satanic mills"—a grimy cluster of factories whose exhaust pollutes Earth and sky.

Although most of the paintings here, with their direct perceptions and their styles that offer only slightly edited varieties of on-the-spot realism, would suggest that America, and American art, have barely changed since the nineteenth century, there are also ecological, technological, and aesthetic exceptions that locate us more obviously in the 1970s. Some artists, for instance, have transformed their documentations into worlds of private, even fantastic rumination. Hawaiian commissions in particular seem to have quickened almost Surrealist imaginations, as in Ann McCoy's underwater view of coral

reefs or Joseph Raffael's immersion in iridescent waterlily ponds that seem to merge late Monet with microphotography. Janet Fish, too, explores the wonders of intensely closeup vision, substituting for her usual glittering supermarket glassware a group of equally light-refracting mineral samples from the U.S. Geological Survey that are both literal in their description (the classification number is included on the specimen) and magical in their magnification, as in a jeweler's glass, of crystalline colors. No less other-worldly are Jack Beal's eerie pastels of sites in Virginia ranging from Mount Vernon to a strip mine, works in which a drawing technique of unmodulated color on a dark gray paper ground can metamorphose, for instance, George Washington's vegetable garden into a dreamlike environment that hovers somewhere between children's book illustrations and Samuel Palmer.

Jack Beal's Virginia mine may have a never-never-land quality, but other pictures in the exhibition are poker-faced before the eyesores and/or glories of the twentieth-century landscape. Sidney Goodman coolly transcribes the spectacular ugliness of a trash incinerator digesting assorted junk in a dazzling chemical holocaust. And John Clem Clarke records the banal industrial fact of a lumbermill in a painting that fuses forest, factory, logs, and water in a silvery, beady, photo-derived stenciled image. Such paintings may seem matter-of-fact before the world of industry, but others can take an optimistic, even futuristic turn before the wonders of twentieth-century technology. So it is with Nancy Graves's enormous polyptych mural, which celebrates an astronaut's-eye view of nature revealed by ERTS (Earth Resources Technology Satellite). Scanning the United States from East to West, she constructs a timely extraterrestrial concept of nature derived from the barely conceivable altitudes of satellite photography. The startling coincidence of what at first seems to be only a complex mix of diverse abstract languages with what in fact are the scientific means of the topographical recording of North American earth and sky is Graves's mind-and-eye-expanding challenge to our thoughts about the seemingly unbridgeable gulf between abstraction and nature. Indeed, she suggests that nature may no longer be definable in the terms still accepted by the other artists in the show.

In the end, though, the stubborn, indisputable truths of the Photorealists deal the most subversive blows to the exhibition's general impression that a nineteenth-century view of America can still be preserved. The oil-and-water clashes of past and present are harshest in Richard Estes's and Robert Bechtle's shrill ironies. Estes, an Easterner, does it in architectural terms, choosing to paint the Colonial restorations near Philadelphia's Independence Square within their true urban context. Dwarfed by high-rise office buildings and viewed at the end of a long commercial street gleaming with cold light

80. Ben Schonzeit: *Greenport Sunset*. 1973. Acrylic on canvas, 90″ x 96″. (Photograph: Robert E. Mates and Paul Katz; courtesy Nancy Hoffman Gallery)

reflected in plate glass and metal, Estes's diminutive eighteenth-century brick buildings become anachronistic relics of a buried American past. Bechtle, a Westerner, blasphemes in turn the nineteenth-century American Garden of Eden by recording a breathtaking view of Palm Springs as an incidental backdrop that is almost completely blocked from sight by the ubiquitous American truth of the rear end of the parked family car and the wife and kids at awkward ease before the tourist's-eye view of artist-photographer-husband.

Yet the camera-lens vision preferred by so many artists of the 1970s need not entirely rule out eighteenth- and nineteenth-century beauty. Ben Schonzeit, facing the Continental Divide with a camera as his sketch pad, demonstrates that the mountain grandeurs of a Bierstadt are capable of unexpected revitalization in Photorealist terms. His transcription from photograph to canvas catches the sharp-focus wonder of geology and botany as well as the soft-focus sweep of miles-wide, miles-high vistas. And by joining in a diptych two disparate but related views of the western and eastern sides of the Divide (each 7 feet square), he creates a vertiginous collision of double amplitude that freshly captures what the Department of the Interior is trying to preserve.

Once again, then, this exhibition proves that art is capable of making us feel and see more acutely the world around us, a kind of pulse reading of the way things are now. We should therefore loudly applaud this grand Washingtonian scheme of calling in so many artists for help in reconsidering the American scene in 1976. Is it too much to hope that, after the flurry of the Bicentennial year, the U.S. government will continue to give artists the chance to reexamine America and to show us what they find?

MICHAEL MCDONOUGH

Architecture's Unnoticed Avant-Garde (Taking a Second Look at Art in the Environment)

In discussing the relationship of architecture to environmental art, Michael McDonough, the author of several articles on architecture and a teacher at New York University, poses some key questions relating to the basic kinship between architecture and art in general. Why has architecture taken so long to be considered an art, and how has the advent of earth art perhaps made the natural connection more obvious and acceptable? Architecture must fulfill a function and be useful and then take art into consideration. Conversely, does this exclude art, especially environmental art, from having its own functional and useful elements? McDonough examines the social and artistic history of architecture's growth, such as the difference between architecture schools and art academies. Much of his thesis rests on the notion of the "aesthetics of the sketch"—an idea that he feels may prove to be the missing link between these wrongly estranged worlds. Tom Wolfe dedicated From Bauhaus to Our House *to Mr. McDonough for his inspiration in its creation.*

The true avant-garde of architecture, the adventurous, risk-taking, experimenting, problem-seeking, redefining fringe, is not in architecture. It is in the jetties, towers, tunnels, walls, rooms, bridges, ramps, mounds, ziggurats, the buildings and landscapes, structures and constructions of environmental art. The work and processes of environmental artists, although excluded from official architecture, are nonetheless historically ordained, integral parts of architectural aesthetics. They function in much the same way the sketch painters, or "pre-Impressionists," did in the nineteenth-century Academy. That is, they bring personal, spontaneous, and original qualities long associated with the renewal and advancement of art directly into architectural thinking, and in doing so, point the way to the future. The architectural profession, long castigated from within and without for its dry,

narrow, and unresponsive approaches to conceiving the built environment, has available in environmental art a reserve of fresh, innovative aesthetic options. Environmental art is the missing, mysterious, libidinous id of architecture. And there is only one caveat: no one has noticed.

Broadly defined, *environmental art* is equatable with the act of building. Its legacy includes the prehistoric earth mounds and cities carved from mountainsides in the Americas, the upright stone avenues and sacred rings such as Stonehenge in England, the burial monuments and cities of the dead in Egypt, and, in fact, most of the built, carved, or painted evidence the world over, telling us that man recognized the spiritual and symbolic dimensions of shaping his surroundings. In the twentieth century it has taken the form of art that uses the Earth (forests, mountains, rivers, deserts, canyons, fields), and art that uses the components and processes of buildings (columns, walls, facades, excavations) and buildings themselves (either created or "found" objects in the landscape) for expressive purposes. It is art of the natural and built environments; hence, environmental art.

Architecture had a flirtation with art of this type during the first stages of Modernism. The De Stijl movement, the early Bauhaus, individual artists and architects like Constantin Malevich, Vladimir Tatlin, El Lissitsky, certain Dadaists such as Marcel Duchamp, and the American "bohemians" group all advocated or made art that was architecture, or architecture that was art. Representative works of the time include murals on railroad trains, music composed for factory sirens, whole rooms treated as artworks, and buildings and landscapes synthesized into vast sculptural/architectural statements.

Early Modernist architects commonly took their leads from experimental painting and sculpture, and contemporary painters and sculptors learned from the structures and proposals of architects. One group in Russia even paid homage to the idea by taking its name—ZHIVSKULPTARKH—from contractions of the Russian words for painting, sculpture, and architecture. At the time artists and architects fully expected such work to set the tone for all the arts of the later twentieth century. Known by many names, and eventually repudiated and forgotten by what we know as Modernism today, the spirit of ZHIVSKULPTARKH was a powerful presence in the early Modernist avant-garde.

As powerful as it was in the beginnings of Modernism, it vanished unceremoniously as social, economic, and political upheavals, and eventually war rocked and destroyed much of Europe. After World War II the immediate task at hand was rebuilding. Pragmatic reality dictated that this proceed quickly and efficiently, and in many instances expediency won out over

artistic adventure. That and the concomitant rewriting of architectural history by Modernist critics and theoreticians saw the idea of an active art/architecture synthesis fall into relative obscurity and, indeed, disrepute during the postwar period.

It resurfaced in the mid-1960s when artists attempted to move the aesthetics of painting and sculpture into larger, more public circumstances. This began with gallery-scale pieces that filled whole rooms, penetrated or appeared to penetrate floors and ceilings and walls, or that symbolically invoked natural landscapes. It soon gave way to a search for broader, traditionally nonart audiences, and bolder attempts to reach the general public. Art was brought literally into the streets and parks and roadways to escape the constrictions of what was seen as a too-narrowly-defined gallery and museum structure, reflecting, in part, the wider upheavals and social consciousness of the Vietnam War era and, in part, a loosening of aesthetic ties and boundaries inherited from the postwar years. If Abstract Expressionist painters such as Jackson Pollock used canvas to express an interior of psychological landscape in the 1950s, then environmental artists used the built and natural landscape as an exterior or cultural canvas in the mid-1960s and early 1970s.

Younger architects were involved in many of the same political, social, and aesthetic concerns as the art community, and an active dialogue between the two groups produced an atmosphere of possibility. Artists were soon working at the scale of architecture, using the materials of architecture, and the imagery of architecture, drawing on methods, areas, and ideas that architecture had either stylized, deemphasized, or renounced as acceptable mainstream concerns. Sometimes known as an-architecture, de-architecture, bizarre architecture, and anti-architecture, but collected for our purposes under the term *environmental art,* this work was heretical by Modernist standards, to be sure. In seeking to find questions rather than answers, avoiding control, stylization, and quantification, and exploring the mysterious instead of the rational, artists were challenging architects on their own ground. And the results were extraordinary.

The late Robert Smithson, for example, designed jetties, stairs, walls, ramps, mounds, and islands as part of his entropic architecture, in which all order tends to disorder, in which decay is implicit in all growth, in which the future is the past in reverse. In his work, paints and canvas were replaced by dump trucks and tractors moving mud, concrete, asphalt, and earth; sheds were buried and broken to form commemorative monuments, and future airports and museums were to exist among ruins. In the inverted processes of

his architectural landscapes "buildings don't *fall* into ruin *after* they are built but rather *rise* into ruin *before* they are built."[1]

The late Gordon Matta-Clark cut, split, bored, sectioned, and peeled buildings to make architecture by combining politics and art. His "planning methods" were based on guerrilla actions, temporary pieces, dis-functional shelter, and violated forms on the one hand and the desire for a more responsive, politically and perceptually aware aesthetic of building on the other. Reversing architecture's paradigmatic "sensitive solution to the difficult problem," his "an-architecture" put the difficult problem back into the sensitive solution, trusting impulse and inversion of expectation over procedural priorities and rationalist dogma. Matta-Clark cut a series of large circular holes into the upper floors of a Parisian town house in a piece called *Etant d'art pour locataire (Conical Intersect),* also known as *Paris Cutting* (1975). The building had been slated for demolition as a result of the construction of the Centre Georges Pompidou and was easily seen from the streets close to the

81. Gordon Matta-Clark: Untitled. 1974. A two-story frame house sawed in half before it was demolished. Englewood, New Jersey. (Photograph: D. James Dee; courtesy Holly Solomon Gallery)

museum. By cutting holes in the structure, Matta-Clark transformed it into an instant sculpture, making it a ''difficult'' symbol (the police came), and temporarily ''saving'' it by destroying it in an unsanctioned and illegal way. The ''sensitive'' and legal Centre Georges Pompidou eventually won out, of course, but not before *Cutting* had challenged its methods and its imagery. And *Paris Cutting* still ranks as one of the more memorable architectural comments on the destruction of Old Paris by *le nouveau chic techno*.

Alan Sonfist has proposed urban monuments based on earth cores, forests, reflective pools, rocks, wind, rivers, streams, deltas, hills, and the sun,

82. Alan Sonfist: *Towers of Growth* (detail). 1981. Sixteen stainless steel columns in groups of four, covering a 21' cubic area. Four indigenous trees surrounded by stainless steel columns whose height and thickness mark the past and future growth of the trees. (Photograph: J. B. Speed Art Museum)

writing: "Now, as we perceive our dependency on nature, the concept of community expands to include nonhuman elements, and civic monuments should honor and celebrate the life and acts of another part of the community: Natural phenomena." His use of the natural environment as source material proposes a perceptual restructuring of our urban areas, calling for the reintegration of natural imagery in cities and buildings with an iconographic and methodological shift away from technology and artifice. His *Time Landscape for New York City* (1965–1978), for example, reconstructs a primeval forest in three stages of growth on a plot in Greenwich Village. The

83. Alice Aycock: *A Simple Network of Underground Wells and Tunnels.* 1975. Concrete blocks and earth, 20' x 40' overall. An underground maze of six concrete-block wells, some connected by tunnels, some with access through open "entry" wells. Merriewold West, Far Hills, New Jersey. (Photograph: John Weber Gallery)

unregulated growth of the forest stands in contradistinction to the man-made city around it, making tangible the wilderness that once flourished there and offering the complex processes of the natural environment as an alternative to monolithic urban imagery. With Sonfist, form follows nature, and function is a reassessment of where we have come from and where we are going.

Alice Aycock's sheds, tunnels, towers, cities, labyrinths, and machines constitute an architecture about emotion, association, and implied narrative. With titles like *Circular Building with Narrow Ledges for Walking* (1976) and *The Angels Continue Turning the Wheels of the Universe Despite Their Ugly Souls; Part I* (1978), rendered in the simple technology of wood construction, her work is full of images suggested, invitations denied, processions violated, and stage sets without plays. In architecture a wall is structure and materials; to Aycock it is charged with psychological and mythological possibilities. Haunted, mysterious, threatening, it is as full of tales as it is of nails.

And there are plenty more: Dick Haas's archaeological/trompe-l'oeil wall murals, and Charles Simonds's imaginary miniature civilizations, and George Trakas's walkways and processions, and Michael Singer's landscape sculpture, and Mary Miss's architectural siteworks, and Walter De Maria's vertical kilometers and lightning fields and earth rooms, and Herbert Bayer's earthworks, Jackie Ferrara's zigguratlike bridges and towers, and Allan Kaprow's *Happenings* with ice or tires or other materials, and Chris Burden's highways and rooms of risk and threat, and Gianni Pettena's ice- and mud-covered buildings, and Anne and Patrick Poirier's fabricated archaeology, and Edward Ruscha's photographs of parking lots and apartment buildings, and Red Grooms's *Ruckus Manhattan* (1976), and Nancy Holt's constructed vistas and paths, and Siah Armajani's bridges and houses, and Christo's wrappings, and Dennis Oppenheim's psychological environments and fantastical machines, and the Punk-art–Found-art of parking lot sheds and South Bronx ruins, and Will Insley's *ONECITY* (1975), and John Baeder's diner paintings, and even Robert Wilson's stage sets, to name an incomplete but representative few.

They form a compendium of architectural experiments, innovation, and derring-do. The artists know how to make architecture by being intuitive, spontaneous, original, and personal. Many of them are reinventing architecture as they go along, discovering new facets of ordinary things, exploring new expressive modes. Their work is a type of primary architectural research, a poetic architecture, and, when it stands in opposition to mainstream architectural practice and theory, a type of built architectural

criticism: architecture's avant-garde. It is an unnoticed avant-garde, however (remember our caveat), because to the architectural profession the work is not architecture: to call it architecture is anathema.

Architecture, in a technical and legal sense, is work done by architects and nothing more. This fact carries tremendous weight within the systems of architectural education, history, criticism, employment, finance, professional hierarchy, and jurisprudence. Violation of the laws defining architecture, including "unauthorized" use of the words *architecture* and *architectural,* for example, is a criminal offense in many states and carries time in prison as punishment.

Even as the architectural profession itself trumpets loudly the spectacular failures, oppressive homogeneity, and other consistently alienating qualities of Modern Architecture, that same profession continues to seal itself off from

84. Charles Simonds: *Excavated Habitat, Railroad Tunnel Remains and Ritual Cairns.* 1974. Worked and unworked stones, 60' x 20' x 40'. Artpark, Lewiston, New York. (Photograph courtesy the artist)

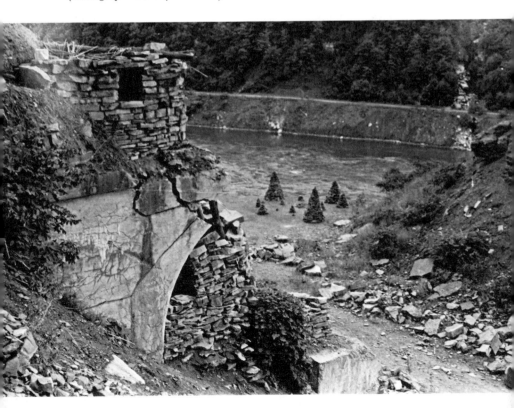

the outside world. Conrad Jameson has written in his essay "Modern Architecture as an Architecture as an Ideology,"

> ...under the name of professional standards, the Modern Movement tries to bolster the profession's prestige, even while restricting freedom of entry. As the architect's qualifications are defined by the Modern Movement, some of the great amateurs of the past—a Vanbrugh, a Michelangelo, a Thomas Jefferson—would be refused admission."[2]

One might add, the great "amateurs" of the present and future and the insights and intelligence they might bring are also refused admission and serious consideration. Jameson continues,

> The Modern Movement attempts to draw a mighty arc between art and engineering. No longer is the architect a superior kind of surveyor or draftsman: he is now a master of a special and even mysterious skill in which art and engineering are so seamlessly and uniquely joined as to disqualify those who do not possess it.[3]

85. George Trakas: *Union Station.* 1975. Wooden walkway, 144', steel walkway, 106'. Far Hills, New Jersey. (Photograph courtesy the artist)

Architecture's ideology is manifested in its predilection for statistical studies, surveys, pseudoscientific rationalizations, computer-generated investigations, and constant categorization of humanity and its expressive wing, art, right along with engineering. It presumes that the built environment is at its best when it is controlled, stylized, quantifiable, and rational: all the things environmental art isn't. Glass boxes, windowless concrete shopping malls, geometrically gymnastic vacation houses, and vast empty plazas with pathetic dying trees continue to proliferate, win accolades, and dominate our ever more homogeneous landscape because they are what

86. George Trakas: *Route Point*. 1977. Bridges 156′, frame 16′ x 22′ x 29′. Walker Art Center, Minneapolis. (Photograph courtesy the artist)

tautological systems of architecture have to offer. Modern architecture's primary assumptions about the world preclude the possibility of the messy or the indeterminate having a proper place in it, and, yes, exclude nonprofessional "amateurs" (especially artists) from making contributions because architecture, more than any other visual art, shuns personal expression and aesthetic experimentation as an ideological or professional base. The key to understanding why lies, as much as anywhere else, in architecture's own nineteenth-century history and what architectural historian Rayner Banham has called the "predisposing causes" of Modern architecture.[4]

However "mysterious" and ideologically isolated now, architecture in the nineteenth century was an integral part of the pervasive and tightly controlled system of visual art instruction and marketing known as the Academy. The Academy, centered in France and enjoying the support of similar systems in England, Italy, Germany, the United States, and other countries,

87. Mary Miss: *Veiled Landscape.* 1979. Wood and steel, 12′ x 15′ x 6′. Viewing platform, one part of a structure that covers 400′ overall. Commissioned for the 1980 Winter Olympics, Lake Placid, New York. (Photograph courtesy the artist)

constituted a virtual monopoly, an artistic empire. Under it, architects were considered to be artists, and so were trained under the same Academic rules, theories, and methodologies as painters and sculptors.

The primary objective of the Academy was to preserve traditions, not create new ones. Art instruction was organized pretty much as it had been from the time of the medieval guilds: an artistic hierarchy, unquestioned theoretical propositions, and an aesthetic framework that demanded imitative skill over originality, assumed the superiority of the antique over the contemporary, and viewed personal and perceptual modes of expression with suspicion and disdain. Painting, sculpture, and architecture were, in fact, known as the "imitative arts."

As the century progressed, cracks began to appear in the Academic monolith. Painting and sculpture moved away from pure imitation of antiquity—gradually to be sure—and began exploring more personal and original modes of expression. The growth of new audiences among the monied mid-

88. Mary Miss: *Field Rotation.* 1981. Wood, gravel, concrete, steel, earth, and water; the pinwheel-shaped structure (7' x 56' x 56') is centered in a 4½-acre area that comprises the whole artwork. Governors State University, Park Forest South, Illinois. (Photograph courtesy the artist)

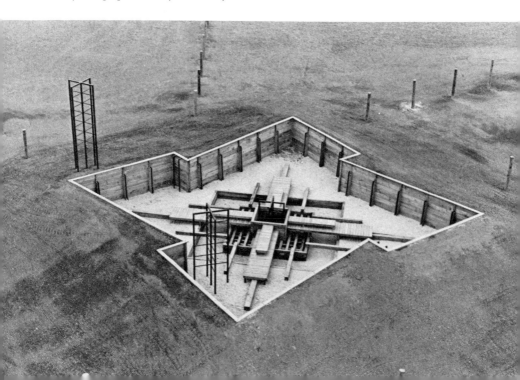

dle classes, their preferences for the newer work, and their emergence as influential consumers of art at the Academic salons, all provided incentives for experimentation and even precipitated the appearance of individual artists working outside the Academy.

Architecture, although occasionally forced to come to terms with technical advances such as railroads, was not appreciably influenced by the middle-class market. Public buildings continued to be the determining factors in architectural tastemaking and, financed principally by the government, continued to fit comfortably within the government-mandated Academic market structure. And while Monsieur Bourgeois Marchand might be able to collect enough francs to keep several independent artists going at once, the chances of his being able to raise the vast sums necessary to construct enough major buildings to exert a stylistic influence were just about nil.

This schism is of more than passing interest because it colored the development of art and architecture up to and beyond the emergence of Modernism, and set the stage for the exclusion of environmental art. The twentieth century has rejected many Academic principles to be sure, but the break has

89. Jackie Ferrara: *Laumeier Project.* 1981. Cedar, 16′ x 21′ 8″ x 19′. Laumeier International Sculpture Park, St. Louis, Missouri. (Photograph: Laumeier International Sculpture Park)

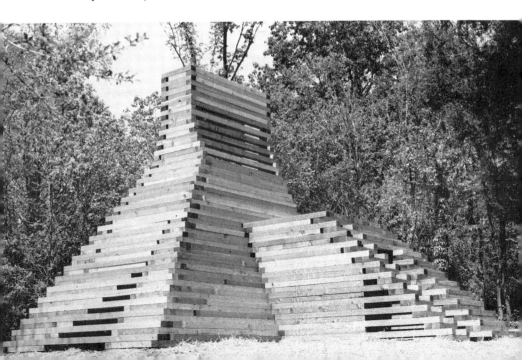

90. Anne and Patrick Poirier: *La Grande Nécropole*. 1976. From the *Domus Aurea* series, 1975–1977. (Photograph: Puyplat; courtesy the artists)

never been so clean or complete that the Academy's influence can be dismissed wholesale. While changing market conditions outside the Academy are significant, they do not determine specific artistic developments so much as set the stage for those developments. Academic instruction—they had a maxim: "Control instruction and you will control style"[5]—remained the mechanism through which change was ultimately effected, through which ideas were transmitted. And it is here that the schism between art and architecture indicated in the marketplace takes on even more significant dimensions.

Albert Boime in his book *The Academy and French Painting in the Nineteenth Century* describes the beginnings of twentieth-century art as traceable in large part to a specific aesthetic debate within the Academy itself, a recurring and challenging series of disagreements among young artists and theoreticians in the ateliers and public salons of the Academy during its twilight years. It is this debate that ultimately separates the exclusive, rationalist ideology of ar-

91. Nancy Holt: *30 Below.* 1979. Red bricks, steel, concrete, and concrete block, tower 30' x 9' 4", arches 10', openings 8'. The arches and openings face the cardinal points. Commissioned for the 1980 Winter Olympics, Lake Placid, New York. (Photograph courtesy the artist)

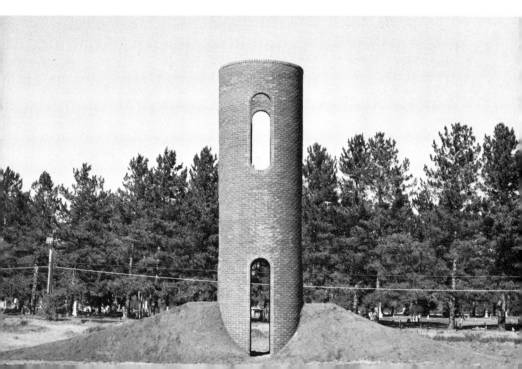

chitecture from the expressive, inclusive ideology of art, and in turn explains the yawning gap between architecture and environmental art today. Dr. Boime calls it the "aesthetics of the sketch."

The Academics, it seems, had two distinct and separate steps in producing an artwork: the first called the *sketch*; the second called the *finish*. The *finish* was the finished work—smooth, refined, "realistic" in the sense that it depicted things as they seemed to be to the ordinary observer. The *sketch* was rough and unfinished, a fleeting attempt to capture an effect (*effet*) or an impression. It was both a preliminary study, and a sort of model for the finished piece. The trouble was that some saw the sketch as the more telling indication of the artist's talent and wanted sketches entered in the salons. The debate between finishers and sketchers touched on issues as old as the Academy itself and, according to Dr. Boime, rocked it to its very foundations.

> Since the seventeenth century the Academy had held that a sketch, as a preliminary step, was crucial to the artistic process. During this stage the artist was taught to manifest his *première pensée,* that is, the spontaneity and movement of his initial inspiration. However, he could not regard his work as finished at this point. Reason and deliberation were considered indispensable to the creative process, and so the sketch had to be carefully reworked and finished. It was his capacity to execute the dutifully finished work which proved a painter a true artist. Yet it could not escape the notice of enlightened artists and critics that the personal qualities and philosophical values associated with the sketch—originality, spontaneity and sincerity—often ran counter to the qualities displayed in the Academically finished work.[6]

As time went on, certain artists and critics also began to feel that the qualities and philosophical values associated with the sketch were what art was all about; the *sketch* was in fact *the finished work*. Dr. Boime summarizes,

> Through spontaneous execution the artist's sincerity and individuality emerged—unmediated by the trappings of Academic requirement. The removal of this conventional interference with perception corresponded to the advanced conceptions of originality. Indeed, the mid-nineteenth-century preoccupation with contemporaneity (which is still with us) is intimately connected with sketch aesthetics.[7]

The aesthetics of the sketch establishes the Academy's debate on method and technique as a necessary link between nineteenth- and twentieth-century art, a kind of springboard for artistic progress, and an indispensable step in

the evolution of individual artists. In this sense it is the basis for the perceptually oriented, creative, original, spontaneous, curious, iconoclastic, individualistic, nonhistorical, abrasive, challenging, mysterious, dark, shocking, investigatory, good, bad, or ugly art we claim as our own. In this sense, too, it indicates that architecture has a historical claim to the legacy of experimentation—originality, spontaneity, and sincerity—that constitutes environmental art. Or it would, save for one complication: architecture got left out.

Although architecture enjoyed a close relationship with painting and sculpture throughout most of the eighteenth and up to the mid-nineteenth century, by the beginning of the twentieth century it was moving in a distinctly different direction. Would-be architects in the 1850s, for example, had to display proficiency in figure drawing and bas-relief casting, the same as would-be painters and sculptors; and those painters and sculptors, in turn, had to display proficiency in architectural composition. Starting with academic and administrative reforms in 1863 and continuing throughout the late nineteenth century, however, art and architecture courses became progressively more divergent. The number of architecture courses doubled, with new emphasis on building construction and technology, a *diplôme* in architecture was instituted, the number of juried prizes and the number of students in architecture increased, and in general a less informal atmosphere prevailed.

Pedagogy changed, too. In 1867 Charles Blanc's *Grammaire des arts du dessin,* the bible of arts studies at the Academy, described architecture, sculpture, and painting as being united by universal human proportions and a common cultural and intellectual heritage. By the turn of the century Julien Gaudet had thoroughly organized, catalogued, and codified the study and practice of architecture as a separate and distinct art in his *Éléments et théorie de l'architecture* (1870–1880), a book by an architect for architects about architecture.

In addition, while the nature of the *esquisse,* or sketch, had always carried a somewhat different connotation in architecture than in the other arts, the strict new architecture course exacerbated the differences. The sketch in painting was a preliminary working study. In architecture it was an integral part of increasingly rigorous student competitions. If a student's architecture project varied in any substantial way from the initial sketch, for example, the entire entry—and the months of work behind it—was totally disqualified.

At one time the conceptual leap from painting to sculpture to architecture had been as easy as the leap from painting to sculpture is today; by the turn of the century it had become tough. (Michelangelo did buildings and paint-

ing and sculpture; for Degas and Seurat buildings just weren't in the cards.) Matisse, an aberration, managed to build a complete chapel at Vence, France (1948–1951), down to the last detail of furniture and decoration, but underwrote most of the project himself.[8] Already distanced by market conditions, technical concerns, and an inability to absorb artistic change quickly, architecture's increasing academic isolation had it turning away at the moment the world changed. Those early Modern artist/architects—from El Lissitsky's *Prouns* or "projects concerning the new art" to the Bauhaus's *Baukunst* or "building art"—had tried to pick up where the architectural *académiciens* left off. But the momentum had been lost: architecture missed the Great Debate. You cannot build buildings and monuments from sketches, or so the architects thought, so the "aesthetics of the sketch" just never came up. Separated from its sister arts, architecture is still stuck in its Academic mode, without the aesthetics of the sketch.

Instead of imitating classical antiquity, for example, architecture emulates classical Modernity. Ludwig Mies van der Rohe, Le Corbusier, and Walter Gropius occupy places in the pantheon of architectural gods once reserved for Vitruvius, Palladio, Scamozzi, and Vignola. Modernist (and post-Modernist) styles and motifs are reinforced through exclusionist architectural history, design methodology, academic and professional hierarchies, emphasis on technique and rote learning of aesthetic theory, and a preference for imitation over originality. ("Control instruction and you will control style.") Students are, in a real sense, acolytes for their professors, dependent on them for approval and professional contacts. The salons are intact, taking the form of architectural competitions judged by other architects. Jameson observes:

> . . . the Modern Movement seals off criticism from without by all but preempting the right of criticism to its own followers: only an architect can truly judge another architect's work, and even he must be schooled in Modernist beliefs before his criticisms will be allowed to carry weight.[9]

In architectural theory the art/architecture hybridism of the early Moderns, the shared aesthetic heritage, and the continuing common ground of architecture and other visual arts remain ignored, treated as a curious anomaly, or squeezed into the cracks of architectural theory. Knowing no other way, architecture acquiesces: environmental art remains the unnoticed avant-garde, architecture's expatriate "aesthetics of the sketch."

If architects could get beyond architecture as they know it and learn to look at environmental art, they could see how other planners and builders

—operating under radically different assumptions—conceive of space and form and image and could learn to unlearn the unnecessary and inhibiting aesthetic constraints "classical Modern" architecture has fostered. With so much of our environment being the result of the planning and decision-making process, with the projected growth of the work-at-home future, with more time being spent in the designed indoors, and with ever larger, more complex, more contained environments being built all the time, and, especially, in the context of architecture's self-styled searching for what comes after Modernism and the widespread dissatisfaction with the built Modernist legacy, architects could use some aesthetic and methodological alternatives. In deserts, fields, mountains, and lakes, in galleries, art schools, art magazines, and art books, on video screens and in the movies, in suburban towns and cities, artists are already employing these alternatives, working with scale, form, association, myth, archaeology, history, inversion of expectation, gesture, technology, procession, events, impermanence, perception, fantasy, and indeed the whole cornucopia of natural and built environments, holding their own versions of architectural Salons des Refusés, and succeeding marvelously well.

Describing the role of the architect as an artist in his *Grammaire des arts du dessin,* Charles Blanc wrote,

Comme artiste, l'architect invente les combinaisons de lignes et de surfaces, de pleins et de vides, qui devront éveiller dans l'âme du spectateur des impressions d'étonnement ou de majesté, de terreur ou de plaisir, de puissance ou de grâce.

Astonishment, majesty, awe, delight, power, and charm in building are an extraordinary legacy, indeed. In the face of it and in the face of much vital and innovative work coming from young practitioners, it is time for architects to reclaim their historically mandated right to treat architecture as an art form as well as a science, to reclaim its expatriate avante-garde, and to renew the dialogue between architecture and the other arts.

It is time architecture picked up where it left off.

NOTES

1. Robert Smithson, "The Monuments of Passaic," in Nancy Holt, ed., *The Writings of Robert Smithson* (New York: New York University Press, 1979), p. 54.
2. Conrad Jameson, "Modern Architecture as an Architecture as an Ideology," *Via: Culture and Social Vision* 4 (1980), p. 19.

3. *Ibid.*

4. Rayner Banham, *Theory and Design in the First Machine Age* (New York: Praeger Publishers, 1960), p. 13.

5. Albert Boime, *The Academy and French Painting in the Nineteenth Century* (New York: Phaidon, 1971), p. 4.

6. *Ibid.*, p. 10.

7. *Ibid.*, p. 1.

8. Alfred H. Barr, Jr., *Matisse: His Art and His Public* (New York: The Museum of Modern Art, and Boston: New York Graphic Society, 1951), p. 279.

9. Jameson, "Modern Architecture," p. 19.

KENNETH S. FRIEDMAN

Words

on the Environment

What are the connotations of the word environment *as applied to a body of artwork and is this word truly descriptive of this kind of art? In his essay on the exact meaning of the term* environmental art, *Kenneth Friedman, editor of the* Art Economist, *wonders about the difference between the drilling of an oil company and the making of outdoor art, for instance. Are not both environmental activities? Should the word* environmental *be applied to two such seemingly opposite frames of reference? Friedman suggests the possibility of a connection between the two, namely that each is a human activity.*

In *Frame Analysis: An Essay on the Organization of Experience* (1974), social anthropologist Erving Goffman made a charming leap of imagination that is instructive for the study and criticism of environmental art. He perceived that words shape the organization of experience, that our organization and framing of experience shape our perception, and that all the many factors involved in the development of ''words'' of ''organization'' or of ''framing'' are theoretically of equal importance, differing in reality only according to time and circumstance. As a result, he took a truism on which most social scientists agree, using it to create the framework for a remarkable volume by drawing on sources as common as newspaper articles. Rather than using constructed experiments or observed interactions as he had with great success in past studies, Goffman's leap consisted in the sensible choice of using some of the very materials that create and frame experience in the most common and pervasive manner.

In considering environmental art, most critics and artists have failed to appreciate the meaning, context, and nature of the environment. That is to say that a notion of *environmental* art has been elaborated from theories of art and

from notions of an art that is related to nature, nature being "the environment" in which "environmental art" takes place. Nothing could be more evidently sensible in today's art world—and nothing could be more wrong.

To understand environmental art, one must begin with a simple yet significant question. What is the environment? Or perhaps, what does the word *environment* mean?

Webster's Collegiate Dictionary (1943), an excellent version of *Webster's New International* (second edition), defines the word *environment* in this manner: "1: act of environing; state of being environed 2: That which environs; surroundings; specifically the aggregate of all the external conditions and influences affecting the life and development of an organism, etc., human behavior, society, etc."

The degree to which the word *environment* is related to the sense of surrounding or of overall placement and situation can be seen through the development and descent of the word from its origin in Latin. Bloch and von Wartburg in their *Dictionnaire Étymologique de la langue française* (second edition, 1950) locate its origin in the Latin word *vibrare*, which Partridge reports as meaning "to shake or brandish" in *Origins: A Short Etymological Dictionary of Modern English*. From that word grew *virare* of Vulgar Latin and *gyrare* of Late Latin, *gyrare* meaning "to turn (something), (anything) about" and *virare* meaning "to cause something to go about," particularly—in its original meaning—a vessel or ship. Through Old French and French, the word became *virer*, and into English as *veer*, as well as the nautical term *wear* meaning to cause a vessel to go about by turning the bow away from the wind.

The word *virer* in Old French and French had a derivative word, *viron*, meaning "a circle, a round, the country around (or surrounding something)," which appeared in Old French and in Early Modern French. From that word Old French and French gave birth to the word *environ* meaning "in/around" and functioning as a preposition and later as an adverb. In Middle French and Early Modern French *à l'environ* came to mean "in the vicinity," and from it the plural noun *environs* was adopted by the English language. The Old French preposition *environ* also gave rise to the verb *environner*, whence emerged the verb "to environ." While other Old French and Middle French words are related—as are certain archaic meanings from Early English, including the rare word *environment*—the current meaning and use of the word *environment* apparently derives from the verb "to environ."

Current acceptable meaning in common English is evident in *Webster's Seventh New Collegiate Dictionary* (1969), based on *Webster's Third New International Dictionary:* "1: something that environs: surroundings 2a: the complex

of climatic, edaphic, and biotic factors that act upon an organism or an ecological community and ultimately determine its form and survival b: the aggregate of social and cultural conditions that influence the life of an individual or community.''

With the growth of concern for the biosphere as a political issue of the movements identified with ''ecology'' and ''environmental activism,'' the term began to be inappropriately and almost exclusively applied to ''nature.'' The misunderstanding bound up in this media-influenced slippage of meaning should be evident in the fact that it is the total environment (social, political, economic, cultural, and natural) that affects our relationship to ''nature and ecology'' as it has come to be understood. Given that human beings and their culture are in the largest scale of description simply a form of life moving about and acting on the surface of the planet, the drilling of an oil

92. Dennis Oppenheim: *Radicality.* 1974. Red, yellow, and green strontium nitrate flares, 15 ' x 100 '. Long Island, New York. (Photograph courtesy the artist)

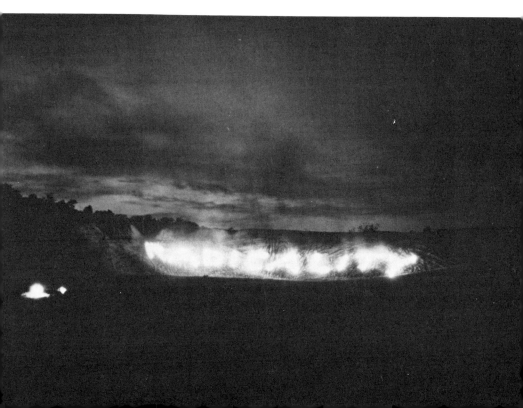

company is as much a part of the "environment" as a tree. That the oil company acts differently toward its host organism, the planet, than does a tree is significant, but both exist and remain. In some senses one can view human culture in its use of planetary resources much as one can view a colony of animals in its use of a forest or a group of insects meeting in the core of a planet. It is the decisions that human societies make that control their uses of nature and of the planet. Thus it is that, at least in human terms, the widest use of the word *environment* is in a direct sense the most appropriate.

Thomas Ford Hoult's *Dictionary of Modern Sociology* (1977) defines the word *environment* appropriately for our purposes: "In the most general sense, all the external conditions, physical and sociocultural, which can influence an individual or a group; sometimes used to denote physical surroundings as distinguished from the sociocultural; when employed in the general sense, often used synonymously with *milieu*."

Hoult goes on to cite Kingsley Davis, who in *Human Society* (1949) wrote that "there is no such thing as 'the' environment. There are many different environments, and what is environment in one sense may not be so in another."

The term *environmental art* has come to have a meaning that summons up images of earth art or art forms involved with "ecological investigations." A closer look at environmental art and at artists who engage environmental concerns in their art will reveal dimensions that are as much cultural as natural. Human beings create art as a cultural act, commenting through culture on culture itself and on all those aspects of existence and experience that affect them—including nature.

Only false romanticism or thin analysis can imagine environmental art to be related exclusively to "the natural." A phenomenon is lodged within the contexts of both culture and nature, as are all forms of art to a greater or lesser degree. As an art form concerned with the relation of our species and our societies to the planet on which we live or as an art form using our placement on and perception of the planet, what is called environmental art is as clearly focused on culture as it is on anything else. The focus may be diffuse, it may change and vary in proportion and perspective in the work of one artist or another, it may even seem to have more to do with "nature" than with "culture" as subject matter, but environmental art remains an art form that must—in order to be successful—deal with "all the external conditions, physical and sociocultural, which can influence an individual or a group."

CINDY SCHWAB

The Presence
of
Nature

Cindy Schwab, a frequent contributor to Arts *magazine, was one of the organizers of the downtown Whitney Museum's 1978/79 "Presence of Nature" show. In her essay, which served as an introduction to the catalogue of the show, she discussed the work of a range of artists, mostly sculptors, who "are drawn to trees, mud, leaves, hemp, skin, and so forth as ready-made materials requiring no further transformation." She describes how elements like process, repetition, and the artist's memory have taken on new meanings in these artworks.*

The American landscape has long been a source of inspiration for artists who have celebrated its physical beauty and fertility, but the act of using the land directly for sculpture is a recent development in art history. In the late 1960s artists began to question the very notion of the art "object" and sought ways of making art outside the traditions of painting and sculpture that resisted the use of conventional gallery space and the injustices of the marketplace. Large-scale projects were realized in remote regions of the country and often required the use of heavy machinery that altered or relocated sections of earth according to the artist's instructions. There was little concern for portability, public access, or marketability, now very legitimate factors of an artist's intention.

Although many artists continue to work out of doors in site-specific works, we in this exhibition were concerned with those who have responded to the more romantic possibilities overlooked by the modernist polemic of the past decade. The Earth has supplied artists with pigment for centuries, but these artists, most of them sculptors, are drawn to trees, mud, leaves, hemp, skin, and so forth, as ready-made materials requiring no further transformation. While some of these artists have erected pieces in natural sites, they have all, for the most part, returned to the studio environment where execution is private and laborious. The works in this exhibition take on many forms, yet

they are unified by the intention to preserve the natural appearance of the materials, which has been accomplished by simple means not ordinarily associated with studio procedures. These materials have not been transformed, but reshaped, rearranged into structures and images by craftlike manipulations, such as binding and tying.

Process and repetition, two important aspects of Minimalist strategy, are given new meaning when applied to natural materials. The look of the handmade object is a dramatic turn from the fabricated structures that appeared in the early 1970s. These artists practice an ethic of hard work, labor, craft (and the tedium that goes with it), demands implied in most work related to the land. The act of binding is common to many of these works, but is most apparent in Jackie Winsor's *bound logs* (1972–1973), in which the artist has methodically secured two 9-foot logs in four massive balls of hemp; and Harriet Feigenbaum's *Philadelphia Pentagon* (1978), in which each branch is laboriously joined with small bow-ties until all five sides are erected. Binding gives a very different connotation in Sarah Draney's *Leaning Bound Stick Piece # 4* (1973), a bundle of long thin sticks that have been tied with colored threads. References to traditional woman's work, sewing, weaving, are implied, yet none of these women has suffered any intimidation in the handling of cumbersome objects.

Sometimes the application of process results in stunning patterns that are part of the process itself. Alan Sonfist has troweled mud over the surface of canvas, where it is left to crack and separate creating an allover pattern of webs and lines. In a sense these paintings continually re-create themselves through time, ironically preserving their disintegration. In *Some Lines for Jim Beckwourth* (1978) Martin Puryear twists long thongs or rawhide whose small tufts of hair expand or contract according to variations in the weather. Resembling an abacus or a muscal staff, they also elicit a more visceral response, as does Sarah Draney's *Green Sound Skin* (1973).

These elegant pieces, like Alan Sonfist's *Cracked Earth Paintings* (1969), in which different soils on canvas reveal their own innate structures, renew a mythology that the land has held for urban society. Michelle Stuart's recent rock books act as literal histories, yet become poetic metaphors of secret knowledge. Titles refer us to places of visitation by the artist (Salinas, California; Raritan River, New Jersey) but as well to the origins of the books whose pages have been rubbed with earth from those regions. Deborah Butterfield's involvement with nature has also provided the inspiration for *Small Dark Fork Horse* (1978); made of mud and sticks packed tightly into a steel armature, it looks as if the land itself had given birth. Butterfield whimsically

gives this newborn colt six legs, but its weatherbeaten appearance assumes the wisdom and experience granted only by age. Similarly, Alan Sonfist has reconstructed the frozen pond where he once skated as a child. By laying canvas beneath falling leaves he is able to capture their own arrangement, which when embedded in encaustic do recall leaves frozen "in time." Again, Sonfist illustrates cycles of growth and decay with pungent irony. Rosemarie Castoro's *Beaver Trap* (1978) also displays a penchant for the ironic. Wooden spears arranged around a 12-foot diameter also look as if they had been planted. Yet this piece relies on its balance to, in effect, work. Conceived as a trap (for unsuspecting trespassers), each branch has been carved and smoothed to a fine point. Rudolph Montanez's *Clover Leaf* (1978) ironically sprouts into the shape of a clover with the help of an aluminum armature. A siphon hidden inside the pedestal transports a continuous supply of water, and special grow lights hasten the natural growth toward an "unnatural" image. On the other hand, Marilynn Gelfman-Pereira uses delicate twigs and Monel Metal to construct geometric structures similar to shapes already found in nature. Enclosed in Plexiboxes, they take on the appearance of precious gems, at other times they appear to be miniature tableaus where anthropomorphic twigs ready themselves for attack. This quality takes on a humorous note in Harriet Feigenbaum's *Philadelphia Pentagon,* in which curved branches display an amusing ambivalence. Surrounded by a garden of stumps, the pentagon with its associations of history, war, and government becomes a target of ridicule but also a shelter providing security and safety. *Expansion Circle* (1975) by Patsy Norvell is another transparent enclosure through which both sides are seen at once. Like a drawing in three dimensions, long thin sticks are crosshatched at a chosen width to determine the size of the circle. The piece is first woven on the floor, then raised and joined with fine wires. Ironically, Norvell has captured the more illusive qualities of air, light, and space that also make up the natural environment.

All these works share a sense of irony that occurs when art and nature are directly involved with each other. The collection of these materials from the natural environment implies a separation from their origin, which is their source of life; yet these artists have taken special care to preserve these materials as they have found them. In so doing, they have exchanged roles with nature, creating illusions, images, and structures that look as if nature itself had designed them. Even when works are solely the results of physical processes, their link with nature imbues them with mystery and metaphor. These artists have explored a third region where paradox and irony reign and where simplicity meets with extraordinary complexity and beauty.

JEFFREY WECHSLER

Response
to the
Environment

In this essay Jeffrey Wechsler discusses just how it is that environmental artists respond ar-tistically to their works' natural settings, how the environment's changes augment their work, and what concessions must be made to its cycles. By giving examples of several artists' works Wechsler, a curator at Rutgers University Art Gallery, raises the question: Just what makes all of these very diverse and individual works examples of environmental art? And assuming that all of the artists mentioned fit into this category, are all trying to express the same philosophy through this relatively new medium, the environment? Does all environmental art spring from a similar attitude toward nature?

There is not yet a catch-all historical term for recent art that uses the natural environment and natural processes as its creative sources and there may never be. This is perhaps a fortunate situation, considering the diversity of intent, method, and product evidenced in art of this type. However, a large enough number of artists have been directing their work toward the investi-gation of natural phenomena, creating a body of art that might appear to have the vague outlines of a potentially nameable "movement."

Earthworks, direct manipulations of the landscape that are possibly the best-known manifestations of environment-related art, comprise only one variation within the total output of art presented in this exhibition. As does much of this art, earthworks may show influences of artistic tendencies that reach back to the early 1950s. At that time, for example, Robert Rauschenberg was probing the boundaries of traditional art media with his "earth paintings," which incorporated soil and grass—in a way, indoor wall-hanging earthworks. In the early 1960s in France Yves Klein was attempting to expand the scope of visual art by having it interact with the environment. He exposed paintings to the effects of wind and rain, produced sculptures from natural sponges, and made reliefs mimicking geologic formations.

Beyond these early isolated efforts, the late 1960s saw a widespread turn

toward media and formats previously considered subaesthetic. Random or semistructured composites of pliable, amorphous, or organic substances were experimented with, and revealed great promise as fresh conceptual and material sources of art. The acceptance of naturally occurring configurations as viable art forms, the growing concern of younger artists visibly to infuse the actual processes of artmaking into their works, and a general search for new materials that would better reflect a more inclusive attitude toward what may constitute the territory of art were all conducive to the natural environment becoming a logical and, ultimately, fertile field for aesthetic examination.[1]

Of course, nature has been "inspiring" artists for centuries. But in the past decade the production of environment-related art has undergone a noticeable upsurge and has taken on a multilevel expressivity through inventive elaboration on conventional methods or wholly innovative aesthetic schemata. Perhaps certain artists are, in part, mirroring the concerns of contemporary Western society—witness the current ecological awareness, Earth Days, environmental action groups, even the "natural foods" wave.

Whatever the sociological or aesthetic forces at work, the purpose of this exhibition is to show recent environment-related art in its many forms, which are indeed numerous. Specific pieces selected for this show have at times been categorized as process art, Conceptual art, performance, earthworks, ecological art, combinations of the above, or, for some, none of the above. What has brought these works together is a belief that the creation of each was dependent on a deeply felt reaction, understanding, interest, or concept stemming directly from the natural environment and/or the processes functioning within it.

An important factor to be appreciated in the works in this exhibition is the heterogeneity of means that emerges from the filtering of the environmental theme through the individual sensibilities of the artists. As far as scale is concerned, the artists who create earthworks seem quite willing to meet nature on its own terms and at its own dimensions. Contemplation of works of art that cover 500,000 square feet or require the displacement of 40,000 tons of earth evoke, at the least, one's awe.

When you are dealing with a great mass, you want something that will, in a sense, interact with the climate and its changes. The main objective is to make something massive and physical enough so that it can interact with those things and go through all kinds of modifications. If the work has sufficient physicality, any kind of natural change would tend to enhance the work.[2]

As the above statement by Robert Smithson suggests, it must be realized that grandiose efforts to rival the physical size of nature's achievements inherently involve subjecting the work to whatever natural forces act at its particular locale. But unlike the unwanted dust that may settle on an art object in a museum, such conditions, even if destructive, are acceptable as part of the ongoing processes of nature, of which the earthwork is now a segment. By the vastness of the art project and the sharing of its substance with its surroundings, the art and the environment become confluent in the viewer's experience.

Smithson was fascinated by the concept of *entropy*, the gradual, inevitable distribution of energy in any natural system toward a static base level. In his *Spiral Jetty* (1970), 1,500-foot spiral of earth and rocks constructed in the Great Salt Lake, Utah, and in his other outdoor projects Smithson appreciated the changes wrought on his work by the environment, including disintegration, sedimentation, and even eventual disappearance. At times the *Jetty* may be submerged; at other intervals it is densely encrusted by a crystalline layer of salt.

An observer of an earthwork can therefore feel a strange tension in this artificial/natural object. Although man-made, the pleasure derived from its presence can be analogous to that of viewing, say, a natural bridge hewn by the wind. The *Jetty* and the natural bridge will both be shaped and eroded by nature, and may lose their gracefully curving forms. The grand-scale intrusion of an earthwork into the landscape elicits knotty questions about what we consider to be of beauty, of aesthetic validity, in the spectacle of the land, and perhaps raises philosophical points about whether our seemingly instinctive reactions toward natural phenomena can be matched by products of human activity.

One parameter of our comprehension of natural forces is time. Mountains, as well as earthworks, will be transformed in time. Our understanding of the processes at work in nature depends on seeing change and somehow measuring it. Artists who are attracted to natural processes must respect the temporal element of their media, and therefore they devise methods of making natural change visible, or at least venture to construct systems that suggest their presence. They try somehow to focus our attention on what we might have otherwise overlooked, or have been unaware of.

With his *Condensation Boxes* (1963–1965), Plexiglas enclosures containing distilled water, Hans Haacke makes us aware of the very atmospheric conditions that envelop us at a given moment. The droplets of water that condense on the interior surfaces of the boxes are a visible record of the thermal and

barometric state of their location. Fluctuations in these conditions reveal new arrangements of condensation; the art is a literal response to the environment.

The surprising forces latent within germinating plants are explored by Robin Mackenzie in *Concrete and Green Seed* (1971). Several pounds of seeds are incorporated into a 3-inch-thick mat of wet concrete, sand, and gravel. After the mixture has solidified, a sprinkling of water induces growth in the seeds, which then sets up sufficient stress within the stone actually to crack it apart. Viewed over a few weeks' time, the progressive shattering of the concrete turns the presumably fragile process of germination into a dramatic display of strength.

Alan Sonfist has made many works involving the molding of canvases. Displayed either open to the air or eventually sealed in a glassed-in frame, the slow growth of the microorganisms is partially exposed, partially hinted at. Like natural abstract paintings, the fields of color, texture, and areas of concentration catch one's eye. Implicit is the passage of time needed for the cells to reach the specific pattern of development that is perceived at any instant. Sonfist has stated:

> My work deals with the idea that the world is always in a state of flux. My art deals with the rhythm of the universe. The pieces are a part of the rhythm. A plant grows in cycles—a man moves in cycles—my work tries to bring about awareness of these movements. My works are transitions—they provide associations. One has to mediate with my work to gain an understanding. It is not the beginning or the end that I am concerned with but the energy that is given or received through communication with my work.[3]

Energy, associations, cycles, and even a form of "co-authorship" with another natural creator of sorts, all mark Sonfist's *Abandoned Animal Hole* (1971). It is a plaster cast of the vacated underground living quarters of a burrowing animal, a weird solid translation of the negative spaces produced by months, maybe years, of excavation by the animal. With dirt, grass, rocks, nuts, and so forth, fixed in place, the maze of tunnels, chambers, and surface "openings" meanders for twenty feet or so. It is a natural wonder of engineering brought to light, and one marvels at the continual creations that proceed unsuspected beneath our feet.

Humans also travel through the environment, albeit above ground for the most part. As one might take a snapshot during an encounter with the outdoors, or just collect memories, some artists find such a sojourn an ap-

propriate subject for their art and try to capture the transient feelings. Richard Long sets out on walks through the countryside and records the time taken for specific journeys, photographs areas along the route, or marks his passage by placing stones at predetermined intervals. His experiences are distilled for presentation into a few explanatory words, perhaps a few photographs, and maybe a map to show us his way. Our imaginations are set free to retrace Long's peregrinations and share in his past adventures.

Sylvia Palchinski, who has made many nature-related mixed-media constructions, now turns her experience of a site into an event (*Earthspeak,* 1971). She has produced performance pieces, in open landscapes or in gardens, that are rituallike ceremonies incorporating strange costumes and symbolic structures that refer to the local topography and her reactions to it. Often, certain ritual objects are set afire, and blaze iconic shapes against the landscape or the sky.

Martin Hirschberg carefully studies sections of the Canadian landscape, making notes and drawings of the site, commenting on its ecology. Collecting samples of vegetation, rocks, sand, and other elements, he fuses these in position with a melted sheet of plastic and displays the conglomeration on a platform lit from beneath (for example, *Sublimation,* 1973). With the drawings, the stagelike mini environment is a specimen of what Hirschberg chose to record about the original area.

An artist's selection and mode of presentation of natural materials for an art context can, through visual means, attune the viewer to new inflections of thought and emotion concerning the materials, and reassemble and redirect one's usual attitudes toward nature. Logs, one supposes, should just lie down on the ground, once detached from the tree. But Jackie Winsor's logs often lean against walls and, what's more, they aggregate into squares, rectangles, and grids by means of outlandishly large ravelings of hemp that bind them together at their ends. The naturally brutish, heavy quality of large logs seems slightly compromised in these odd configurations, although they retain quite enough of a sense of their woody origins to evoke an ambiguity as to the naturalness or artificiality of their situation.

Without partaking of the massiveness and weightiness of Winsor's logs, Sarah Draney's constructions of branches and twigs are also wall-leaners. Instead of bulky windings of hemp, Draney uses thread, connecting the standing shafts with a fragile web, emphasizing the delicacy of her modestly proportioned materials.

Bits of the environment can also be manipulated to demonstrate more theoretical propositions than visual power or grace. The divisions of Michael

Snow's *Log* (1973–1974) refer back to a series of four photographs of the log. The difference in height between the vertical composite of photos and their subject is a function of the camera angles used in shooting the pictures. Recently, Snow has found natural occurrences, ranging from a grassy field to insects splattered against a car windshield, adaptable to his conceptual explorations. In *Log* the environment is in the service of perspective.

Jan Dibbets also enjoys conceptually tampering with the landscape's status quo. Photographically, he has coaxed mountains to rise out of Holland's flat seacoast and has produced other compelling disturbances of level topographies through the incremental tilting of his camera and the joining of the resultant images. Such aberrations as diamond-shaped sky holes in the middle of a landscape can ensue.

With an impressive list of past practitioners to its credit, two-dimensional representation of the environment continues unabated, although many new twists have lately enlivened this venerable tradition. For example, Ann Mc-Coy has pushed the detailed rendering of landscape into a sort of compulsive gigantism, producing colored-pencil drawings reaching dimensions of 8½ by 19½ feet, and has also seen fit to punctuate these panoramas with fanciful anomalies such as airborne starfish and butterflies inhabiting mountain peaks. She also respectfully acknowledges her predecessors:

> For the past eight years I have been interested in what some art historians have labeled "the cosmic landscape tradition." A childhood love of nature, coupled with an interest in transcendental philosophy, has made me interested in the artists who were concerned with both: Moran, Cole, Church . . . The artist should be a novice unbound by the intellect and its restrictive manifestations—a vehicle, a transparency through which a universal force can flow. For me, the wordless dialogue with nature, which becomes the monologue of transcendental unity—the nature experience—has other dimensions, and is not purely an empirical or sensual experience.[4]

Recent two-dimensional depiction of nature has annexed aspects of the environment that expand its visible territory. Pulling back as far as possible while still maintaining a sense of the earth, both Rafael Ferrer and Nancy Graves are making pictorial statements based on maps. And Paterson Ewen strives to catch the essence of temporary natural phenomena in the landscape, including precipitation and the movement of rocks along a riverbed.

Presentation of the landscape in painting is familiar enough, but can the subject be translated into sculpture? Somehow the task of convincing replica-

tion of the substance of the environment seems unthinkable. Yet Tom Benner reproduces life-size boulders in fiber glass, the easy movability of which has surprised unwary leaners. Sam Richardson uses a variety of plastic media, meticulously finished and carefully colored, to make miniature "plugs" of the landscape, which appear to be sliced out of some tiny planet for our inspection.

Interestingly, the response to nature that spurs an individual to create this type of art needn't be the idyllic nature loving attitude that one might assume. At first glance, some of Ira Joel Haber's little boxes may appear to be paeans to the goodness of Mother Nature. However, the artist comments:

> Nature frightens. No slow early morning walks in the country for me. Nature is a mother with a knife, ready to pounce on us without warning. Mountains collapse, rivers reclaim, skies open up, and caves swallow. But there is also beauty in this destruction. Keeping as far away from all things that are natural is what I have a sweet tooth for. The landscapes of my mind reach out for other minds in beautiful acts of aggression. Having never felt the pressure to work large or outdoors, I've been left alone long enough to find my tongue and speak the truth. There is a bigness about working small.[5]

Thus one discovers the darker side of nature at large, as Haber presents expanses of blackened poles—forests ravaged by fire. And there are cases in Haber's world where little trees have pitilessly collapsed on, and smashed in, the roofs of little houses.

Far from recounting the devastation wreaked by nature on itself and humanity, other artists seek ideas to prevent the world from falling into an ecological calamity of human origin. Since 1971, Newton and Helen Harrison have been working with *Survival Pieces*, which fuse their aesthetic interests in natural processes with practical design and the application of artificial life systems that may provide food for considerable numbers of people. They have built a *Portable Orchard* (1975) for Orange County, California; ironically, given the ecological decay of that area, within a few years the indoor *Portable Orchard* may be the only grove capable of existing in the region.

Harrison's current projects include designing artificial lagoons and estuarial systems to support huge quantities of mollusks and crustaceans for periodic "harvests." How the aesthetics still flourish in this state of art/science symbiosis is discussed by Harrison:

> When I commit to an idea as complex as the *Survival Pieces*, I make a private bargain to stay with it no matter the time, labor, or difficult turns the work may

take. This contract carries with it the inference that as an artist I will be able to distill from the many processes involved the very specialized functions that carry the message "art." The idea of making a primary choice of some kind and then "behaving it out" is very attractive. And with good reason; it is at the core of many people's work aside from my own. It offers ongoing rediscovery of the art sensibility and endless new forms. Reification used in this way brings formerly inaccessible material into the domain of art. The temptation to manipulate this material until it resembles already known art carries with it the danger of losing the power of the original subject matter, once more reinforcing the narcissistic position that art is the only fit subject matter for art.[6]

As with any of the process pieces it includes, this exhibit cannot presume to delimit and define its subject matter in toto, fix it in time, or elucidate its "meaning" with finality. However, the show should serve as a useful cross section, taken at an appropriate moment, which allows a sustained, interested examination of its protean theme. Yet within the infinitely expansible context of art, environment-related art carries the happy inference that the making of art, an exclusively human enterprise that in a way sets us apart from the rest of nature, may now lead us full circle into a mutually beneficial interaction with nature. *Homo sapiens* is, after all, just another component of the natural environment, and at some locus, his production should attain congruence and compatibility with that of nature. If art, a continuous process of generation, can frequent that locus, it would seem only natural.

NOTES

1. Documentation and discussion of these contemporary art tendencies can be found in such books as Lucy R. Lippard, ed. and annot., *The Dematerialization of the Art Object from 1966 to 1972* (New York: Praeger Publishers, 1973); Jack Burnham, *Beyond Modern Sculpture* (New York: George Braziller, 1968); Sam Hunter, *American Art of the Twentieth Century* (New York: Harry N. Abrams, 1973); and Gyorgy Kepes, ed., *Arts of the Environment* (New York: George Braziller, 1972).

2. Robert Smithson and Gregoire Muller, "'...The Earth, Subject to Cataclysms, Is a Cruel Master,'" *Arts* 46, no. 2 (November 1971), p. 40.

3. From a personal statement by the artist, 1971.

4. From a personal statement by the artist in the *Allen Memorial Art Museum Bulletin,* 30 (Spring 1973), p. 103.

5. From a personal statement by the artist.

6. Newton Harrison, *Lagoon: Survival Piece 8,* in "Three Projects: Harrison, Mock, McGowin," *Art in America* 62, no. 1 (January–February 1974), pp. 68–69.

INDEX

Page references for illustrations are in **boldface** type.